THE ROAD TO RIVERDANCE

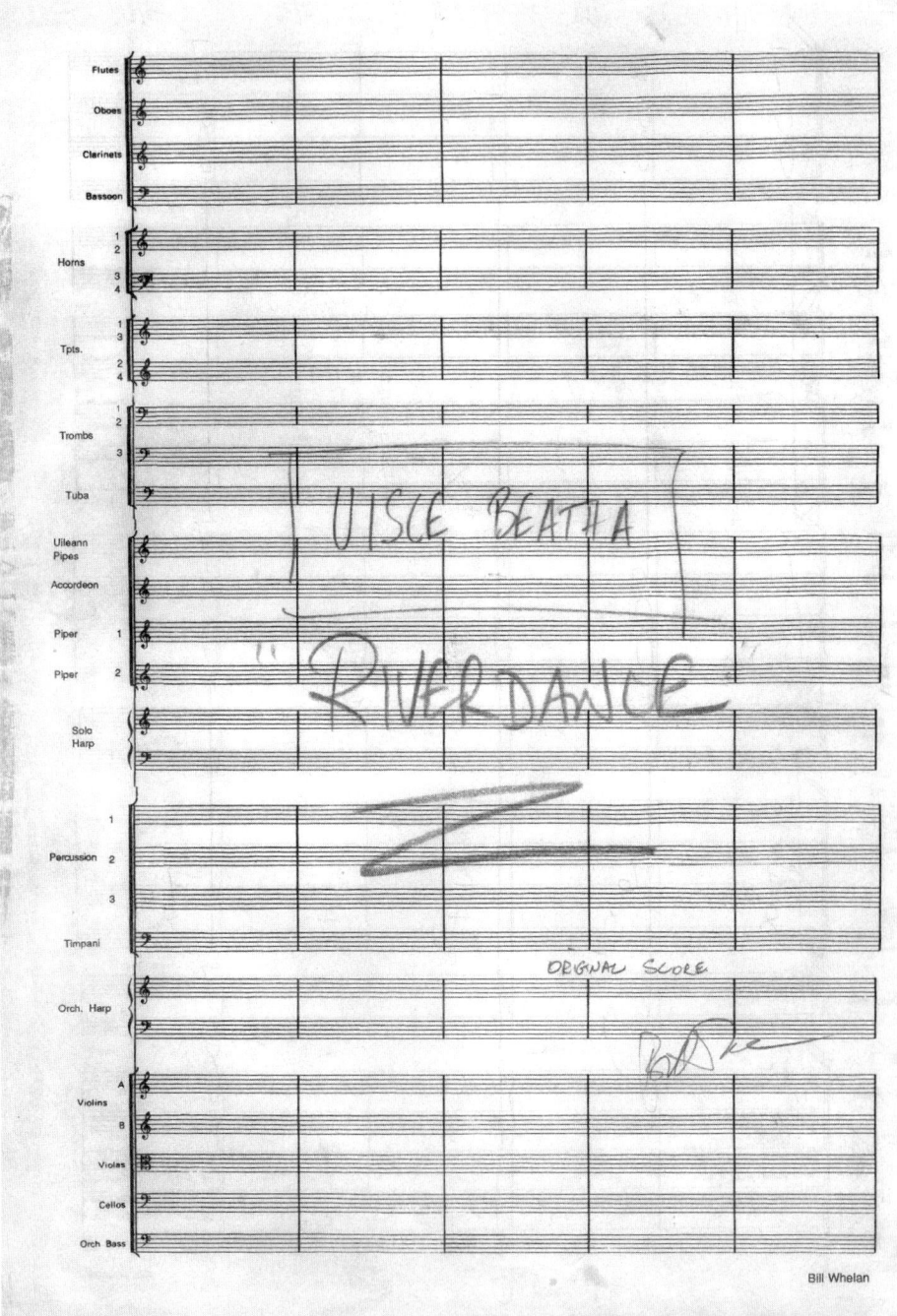

Original handwritten score of Riverdance, *1994, showing the subsequent name change.*

THE ROAD TO RIVERDANCE

BILL WHELAN

THE LILLIPUT PRESS
DUBLIN

First published 2022 by
THE LILLIPUT PRESS
62–63 Sitric Road, Arbour Hill
Dublin 7, Ireland
www.lilliputpress.ie

Copyright © 2022 Bill Whelan
Foreword © Fergal Keane
Index © Julitta Clancy, assisted by Elizabeth Clancy

Paperback ISBN 9781843518525
Hardback ISBN 9781843518600
Ebook ISBN 9781843518617

All rights reserved. No part of this publication
may be reproduced in any form or by any means
without the prior permission of the publisher.

A CIP record for this title is available
from the British Library.

10 9 8 7 6 5 4 3 2 1

The Lilliput Press gratefully acknowledges
the financial support of the Arts Council/
An Chomhairle Ealaíon

Set in 12pt on 16pt Granjon by iota (iota-books.ie)
Printed in Spain by Castuera

*For Dave and Irene
who built the boat
and for Denise,
who always fills the sails.*

Contents

Foreword ix
Acknowledgments xi

Prologue: The Point Theatre, Dublin, 1994 xv

PART 1: 1950s – NEST AND NOURISHMENT

1. A Limerick Childhood – Home and Family 3
2. Pipe Bombs and Newsprint 15
3. The Nuns – Holy Disorder 19
4. Dave Whelan – Opening My Ears 23
5. Irene Lawlor – Love and Sacrifice 31
6. The Jesuits – Musical First Steps 38

PART 2: 1960s – GROWTH AND DISCOVERY

7. Comedy, Bands and Travel 53
8. Crime and Punishment – the Docket Book 63
9. Limerick's Abbey Road – the Vortexion 69
10. UCD and a Crash at Lissycasey 74
11. College Life, Denise Quinn and London 83

PART 3: 1970s – LEARNING AND GRIEVING

12. Denise – the Second Sighting 97
13. Richard Harris, *Bloomfield* and the Limerick District Court 102
14. The King's Inns and John Cosgrove 114
15. Dave Whelan – Leavetaking 119
16. Trend Studios and Down in the Pits 123
17. Denise in Belfast – Joining the Dots 133
18. Danny Doyle and *Saturday Live* 142
19. A Honeymoon 147
20. Stacc, the Jingles and the Springer Spaniel 153
21. The Dubliners, the Bards and Windmill Lane 165

PART 4: 1980s – HINTS AND EXPLORATIONS

22. What's Another Year	175
23. Irene Departs	184
24. The Winds of Change, the 'Galways' and Planxty	187
25. Kate Bush	201
26. Van the Man	205
27. U2, Minor Detail and Dickie Rock	210
28. Noel Pearson, the Dublin District Court	218
29. New York – Beating the Golden Pavements	226
30. Seán Ó Ríada and Elmer Bernstein	238
31. Alcohol – the Yeats Festival	247

PART 5: 1990s – *UISCE BEATHA* – THE WATERSHED

32. *An Eye on the Music* and Seville	257
33. *Trinity* – Leon Uris	264
34. *The Spirit of Mayo* and Working with the Corrs	270
35. *Riverdance* – the Interval Act	275
36. *Riverdance the Show*	287
37. Reflections	306
Notes	311
Catalogue of Compositions by Bill Whelan	321
Index	327

Illustrations fall between pages 112 & 113 and 224 & 225 respectively.

FOREWORD

I have a bias. It is implacable. And remorseless. These pages are not the place to deny it. In fact, there is no place to deny it. If there was, you would not find me there. I belong to the Arch Confraternity of Bill Whelan Admirers (ACBWA) – a secret society of writers, musicians, dancers, chancers, Munster Rugby parking attendants, crubeen curers, dipsomaniac reverend mothers and the kind of people your in-laws would not want at the wedding. If you had a spare fiver, we would be on to you fast. And we know each other. A sly glance, a smart-alec remark, a sardonic snort half-heard. These are our rituals of recognition.

The Limerick evoked in this book was already vanishing when I lived there in 1979 as a reporter for the *Limerick Leader*. Bill brings it to life with verve and sympathy. We are shown the Limerick of Jesuits and convents, horses and hansom cabs, steam trains and coalmen, shawlies and hawkers. We visit places that have since disappeared, like Matterson's bacon factory, Naughton's chipper and Bill's own family shop Whelan's, where newspapers like the *Irish Press* were sold alongside *The Beezer* and *School Friend*. Always in the background are the

acoustics of Bill's formative years, the speech-music, accents and mannerisms of the Limerick people. We are taken through the sounds of the 60s where 'Telstar' sits comfortably alongside 'The Walls of Limerick' and where the teenage Bill (in his fledgling recording studio housed in the family attic) takes on the rock 'n' roll dreams of Limerick's aspiring stars alongside a determination to compose and record his own music.

But there are hard realities to face when making a living as a musician in Ireland. Bill takes us through the joys and despairs that go with holding onto a dream while trying to survive in an industry that was second-guessing itself long before the explosive phenomenon of *Riverdance*. Whereas the likes of myself – a young singing-guitar player back in the day – drifted the way of many would-be stars where my talents were only called upon at social occasions where audiences were dulled by porter and grim wine, Bill stayed the course. Some might say this was because of his innate tenacity; he says it's down to 'luck, experience, and hard work'. But I think it's because he loves what happens when he sits before a piano. It brings out a magic in him that he can't name but that he knows belongs to him and him alone.

Thankfully for us, he has honed and shared this magic; his creative and collaborative instincts have taken him and Irish culture worldwide. In these pages, he has written a warm, affectionate hymn to Irish music and the men and women who gave it to the world. He is one of those rare figures who changed how Ireland felt about itself and how the world saw Ireland. He is one of our 'greats'.

With reluctance, Bill was persuaded by the ACBWA to commit the stories of his life to print. He is a modest man. Nearly. In a life dedicated to music – and with the love of a great woman, Denise, four fine children, being blessed with the gift of friendship and having the occasional brush with enemies – he has much to tell us. The result is a mighty book. I laughed a lot.

Fergal Keane, August 2022

ACKNOWLEDGMENTS

To Kathy Gilfillan, who was the first to see there might be a book here, and who convinced and encouraged me to get up onto the bike. To Jennifer Brady, the most particular of editors, who combines the qualities of a microsurgeon with those of an evangelist – each time I looked up, there you were.

Thank you to Julia Kennedy, my researcher, who delved into the archival dust of Limerick newspapers, the King's Inns, RTÉ and other sources, and who spoke on my behalf to so many figures from my past – you have made my job so much easier.

I am ever grateful to the first readers who pored over early versions of the text and came back with many helpful observations and encouragements: David Brophy, Gabriel Byrne, Aidan Connolly, John D'Ardis, Mary D'Ardis, Barbara Galavan, Teri Hayden, Andy Irvine, Fergal Keane, Lara Marlowe, Liz Nugent, Brian Palfrey, Barry Quinn and Darren Timoney.

To Antony Farrell at the Lilliput Press for all the advice and good counsel and to Ruth Hallinan, Bridget Farrell and Djinn von Noorden for so expertly guiding the boat into dock. To Niall McCormack for

ACKNOWLEDGMENTS

bearing up with the back-and-forth of the cover design. For the darker art of typesetting, thank you to Cillian and Marsha at iota-books.ie – together with the indexing work of Julitta Clancy and Elizabeth Clancy, all of you brought home the bacon (not Matterson's).

To Barbara Galavan for overseeing the oversights and spotting the potholes. To Aislinn Meehan, ever the shepherd and goalkeeper and the best PA on earth. To Paul McGuinness for shouldering the wheel just when it was needed. To Padraic Ferry for his gimlet legal eye. To Peter O'Connell for skilfully ushering the book into the wider world of broadcast and print media. To Grant Howie at Grants for scanning the images.

To the following friends and colleagues who so generously took phonecalls, looked up diaries, adjusted my faulty recall and reminded me that I wasn't the great fella I thought I was: Peter Ahern, Mavis Ascott, Robert Ballagh, Jean Butler, Maurice Cassidy, Pat Cowap, Joe Dowling, Colin Dunne, Julian Erskine, Anne Flanagan, Donal Fitzgibbon, Jim Flannery, Merle Frimark, Brendan Graham, John Halpin, Eileen Hudson, Cliona Lyons, Bill Myers, Brian Nolan, Aidan O'Connell, Paul O'Mahony, Peter O'Dowd, Peadar Ó Ríada, Aidan O'Sullivan, Roman Paska, Mick Reeves, Billy Sinden and Ged Spencer.

To Niall Connery, friend and lyricist, whose presence is threaded throughout this book. I was your Best Man, and you were mine – in so many ways.

In memoriam of my life-long friend Conor Gunne (1950–2022) and with sympathy to his love, Nessa.

And especially to Denise. And to David, Nessa, Fiona and Brian Whelan, whose influences are everywhere. To their partners Veronika Soumarova, Saad Filali, Darren Timoney, Eimear King and our grandchildren Riad, Aidan, Bill, Theo and Julian. I am blessed to have you all in our growing family – I hope you are only mildly embarrassed by what you read here.

To my Aunt Flo, for introducing me to harmony, now in her 99th year as I write this (and still singing).

Finally, to all in my wider musical recording and performing family. There is no way to bring what begins on the page to the eyes and ears of

the audience without each of your gifted interventions and interpretations. I won't say anything schmalzy like I love you all, but if love has a mix of wonder, empathy, attachment and admiration, I probably must do anyway. Thank you.

Bill Whelan, Roundstone, August 2022

PROLOGUE
The Point Theatre, Dublin, 1994

Dark-suited armed security men stand about twenty feet apart in front of the stage, arms folded, facing the audience, eyes scanning the crowd – impassive, watchful and seemingly impervious to what is happening behind them. For them, the show itself is not the focus; the attendees are: the Israeli delegation comes in for special protective attention; the Belfast/Good Friday Agreement is a few years away; who knows who might use the Eurovision as a platform for a spectacular political stunt? The theatre is at full capacity, including special guests, the President of Ireland, Mary Robinson, several TDs and dignitaries from many countries. The audience is high-spirited throughout the evening, waving flags and cheering. But the security team stand stock still, expressionless, a study in sphinx-like professionalism.

It is 1994, and the Point Theatre in Dublin is hosting the Eurovision Song Contest. Denise and I are in one of the front rows; the first part of the contest has just finished, and the juries are considering their verdicts – our moment has come: the interval act. The tension is unbearable.

PROLOGUE: THE POINT THEATRE, DUBLIN, 1994

Four months of composition and intense rehearsal is about to be revealed before a 3000-strong audience in the theatre, but even more nerve-wracking, a TV audience of 300 million. Of course, it would be live. No margin for error. No safety net. Twenty-six dancers, led by the remarkable Jean Butler and Michael Flatley, are about to perform what has been endlessly rehearsed for weeks in sweaty dance studios.

With theatrical gravitas, the presenters, Gerry Ryan and Cynthia Ní Mhurchú, simultaneously announce: 'Ladies and Gentlemen … "Riverdance!"' Katie McMahon, soprano with the chamber choir Anúna, begins the choral introduction. In such an enormous venue, her pure ethereal solo voice commands attention and focuses the audience as a prelude to what is to come.

Over the next seven minutes, something unforgettable happens. The developments in Irish music over the preceding decades unite with the power of Irish dance in a celebratory and theatrical way that evokes a visceral response from the audience. It is as if we had been waiting for this type of performance for a long time, here it is at last and yet it catches everybody by surprise. The audience greets it with an exclamatory 'YES!' as if 'Riverdance' sprang from nowhere.

But 'Riverdance' did not spring from nowhere.

There's a saying: luck is what happens when preparation meets opportunity. Luck, in this case, was the result of meticulous months-long prep, decades of experimentation in Irish music and technique and prowess in Irish dance and *centuries* of Irish culture.

As the last note sounds and the final footfall of 'Riverdance' pounds the floor, the audience jumps to their feet and rewards us with prolonged applause. I look at the security men, impassive, poker-faced and watchful. They are exactly as they were before the piece began.

But for the rest of us, everything has changed.

PART I
1950s – Nest and Nourishment

If we've lived in a city long enough to have given our truest and deepest feelings to its prospects, there comes a time when – just as a song recalls a lost love – particular streets, images, and vistas will do the same.

– Orhan Pamuk, *Istanbul: Memories and the City*

1. A Limerick Childhood – Home and Family

A voice. Late afternoon. Echoing round the streets of Newtown Pery.
 'Co-hole!'
 Barely audible …
 'Co-hole!'
 Two notes – as in the cuckoo's song.
 'Chronny-co-hole … Haddle Limmry-Chronny-co-hole!'
 Approaching the back lanes.
 'Pressaddled, Limmry-Chronny-co-hole.'
Jack Nash's song floats around the Georgian corners of Limerick's streets. The words sound like some esoteric chant, becoming clearer as he approaches, though their meaning eludes all who do not understand the local accent.
 Pressaddled, Limmry-Chronny-co-hole is how Jack pronounces *Press, Herald* and *Limerick Chronicle*. His customary sales position is outside the *Limerick Leader* offices on O'Connell Street, where the newspapers are stacked in a nest of fruit boxes. But he also operates a mobile service, wandering jauntily through the streets and lanes, coat-tails

a-flitter, singing the names of the sheaves of newsprint bunched under his arm. He is young and fit and wears a hat like the ones the Men of the West wear in a Seán Keating painting, though Jack's is battered, greasy and often rainsoaked. On Sundays, his barker's call is for the *Press, Independent*, *Review*, *Dispatch* and *People* delivered in plainchant style, and I remember that the 'Pee-pul' had a similar cuckoo two-tone cadence to the 'Co-hole' at the end of 'Chronicle'.

I lie in bed in Barrington Street, the sun setting in the gap between St Joseph's Church and O'Malley's house next door, Jack doing his evening rounds. Early bed in summer means lying in dusky crimson light, listening to the aural fade of the city: older kids still playing in the lanes, swallows swirling round the eaves and the evening flights making their growling westerly approach to land at Shannon Airport. Soon all will be quiet, bar adult-murmuring from the kitchen. I will be left to my thoughts. I am drifting off, having said goodnight to my guardian angel:

> *Angel of God, my Guardian dear*
> *To whom God's love commits me here*
> *Ever this day, be at my side*
> *To light and guard, to rule and guide*
> *Amen*

A kiss from my mother; curl into the sheets.

Sleep will not come; fears and terrors invade my mind. I have recurring horrors. One is that the end of the world is imminent; a car horn (Gabriel's trumpet announcing the Apocalypse?) sets off panic. Another is that time will pass too quickly. My parents will die. I'll be abandoned. (In time, this did happen, and neither my guardian angel nor I could do a thing to stop it.) But my absolute tongue-biting, stomach-clenching horror is especially reserved for a concept:

ETERNITY

1. A LIMERICK CHILDHOOD – HOME AND FAMILY

When I allow my imagination to pore over the notion that conscious experience might never end, the sheer size of that thought, and the inability of my brain to accommodate it, propels me with a whiplash-like force, upright in the bed, eyes wide, breathless, close to vomiting. My parents find me back down with them in the kitchen on nights like this, shivering and mute; these sporadic moments of terror punctuate my early memories.

Our sense of place defines us; growing up when, and particularly where I did in 1950s Limerick, profoundly affected how I perceived the world and my position in it. Our house, 18 Barrington Street, presented contrasting impressions depending on which exit you used. From the front door, you got Limerick's version of Harley or Wimpole Street. Private nursing homes (mostly maternity) and medical practices implied security and care. Doctors and dentists ran their clinics from the ground floors of their five-storey Georgian homes, lived upstairs with their families and parked their swishy cars outside. (Dr McDonnell, for example, had a massive imported American Buick.) St Michael's Protestant church and school at the end of the street implied solid sensibility and conservative gentility. From the back door, the picture was dramatically different. Little Barrington Street (or School House Lane) comprised a terrace of tiny two-storey cottages where cramped living conditions and poor facilities made for a more frugal kind of living; nevertheless, these homes accommodated large families. The Tobins, directly behind our house, had so many children I never got to know them all; they were coming and going, day and night. An open sewer ran the length of the lane and emptied into a shore-hole covered with a slate slab where you would see rats foraging among the eggshells and potato skins.

Ab Sheahan, uncle to Frank and Malachy McCourt Jr, lived in one of these houses.[1] The McCourt family had emigrated at that stage, and Ab lived alone. When Ab became frail, and even his customary lopsided gait deserted him, my mother sent me to his house with his lunch every day. His kitchen was dark. Sooty grime covered the walls from the open

fire where he cooked. The house was lit by candles, and while I never knew what Ab's toilet arrangements were, I knew that the house next door had none.²

At the end of the lane were the Lillises, who kept chickens and geese that wandered freely around the street. Beside the Lillises was a place of particular significance: the house of Imelda Lyons and her two beautiful daughters, Sylvia and Phyllis. I never knew where their father was. England, somebody said. Being a few years older than me, Phyllis was the subject of many boyhood fantasies. She had long hair, a luminously beautiful face, big eyes and a full mouth. She wore red lipstick, hooped gypsy earrings and clothes that recalled *Carmen* or one of those exotic women from my father's films. I once overheard my father say that her sister, Sylvia, had a 'beautiful carriage'. When I asked where she kept her horse, my father laughed and told me to run and play.

Occasionally, I was left in the care of Imelda, their mother, who also did some cleaning in our house. We called her Lyonzie, and I doted on her. Not only was she great fun to be with, but she took me for walks down Parnell Street, where all the pigs and bacon shops were. We'd pass the side of Matterson's on Lady's Lane, where through a small, barred window, we'd see pigs squealing and screeching down the narrow corridor on the way, Lyonzie told me, to becoming sausages. I was spared the details of how this transformation was achieved, but I certainly relished the results.

On the way home, Lyonzie would bring me into Naughton's chip shop and buy me a bag of greasy sausage and chips with lashings of salt and vinegar. I devoured these with the kind of delight my mother never saw over her carefully prepared dinners. These extra-gastronomic excursions were not encouraged, but their clandestine nature brought extra relish to the taste.

'Why aren't you eating your dinner, Billy?'
'Not hungry, Ma.'
'Hmm … were you out with Lyonzie for a walk today?'
Silence.

1. A LIMERICK CHILDHOOD – HOME AND FAMILY

In those days, goods and products were transported around the city by horse and cart. Each house on Barrington Street had a manhole with a cast iron cover concealing a cellar. The coalman arrived with his horse and dray, removed the cover and, hefting the big bags one by one onto his shoulder, emptied them down the manhole. I loved the sharp crack as the heavy inverted sack hit the path and then the long, shivering shower of coal spilling into the chasm, twelve feet below, the sound bouncing off the curving cellar walls. To protect his coat, the coalman always put a disused bag on his shoulder first, pointless since the coat was grungier than the bag. When I got older, I was sent to the front window to count the bags, to make sure we were getting what we had ordered.

We were so accustomed to horses on the streets in the 1950s I even have a foggy recollection of going to a Whelan family funeral in a growler or hansom cab. Horses were everywhere, as was evidence of their passing with its distinctive and evocative horsey smell. Bertie Hogan drove the horse and cart for the Tinsleys and the McMahons, the timber people. He also did nixers for my parents, for example, if they wanted something like a piece of furniture moved. Bertie was almost deaf, which meant you had to shout at him before he heard the request. Otherwise, he'd nod his head as if he understood, then ignore what you *thought* you'd asked him to do. Even if you were right beside him, you'd have to roar as if he were three fields away.

One day I was kicking a football with Mick Fraser, who lived in the tenement end of Barrington Street where five houses were let out in flats when our brave horseman Bertie passed by on his bike.

'Hey Bertie,' Mick roared, 'will you be carryin' down the horse?'

'I'll be goin' below to the yard in a while,' says Bertie.

'Will you give us a jant, will ya?' bellowed Mick. 'Ah g'wan, will ya?'

Bertie cycled off down the hill of Schoolhouse Lane and reappeared as promised, with his old brown mare pulling the big red low-loading dray behind him. As he turned into Barrington Street, he gave Mick a nod. We jumped onto the cart, and off we went, two outlaws on the streets of Laramie, with Champion the Wonder Horse trotting

unevenly over the teeth-shattering cobbles, ready to fight any sheriff or redskin varmint we might encounter. We were, as the old Dublin saying goes, 'in our Grannies' – the place where anything is possible, and all is permitted.

There were many such opportunities in 1950s Limerick for young adventurers. The arrival of health and safety regulations changed that. Sensibly, these exploits would now be deemed hazardous, but back then, nobody seemed concerned. My boyhood pal, Leo McDonnell, and I occasionally wandered to the railway line at Limerick station while our mothers thought we were playing in the park on Pery Square. The romance of rail travel was magnetic, and we picked our way over the sleepers to where the massive steam engines were shunting goods-carriages and hitching up cars from the cement factory in Mungret. The trick was to place ourselves at the steam engines when they paused, hissing and belching like Bertie Hogan's horse after climbing Barrack Hill. We'd look pleadingly at the driver and make signs with our thumbs like we'd seen hitchers do on O'Connell Avenue looking for lifts to Adare or Cork. Eventually, a driver would melt to our charms, reach down and lift us into the cabin: 'Right lads, only a short run now. That's all ye're getting.'

He'd put his hand on the iron throttle and turn it to the right. Then we'd hear the powerful whooshes of steam from underneath us as the engine moved slowly through a curtain of vaporous haze and a chorus of screeching steel and iron. Off we went, out along the shunting spur line to Rosbrien. Sometimes the driver let us pull the chain, and the whistle's reverb sounded around the houses of Roxboro Road. At Rosbrien, we'd reverse down a siding, pick up extra railcars, and then back to Limerick station and the shunting yard. The odd time, the driver let us put our hands on the throttle or shovel some of the oily coal into the fiery mouth of the furnace. I wondered if hell could be hotter than it was in there. Years later, when I heard Warren Zevon's 'Nightime in the Switching Yard', these days were brought vividly to life. Finally, the driver would lower us back down onto the shingle around the rail track near Limerick station: 'Now,

1. A LIMERICK CHILDHOOD – HOME AND FAMILY

feck off home with ye, and tell no one ye were out in Rosbrien, or I'll be murdered.'

His secret was safe.

I recently read Orhan Pamuk's engaging story of his early life, *Istanbul: Memories and the City*, and was taken by a similar experience to his I had as a boy in 18 Barrington Street. In one of our bedrooms, rarely used, was a piece of furniture with a central full-length mirror and wing mirrors that swivelled on hinges. Like Pamuk, whose mother had a similar piece in her room, I could arrange the side mirrors in such a way as to see a million images of myself echoing off into the distance. I'd stare at this illusion, overtaken by existential panic akin to the feeling I had when I thought about eternity.

It was one of the many times as a boy, alone in that big house, I faced intimations of the incomprehensible nature of the self. I'd hear myself say: I am me, not anyone else! And this realization was profoundly upsetting. Often, my instinct was to run; find something to distract me from the dizziness of it. It was like staring down a bottomless well. Times like these I wished for a brother or sister.

My parents – Dave Whelan and Irene Lawlor – were late to child-bearing. He was forty-four and she was thirty-five when they married on 29 June 1945. I was an only child. They lost a baby before I arrived on 22 May 1950. All I knew about the baby was that his name was Stephen, and that he died during, or shortly after, childbirth.

Their backgrounds were diverse. Both came from families who began life in Dublin but moved to Limerick for different reasons. My mother's family, the Lawlors, left Dublin because my grandmother Mary, née Hughes, was unhappy living in a turbulent city of riot and revolution in the early 1900s. She was originally from Monaghan and feared the Irish Republican Army (IRA), the Irish Republican Brotherhood (IRB) or any nationalist organizations active at the time. She persuaded my grandfather, Michael, a tailor at McBirneys in Dublin,[3] to apply for a position as a cutter in Todds of Limerick. He got the job, and the

family moved south. The Lawlors were physically small, middle class and lived in swanky-ish Ballinacurra. Their children were expected to head for careers in religion or the professions.

The Whelans, by contrast, were tall, came from trade (fitters and labourers), were early school-leavers and were marked with Limerick working-class signifiers – accents, for example. My father called me Willum; to my mother, I was Billy. Before advancing to serious competitive rowing, my father was a member of a *junor rown* club; to my mother, he was a member of a junior row*ing* club – those extra syllables or elisions said much about where you came from. The native Limerick accent has a distinctive music to it. It is spoken slowly, largo, as opposed to the clipped staccato of Kerry or Belfast. Despite its unhurried pace, syllables considered unnecessary are dispensed with: junior becomes junor. And William becomes, well, Willum.

When I heard WILLUM bellowed in the house, I knew things were amiss. This was not often. My father, Dave Whelan, was mild-mannered, and (this may seem odd in the context of today's style of parenting), he only hit me once. I don't recall what it was about; we were in the kitchen, him leaning over the sink washing dishes, when he turned suddenly and whacked me on the shoulder. The shock. A stream of hot pee coursed down my leg. I was so winded I couldn't cry.

Time stopped ticking.

I can still see the blue tiles behind the sink, the yellowing cracked plaster, the Ascot geyser running hot water into the basin, and my father's face furrowed, frowning: 'Go upstairs and change your pants, Willum.'

Time started ticking again.

Now, when my daughter or her husband threatens our grandson Riad with 'time out', I remember what 'time out' meant to me that day at the sink in Limerick. A rare display of anger from my father. I had rattled his cage about something. Mostly, he was the peacemaker between my mother and me. She had easy recourse to the wooden spoon: my scarlet legs were a testament to the creative uses of kitchen utensils.

1. A LIMERICK CHILDHOOD – HOME AND FAMILY

The Whelans were in Limerick because my grandfather had a chequered history with the British authorities. Dave Whelan was born in 1901 in Limerick. His father, William Whelan, a Dubliner, was born in 1853. It only dawned on me recently that my grandfather was a baby around the Famine years, a realization that draws that genocidal period closer than it seemed in history class. As a youth, Grandfather William (Bill, as he was known) was a member of or closely associated with the Invincibles – a nationalist group splintered from the IRB. His brother Daniel was arrested and imprisoned in Kilmainham Gaol in 1882 for conspiring to distribute 'large quantities of arms and ammunition to disloyal persons and other illegal abuses'.[4] Bill himself was incarcerated in Harold's Cross Gaol, aged fourteen, for some anti-British offence. When he was released, he couldn't find work in Dublin because of his republican record. So, he moved to Limerick, where he found more appreciation for his past achievements. He met Mary Campbell (my grandmother) there and married her in 1884.

> **MR W. WHELAN, LIMERICK.**
> Our obituary columns this week announce the death of Mr William P. Whelan, of Limerick. Mr Whelan was the brother of Mrs F. J. Doran, of Massabielle, Watson Avenue, Rutherglen. He died at his residence in Limerick on the 22nd inst. Mr Whelan was for a number of years resident in Glasgow, and will still be remembered affectionately, especially by Nationalists of the Hutchesontown district, with whom he was closely associated. Like all his family, he was a Nationalist of the most uncompromising type, and while quite a lad had the distinction of being arrested, on Ash Wednesday morning, 1867, the morning of the Fenian rising, as a Fenian rebel. He lay for months in Harold's Cross Jail without trial, an experience which his brother, the late Mr Dan Whelan, was destined to repeat for even a longer period under Forster's infamous Coercion Act. Mr Whelan, during his stay in Glasgow, took active part in the National movement in its every aspect. He lived in St Francis' parish, and was one of the original founders of the Electoral Union, which afterwards became the "William O'Brien" Branch of the National League. He left Glasgow for Limerick over twenty years ago, and has resided there ever since, having taken active part in political and municipal matters in the city of his adoption during his residence there. R.I.P.

Obituary from a Glasgow newspaper for grandfather William Whelan.

PART I: 1950S – NEST AND NOURISHMENT

My father's side of the family observed an omertà on all matters to do with 1916, the subsequent War of Independence and the Civil War. His three brothers and four sisters were a reserved brood that kept mainly to itself. This reticence to engage in too much sociability may have sprung from living during the Irish struggle for independence, where a stray word could have disastrous consequences. I only found out recently that as a teenager, my father was involved in blowing up two bridges: one in Annacotty in County Limerick and the other in Bunratty, County Clare. I never realized he was so active. However, bubbling under this opaque exterior was a gentle humour: wry, ticklish and sharp, that occasionally stretched to the scatological, delivered with winking schoolboy mischief, evoking eye-rolling mock annoyance from my mother.

My father's two sisters, Celia and Kathleen, were kind and lavished attention on me, their nephew. I was the only Whelan offspring to keep the name alive: none of my father's three brothers produced heirs. One brother, Willie, was a monk in Roscrea. He was gentle and, like the rest of them, so tall, I was convinced he could touch the clouds. As a boy, I accompanied my father on his yearly visit to the monastery where I learnt what a vow of silence meant. I witnessed my uncle Willie communicating with the monks by sign language, though he was allowed speak to us. Another brother, John, taught at the Municipal Technical Institute on O'Connell Avenue. I have no memory of him except for a vague image of a moustache.

Celia and Kathleen ran a sweet and newspaper shop on Wolfe Tone Street under the name Pádraig Ó Faoláin.[5] My uncle, Pat Whelan, had owned the shop, but as he became more involved in Limerick political life, his sisters took over the running of it. I was fond of Uncle Pat – he'd an upright, military bearing and a bulbous nose advertising familiarity with whiskey and late evenings; he conducted much of his political business from Mulcahy's pub on High Street. I remember being sent there to give him a message and was struck by the dark, musky atmosphere oozing from the wooden barrels in the conspiratorial sawdust.

For all the Whelans' habitual silence on matters historical, I discovered via the Bureau of Military History (BMH) that my uncle Pat served

his country well during the revolutionary period around 1916.[6] One of the most striking stories from his witness statement concerned his membership of the IRB, a revolutionary organization bound by an oath of absolute secrecy. One evening he attended a clandestine meeting of the IRB in Limerick. He arrived at the appointed house and, looking around the room, saw a few faces he recognized. One of the senior men present was his own father. He had no idea until he saw William Whelan sitting there that they were members of the same underground organization.

Given that both men lived in the same house, this was a testament to their absolute and strict observance of secrecy. Pat was active up to and including the War of Independence 1919–21. My father told me that he was regularly pulled out of his house at night by the Black and Tans. He was sometimes blindfolded, put on a truck with a gun to his head, and driven around the city as a human shield into areas of Limerick where the Tans knew they'd be targets. He continued his active involvement in the IRB, but a murkier silence descended when the Civil War ensued (1922–3). I have no idea what he got up to then. Given their Labour affiliations, I suspect all the family took little or no part in proceedings. Pat did not reappear until his involvement in Limerick local politics later when he later ran unsuccessfully for mayor.

Pat, Celia and Kathleen lived together in the Whelan family home, Celtic Villa, on a terrace of neat houses on O'Connell Avenue, suitably middle class – distinct from the nouveau riche in emerging Ballinacurra or the old merchant money on the Ennis Road.

On the rare occasions when my mother and father went to the 'pitchers' at one of Limerick's many cinemas, my two maiden aunts, Celia and Kathleen, babysat. They arrived, pockets full of sweets or biscuits, which I happily stuffed into myself, only to return them later via an explosive semi-digested spume having had some nightmare involving banshees or the boogeyman. The challenge then, for all three of us, was to get the puke cleaned up and me back into bed before my parents returned from an evening with Greta Garbo or James Cagney.

The rest of my father's family remains a mystery to me. I remember when my uncle Willie died in the Cistercian Monastery in Roscrea.

PART I: 1950S – NEST AND NOURISHMENT

My father returned from Willie's funeral having witnessed his brother being buried in a sack. Willie's possessions came back to Limerick in a shoebox. In it were rosary beads, a penknife and a prayerbook – nothing else. As a boy, I often pulled out this box, examined the contents and wondered how a man got through life owning just three things. Well, four if you include the box.[7]

2. Pipe Bombs and Newsprint

BANG! The explosion echoed around the red-brick walls of Newtown Pery, the Georgian Quarter of Limerick. Here, amongst the half-built or abandoned houses, is where we climbed, explored and got up to mischief – Cowboys and Indians; Germans and GIs, Japs and Geronimos peopled these urban theatres. Our young minds gave free rein to imagination and enacted mayhem and havoc. From time to time, as a break from the fantastical, they strayed into the real world.

'Reeves knows how to make a pipe bomb,' said Blookie Coughlan, removing his brother's FCA helmet and laying down his wooden machine gun, which doubled as a hurley. We'd just had a ferocious gun battle with the Japs in the hot streets of Mandalay.

'What?' we all stared at him.

'Yeah, he told me last night. Just a mixture of weedkiller and sugar, a fuse, and a length of copper pipe. Fill the pipe with the powder mix, shove in the fuse, hammer both ends closed, stick it in a brick wall, light the fuse and stand well back.'

Our mouths were open.

'My da has loads of weedkiller in the cellar,' I offered.

'And I can get any amount of sugar from our pantry,' said an excited O'Connell.

'No problem with the copper piping,' said Wirey Spencer, whose father had a plumbing business.

The four conspirators sat and considered the plot.

'The fuse,' said O'Connell. 'We have no fuse.'

'Sully will know,' said Blookie. 'I'll be seeing him tonight. The rest of you bring your stuff, and let's meet here tomorrow after Benediction in the Jesuits.' He flipped his helmet on and headed back into the killing streets of Mandalay.

The following day at the appointed time, the deadly gang had morphed from soldiers in the heat of Burma to explosive experts planning to blow up the English Parliament. We assembled in the old, ruined buildings at the back of Verona Villas. There was still a perfume of ecclesiastical incense about us after our half-hour of devotion to the Blessed Sacrament. The puzzle of the fuse was solved by the ever-resourceful Sully, who fashioned a suitable charge with one of his uncle's pipe-cleaners and some Airfix glue from a model aeroplane kit.

Fireworks were illegal in Ireland (still are), the government deeming it too dangerous to leave explosive material in the hands of its volatile citizenry. So, we were forced to make our own. Following Reeves's instructions, we set about mixing the materials, stuffing the pipe, and inserting the fuse. Then the bombers picked a vulnerable spot in the 'parliament' building, crept up and planted the delicate device. Sully lit the fuse. We ran behind a wall and waited. It took so long to ignite we were nearly tempted to go back and see what had gone wrong when the blast happened. It wasn't the cataclysm we'd hoped for, but there was a satisfaction in picking up the fragments of shattered bricks and dried cement that littered a small area around the parliament walls.

The young guerrillas retired for the day, vowing to return for more of the same exciting adventures the next day. Which we did, several times, until Mrs Slattery, who lived on Verona Villas and sat staring out the window all the time, told our parents. That was the end of the

2. PIPE BOMBS AND NEWSPRINT

explosive careers of the bold Verona Villa Bombers, most of whom got their arses reddened for their trouble.

My parents, Dave and Irene, spent their married life working alternating shifts in our shop. Positioned at the top of William Street, it sold, well, everything from newspapers and comics to what was referred to as 'fancy goods' – from sweets to watches and jewellery. Adjacent to the main shop was a smaller premises we opened occasionally. At Christmas, we sold toys here, and when the big Munster Gaelic football or hurling games were on, we got up early, made ham sandwiches and sold them to the crowds on their way to the match.

The main shop operated 364 days, 7.30 a.m. until 10 p.m. We were closed on Christmas Day, the only time my parents and I sat together to eat. Normally, I had lunch (or dinner as the midday meal was called) with my mother and supper (or tea) with my father before he returned to the shop for the evening shift.

The shop dominated our lives. We never took a family holiday. I can't remember either of my parents taking time out. My mother did go to Kilkee once with Betty Smith, my godmother, but that's about it. The shop was our anchor. It rooted us geographically and adhesively to the source of our livelihood. Every morning at 7.40 a.m., a man I called Browncoat – he wore the same brown coat every day tied around the waist with a string – pulled up outside on his bicycle, entered the shop and bought *The Cork Examiner* and twenty Woodbine. He never spoke a word as he took the newspaper from the counter and pointed at the cigarette display. It was essential to be there for him in case he went across the street to Nellie Woods, the competition, and we'd lose a customer.

More than anywhere else in my young life, the shop introduced me to the strata of Limerick society. Our customers included local politicians, bankers, tweedy county types, labourers, scrap-metal merchants, coalmen, teachers, farmers, lawyers and shawlies – women who looked like they'd wandered off a page of history, dressed in black shawls, who sold things like molluscs, periwinkles and seaweed from handcarts on street corners. My memory of this colourful collection of Limerick folk

is strong. I became aware of the speech-music, accents and mannerisms particular to each group. I was also introduced to the off-handed style of Limerick humour, still in evidence today – slightly mocking but ultimately warm.

There were three principal daily newspapers: the *Irish Press*, the *Irish Independent* and *The Irish Times*. The *Irish Press* was run by the de Valera family, and it was the organ of the establishment party: Fianna Fáil. The *Irish Independent* was the mouthpiece of the opposition party, Fine Gael, which had taken a pro-Treaty stance during the Civil War. *The Irish Times* in those days was the paper for a Protestant and somewhat West-British viewpoint. In the 1950s, our shop stocked hundreds of the *Irish Press* and *Irish Independent* and about ten of *The Irish Times*. It's interesting that nowadays, the *Irish Press* no longer exists, the Independent Group has become powerful, and *The Irish Times* is distributed in large quantities to every town and village in the country.

Besides these daily publications, my father insisted on stocking nationalist papers like the *United Irishman*, *Rosc*, *An Phoblacht*, *Aiséirí* and the occasional left-leaning pamphlet. We also sold a wide selection of children's comics: to this day, I still meet people in Limerick who were brought to Whelan's to buy *The Beano*, *The Dandy*, *The Beezer*, *The Topper*, *School Friend*, *Bunty*, *Judy*, *The Hotspur* or one of the American Dell series comics.

3. The Nuns – Holy Disorder

The crude wooden box was wheeled into the classroom on wobbly castors. Sister Raphael took a ring of keys that hung beside the rosary beads beneath her voluminous habit, put a key into the brass padlock, and snapped it open. She swung back the door. Out tumbled a pandemonium of tambourines, triangles, snare drums, cymbals, whistles, recorders and maracas. The excitement, the sense of possibility this little bandbox contained when Sister Raphael released its frolicsome contents, is among the more evocative memories from my days in the Presentation Convent School; another is the vinegar tang of the sour milk distributed at school lunch. The remaining memories are a collection of incoherent impressions I wouldn't describe as particularly happy – more neutral and impermanent. There was a vague feeling of being set apart from the boys in my class; I recall being mildly bullied by older boys from places like Roxboro, Pennywell and Garryowen. That my aunt Flo (Sister Alphonsus as she was known) was a teacher in the affiliated girls' school gave me some advantages that had the unfortunate side-effect of making me different to my classmates. Not belonging was something I didn't like. I wanted to be accepted by my peers, not particularly by the nuns.

PART I: 1950s – NEST AND NOURISHMENT

'Billy, come on now, leave that train set,' said my mother. 'We'll go up and visit Auntie Flo for the afternoon.'

I knew what was ahead of me.

My mother dressed me in my Sunday best, and because my legs were so thin (and she was ashamed of them), she insisted I wear long trousers, which was an anomaly for a boy in the 1950s – you didn't wear long trousers till you were a teenager. So, I was dressed like a little man for the outing.

At the convent, a nun showed us into the parlour and rang Flo's bell – each nun had a distinctive pattern of rings. Flo arrived, breathless from halls and stairs. She was my mother's youngest sister and occupied an important position in my early life. She trained a small singing trio, and it was with Flo I heard harmony for the first time. I still recall the feeling that came over me as those three voices separated and combined into something profoundly beautiful – an early glimpse of the exquisite.

The parlour, like the rest of the convent, was spotless. Not a speck of dust, parquet floors buffed and shining and the perfume of beeswax.

'How are you love?' my mother greeted Flo.

'Oh, fine,' she said. 'And how's my favourite nephew?' Flo had many nephews, but the one in the room was always her favourite.

'I'm fine, Aunty Flo,' I said.

She planted a kiss on my cheek. It was a pleasure being kissed by my young aunt Flo. She was pretty, unlike some of the more gnarly nuns in the convent. Flo reached into the sleeve of her tunic and, with an abracadabraesque flourish, produced a bar of Cadbury's Dairy Milk.

My mother and Flo got down to some adult conversation while I made inroads into the chocolate, staring at pictures of saints with holes in their hands, arrows in their chests, bleeding hearts and other physical wounds of the kind that fascinate the imagination. My aunt Flo's sweetness and harmonic musicality were at odds with these images of suffering.

The rest of the afternoon involved walking slowly behind Flo and my mother around (and around) the endless oblong convent garden. To my squirming embarrassment in later life, Flo loved telling how I

stared up at the statue of the Infant of Prague who stood in kingly attire, one hand holding a globe, the other raised in a posture rather like that of an orchestral conductor: 'Gimme the ball,' I demanded.

The statue stared beyond me towards some celestial horizon.

'Gimme it,' I insisted.

Still no response.

'You can't conduct. You're not able to conduct!' I shouted at the unfortunate infant. 'Gimme that ball!'

We moved on, passing St Patrick with his crozier and his collection of nervously departing snakes, and onwards to the beatifically beautiful and serene statue of the Blessed Virgin, eyes downcast, her expression showing how serenely and sadly she carried the sorrows of the world.

Multiple circles around this devotional space ensued, a few additional visits to the glasshouses and vegetable gardens thrown in for luck, plus several encounters with Flo's 'sisters'. Finally, when both my chocolate and patience were long exhausted, I resorted to the effective repetition of that well-known children's refrain while tugging on my mother's sleeve: 'Will we be going soon?' This song was delivered in what my mother referred to as my 'cry-nawny' voice designed to grate on the nerves of the most tolerant of adults.

At last, escape was near. We were saying goodbye to Flo in the main hallway when, through some miraculous semaphore, our departure was signalled to the community, who now appeared from the labyrinth of quiet nooks and corridors to say goodbye. I was put sitting on the hall table, and the comforting faces of Sister Raphael and Sister Berchmans, who taught me in kindergarten, appeared. All was going fine in the farewell ritual until out from the forest of wimples and veils, belted habits, crucifixes and rosaries appeared this large elderly nun I hadn't seen before. She was clearly someone important since a path appeared through the crowd so she could reach me. In her hand, she'd some Cleeve's toffees. She held them out to me and, just as I was about to take them, put her face up close to mine. There was a whiff of snuff and onions about her, and she'd the beginnings of a moustache like my uncle John Whelan's.

'What do you say, Billy?' she asked.

I looked at my mother for a hint. She was nodding and smiling as if I should know. The big nun's face drew closer, obliterating all else from my vision. 'What do you say?' the nun's cheek was a millimetre away from my lips. The pong of Lifebuoy soap joined the scent of onions.

I panicked. I was not going to kiss this strange face. I pulled away and heard myself say: 'I am sick and tired of bloody nuns!'

I looked around for support.

A moment of silence was followed by sharp intakes of breath from the older nuns, and titters from the younger ones. The old nun seemed amused and, pressing the toffees into my hand, gave me a little hug. 'Oh, you're a *real* ticket,' she said and looked sadly at my mother.

I was hurriedly gathered up like an embarrassing bundle of laundry and propelled along Sexton Street and home to bed early – without tea.

4. Dave Whelan – Opening My Ears

> *The Minstrel boy to the war has gone,*
> *In the ranks of death you will find him;*
> *His father's sword he hath girded on,*
> *And his wild harp slung behind him;*
> *'Land of song!' said the warrior bard,*
> *'Though all the world betrays thee,*
> *One sword, at least, thy rights shall guard,*
> *One faithful harp shall praise thee!'*[1]

My father was on the Wurlitzer organ in our music room, which we called the drawing room for some reason. With his limited technique, he one-handedly picked the tune out on the keyboard like somebody rooting in a rattle-bag for jewels. I never hear the melody of 'The Minstrel Boy' without feeling an emotional twinge. The beautiful melodic structure of the tune evokes the brave and noble self-sacrifice that motivated those who fought in 1916. Though written for the fallen in the 1798 rebellion, Thomas Moore's lyrics still carries feelings of the altruism, anger and desperation that drives men and women to extreme action in the name of their home place and tribe.

PART I: 1950s – NEST AND NOURISHMENT

I've many memories of my father's influence on my love of music, although he was long gone before I appreciated it. It was as if he'd slipped these gifts into my pockets without my knowing, only for me to discover them in later years. His harmonica-playing was better than his struggles with the keyboard. I used to sit under the kitchen table with two knives and a biscuit tin and drum along to his renditions of 'Scotland the Brave' on the mouth harp. Later, I added a spoon to the biscuit tin lid to give it a rattle like a real snare drum. He sometimes appeared in my room if I was sleeping late, playing a tune with the harmonica in one hand to wake me up, the other hand beating out the tune's rhythm on the resonant wooden doorframe.

He was a one-man band on these occasions. Mad improvisational possibilities transfixed my musical brain. Whether on biscuit tins or hot-press doors, music-making was available everywhere. He would take me to the rehearsals of the Limerick Pipe Band in a small house on the Boherbuoy beside the People's Park. I'd sit beside the drummers in this tiny room as red-faced pipers blew into their bags and tore into a selection of marching tunes. I can see how they were called 'war pipes' – the noise was thunderous and stirring. The crisp detail of the drumming got me going – all those complex cross patterns.

Once my father called me down to meet Mick Dunne, a commercial traveller who sold miscellaneous items to the shop. Mick, a keen amateur drummer, always had his sticks with him. He taught me the correct way to hold them and introduced me to the rudiments of drum rolls and paradiddles. I was mesmerized by how the two-handed pattern of 'mama-dada mama-dada' turned into a seamless drum roll on the counter of our shop when he upped the tempo.

In 1959, days before my ninth birthday, an amazing South African group called the Golden City Dixies[2] were on tour and played at the superb Savoy Theatre in Limerick. The Savoy was a cinema, but it had a great performance stage, with a massive organ set into the structure of the building, which seated 1500 people. The Dixies were distinguished not only by their excellent music but also because they were black South Africans, unlike the blackface acts that proliferated in the UK at that

time. My dad took me to see this show; I was open-mouthed throughout the performance.

A friend of his, Jim Carroll, was in the orchestra pit recording the show. When it was over, we went down to the pit, and my dad asked Jim if we could have a copy of the recording. Sure enough, a couple of days later, my dad appeared with a BASF reel-to-reel tape recording of the whole evening. I listened to it daily on our Philips tape machine for months and had it nearly off by heart. I even learnt a couple of their South African songs phonetically (in Xhosa or Zulu), as well as the anthemic 'Marching to Pretoria'.

By now, I'd learnt a bit of banjo and ukulele from my uncle Harry and had performed the three Dixies pieces on the stage of the Crescent College Mission Concert. I had to stand on boxes to reach the mic, which was suspended from the ceiling – nonadjustable. I still think the audience wasn't sure if this was a musical item or a circus balancing act. I suspect my lifelong discomfort with heights began here at this, my very first public performance.

Dave Whelan's interests were broad. He was an amateur photographer (I still have many of his photos) and converted a pantry in our house into a darkroom where he installed a Durst enlarger and stored chemical accoutrements for developing film. This room was kept locked in case curious young hands found their way to the bottles of toxic developers or fixers. It was a magical place. I used to sit on the counter with him in the amorphous bordello-red gloom and watch the ghostly images slowly and miraculously materialize on the printing paper. He was constantly experimenting with different cameras. His friend John Ryan had a camera shop and allowed him to exchange, try out or trade in cameras as new models became available. At various times there were Hasselblads, Nikons, Rolleiflexes, Minoltas and Leicas, and a raft of accessories in the house. It was a source of endless puzzlement to me later how my father managed to pay for these things, given that our shop wasn't exactly a major retail outlet.[3]

One example of his creativity around financial matters concerned an oil painting by Seán Keating. Both parents were interested in art.

PART I: 1950S – NEST AND NOURISHMENT

They went to evening auctions in Limerick to acquire Irish paintings to hang on the walls of our house. My father also made regular visits to local galleries to keep an eye on what might come on the market. One day, he made an appointment to meet the manager of the Munster and Leinster Bank on O'Connell Street in Limerick. He arrived at the office, spruce as always – bow tied and suited.

'Well, Dave, nice to see you,' said the manager as they sat down. 'What can I do for you today?'

'I wanted to see about a small loan,' said my father.

'I see. And how much are we looking for?'

'Eh, I was thinking about £400?' He was trying to sound casual.

'Holy God, Dave, that's not a "small" loan. Are you buying a car or something?'

(We never had a car – the Whelan family went everywhere on bicycles.)

'Ah, no,' said my father. 'You see, we're having some trouble with the drains at the back of the house – dampness seeping into the walls, d'ye know? I wanted to install new chutes and down-drains and replaster the back wall.'

They talked it back and forth, and finally, having been assured that business was good in the shop and Christmas was coming, the loan was approved.

Later that day, the manager closed the bank as usual and went on one of his regular strolls around Limerick, calling in to see his various clients along the way. One of those clients was the Goodwin Gallery on O'Connell Street. He browsed around the gallery floor, looking at the paintings, and encountered the owner. They exchanged pleasantries, and then the bank manager inquired: 'I notice that the Seán Keating painting has gone. A great piece, wasn't it? When did you sell it?'

'Funny you ask,' said the delighted owner. 'Only this very morning.'

'Ah, go on,' said the manager. 'And may I ask who bought it?'

'You know Dave Whelan?'

The manager's eyes widened. He nodded.

'Dave's been in and out looking at it for weeks, and didn't he appear about three hours ago and bought the bloody thing!'

'Did he now?' said the manager, barely smothering his ire. 'And what did it go for, can you tell me?'

'The asking price,' said the proud gallerist with a big smile, '£400.'

My father struck the Munster and Leinster Bank off his list for future potential loans. And anyway, he fixed the drains and did the plastering himself.

My dad was fifty years older than me. While we didn't play football or engage in father-son physical activities together, he did stimulate my auditory imagination with an eclectic range of music. His record collection included jazz musicians Thelonious Monk, Art Blakey, Dave Brubeck, Wynton Kelly, Duke Ellington, Glen Miller and Johnny Hodges; opera greats like Jussi Björling, Joan Sutherland and Renata Tebaldi; boogie-woogie and ragtime artists like Winifred Atwell; folk singers like Connie Foley, and the Clancy Brothers; music-hall, variety and vaudeville artists like Harry Lauder and Victor Borge. And that was just the vinyl. He had a massive collection of 78s that I still haven't had the nerve to examine.[4] Later, rock 'n' roll came into the mix with Bill Haley and the Comets, Elvis Presley, Johnny Kidd and the Pirates, Emile Ford and the Checkmates and Tommy Steele. His musical curiosity was restless, scanning for what was new and interesting.

And then there was film.

One day, my mother came in for lunch to find my father and his friend, Fr Jim Fitzgerald in their shirtsleeves mixing sand and cement. They were converting the pantry adjacent to what we called (grandly) the breakfast room into a projection booth. They'd drilled two holes in the wall, one for projecting and one for the projectionist to view the movie. He had a 16 mm Bell and Howell projector on a stand he'd made himself. A bedsheet, eventually to be replaced by a snazzy foldable screen, displayed the movies in the breakfast room. To my mother's patient resignation, exit breakfast room, enter home cinema. Now they could go to the 'pitchers' whenever they liked.

Every second Friday, my father cycled to Limerick railway station and collected a box of films rented from a company in Dublin. They had to be returned on the Monday train. So, on those weekends, we

PART I: 1950S – NEST AND NOURISHMENT

gorged ourselves on Charlie Chaplin, Buster Keaton, Harold Lloyd, Laurel and Hardy, Abbot and Costelloe and feature films with famous English or American film stars fighting heroic battles against Red Indians, Japanese, Nazis, Russians or Mexicans. Often these kinds of action films disappointingly descended into boring talking and kissing with glamorous swooning women, something I hadn't come to appreciate yet. If things ever got steamier, my mother said: 'Billy, go upstairs and get into your pyjamas,' or some similar diversionary tactic.

The evidence of Dave Whelan's handyman skills was everywhere in the house. Each year at Christmas, we dragged down a battered suitcase from the attic and gingerly unpacked the Nativity cast from their cosy newspaper wrappings. All present and correct – the Holy Family, a few shepherds, various farm animals and a trio of wise Kings awaiting their cue in the wings. One by one, we placed the little statues into a wooden box in a cubbyhole under the stairs. We arranged Joseph and Mary around the crib that held the Saviour. Somewhere in history, Jesus had lost a hand, but we covered the disability up with surrounding straw and hoped no one would notice. My father added an electric star over the manger, turned on from a switch in the hall. We stuck cotton wool snow around the edges and added sprigs of holly and ivy. It was lovely. The star stayed lit all night and filled the hall with a gentle Yuletide glow. Then, one year my father had a bright idea. All this hodding of suitcases either side of Christmas could be ended by a simple solution. He got some wood, made a door, put hinges on it, and mounted it at the cubbyhole entrance. Then when Christmas was over, he just closed over the door, turned off the star, and bade them all farewell until next year. I imagined the confusion in the manger when the lights went out, and the entire cast was left trying to figure out the cause of the blackout. I suppose it was better than lying wrapped in crumpled copies of the *Irish Press* in the hot attic during the summer months with only the odd mouse for company.

Dave Whelan was private about his religious observance. Like many of his generation, as long he was alive and able to move about, he went to Mass and Holy Communion daily. At 7 a.m. he quietly slipped

over to the Jesuit church at the Crescent on the next block to our house. He chose the same pew at one of the side altars – I think for its discreet positioning and because it was a seatless pew, meaning he would kneel for the entire Mass.[5] He would then have a quick cup of tea at home and cycle the five-minute journey to 8 Upper William Street to open the shop before Browncoat arrived, gasping for his first Woodbine and a read of the paper.

Limerick had no shortage of churches. Within a stone's throw of our house, there were six Roman Catholic churches. For those who grew up in the 1980s and onwards, it's difficult to appreciate the all-pervasive influence of religion and its ritual on citizens' daily lives. The reputation of clerical abuse and betrayal has since been well recorded. What is not often understood is how much people's lives were penetrated by constant reminders of the pre-eminent position religion held in our consciousness. So in Limerick, for example, when the Angelus bell rang at noon and again at 6 p.m., all non-religious activity ceased. Men dismounted from their bicycles, took off their hats, blessed themselves and stood on the street for the time it took to recite the Angelus prayer. Processions were commonplace. Veiled ladies, dressed in virginal blue and white, serenely paraded under statues or banners singing devotional hymns or reciting the rosary. Everybody attended Mass on Sunday. The small number of non-Catholics were left in no doubt who owned the civic space on these occasions. It rarely occurred to us at the time, but it must have felt profoundly overpowering.

My father kept to himself. He did not partake in these displays of public fidelity and reverence. He wasn't a joiner, preferring to adopt the Marxian principle to avoid any club that would have him as a member, except, of course, for his earlier youthful rowing club memberships. However, he did observe private aspects of church rituals and regularly attended confession, even if Fr Guinane, or 'the Guinner' was the priest hearing it.

The Guinner was a legendary Jesuit priest in Limerick with an insatiable passion for rugby. As he advanced in years, he became profoundly deaf, probably due to a lifetime of noise at Thomond Park or Lansdowne

Road. If you confessed to the Guinner, softly mumbling your transgressions, you were likely to hear: 'Louder, please.' My father once told me he went to the Jesuits for confession on a Saturday evening during a retreat. There was only one confession box in operation. Unbeknownst to my father the Guinner was on duty. There was a queue outside the confessional, and as my father approached, he tapped the nearest man on the shoulder.

'Who's hearing confessions?'

A withered whisper came from the resigned penitent: 'The whole feckin' place!'

5. Irene Lawlor – Love and Sacrifice

If Dave Whelan's family were quiet and reserved, keeping to themselves and rarely flaring up at each other, he married into a family that couldn't be more different temperamentally. My mother, Irene Lawlor, was the eldest of ten. They were remarkably balanced, numerically speaking: five boys, five girls; five born in Dublin, five born in Limerick; five entered religious life, five remained in the secular world. When Irene was twenty-nine, her mother died, and Irene became the mater familias. The youngest of her siblings was just ten years old. This responsibility on her young shoulders robbed her of a social life. She was in her mid-thirties by the time she married Dave.

They used to see each other when she was on her way to Todds, where she had an office job. Her father was the chief cutter in the tailoring department. Dave would be at his daily early morning Mass before heading downtown to open the shop when this mature-young woman occasionally appeared. After several casual collisions, they struck up a relationship and began dating or 'walking out', as it was called.

I'm not sure what Dave Whelan thought of the Lawlors when he first met them, but they must have presented him with challenges. They were

PART I: 1950S – NEST AND NOURISHMENT

a lively, good-humoured bunch, forever up for roguish fun, excellent mimics, great storytellers, with a gift for parody and satire that occasionally strayed into hurtful territory, intended or not. At these times, offence might be taken, leading to rows that could be over in twenty-four hours, or might stretch into longer and frosty periods. After some calming family mediations (often from Dave himself), equilibrium was restored, but the hurt could be resurrected if the need arose later. However, for all the fireworks, the Lawlors were fiercely loyal to each other.

They were also talented in music, drama and sport. My mother was an accomplished musician. She was a fine pianist despite an early injury to her index finger, which she caught in a door. In her twenties, she could have pursued a career in music, but her mother's death, and the restraints of family obligations, put a stop to that. However, she played the piano all her life. I have memories of listening to her play Chopin, Debussy, Scarlatti, Beethoven, Mozart and – my father's favourite – Thalberg's flamboyant 'Home Sweet Home with Variations'. Always an excellent way to close a musical evening on a high.

While I was still a boy-soprano and hadn't yet turned into an adolescent yodelling frog, she taught me 'At the End of the Day' by Donald O'Keefe (not the song of the same name from *Les Miz*). We would perform this together to indulgently smiling visitors, she on the piano and me squirming beside her:

> *At the end of the day just kneel and say:*
> *'Thank you Lord, for my work and play.*
> *I've tried to be good, for I know that I should.'*
> *That's a prayer at the end of the day*[1]

In time, I found this excruciating and was relieved when I got older, my voice broke, and I was invited to play 'Brazil' or sing 'What'd I Say' by Jerry Lee Lewis – and some of my own early songs. O'Keefe's pious verse was returned to the sheaves of music underneath the lid of the piano stool. Still, I know I was learning something about performance, tempo and dynamics as I locked into my mother's sensitive accompaniment.

5. IRENE LAWLOR – LOVE AND SACRIFICE

The names my maternal grandparents chose for their offspring hinted at their social aspirations. The boys were called Frederick, Harold, Thomas, John and Michael, but the girls' names held the real clues: Edith, Mabel, Florence, Gladys and Irene. To my father, with his solid Irish nationalist and Limerick working-class background, his new sisters-in-law must have seemed like the cast of a British Victorian drama, or perhaps the bargirls at the Old Bull and Bush. I know that they were fond of him – he was tall, handsome and didn't take sides in the many spats that flared amongst my mother's siblings.

The Lawlors were a lively group. My uncles occupy a significant part of my childhood memories, particularly Uncle Harry, a Jesuit priest. He taught me to play the banjo and sent me daft postcards with stick drawings and punny little poems:

> *There was a young fella from Prosperous*
> *Who painted his trousers with phosphorus*
> *Wherever he'd go*
> *He would glimmer and glow*
> *So he never would ever get lost for us*

Harry taught in Gonzaga in Dublin and Clongowes near Prosperous in County Kildare, so I only saw him during the holidays. My other uncles, Mick and Fred often took me on seaside trips or picnics. We would pile into Fred's Morris Oxford or Mick's Ford Prefect and head to Kilkee or Lahinch. It was a treat for me to be in those cars with all my cousins. After sixty years, I still remember GZC 671, the registration of Mick's car. I would sit at the window in our front room for hours before he was due to collect me and wait for that registration to appear around the corner. And it wasn't just the destinations; the journeys were filled with diversions and fun, songs and games. My Lawlor uncles were just grown-up kids as they led us all in choruses like 'The Monkeys Have No Tails in Zamboanga':

> *They grow potatoes small in Iloilo*
> *They grow potatoes small in Iloilo*

PART I: 1950s – NEST AND NOURISHMENT

> *They grow potatoes small*
> *And they eat them skins and all*
> *They grow potatoes small in Iloilo*[2]

Iloilo had a particular resonance for us as our uncle John was a Redemptorist priest and spent most of his life there or in Cebu in the Philippines. As we cruised through Ennis and Kilrush, the startled local people were treated to renditions of Zamboanga and other songs from a carful of joyful kids. When we infused the salty perfume of sea air, the excitement was intense, and we competed for who would see the blue Atlantic horizon first.

My uncle Fred was the youngest of the Lawlors and the coolest. (Cool was measured by size of car.) He ran an auctioneering business and often popped into the house and took me out for a drive.

'Morning Billzer!' he said on one of the summer holidays endless days. 'God, you're looking very eukaterical.' Fred was forever inventing extensions to the English language. 'Fancy a drive out the country while I make a call?'

Would I what!

We boarded the Morris Oxford – one of the new cars with wings at the back like the big American limousines. Off we went, me up in the passenger seat beside him (no seat belts in those days). He drove faster than my other uncles, but you felt safe. Soon we came upon an old grubby Morris Minor hogging the centre of the road. You could see the driver's elbow jutting out the window. The occasional wisp of cigarette smoke caught on the breeze and was blown back at us. The driver was not in any hurry.

'Feckin' eejit,' said Fred.

Not known for his patience, he tried to overtake, but either a tractor appeared in the opposite direction, or that feckin' eejit chose that moment to sway out on the wrong side of the road, causing Fred to jam on the brakes. Finally, we hit a long straight stretch. Fred said: 'Roll down your window there, Billy, I'll give this bloody fool something to think about.'

5. IRENE LAWLOR – LOVE AND SACRIFICE

I wound down the window. We pulled out to overtake. I shimmied down in my seat, and Fred leaned over me as we drew alongside. He took a deep breath and shouted, 'Is the road not feckin' wide enough?' He broke off. 'Ah, morning, Father! Lovely day for a drive.'

The bemused priest waved at us; as Fred put the boot down, off we cringed in a plume of mortification. 'That was a close one, Billyboy,' exhaled Uncle Fred. 'He nearly heard prayers he'd never heard before!'

When I think about my mother's life, two words reoccur: sacrifice and worry. She worked every day of her life. Each thought and action was motivated by her commitment to my father and me, our shop, our house, her family, and her few friends. I rarely saw her put her feet up and never saw her read a book. Her only moments of relaxation were when she played the piano or asked Tessie Woulfe to read the tea leaves. Tessie worked for us in the house and shop and for my mother's family before Irene married. My mother half-believed Tessie could tell fortunes by looking at the tea leaves remaining on the side of one's cup. We had great fun listening to her outlandish predictions. My mother was superstitious and would tear around, covering the mirrors in a thunderstorm. She never opened an umbrella indoors as this would bring down some vile catastrophe on our heads. A robin in the house portended a coming death.

When Uncle Harry became a priest, Dave and Irene hosted a breakfast for him in our house after he said his first Mass. For this, my dear mother preserved the modesty of the few nude, or semi-nude, statues that my father had bought over the years by covering them with white sheets. I was too young to remember this, but an older cousin told me the place looked like a museum, closed for the holidays.

My mother's anxieties were endless. She worried about me as an infant. I was unvaccinated since she didn't trust that vaccines *wouldn't* maim or even kill her son. She fretted if I was out of her sight. She only entrusted me to the most reliable of carers – even they were subject to interrogation from time to time. She insisted I had to be fattened up to survive (to be fair, I weighed 4 lbs at birth). I remember her extracting

blood from cooked steak by pressing the spoon into the meat. I can still see the tiny red pool with bubbles of fat in the well of the spoon as she encouraged me to open wide. She believed this would save me from diphtheria, pneumonia or worst of all, tuberculosis. Pernicious anaemia was also a threat. I discovered recently that this was what killed my Whelan grandfather, so understandably it made it onto her fear list.

When I miraculously survived to my teens, her anxieties multiplied. Now the problem was my friends. Many's the pal of mine had the door slammed in their face, a greeting typically reserved for Jehovah's Witnesses or proselytizing Mormons, but as I moved into puberty, the list of undesirables grew. Some of my favourite friends were the type parents might regard as dangerous or a bad influence – I admit, if some of these guys turned up to see my daughters when I became a parent, I might have felt the same. However, the anger of the door-slammer had little to do with the slammee. What my pals didn't know was that my mother and I might have just had a blazing row; they happened along at the wrong time – a kind of innocent collateral damage that left them head-scratching, and which I would then have to explain and smooth over.

Girls never entered the picture at this stage. For many male teenagers back then, access to females was rigidly controlled. Co-education was abnormal, and we saw girls through a fog of frustration, misinformation and wild invention. We didn't have girlfriends in the sense of being pals with them. We knew nothing about their bodies or how they worked. I was further disadvantaged in that I had no sisters, so the mysteries of the female were even more alien to me. The feminine world was a vast foreign land, as exotic as Atlantis and, for much of our teen years, just as reachable. I recall being in Vincent Mulrooney's house, and his older sister was in the basement practising jazz-dance moves with her friends. They were all in leotards and tights. The air was alive and fizzling. Vinny took it all in his stride, but I found the experience intoxicating. That day, I crossed over some unexpected boundary onto a new path, full of confusion and excitement in equal measure.

It was up to our parents and educators to tell us how to navigate the hormonal turbulence we were already aware of, courtesy of our

awkward bodily awakenings. Unthinkable I'd *ever* discuss this with Irene, so Dave became the target of my mischievous baiting.

I sat with my father at our customary evening meal. He always ate the same thing for his tea: tomatoes. He would first quarter them on his plate and then, with surgical skill, deftly remove the skins. These he would pile at the edge of his plate and before eating the seedy fruit, he sprinkled sugar over the pieces.

'Dad, we have sex education in school at the moment.'

He studied the tomatoes and moved them like chess pieces around the plate.

'They told us to ask our parents if we had any questions.'

Pawn to queen's bishop 4. A sprinkle of sugar. He looked up. 'What kind of questions, Willum?'

'Well, y'know, how babies are made. What exactly happens with the parents beforehand. That kind of thing.'

Queen to rook 5.

My father thought long and hard. Then, lifting the bread knife, cut himself a slice of turnover pan. He buttered it and then poured the tea.

'Willum,' he said, 'when the time comes for you to know about that kind of thing, well,' – he paused, spearing a wedge of tomato, and looking directly at me – 'you'll know all about it.'

Checkmate.

6. The Jesuits – Musical First Steps

Collegium SS Cordis Limericense was the Latin inscription emblazoned over the door of the Sacred Heart College Limerick, also known as Crescent College due to its position within a curved block of Georgian buildings near the city centre. A monument to Daniel O'Connell, the Great Liberator, stood in the middle of the street, staring off in the direction of his birthplace, Caherciveen. In 1957 I mounted the steps of the Crescent at seven years of age to begin an eleven-year endeavour to be liberated from the darkness of ignorance courtesy of the Jesuit order. Here I was now, and amazingly near home. I could walk to school on my own instead of being hoisted onto the crossbar of my father's bike or into the baby seat on my mother's rickety old Raleigh.

The first noticeable change was the gender of my teachers. In the Presentation Convent, it was all women – primarily nuns. Here it was all men – priests or scholastics. A scholastic was a young man studying and then teaching his way through the fifteen-year training to become a Jesuit priest. The second significant change was that, unlike my small preschool, hundreds of boys attended the Crescent, which was divided into a junior and senior school. The juniors were divided into five classes

6. THE JESUITS – MUSICAL FIRST STEPS

or *Bun Rangs* 2–6. (*Bun Rang* is Irish for lower or junior class.) The six senior school classes dropped the Irish names and were called Elements, Rudiments, Grammar, Syntax, Poetry and Rhetoric. I often wondered why these rather lofty titles replaced the Irish class names. The attitude to the Irish language in our education system seemed more aspirational than actual. How so many of us came through fifteen years of being taught Irish without becoming fluent is one of the great mysteries of our school pedagogy. The Christian Brothers seemed to have more success, but it's fair to say that in my generation, the Jesuits turned out few Gaelgóirí.

Shh-shh-shh-tschhh. Everything Fr Tormey said was prefixed by these gentle pleas for quiet. Years of teaching *Bun Rang 2* had convinced this mild-mannered priest that incoming boys had to be silenced before any information could enter their heads. He shissed so much it surely seeped into his life outside *Bung Rang 2*. I have little doubt that sitting amongst his community at dinner, he shissed the occasional rector or visiting Jesuit with similar demands for silence.

I looked around for a seat in Fr Tormey's class on my first day. He wore one of those long, black academic gowns with wings sprouting from the shoulders, falling out behind him to the backs of his legs – it was rumoured that some of the holier Jesuits could fly. The faces in the class were unfamiliar; many were from St Philomena's, so they were already at ease with each other. Most boys from my previous school had gone on to the Christian Brothers, where (it was said) they'd be treated rough and would have to learn hurling *and* Gaelic football. I scoured the room for anyone from Presentation Convent to sit beside … ah! There was Senan Murphy.

For all his good nature and docile manner, Fr Tormey ran a tight ship. I fell foul of him in that first year and was abruptly brought into contact with a Higher Power. He'd been shisshing as usual so that he could teach the prayers in Irish.

FR TORMEY: *A Chroí Ró Naofa Íosa.*[1] (Sacred Heart of Jesus.)
BUN RANG 2: *Dean trócaire orainn.* (Have mercy on us.)

PART I: 1950S – NEST AND NOURISHMENT

> FR TORMEY: *A Chroí Mhuire gan smál.* (Heart of Mary without blemish.)
> BUN RANG 2: *Guigh orainn.* (Pray for us.)

'*Gan smál,*' I whispered to Senan. '*A Chroí Mhuire* gone big!'

This blasphemous pun came out louder than I expected. The class went silent and looked expectantly at Fr Tormey. I studied the floorboards.

'Billy Whelan, come here.'

The omission of the *Shh-shh-shh-tschhh* signalled we had moved out from the coast and were in deeper waters. I trudged to the front of the class and stood before him in trembling contemplation of my shoes, eyes brimming.

'What did you say?'

I burbled my smart-alec pun through the beginnings of tears and snot.

'Out,' he said. 'Stand in the hall until class is over.'

As I slid out to the silent hallway, I knew there was a strong possibility of an encounter with the spectral Prefect of Studies.[2] In circumstances like these, the halls of Crescent College became punitive limbos which could quickly turn into purgatories, or worse, if the Prefect, bearing the dreaded pandybat, chose to go on a random patrol.[3] I squeezed into a crevice and tried to imagine myself into invisibility.

Footsteps came and went. I heard the slamming of a door, the rattle of keys, and then thick leather soles crossing the upstairs landing. I froze. Heels descended the wooden stair and, with the echoing thud of a judge's gavel, strode heavily towards Fr Tormey's door. I pressed hard into the wall, but the laws of physics held firm. I was unable to disappear. After an eternity, I stared up into a face I'll remember forever. A visage cut from ancient lava and scored with lines that ran up and down the planetary landscape of the jaw. He wore a soutane just like Fr Tormey's but fringed with a brownish sheen at the edges and wings – the kind of rusty colour you see veined into the rocks of Connemara or around corroding trawlers on a forgotten shore. There was a whiff of tobacco

6. THE JESUITS – MUSICAL FIRST STEPS

and old books. The only hint of frailty might have been his glasses. However, perched on the deeply pitted pigment of his nose, their wiry intensity served only to make him more inscrutable: a sphinx, a terminator armed with a pandybat – the most deceptively innocent-sounding weapon since the cat-o-nine-tails.

'Well, boy,' his lips hardly moved, 'are ye bored with the class?'

'No, Father.'

'So, what attracted you to this draughty hallway?'

The pandybat was in the pocket, but the sarcasm was on full display.

What poured from my mouth – punctuated by snivelling, nose-wiping, pointing behind me to the classroom, gasping for breath and other rhetorical devices – somehow communicated what had happened during Fr Tormey's prayer lesson.

'*Gan smál* …' he ruminated, 'and you said, "gone BIG", eh?'

I nodded. Was there a glint of a thaw?

'I suppose, Mr Whelan' – the only moving part of his face was his left eyebrow, forming a bushy pointed arch – 'we would call that some form of "humour", would we?'

I wasn't sure what we would call it, but I would shortly be calling it the biggest mistake of my early days at Crescent College. The pandybat peeked out of his pocket like the tongue of a waiting pit bull, ready to jump at its master's command. No, it would spring into action like Wyatt Earp's six-shooter. It would spring into action, and I'd be lying bleeding from every pore on the tiles.

Then, the dreaded command: 'Put out your hand. Hold it up good and high.'

Somewhere in my internal soundtrack, an orchestra played an ominous drone.

His massive fist rummaged into the abyss of his soutane, and out it came: a monstrously ugly piece of leather, like the paddle of some Stygian canoe, which he now brandished, shaking it awake. He tipped the back of my hand with it to get a better angle and then allowed the momentum of his wrist to build up energy which he released onto my upturned palm.

Swishhhhhh-tash!

An explosion at the back of the eyeballs, tiny, illuminated speckles in my vision, a high-pitched belling in the ears and then the sharp sense of hot contact on the palm followed by a tingling that dulled to a deep throb.

'Left hand now.'

Swoshhhhhh-tish!

Somehow, the distraction of the emergency services dealing with the trauma in the right hand made this second assault less painful, although soon, both palms were pulsing like a pair of twin bellows in the chalky light of the hallway.

'So, what do you say?' the pandy was back in the pocket and old granite face was ready for conversation.

'Sorry, Father,' was my blubbering shot at an answer.

'Ah, no,' he advised, 'you say: *thank you*, Father.'

I was not on for a debate.

'Thank you, Father,' I sniffled.

He turned me around and walked me to the door of the class. He knocked twice. 'Excuse me, Fr Tormey, but young Mr Whelan has given some thought to his recent outburst and would now like to return to his prayers – in Irish.'

* * *

For the next five years, I moved up through the junior school under the tutelage of many priests and a few lay teachers. One of them, Paddy Hughes, took a bit of getting used to. He had taken the trouble to memorize the names of the forty or so pupils in his very first class. As each subsequent year entered his classroom, and to not strain his capacity for recall, he simply transposed the names of that first class onto the new pupils as he saw fit. So, for example, my classmate David Thompson became David Broderick. I was gifted the name of Billy Harris, who had preceded us by ten years or so. Mind you, he was the brother of Richard Harris, the legendary Limerick-born actor. I was

6. THE JESUITS – MUSICAL FIRST STEPS

happy to become one of the Harris family for the purposes of identification under Paddy Hughes. As it turned out, I had much more to do with Richard Harris in my later career.

My time in junior school at the Crescent slipped by. Apart from the pandybat episode, little else looms large in memory, except I recall watching in horror as a teacher slapped Eugene Stretton repeatedly in singing class because he couldn't repeat the notes the teacher sang.

'Sing Ahhh,' intoned the priest in a quivering falsetto.

'Ergh,' was the throaty attempt from poor Eugene.

'Hold out your hand.' Smack! from the small leather.

'Now, sing Ahhh.'

'U-u-urgh,' Eugene slid around the scale in a searching portamento, hoping to arrive at the right note.

Smack!

This went on for some time, and though the slaps were not hard, the cumulative effect must have stung, to say nothing of the shame. I could never understand what this priest hoped to achieve by trying to beat music into someone who did not have an ear for it or was so nervous that they couldn't hear and find the correct pitch.

For the most part, the other teachers were a kindly lot who, like Paddy Hughes, were recruited from the rural outreaches of Limerick, Clare and Tipperary. I remember particularly Mr Clune, who had eyebrows like one of those Russian premiers of the 60s. And, of course, Paddy McCormick. Paddy had the most colourful turns of phrase. These appeared when he became frustrated by the cerebral density of his pupils. He never laid a hand on us, but his threats were enough to make you sit up and take notice. 'C'mere,' he once growled at me, 'ya bounder, ya bloody-lookin' lootheramaun, ya moon-calf, before I catch you be the scraggy neck and put you looking backwards.'

He took great joy in comparing us unfavourably to the 'boys out in our own parish of Tradaree' who were so *schmart* they could build a 'nest in your ear before you had your breakfast'. What use the boys of Tradaree would make of the nest was never explained, but we got the

idea – we were thick. Nor could we tell the future as some in Tradaree could; Tradaree was close to Shannon Airport, and Paddy loved to tell the story of an old woman who was a local seer at the turn of the century. 'She would stare off at the marshlands around the Shannon Estuary,' said Paddy, 'and tell everyone that one day, people would be flying out of the sky in big ships down onto the land there.'

My increasing attraction to music prompted my parents to send me to piano lessons. There was no music training in the Crescent, but a group of freelance music teachers worked in the city. Over the next ten years, I would study with several until their patience ran out, and my impatience to engage with the music I was hearing around me became irresistible. I had hit out on my own.

I was very fond of Miss Dillon, my first piano teacher. She formed a small orchestra with her students, and we played what was widely known as Haydn's *Toy Symphony* (although it has been argued that the actual composer may have been Edmund Angerer).[4] My cousins, Mary and Tom Lawlor were in the orchestra too. I played the drums; Mary played the recorder, and Tom was on trumpet – which called for just one note, G, to be played occasionally, and might have happened if Tom's attention span could withstand the long periods of rest Haydn or whoever, indicated for the trumpet. Unable to keep still, Tom would act the eejit during his off times by tugging girls' pigtails or making fart noises during the quieter sections, resulting in his departure from the orchestra and the end of his brief music career. His family moved to Canada shortly afterwards. On the rare occasions we meet, we laugh about the experience.

The *Toy Symphony* was scored for an unusual collection of instruments, including a cuckoo, a quail and a nightingale. The nightingale was a curious invention. It consisted of a little cylinder filled with water attached to a short mouthpiece. When the performer blew into this, it made a sound like a nightingale.

In Miss Dillon's ensemble, the nightingaliste was Dorothy Tynan who also played the cuckoo; she was pretty, and was my first crush. She

6. THE JESUITS – MUSICAL FIRST STEPS

lived around the corner from us. When we finished rehearsals, I would walk her home from Miss Dillon's on O'Connell Avenue. She wasn't aware of this, as I was at least twenty feet behind her as she chatted to one of her girlfriends. But if asked, I would have claimed that I walked her home. This was the extent of our courtship which was never to blossom into anything more than a fantasy in my head, and nothing in hers.

Unlike Tom, my cousin Mary became a good young pianist, and she and I won a competition for piano duets in the Cork Feis Ceoil under Miss Dillon's tutelage. The competition was in Father Mathew Hall in Cork. It was one of those days of torrential rain familiar to Cork people. I noted as we played that the judges, seated just below us near the orchestra pit, had begun to edge their table further back up the hall away from the stage. The much-admired 'Banks of My Own Lovely Lee' had burst, and the theatre was gradually filling with a greenish sludge not mentioned in the song. The event ended in chaos, and we had to be evacuated by the army, lifted into trucks and taken to higher ground. Despite all this, Mary and I did well and made Miss Dillon as proud as she was drenched.

The rest of my early formal music education proceeded in fits and starts. I did well in the exams but was frustrated that a whole year would be spent learning a few pieces for performance when the Royal Irish Academy examiners came around. After Miss Dillon, I was taught by Charlie Sciascia privately and later by Margaret McKenzie at the new Limerick School of Music. I also had stints at the violin, where I tested the aural endurance of Granville Metcalfe, Eileen Hudson and John McKenzie, the principal at the school. I discovered lately that Prof. Metcalfe had also taught violin to a young Seán Ó Ríada when Seán lived in Adare. To add to these musical connections, my mother was taught by the Belgian organist Firmin van de Velde,[5] who also taught Ó Ríada. For someone who was later to spend much of his professional life among violinists, orchestral and traditional, my early engagement with the instrument was far from happy. I could never make it sound

anything beyond tortured, and my respect for those musicians who have made it sound heavenly will never be diminished.

I remember the moment I decided to put my benighted violin in its case for good. I was standing in John McKenzie's room on a wet and wintry Friday in the Limerick School of Music with the instrument tucked under my chin. Straight across from his window loomed the dark concrete facade of Limerick Prison. If you moved slightly to the right, the grey walls of St Joseph's Mental Hospital appeared, and if you stood close to the window, the headstones at Mount St Lawrence Cemetery came into view. It was like a scene from Alan Parker's *Angela's Ashes* scored by the scraping of my demented bow. In my mind's ear, I imagined the occupants of all three institutions rising as one and screaming, 'STOP!' That evening, I announced my intention to concentrate on piano rather than violin. My parents seemed relieved.

I was terrified of Charlie Sciascia. Small and stocky in stature, he had an aloof air. He approached the task of teaching piano in a determined and humourless way. (For some reason, the colour brown is always in my mind when I think of him.) He would patrol sentry-like up and down our music room, hands clasped behind his back. Whether he intended to or not, he made me feel distinctly uneasy. He never took his overcoat off, which added an air of impermanence to the lesson. I was on home turf when it came to anything to do with ear training, but when sight-reading was on the agenda, I fell to pieces. Sciascia would put unfamiliar music on the stand and instruct me to play it. I would go into a panic which included breathlessly watching the music staves see-sawing erratically on the page. This wonky relationship with sight-reading has stayed with me all my life. While I can sit and write a score with ease, those tense days with Charlie Sciascia are never too far away. When, for example, I am required at a recording session to make a quick decision about something on the page, I feel that creeping anxiety and have to take a steadying pause before dealing with it. If I could have days back in my music education, I would hone my skills in sight-singing and sight-reading. It's an invaluable skill for any composer, arranger or producer of written

6. THE JESUITS – MUSICAL FIRST STEPS

music. But for all that (or perhaps because of it), I probably learnt more music in my time with Charlie Sciascia than at any other period in my education.

Although my parents were quite religious, I was unprepared for the rigour of observance at the Crescent. We didn't do the rosary at home, but in school, the entire student body trooped into the adjoining church after lunch and mumbled its way through the five decades of Hail Marys preceded by an Our Father and followed by a Glory Be. On Wednesdays, we had Mass, and on Saturdays, benediction.

The juniors drilled in first, all blue-blazered and coiffed, marshalled tidily into their rows. Then, the anarchic glowering turks[6] from Elements and Rudiments, simmering and barely cooperative. Finally, the lads from Poetry and Rhetoric lumbered to their pews with the weary gravitas of men who have glimpsed the wider world and are holding their strength for bigger struggles ahead.

Towards the end of junior school, I became an altar boy. So now, in addition to daily church attendance after lunch, there were mandatory early morning visits, often in the frosty dark. Before dawn, we gathered shivering in the sacristy, donned our surplices and red soutanes, and performed our duties at one of the five altars in the main church or one of the remote chapels nestled in the quiet Jesuit house. Through the scent of coffee and toast, we scampered like mice to our various posts and recited responses in Latin to the priest.

> PRIEST: *Introibo ad altare Dei.* (I will go unto the altar of God.)[7]
> SLEEPY ALTAR BOY: *A deum qui laetificat juventutem meam.* (To God who gives joy to my youth.)

You hoped for a speedy celebrant like Fr Willie Troddyn or Fr (Tiny) O'Sullivan, whose names brought relief to those young acolytes with a gnawing hunger for breakfast. These priests didn't dawdle. Fr Troddyn turned to me in the sacristy one morning after Mass, checked his watch and said: 'Did I leave out a part?'

If you got one of the pedantic fathers, then the possibility of breakfast floated off into the future, a pleasure postponed until each Latin syllable was punctiliously delivered, every scintilla of the sacred ritual scrupulously observed.

As an altar boy, there was much to do: lighting or snuffing out candles, swinging the incense thurible, carrying the missal or crucifix, holding the paten, pouring the altar wine, ringing the bells and other duties. In time, these rituals became routine, and the big challenge was staying awake and concentrating. I remember being on the altar for a marathon on Christmas Day; each priest said three Masses. I was given a present of the Beatles album *With the Beatles*. I had listened to it all Christmas Eve and couldn't get it out of my head. The 12/8 strumming pattern on the rhythm guitar accompaniment for 'All My Loving' wouldn't leave me alone. I spent the three Masses replaying it in my head and missed ringing the bell for the most solemn part of the Mass.

The Crescent Church was not just for the school community. It was shared with the Mass-going citizens of Limerick. As an altar boy, you became familiar with faces, particularly since you held the paten beneath their waiting chins during Communion. The church was also a haven for some of the city's colourful eccentrics: shouters, singers, mumblers, tut-tutters, St Vitus dancers and the like. One woman who attended 8 a.m. Mass every morning carried a bag of empty milk bottles, clattering her way up the aisle to the front pew invariably just minutes after Mass began. She'd set the bag down, fiddling and footering with the contents, causing the bottles to fall out like playful puppies and roll over the hard tiles and onto the resonant wooden floorboards. These were then loudly and theatrically retrieved, returned clinkingly to the bag, and thus began the whole Beckett-like drama again.

The church also brought me into contact with a less laudable aspect of Limerick life. There were two entrances to the church. The main doors faced the O'Connell monument, but to the right and up some steps was a black door through which those in the know had access. On Sunday mornings, that door was left off the latch, and Limerick's

cognoscenti would enter and walk down the long conservatory-style hall to arrive at Our Lady's altar in the church proper. Halfway along the hall was a table with a collection plate where the faithful were expected to pause and be extra faithful by depositing nothing less than silver coins. The portion of the church in front of Our Lady's altar was cordoned off by a red rope with golden hooks of the kind used today by nightclub bouncers to keep riff-raff out. The man in charge of this elitism had the odd name of Brother Priest. He was one of the Jesuit order who would never proceed to the priesthood and would serve a lifetime as a brother. After Mass each Sunday, when the faithful departed, Brother Priest would collect his pieces of silver. Thus, social order was copper-fastened; we all knew where we stood – or knelt.

PART 2
1960s – Growth and Discovery

Music expresses that which cannot be said and on which it is impossible to be silent.

– Victor Hugo, *William Shakespeare*

7. Comedy, Bands and Travel

Increasingly I was drawn to music and the stage. I particularly liked comedians Tom & Paschal, who presented a yearly Christmas show: *Tom & Paschal's Christmas Crackers* at the Mechanics' Institute, and later, annual runs at Jack Bourke's City Theatre. The shows were in the traditional style of variety entertainment with Tom & Paschal as the focus with their comic sketches, featuring other performers from magicians to tumblers to Irish tenors like Louis Browne.

Since the Mechanics' Institute on Hartstonge Street was around the corner from our house and Tom & Paschal were customers in our shop, I was allowed to sit in the orchestra pit and watch the show. And I went to many, entranced – I couldn't get enough. The comedy was pitched to a Limerick audience. They invented two characters, Nonie and Katie, complete with prams and headscarves whose dialogues about the difficulties of Limerick life always ended up with 'we never died a winter yet!' They also had a Laurel and Hardy type routine where Tom was the bumptious know-all and Paschal the toothless dimwit with a knack for innocently deflating Tom's pomposity. Paschal also did hilarious mimes to tracks by Jerry Lee Lewis or Little Richard. With hair

plastered to his head, dressed in a cheap and frayed dinner jacket, collar and bow tie, trousers reaching just below the knee, and with his false teeth removed, he writhed and shimmied and shuddered until his elastic limbs seemed to disconnect from his body. 'Oh! -My S-s-oul,' he lisped as the Little Richard track blasted out from the speakers. The place went wild.

Eamonn O'Connor – a freelance cameraman who supplemented his journalist's income with stints as a magician and comedian – became a regular ventriloquist and sword-swallower in *Tom & Paschal's Christmas Crackers*. This yearly confection ran from St Stephen's night until February, sometimes March, to packed houses unequalled before or since in Limerick.

Another memorable act was Jackie Farn, aka Valentino – King of the Music, quite a title to uphold, but it didn't bother Jackie, who played an extraordinary instrument called the Cordovox. This contraption was an electronic piano accordion boasting a library of 1000 sounds. Today such a boast would not impress any kid with a computer, but in the 60s, it was the cutting edge of keyboard technology. Jackie was an accomplished musician, though somewhat tawdry in his presentation – not that I noticed back then. In fact, like everyone else, I was captivated. His Cordovox, like his stage wardrobe, was studded with tiny disco-ball-style mirrors which sent shafts of light slicing through the fog of cigarette smoke in the Mechanics' Institute, dazzling the audience. We were impressed, particularly when he played his encore, invariably the Tornados' current hit 'Telstar'. This piece, written to celebrate the launch of the first communications satellite in 1962, had reached No. 1 in the American charts – a rare feat for a British band playing instrumental music. Valentino brought the house down at *Christmas Crackers* with this finale of technology, theatre, light show, and bravura showmanship. Where is he today? He seems to be still at it. His website tells us that he has rubbed shoulders with the Beatles, Dusty Springfield, Sammy Davis Jr and Liberace. Heady company indeed. Hope the disco glitter stayed in place during all those shoulder rubbings.

7. COMEDY, BANDS AND TRAVEL

By now, I had entered senior school, the world of big boys where serious rugby was played, and some lads started shaving or developing pimples and body hair. Other physical transformations materialised. We were discovering girls. There were two girls' schools nearby: Laurel Hill, a mixed boarding and day school, was closest; and the Presentation Convent beside the Christian Brothers on Sexton Street was further away and offered less opportunity for mixing. It was expected that Crescent Boys and Laurel Hill girls were fated to hook-up for socio-economic and proximity reasons. Another illustration of Brother Priest thinking in Limerick.

Events were held in school, like debating society competitions, to encourage mingling. Fr Vailintín Mac Lochlainn S.J. ran mixed gatherings in the Crescent called An Cumann Caidreamh. Literally translated, this means the Intercourse Community, though surely Fr Val preferred a broader interpretation like the Social Club or similar. It was set up to bring Crescent boys together with girls from any school (mostly Laurel Hill) to encourage Irish speaking, Irish dancing and, of course, to provide a supervised environment for mixed social engagement.

The dancing was the most comical. Lumbering second-row rugby forwards collided as they struggled to remember the patterns of Irish set dances like 'The Walls of Limerick'. The more aggressive lads saw it as an opportunity to display physical prowess to visiting females, and while things never got out of hand, there were moments when the line between dancing and open combat became blurred. The Cumann Caidreamh only lasted until Fr Mac Lochlainn moved to another Jesuit school, and no other teacher was enthused enough to continue with it. My memories of those nights in the assembly hall are infused with the vinegar aroma of perspiration seeping through Bri-nylon shirts mixed with Aqua Velva aftershave and cheap perfume.

We packed into the large lounge in Maurice Stokes's house in Fedamore, County Limerick. The room was hot. Very hot. Maurice went to the Crescent, and his family was part of Limerick's county set. They had ponies and won rosettes at gymkhanas and other horsey events. This

world was very different to life in the city where Bertie Hogan's dray horse was the zenith of my equestrian activity.

Here we were, dripping in teenage perspiration after a long dance set of fast songs by the Beatles, the Stones, the Hollies, and of course Brendan Bowyer and his dance craze. His cover version of Chubby Checker's 'Hucklebuck' had hit the 1965 charts in Ireland and made him famous. Nobody knew how to dance the 'Hucklebuck' even though the lyrics in Checker's version gave detailed instructions:

> *Push ya baby out (yeah)*
> *And then you hunch her back (yeah)*
> *Start a little movement in your sacroiliac*
> *Wriggle like a snake, wobble like a duck*
> *That's what you do when you do the hucklebuck (oh)*[1]

Even though few of us had the slightest idea where our sacroiliac was, we threw ourselves enthusiastically into the dance with those wild improvisational moves that were part of that 1960s', less formal approach to dancing. My mother used to say: 'Are that pair *actually* dancing together?'

The Stokes parents were somewhere else in this sprawling country home, and we teenagers were left to our own devices. As soon as the riff at the end of 'Wild Thing' by the Troggs faded, the DJ put on 'This Boy' by the Beatles. We were now in a slow set, and I found myself standing right in front of Anne Flanagan. Anne was an olive-skinned petite stunner who I barely knew but admired from afar. She had the most beautiful blue eyes and long straight hair parted in the middle, reminiscent of Jane Asher or Marianne Faithfull. She wore a miniskirt and boots and had a playful, mischievous smile that encouraged invention in a young fella's head.

'Would you like to … dance?' I stammered.

'Sure,' said the lovely Anne.

My heart soared.

Anne was surprisingly responsive as we mooched around the floor, navigating our path among the other dancers. Arms around my neck,

7. COMEDY, BANDS AND TRAVEL

she now put her head on my chest. Soon we were sailing close to Mickel O'Riordan, draped around a girl from Villiers School. Mickel was popular with the ladies being a good-looking rugby star who had a tinge of danger about him and, more importantly, had the use of his father's car. He and I were pals, and as Anne and I sashayed near him, he gave me an encouraging smile. Anne looked up from her nested position on my chest and, nodding towards Mickel, uttered the devastating word: 'Switch'.

'Huh?'

'Switch,' she whispered and rolled those blue eyes towards Mickel and his partner.

A trapdoor opened, and my hopes for a steamy evening with her fell right through it and lay in rubble beside my brittle self-esteem. She wanted to dance with Mickel, I thought, like so many other girls in the room. 'Eh, switch?' was as much a question as I could muster.

'Switch,' she repeated, impatient with my dense stupidity.

I struggled with what to do next when she said, 'Get the light switch, silly!'

The switch that controlled the chandelier was behind where Mickel and his paramour were attempting some kind of bodily osmosis. It dawned on my thick head what Anne's intention was. Oh, happy day! I left her standing there as I scrummaged a frantic path to the switch. The room was plunged into darkness. I stumbled back, crashing into the dancers to where I remembered she was waiting.

'Anne?' I called out through the dark in a loud whisper.

At that moment, the room was illuminated, and a stern Mrs Stokes stood frowning in the doorway, hand on the light switch.

'There will be none of that in here,' she announced firmly, 'this light stays on!'

Mrs Stokes may as well have poured a bucket of ice over us. Anne and I looked at each other. Our moment had passed. The DJ quickly dropped the needle on the Rolling Stones. 'I can't get no satisfaction,' proclaimed Mick Jagger.

A truer word was never spoken.

PART 2: 1960s – GROWTH AND DISCOVERY

While London and San Francisco throbbed to the new social freedoms of the 60s, life in Limerick revolved around school and the shop. However, we were getting hints of what was going on elsewhere, and we devoured anything connected to this new energy. My best pal in those early- and mid-teen years was John Cosgrove. We were both members of the Heanor Record Centre in Middlesex, which published a catalogue every week of available records. We often received albums weeks ahead of the Irish release date – we got the Beatles' *Sergeant Pepper* way before it hit the shops in Limerick in May of 1967. A group of eight of us retired to Billy Sinden's house – they had a fantastic stereo gramophone – and listened endlessly to the album, lifting the stylus, slowing it down, playing it backwards to search for any subliminal messages that the band sneaked in. That summer was filled with long nights sitting together listening to albums like *Pepper*, discussing, analysing, and learning the songs.

Every Friday after school, John and I went to Nellie Martin's on O'Connell Street to pick up John's reserved copies of *New Musical Express* (*NME*), *Record Mirror* and *Melody Maker*. First, we'd stand outside the shop poring over the *NME*'s Top 50 to see where our favourite artists were that week. Next, we'd head to the Talk of the Town coffee bar at Limerick's Savoy cinema. The following couple of hours were spent reading the mags from cover to cover while stretching out two cups of coffee. We were also fascinated by the Arab–Israeli conflict and avidly followed the progress of the historic 1967 Six-Day War. Invariably the manager, Ma Ryan, came in and moved us along: 'C'mon, get up outa there, ye've been sittin' taken up a table for hours while there's loads of paying customers waiting outside. Out ye go!'

Tall and imperious, Ma Ryan's orders were always obeyed.

Around this time, I started gravitating towards schoolmates who played instruments. We were forming bands or 'beat groups'. The Swinging Four was the first one I was in. When I think of that name now, I cringe. We thought we were the bee's knees. The line-up was Des Deeney on piano, Billy Sinden on guitar, Ged Spencer on vocals, and me on drums. These guys were a couple of years ahead of me in school,

7. COMEDY, BANDS AND TRAVEL

but there were no musicians in my class and no drummers in theirs, so we found each other. We rehearsed in the basement of the Crescent or at my house. We even had a band uniform – specially designed bow ties which were very trendy at the time.

Our repertoire comprised hits of the day by people like Cliff Richard and the Shadows. Billy Sinden was a huge fan of Hank Marvin and played 'Apache' just like Hank. Ged Spencer sang 'Living Doll', and Des Deeney played the theme from *Exodus* – a solo piano showstopper. We just looked at him in wonder as he arpeggiated his way up and down the keys. I did my version of Sandy Nelson's 'Let There Be Drums'. This drum solo with an occasional guitar riff reached No. 1 in Australia and made the Top 10 in the US and the UK – Sandy's version, not ours.

The Swinging Four had a short career as exam pressure interfered. Anyway, other things were happening musically to pull us in different directions. We did manage to play one major concert in the Crescent Hall. The Jesuits had a show to raise funds for the Foreign Missions every year that all the local schools attended, and it was a big deal to get a spot on this. It was the zenith of the Swinging Four's performing career.

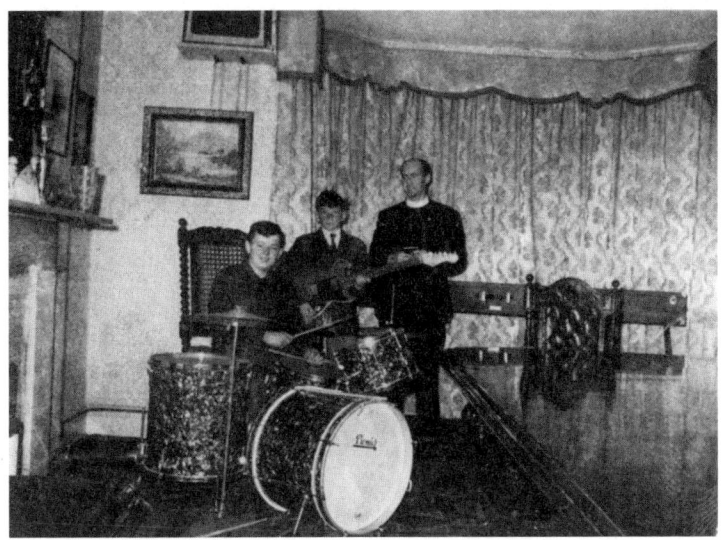

Two members of the Swinging Four (left to right): Bill Whelan on drums, Billy Sinden on guitar and Fr Kennedy (not in the band!).

PART 2: 1960S – GROWTH AND DISCOVERY

I went on to form and join other bands, sometimes as drummer, sometimes as guitarist or pianist. These bands have been well erased from Limerick's musical memory. Still, for the purpose of record, they were bands like Little Cicero and the Senators, where I played disguised in sunglasses and a bowler hat so that my parents wouldn't find out about it (of course, they did).

There was Climax 6 Plus 3, a nine-piece outfit, where our pianist suffered from such stage fright that he could only play unseen in the wings; idle audience members with little to do but count the band members would have noticed that it looked more like Climax 5 Plus 3. The 3 were our backing singers, Annette Clarke and the Quinn twins. It was an unwieldy group but introduced me to the process of arranging for larger ensembles, something I was increasingly attracted to.

Parallel to all these extra-curricular musical activities, school life ground on. In 1965, my parents signed me up for a five-week European school tour. It cost £115, a considerable amount – equivalent to about 2,000 nowadays. Two Jesuit priests, Fr Tom Callaghan (or The Bull) and Fr Paddy Kelly would be our custodians. Nine boys signed up, including me, and all eleven of us headed out from the Rosslare ferry to the UK and then onwards to Belgium, France, Italy, Austria, Switzerland and Germany. We made use of the *Jugendfahrkarte*, allowing for intercontinental rail travel at a fixed price. We stayed at deserted boarding schools, convents or hostels.

In preparation for this tour, my mother decided I needed specially commissioned luggage; not for her the common or garden rucksack the other guys were getting at the Army Surplus Store in Parnell Street. No. Her boy would have to have something specially made for this five-week gruelling odyssey. So, she asked one of the local leather tanners to cut her out a big duffle bag, into which would go my sleeping bag and clothes. This would then be tied with leather straps and carried, slung over my shoulder, like a sailor's seabag. After five weeks of hodding this contraption around Europe, my respect for sailors will never leave me. While my pals moved comfortably around with their gear strapped neatly to their backs, I trudged up and down mountain paths,

hot streets of Venice, crowded German railway stations, in and out of cathedrals and museums, all the while leaving a leaking trail of possessions behind me and building up remarkable upper arm strength and shoulder muscles.

The folks at the Army Surplus Store were also bypassed when it came to my sleeping bag. My mother got a seamstress friend to make a sleeping bag out of a rug, of the kind that you would take with you to lay out on the grass for a picnic. It was hot and hairy, and extremely itchy against the skin. On one of our stops, we were billeted in a barn attached to a Tyrolean hotel called Schöne Aussicht in the beautiful Alpine village of Neustift. We slept in the straw with the cattle around us for three nights. By the time we left, not only did my sleeping-rug give me an angry rash in the July heat, but nearly every other kind of barn life, except the cattle, joined me in my shaggy cocoon. I was still picking bugs and straw out of it days later in Florence and Venice.

Apart from these irritants, the tour was educational, and while there wasn't a church or cathedral in Europe that we passed without calling in, we did have some non-church-like memorable moments. Arriving by train at Venice station and taking the boat up the Lagoon to arrive in St Mark's Square at the Doge's Palace was unforgettable. Over the five weeks, I lost 20 lbs carrying my pilgrim bag of penance on my shoulder, but I soon got used to it, and the journeys passed easily as Josh Harold and I sang songs like Peter & Gordon's 'True Love Ways' in harmony. A big novelty was when we got to Italy, and like in the James Bond films, we saw real live girls in bikinis for the first time. Such flaunting of the female form was new to our Irish eyes. We were used to seeing girls changing into one-piece bathing costumes under modest towels on the semi-tundra beaches of Lahinch or Kilkee, and this wasn't long after Brian Hyland had a hit in 1960 with 'Itsy Bitsy Teenie Weenie Yellow Polka Dot Bikini'. Innocent times. After Italy, we were all hot and bothered, and fights broke out by the time we got to Munich.

She was afraid to come out of the locker
She was as nervous as she could be

PART 2: 1960S – GROWTH AND DISCOVERY

> *She was afraid to come out of the locker*
> *She was afraid that somebody would see*
>
> *Two, three, four, tell the people what she wore*
>
> *It was an itsy bitsy teenie weenie yellow polka dot bikini*
> *That she wore for the first time today*
> *An itsy bitsy teenie weenie yellow polka dot bikini*
> *So in the locker, she wanted to stay*[2]

Try releasing that record today!

8. Crime and Punishment – the Docket Book

It was our final year, and we were gearing up for the Leaving Certificate. Our class was now the most senior in the school. Paul O'Mahony, whose family owned Limerick's pre-eminent bookshop, was made school captain, and I was made a prefect. These positions carried responsibilities but also perks like having a key to the prefect's room. There were eight of us, and we used the space for chilling out and having a smoke. The Jesuits disapproved of smoking, but it was difficult to ban since many of them smoked like chimneys themselves. They liked P.J. Carroll's Sweet Afton, a preference that went as far back as World War II when they were supplied cheap smokes by the company. The habit was perpetuated in peacetime by continuing brand loyalty. Or addiction.

For me, discipline in school was more of a light touch than an all-pervasive presence. Still, occasionally I've been surprised by the venom with which some past pupils describe the treatment they received at the hands of individual teachers. Corporal punishment was legal, acceptable, and even supported by parents who felt that a smack would make a man of you.

The Jesuits had a particularly exotic way of dealing with transgressions. Each teacher had a docket book. The design of this weird item was like a chequebook. The print on the docket was entirely in Latin. It required the teacher to enter the name of the offending pupil (*pueri nomen*), the nature of the offence (*quam ob causam*), the recommended number of slaps (*poena sumenda*), the date (*die*), and finally, the teacher's name (*magistri nomen*). Each cheque had a corresponding stub, where the teacher entered an abbreviated duplicate for his records. The top of each docket was headed *Ad Maiorum Dei Gloriam* – for the greater glory of God. The teacher would tear off the docket and hand it to the pupil, who was then obliged to cash it within a day or two with the Prefect of Studies. The headmaster administered the recommended punishment. This involved going to his office at a time of your choosing, queuing with other miscreants outside his door to await your fate.

'Good morning, Whelan' – through a haze of Sweet Afton.

'Good morning, Father' – handing over the crumpled docket which had been in my blazer for a few days.

'Hmm, talking in class again? You know Fr Durnin doesn't like to be interrupted in his class.'

'Yes, Father.'

'Was what you had to say more interesting than what Fr Durnin was saying at the time?'

'Can't remember, Father.'

'And who were you talking to?'

'No one, Father.'

'Ah now, Whelan. That's a bad sign. Talking to yourself? Could you not find anyone interested in listening to you?'

Silence.

'Fr Durnin recommends four slaps, hard. Does that seem fair to you?'

'I suppose so, Father.'

'Put out the hand.'

Four whacks are administered with casual indifference, and having muttered the obligatory 'Thank you, Father', you exited the office.

8. CRIME AND PUNISHMENT – THE DOCKET BOOK

Now, the thing here was to appear with an airy sneer on your face as if what had occurred behind doors was mildly amusing. You couldn't show the queuing fellow criminals you were affected in any way, even though your hands smarted in your pockets. Finally, with the headmaster's signature, the docket was returned to the original teacher, who crossed it off in the stub. Justice was done.

One or two entrepreneurial students ran a small forgery business. They became adept at copying the headmaster's signature, and in exchange for cigarettes or other favours, they signed the docket for you. But soon, the Jesuits tumbled to this, and the headmaster acquired a rubber stamp resulting in the collapse of this underground enterprise.

I often think about this whole punishment ritual. The dockets in Latin made it seem as if this was something from antiquity carrying with it the approval of centuries of pedagogy. Also, putting time between offence and punishment was designed to take the heat out of the occasion and allow the student to consider both action and consequence. Teachers were not supposed to hit pupils in class. Punishment, in theory at least, was the sole responsibility of the headmaster, not that this was adhered to. Most of my generation experienced the Bull Callaghan's open palm across the jaw while being called 'a big babby' and Fr Joe Marmion's 'old one-two', which involved putting your leg up on a chair and getting a smart whack on each of your upper thighs. A friend told me he was once knocked out cold by a punch in the jaw from a priest. Nowadays, that would end up in court, but then, nobody said anything.

Marmion was not only a bully, but he also sexually abused many in his care. The Jesuit order remained silent about this abuse, even though they knew of the accusations, and even tried to cover it up for over twenty years. This remains a serious stain on their reputation. I performed in two school operas which Marmion directed. Luckily, I did not experience the misconduct he's infamous for. He was talented musically, none of us liked him, but begrudgingly we admired the results he achieved for the operas. When news broke of his sexually abusive activities, many of my contemporaries were shocked, although none of us were eager to protest his innocence. When I look at the school photographs of the

operas now, young boys in dresses and ringlets, the innocence, I feel deep empathy for any who experienced his violations firsthand. It's profoundly sad that his depravity has spilled into the crevices of our boyhood memories. I also think of the good priests and teachers in the Jesuit community who had a genuine love for education and pastoral care and who now must bear the shame of Marmion's actions.

Fr Hugh O'Neill, to my knowledge, never hit anyone. He was a tall, neat Jesuit who walked ramrod straight, spoke in clipped sentences, had copperplate writing and did his best to teach us Latin. We'd to buy a collection of stories called *Fabulae Faciles* about Perseus, Heracles, Jason and the Argonauts, and Ulysses. The book included an illustration of a naked Perseus killing the sea serpent. One day, at the end of Latin class, Fr O'Neill cleared his throat and said: 'Gentlemen, I want to read *Fabulae Faciles* with another class. Please, hand up your books. I will return them on Thursday.'

We dutifully handed up our books.

On Thursday, the books were returned. Within seconds, a hand went up. It was Eddie Uniacke. 'Excuse me, Father, but one of the boys has drawn all over my book.'

He held his book up, and sure enough, Perseus was no longer naked. He now wore a robe drawn with a black felt-tip pen that seeped through to the reverse page. We all opened our books. Every Perseus was similarly clothed, as were a few other semi-nudes. Speechless, we looked at the reddening face of Fr Hugh O'Neill. 'Open your book of Latin verbs,' he said, breaking the baffled silence.

We closed our mouths and opened our books.

The Jesuits relied on loading you with personal responsibility and expecting you to respond maturely. I'm unsure if the lay teachers fully embraced the Jesuit philosophy of education, though this group was as eccentric and off-centre as their clerical counterparts. We had a marvellous teacher for English and French, Eoin O'Moore, who was not only colourful but a keen amateur actor. Almost bald, he had more hair in his eyebrows than on his head. His lavish eyebrows were used to eloquent

effect. At home I tried to see if I could raise one eyebrow like O'Moore. He wore lavender socks, a beret and a cravat and paraded into class in a cloud of floral cologne. You felt he'd prefer to be treading the boards of the Abbey or the Gielgud rather than trying to educate a lumpen mob of resistant teenagers. Despite this, he gave us a glimpse of how a love of language might enrich our lives, not least by how he addressed us. He swore at us in long French sentences where we discerned words like *putain, salaud* and even *salope*. But it was his glorious English, peppered with ironic wit, we loved the most.

'O'Connell, what are you doing?'

O'Connell's legs had upended Pa Whelan's schoolbag.[1]

'Just stretching my legs, Sir,' said O'Connell.

'Tshhh' – sharp hissing through bared teeth, half-closed eyelids, one eyebrow arched – 'well, O'Connell, if you do not desist from these physical paroxysms, I shall be obliged to descend from the elevated comfort of my podium and strike you sharply!"

In my experience, O'Moore never struck anyone sharply. He succeeded in getting us to read several Shakespeare plays in our final year, not just *The Merchant of Venice*, which was on the exam curriculum. The entire class, while under-achieving magnificently in other subjects, did very well in Leaving Cert English.

My love of English, attraction to the stage, debating, and anything theatrical meant I was active in whatever school dramatic production was on. I played Mrs Stead in *The Private Secretary* by Charles Hawtrey. Later, I landed more prominent roles in two operettas as King Sigismund of Trocadero in *Prince Methusalem* by Johan Strauss II and as Baron Weps in *The Bird Seller* by Carl Zeller. My dramatic career in the Crescent suggested I was best cast as doddering old landladies or blustering aristocrats. Baron Weps's love affair with his little 'chickadee' – the ancient dowager Baroness Adelaïde – provided some high comedy. Roddy Gallivan, whose voice was breaking and who was showing signs of facial hair, played the baroness. Roddy came from a theatrical family; his comic timing was remarkable. We had some scenes together where a look, a pause, an inflection made a strong impact on the audience.

PART 2: 1960S – GROWTH AND DISCOVERY

The heroin hit of getting it right and feeling the audience in lockstep with you hinted at how important dynamics and timing are in any performance, musical or theatrical.

9. Limerick's Abbey Road – the Vortexion

My fascination with recording was becoming an obsession. My father's similar love of technology, and his friendship with Jim Carroll, meant that now and then, a new tape machine appeared in the house, keeping us apace with advancements. We were both equally exhilarated hearing Duke Ellington and Johnny Hodges in glorious stereo on the shiny new Sony reel-to-reel that one day appeared miraculously in the drawing room.

My friends and I started recording songs and experimenting with weird techniques on our Sony tape recorder. We had heard 'phasing' on records like 'Itchycoo Park' by Small Faces but had no idea how to achieve this. However, we discovered that if we lowered our microphone in and out of one of my mother's tall vases, we got an acceptable version of phasing.

I started to collaborate at writing which produced a plethora of songs with titles like 'Kennington Lane' (with Dee Power), 'Reality' (with John Cosgrove), and 'Lady Anne' and 'The Company Line' (with Niall Connery):

PART 2: 1960S – GROWTH AND DISCOVERY

I want to assure you
Your future is safe
The company will protect you
We've your interest at stake
Well we can see you've got the talent
And we know just what it needs
To turn that kind of talent
Into L, S and D
So you've heard some scary stories
And you're naturally slow
To commit yourself to something
When you need the room to grow
But we believe in your development
Integrity's the name
Just sing it as you feel it
And we'll sell it just the same
One more thing and then we're fine
Another glass of Company wine
And sign along the dotted line

Niall was my songwriting partner in those early days. However, we now needed to make proper demos to send to music publishers and get noticed. Once again, my father's love of the recording world came to the rescue. Reading up on professional recording methods, I found that the latest model of a Vortexion tape recorder, a CBL 5, had the professional capability to produce high-quality demos. Jim Carroll assured us he could supply it, and the order was confirmed. Now we needed a studio to put it in.

We had an unused attic in Barrington Street. Together with a carpenter friend, my father built a dividing chipboard wall into which they cut a door and a double-glazed glass panel. Now we had a control room and studio area. A wooden desk was built to receive the Vortexion when it arrived, and all the walls were covered with sheets of aeroboard for soundproofing. A Dutch friend from school, Paul Vos, who was a

9. LIMERICK'S ABBEY ROAD – THE VORTEXION

wizard with electronics, wired the place up. As well as wiring the studio, he ran discreet cables downstairs to the drawing room and mounted plug points in the skirting so we could plug in mics and headphones and record the piano from upstairs in the studio. The hardest part of the whole operation was keeping my mother distracted so the upper part of her house could be converted into Limerick's Abbey Road.

Then the Vortexion arrived. It was a serious-looking piece of kit. None of that fancy mass-produced polish here – this looked like it was built by hand, and its military-like robustness was ready for heavy professional use. It also boasted something that was its selling point for me – SOS or Sound on Sound. This feature allowed us to double-track our performances. So, I could play piano downstairs and then overdub guitar and drums separately upstairs in the studio. We were ready for anything.

Niall Connery, Ged Spencer, Dee Power, John Cosgrove and I formed Verno Ltd.[1] It was a service to make demos, not only for our songs but for anyone who wanted their songs professionally recorded. We also offered the studio as a facility where groups could come to record, although this was subject to the clients being approved by the actual owners of the house – easily the most challenging part of the transaction.

Throughout those exciting years at the end of the 1960s, we spent hours writing songs, recording demos and making full use of the studio. The Summer of Love happened in the Haight-Ashbury district in 1967. Scott McKenzie had a No. 1 with 'San Francisco (Be Sure to Wear Some Flowers in Your Hair)'; apart from being the longest title ever to reach the top of the UK charts, it remains a vivid aide-memoire if you want to be transported back to the era of peace and love. In the attic studio of 18 Barrington Street, we looked west to where all this music was coming from. We were at the dawning of the Age of Aquarius – whatever that was. After a day's recording, I'd lean on the windowsill watching the sunset in the western sky, listening to the Beach Boys' 'Pet Sounds' or Jimmy Webb's 'Wichita Lineman' feeling an inexpressible yearning for the glow and the promise this music expressed. Around this time, I developed a strong attraction to the off-centre rhythms of Dave Brubeck, the beautiful chordal sequences of Antonio Carlos Jobim,

PART 2: 1960S – GROWTH AND DISCOVERY

and the unique song structures of Burt Bacharach and bands like Sergio Mendes and Brazil '66. There was so much varied music in the charts before formatted radio corralled us into readily marketable targets.

During holidays and breaks in the school routine, Verno Ltd. functioned sporadically. Our only client to release a record was a band from Killaloe called the Shannon Folk Four. They recorded 'The Four Who Fell', written by Jack Noonan, aka the Bard of Killaloe. It was a patriotic song celebrating the four men executed on the bridge in Killaloe during the War of Independence.[2] The record appeared on the Verno Label and the Shannon Folk Four did their own distribution. The recording session itself was memorable.

It was a Saturday evening, late September 1968, and the session was scheduled for 8 p.m. Upstairs in the studio, we awaited the arrival of the Shannon Folk Four. Everything was going to plan. They had phoned earlier to mention they'd dropped in to Jack Glynn's music shop in Limerick to pick up some stuff. On the dot of 8 p.m., my mother called up to the studio to say some people were at the front door. She stood in the hall as I went to greet them.

'Who are all those people?' My mother had her stern voice on, and 'those people' immediately put them in the Jehovah's witnesses and 'undesirables' category.

'It's just the band, Mum.'

'You told me there were only four.'

'Yes, that's all.'

'There are eight people out there in a big dirty-looking van. They are all certainly not coming in here.'

I peeked out the window. A Ford Transit was disgorging itself of the band accompanied by what looked like their girlfriends, one or two unknowns, plus a pile of shiny guitar and banjo cases.

These men from Killaloe were honest-to-God lads, coming to Limerick to make their first record at Verno Studios. They were so geared up for the event (due in no small part to the official-sounding letters we sent them) they had stopped at Jack Glynn's previously

9. LIMERICK'S ABBEY ROAD – THE VORTEXION

and bought themselves an entirely new set of instruments. Now they were standing at the door of this private house, looking at the producer-studio proprietor (who still lived with his mother) as he delivered the bad news: 'Lads, I'm afraid only the band members can come in.'

I muttered something about insurance and public liability, but they were crestfallen. I imagined the girls had been invited to witness their partners making their FIRST RECORD and had gotten all dressed up for the occasion. Awful. We talked back and forth, but I couldn't relent without my mother causing a scene. It looked as if 'The Four Who Fell' would do just that at the first jump. Finally, with promises to go for a drink afterwards, the girls agreed to stay in the van.

'It won't be long!' I assured them.

We tramped up to the attic and got down to work.

Which is when the next problem arose. Buying new instruments on the day of recording is not advisable. We spent hours trying to keep them in tune, but new instruments with new strings are slow to arrive at the stable tension to sustain the tuning. It took hours. By the time we wrapped it up, the girls in the van were thirsty and had run out of cigarettes. Still, the Shannon Folk Four had their first single, and Verno Studios had its first (and only) release on vinyl.

Niall Connery and I continued to write and record demos of our songs. I wrote some instrumental music. Pete Ahern, with his multi-instrumental skills, recorded some of these on flute. We sent the lot off to music publishers in the UK and elsewhere in the hope of exciting interest. Little did we suspect that one of these demos would end up in a most unexpected place.

10. UCD and a Crash at Lissycasey

School days ended, and thoughts turned to 'what next?' I wanted to follow my passion for music, but my parents insisted I get a third-level qualification under my belt. We discussed options. If I couldn't do music, I'd do law, particularly the Bar. When the matriculation results came in, and the results were good, I was free to go. My mother and I went to Dublin to arrange digs. We scoured the South Circular Road and Ranelagh, meeting many landladies, none of whom impressed us. We had nearly given up when we got word that accommodation had become available at the Jesuit student hostel in Hatch Street.

The day came to leave for UCD. My father stood at the door of 18 Barrington Street, shirtsleeves rolled up, wearing braces but no bow tie – this was his informal house attire. He always took his shoes off when he parked his bike in the hall and put on his slippers. As we pulled away, waving goodbye, the image of him framed in the rear window of Mrs O'Mahony's car is burnt into my memory. The moment represented the closure of a chapter in both our lives. The excitement of heading to a new life was potent enough to overwhelm sadness, but I must have been aware subconsciously that I was moving on while my

10. UCD AND A CRASH AT LISSYCASEY

father was staying put. This man who played the harmonica while I beat a biscuit tin, who held my hand as we went to hear the Golden City Dixies, who bought tape recorders and soundproofed attic walls, was departing from my life.

University Hall, or Hatch Hall as it was known, is a tall, bleak Edwardian red-brick structure built by the Jesuits in 1913.[1] Paul O'Mahony's mother, Claire, drove Paul and me there in October 1968. I can still see the building looming through the rain on the windscreen of her Hillman Hunter as we drove up Fitzwilliam Street. A five-o'clock shadow of withered ivy grew up the side of its face, and its three copper spires evoked Dickens or the Gothic novels of Mary Shelley and Edgar Allen Poe. On that grey and drenched day, it was difficult to imagine how we were going to live up to the building's motto – *Sic Luceat Lux Vestra* – let your light shine.

We were greeted at Hatch Hall by Seamus, the ever-present concierge, doorman, human alarm clock, message taker and keeper of the keys. Paul and I were assigned to our rooms. He was sharing with Donegal man, Charlie McGonigal, and I found myself in Room 21 with a remarkable fellow Limerickman, Eddie O'Grady. I hadn't known Eddie in Limerick – his alma mater was the Christian Brothers in Sexton Street. He was a bright scholarship student whose ambition for a stellar career in law was about the same as my own, less even. We had much in common. He had an encyclopaedic knowledge of music, leaning towards progressive and psychedelic rock, bands like the Moody Blues, Jethro Tull, Pink Floyd and Mike Oldfield. He listened to BBC Radio One and Radio Luxembourg – he loved the DJ, Kid Jensen. He even kept the radio on while studying for exams in case he missed anything, drumming along with two biros on his lecture notes. If O'Grady failed his exams, you might cite this as the cause; however, Eddie never failed an exam. Not only that, but he also got honours and was near the top of the class in all subjects. He was passionate about the occult writings of Dennis Wheatley. I rarely saw him without *The Devil Rides Out* or *To the Devil a Daughter*, which he read and re-read.

There was a covert responsibility with a long tradition attached to living in Room 21, as Eddie and I discovered in the first week. The room was on the first floor, and it looked out onto the street just over the main door, which was locked at 11 p.m. sharp every night. Only those with a late pass and a key could enter after that.

Occasionally, a student found themselves delayed after an evening in Hartigan's or the Pembroke. Or they might have forgotten to arrange for a late pass and arrived back without a key. This is where the occupants of Room 21 were called to the rescue. In the early hours of the morning, Eddie or I would be woken by the sound of stones being thrown at our window. Down on the footpath we'd see a forlorn stone-thrower swaying, miming unlocking motions with their fists. That was our cue to open the window and throw down the clandestine front-door key, otherwise permanently kept in a drawer. Once inside, the holder had to return the key *immediately* to Room 21 in the event of even later arrivals. At weekends, things got busy. One Saturday night, some callers saw fit not only to return the key but to gift us a couple of oil lanterns Dublin Corporation had placed on the barrels around roadworks outside. Eventually, we cleared the room of visitors, blew out the oil lamps and put them in the wardrobe, intending to return them the following night. We were settling down to sleep when there was a quick knock on the door, and Fr Murray, the principal of Hatch Hall, entered. 'A fierce amount of noise, is there not, gentlemen?'

Eddie and I looked at each other. I offered an explanation: 'A few of the lads dropped in on their way to bed, Father.'

'Hmm. An awful smell of oil in here. Were ye burning something?' He was standing in front of the wardrobe containing the haul of civic property, appropriated by our drunken friends, and now stashed by us.

Eddie rose to the occasion: 'I was filling my lighter, Father, and the whole thing spilt a few minutes ago.'

Fr Murray looked around the room, sniffed and paused at the wardrobe. We held our breath.

'Well, no more noise now,' he said. 'It's three in the morning. These late hours won't help you to follow a path of reflective living.' The

10. UCD AND A CRASH AT LISSYCASEY

Jesuit's prayerful exercise known as the Examen was his spiritual guide.

We nodded, and he left. We suspected he knew but had decided to let a good night's sleep better our chances of reflective living.

There were over a hundred students in Hatch Hall. In hindsight, I was fortunate to be there as opposed to in digs on the South Circular Road or similar. In Hatch Hall, you got to mix with a wide range of students: architects, medical students, engineers, philosophy majors, commerce students and the occasional long-stay inmate doing postgrad work. There were always country lads like Eddie and me. Room 21 became a meeting place for clandestine gatherings, and many of those nocturnal visitors remain my friends today.

Free third-level education was not introduced in Ireland until 1996. For many Irish parents, mine included, sending a kid to college was a stretch, particularly for students who didn't live in Dublin and for whom accommodation was an added burden. I cringe when I think of how casually I treated my parents' sacrifices and aspirations for me. It's of little comfort that I'm also one of the baby-boomers who felt entitled to this and more.

But these thoughts were far from my mind on registration day in 1968 when I found myself sitting in the great Hall of UCD (now our National Concert Hall) beside a fellow legal hopeful who was to become a firm friend, occasional flatmate and long-time financial consultant over the following fifty years. The Hall was bustling with hundreds of students from every faculty, all sitting on wooden benches waiting to register for their preferred discipline. I was looking over the sheaf of papers in my hand, making sure I had all the requisite forms, birth cert and passport, when I heard a sniggering snort beside me. 'Mary!' the stranger chuckled.

'Sorry?'

'Your name is Mary,' he smirked, nodding at my papers.

I looked at my birth cert, which he'd been sideways reading over my shoulder. Boys born in 1950s Ireland to Catholic parents were often given the second name Mary in honour of the Blessed Virgin. 'Yes, my name is William Michael Mary Joseph,' I said sheepishly. I didn't get

into explaining William and Michael were my grandfathers and the other names were two-thirds of the Holy Family – my parents stopped short at the Holy Infant.

He shook his head, puzzled and looked around at the bustle of students and all the girls. This guy was clearly some Leinster toff, and I wanted no more to do with him. We shuffled forward in the queue. He must have intuited my pique because, after a while, he broke the ice: 'I was christened Colm Michael,' he showed me his birth cert, 'but I'm called Conor.'

'Huh?' I feigned interest.

'After I was born, my father was leaving the house to go to my christening – my mother couldn't go, still recovering – he shouted up the stairs, "What are we calling him?" She shouted back, "Call him Michael." At the church, when the priest asked what name we wanted, my father answered, "Colm Michael." Either the priest misheard my father, or my father misheard my mother, but I ended up being Colm instead of Michael. Nobody in the family likes the name Colm, so I'm known as Conor!'

My embarrassing 'Mary' was a mere trifle compared to this tale of Wildean chaos. Having shared our stories of parental foolishness, we were warming to each other when Conor (née Colm) asked, 'So, you're doing law too, eh? What made you decide on that?'

Now he was getting irritating again, but I wasn't going to be discouraged by being asked the only question I had no answer for. Mustering my most convincing tone, I ventured into the fog, 'Well, eh, I've always been interested in law, particularly from the legal advocacy perspective. I'm a big admirer of Séamus Sorohan, the great senior counsel and criminal defender, and Patrick McEntee.'

Having delivered this partly true but aspirational and flimsy justification for my assault on the Irish Bar and before he had a chance to ask another question, I countered quickly with, 'And how about yourself? What brings you to the law?'

Without hesitation, Conor replied, 'I'm four days late to register for medicine!'

10. UCD AND A CRASH AT LISSYCASEY

However bloodless my commitment, this was in an entirely different league. My admiration for this guy soared – the cojones of it. I was almost too awestruck to ask for an explanation. But I did.

After his Leaving Cert, Conor had gone to America to earn money for his college expenses. He flew on one of the many unregulated airlines that proliferated in the 60s. He got a job vacuuming the dining room and cleaning the toilets in the Concorde Hotel in the Catskills. When it came time to go home and start college, the airline had gone bust. He was delayed by days so that when at last he arrived home, registration for medicine had closed. With the kind of flexibility that came quickly to students in the 60s, Conor changed horses and now found himself on a bench sliding towards the legal profession beside a fellow student with an equally clear commitment to a career path. It is worth noting that Conor went on to shine in his, em, chosen profession. He did well at both the university degree exams and later at King's Inns, qualifying as a barrister and finally ended his legal academic career writing his thesis for a master's in law. He then zoomed through accountancy, when others were taking years to qualify, and ended up with his own accountancy partnership. He is an eloquent example of how being committed at the start of a career is not always essential to success.

In that first year, John Maurice Kelly was Dean of the Law Faculty. As an active politician as well as a professor, he divided his time between his civic and academic duties. Occasionally he left us reading his book *Fundamental Rights in the Irish law and Constitution* explaining that he had 'important matters arising in the House today, so please read from pages 51–76. We will discuss on my return.'

Off he'd fly to Kildare Street to attend to whatever pressing matter had arisen in his political life. Despite this desultory approach to teaching, Prof. John Maurice Kelly, along with another lecturer, Prof. Niall Osborough introduced me to the kind of disciplined consideration, attention to detail and circumspection that should inform any thinking around legal matters. If I took nothing more from my time spent with these men, it was the importance of getting into the minutiae of any issue while taking a reflective overview. I am grateful for their

insight – later in my musical career, I often needed to activate this part of my brain.

Most weekends, I went home to Limerick, back to the studio, writing songs with Niall, recording demos, and doing stints in the shop. During summer, we'd go to Durty Nelly's (a pub in County Clare) with our guitars and sing songs by Carole King, James Taylor, Simon and Garfunkel, Jimmy Webb and the Beatles. If we had a car, we'd head as far as Kilkee and gig in the Hydro Hotel or visit the Pollock Holes.[2] Our audience was a mixed bag of hippie types. Nobody seemed to need to get hammered in those days, and while alcohol was around, it was all more about flirting than slammers. Alcohol was plentiful, but I didn't drink. I had tasted Harp lager with Mickel O'Riordan as a teen in Helvick Irish College and decided it was disgusting. In time, and with practice, I would develop a taste for it and more. When I recall that first drink, it seems a long way from the active engagement I was to have with booze later.

One weekend Niall and I headed to Kilkee with his pal, Brian Gaynor, whose mother had lent him her brand-new Austin 1100 – a birthday present from her husband. We brought the guitar, arrived in Kilkee in glorious sunshine, and headed straight for a pub. We set up for the day and sang until well into the evening. Time to go, and we were back in the car on the road to Limerick.

I was in the rear with the guitar, going through the song repertoire, when just before Lissycasey village, there was a wide bend in the road. We took the turn too tightly, and we veered into the verge and kept driving into the undergrowth. At this point, everything slowed down – every bump and judder of the vehicle, I felt in excruciating slo-mo; surely the car would stop, and all would be okay. But, no. When Brian tried to steer back onto the road, the car seemed to take control of itself and headed straight for the ditch on the other side. I was vividly conscious of the noise of the branches in the hedgerows as we mounted the ditch, airborne, then plunged. And that's all I remember.

I awoke in the ditch, guitar in my arms. I stood up – no pain – then I realized: I was no longer in the car; I'd been thrown out the back

10. UCD AND A CRASH AT LISSYCASEY

window as the car tumbled. I looked around, and there was no sign of it, but I could hear a banging sound. Then I saw it: thirty yards away on its side in the middle of the road, Mrs Gaynor's wrecked Austin 1100. I could smell petrol, and my heart sank – we'd been smoking just before the crash. Niall and Brian were stuck in the front seats, trying to break the windshield. I threw the guitar down and ran to them. Between the three of us, banging and kicking, we broke the windscreen, and the lads crawled out. I had some damage to my eye, but none of us was seriously hurt.

We were checking on each other and assessing what to do next when a station wagon approached from the Kilkee direction. It pulled in. Three faces peered out: 'Are ye alright, lads? No one hurted, is there? C'mon, we'll give ye a hand to get the car offa the road and into the side.'

Ourselves and three burly Claremen put our weight behind the sad carcass of Mrs Gaynor's birthday present and heaved it into the ditch with a minimum of ceremony. 'Listen, c'mon now let ye. Fanny O'Dea's will be closed in ten minutes. We were on our way down there for a pint before we came across yourselves in the middle of the road. Hop in. We'll give ye a lift, and ye can sort yourselves out there.'

Fanny O'Dea's was alive with calls for last orders when we arrived. Brian Gaynor asked where the phone was and headed off to ring his parents while Niall and I headed to the gents to wash off some of the countryside. Our good County Clare Samaritans explained to the publican what the story was, and they gave us hot drinks and told us we could stay as long as we liked until somebody came to collect us.

Mr Gaynor arrived to bring us home. He had a private and tense word with Brian outside the pub, and then we all sat into his car – the longest and quietest car journey I can ever remember. It was late when they dropped me off at my house. Both parents were waiting for me. 'Where the bloody hell have you been until now?' my mother went straight into the attack, my father a frowning presence behind her.

'We crashed in Brian Gaynor's car on the road from Kilkee.'

'You WHAT?'

As I tried to explain what had happened, it was dawning on them: this was serious. But my mother got herself into such a state that she was finding it difficult to stem her anger, even as she realized the crash could have killed me. In the end, they sent me to bed with accusations of keeping 'the whole house up all night with work to do in the morning'.

The next day, when things were calmer, I explained more fully what had happened and was sent to the doctor to have a look at my eye. I had a scratched cornea and had to wear a patch for weeks. For a few months afterwards, I was a nervous passenger. The more we thought about it, the more we understood it was three lucky men who made it home that day.

11. College Life, Denise Quinn and London

My first years in college came at an interesting time in UCD's history. Most faculties were in Earlsfort Terrace, a prime city-centre location around the corner from Stephen's Green; the area pulsed with student life. Trinity College was a five-minute walk from UCD. Across the road was Alexandra College, a boarding school for Protestant girls. As well as Hatch Hall, there were several student residences, notably Loreto Hall, which housed the Catholic alumni for the Loreto Convent School, also known as Virginity Hall. It's remarkable how many of these institutions have closed entirely or moved out of the city centre. It's also worth remembering, in the context of what would be about to happen in the wider Irish society, how small this area was and how closely its inhabitants lived, socialised, and rubbed shoulders with each other. By the end of the 1960s, the UCD population had risen from 5,000 to 10,000, and the campus at Earlsfort Terrace could no longer accommodate such an increase in student numbers.[1] The science faculty had already moved to a shiny new campus at Belfield in Dublin 4; others would soon follow. This was the beginning of the end of 'the Terrace' as the hub of university life.

PART 2: 1960S – GROWTH AND DISCOVERY

By the time Conor Gunne and I entered UCD in 1968, we were just two out of the 10,000 students then occupying the college. The original building housed 4,000. The place was so congested, hour on hour, students charged from classroom to tutorial room to the library or crammed into the two main lecture theatres – G32 and G33 – where several faculties squeezed together for shared subjects like English, history or philosophy. It was like Grand Central Station at rush-hour, only less polite. On the second floor, there were spaces like the Kevin Barry Room, with dividing doors that could open out to make one long lecture hall. Unless you were seated in the first or second of these rooms, you had no chance of seeing or hearing the lecturer. This led to the back of the class becoming an area for other activities such as snoozing, doing the crossword, or snogging on the back benches. In college, there was much evidence of young lovers, swooning around the halls, locked in each other's arms in a tipsy dance, prefiguring the lyric in the Joni Mitchell song:

> *Young love was kissing under bridges*
> *Kissing in cars kissing in cafes*
> *And we were walking down Main Street*
> *Kisses like bright flags hung on holidays*
> *In France they kiss on Main Street*
> *Amour, mama, not cheap display*
> *And we were rollin', rollin', rock 'n' rollin'*[2]

Another undertow stirred in the colleges and streets around this time. The first civil rights marches took off in Ulster, revealing the true sectarian nature of the Northern Administration. Civil unrest and the occupation of universities and public buildings in Paris in May 1968 accelerated similar outbreaks worldwide.

There was simmering despair in the US about the continuing Vietnam War, and many US students avoided the draft by attending international study in Dublin. The Students for Democratic Action (SDA) was formed by, among others, Ruairí Quinn, Kevin Myers, Basil Miller and Úna Claffey. To protest the chaotic relocation to Belfield, this

group occupied the admin building, taking the doors off the hinges and blockading the place with furniture. I was in the main Hall, jam-packed with students when a superintendent and a few gardaí arrived. One of the SDA (I think Basil Miller) climbed up on a table and shouted: 'No police in the University!' provoking a roar of approval from the students.

The gardaí looked around, had a few words with the porters and withdrew, like men who had raided the wrong pub, to cheering and jeering from protesters. Over the coming months, teach-ins were happening to raise people's consciousness. Like sit-ins and be-ins, teach-ins were a feature of the US peace movements in universities and were now spreading everywhere in the West. There was a proliferation of published revolutionary material. I bought Bobby Seale's *Seize the Time*, grappling with radical ideas from the Black Panther movement. I sensed I was going to have difficulty rationalizing all of this while entering a profession where the cutlery in the dining hall of the King's Inns bore the Latin motto *Nolumus mutari* – We do not wish to change.

As a first-year student coming from a sheltered existence in Limerick, all of this was quite unsettling. In that first term at UCD, certainties that secured my sense of self were disturbed, leading to a general feeling of unease. While there was something exhilarating about it, I was aware that much of what I had taken for granted was being questioned and undermined. The debates at the Literary and Historical Society (L&H), while providing an entertaining platform for blowhards and verbal exhibitionists, did highlight current issues and contributed to the growing sense of upheaval. Outside the University, other organizations appeared like the Dublin Housing Action Committee (DHAC), plus several left-leaning bodies inside and outside UCD like Sinn Féin, the Republican Club, and various Marx and Trotsky-inspired organizations. The DHAC, with its very visible secretary Dennis Dennehy, did manage to garner support within the University since issues such as social housing were radicalising students who found common cause with revolutionary organizations. Residents of working-class inner-city areas were being evicted to make way for office development. Dennehy squatted with his wife and children in a house in Mountjoy Square,

from where he was arrested and jailed. He went on hunger strike, and there were street demonstrations to protest his incarceration; at one protest on O'Connell Bridge, the gardaí produced batons to keep order. This was an increasing phenomenon in Dublin student and public life in the late 60s and early 70s, and the expression 'scuffles broke out' entered the script of RTÉ newsreaders regularly.

However, it wasn't all riots and revolution in that first year of UCD. Music, as usual, demanded her place, and I scanned around for ways to make and listen to music in college. As Hatch Hall didn't have a Gramophone Society, Eddie O'Grady, Conor Gunne, Paul O'Mahony and I founded the Circular Motion Group (CMG), which met weekly to play vinyl. Just as we gathered in Billy Sinden's to listen to *Sergeant Pepper*, we assembled in the Hatch Hall Reading Room every week to discuss and critique different records. Nowadays, with Mp3s and AirPods, listening is largely a solitary and personal affair, but back in the 60s, it was a social activity. The idea that people would sit in a room and share their responses to a piece of music by nodding, shaking their heads, or uttering the occasional exclamation must seem strange to music listeners today. It was the musical equivalent of a book club and exposed us to sounds we might not have heard otherwise. It was at one of the CMG sessions I first heard the Band and was immediately taken by the musical complexity in the folksy guise of Americana and rhythm and blues. The Southern Dixie lyrics made their sound antique while being inventive and up-to-the-minute musically.

I missed playing guitar sessions like in Kilkee. However, there were a few guys in Hatch Hall who looked promising. A second-year philosophy student from Ontario, Bill Higgins, gave a tremendous rendition of Gordon Lightfoot's 'Early Morning Rain' as a party piece. As Bill sang, we could virtually see the silver wing out on 'runway number nine' and hear 'the mighty engines roar' as she took off westward bound; the romantic lure of the West was present in many songs then.

Bill was a year older than us. With all the aura of the wide-open Canadian country about him and hints of much greater (that is, 'any')

sexual experience, he cut a magnetic figure in our group. Bill shared a room with Gerry Lynch from Omagh. Gerry was a good guitarist with a love of jazz but was equally at home with any songs we liked to play. We went to the Pembroke – a pub down the road from Hatch Hall – and convinced the owner, Brian Crowley, to open its cellar bar for us. Together with engineering student Pete Ahern, we started a weekly session there and soon attracted a regular student crowd and filled the place week after week. This was not a professional arrangement, and no money changed hands, although one night Crowley gave me five pence off a sixpack to take to a party. Other musicians who ran sessions in the Pembroke were Gary Moore and Ed Deane, who played memorable duets. I was mesmerized by these two guitarists, one right-handed and the other left-handed, playing marvellous acoustic blues in a hushed and reverent cellar bar.

In November of second year, I walked into the Pembroke and had to step aside to allow a couple to get by. He was a scruffy-looking bearded student wearing a dress suit who I recognized as a classmate of my friend Paul O'Mahony. The girl with him was a different matter altogether. She had startling blue eyes and a wonderful figure, and I can still see that warm smile as she passed me by. It is funny to say, but after all these decades, that first sighting of her has stayed with me as vividly as if it was yesterday. The couple went off into the night, and I went down into the cellar, joined the gang, picked up the guitar and launched into the set for the evening, but I knew something had shuddered in the subterrain.

The next morning Paul O'Mahony was sitting beside me at breakfast.

'Hey, Paul,' I said, 'you know that guy in your class who looks like one of the Dubliners?'

Paul surveyed his egg. In the Hall, we had boiled eggs every morning. They were presented in three large bowls marked 'Soft', 'Medium' and 'Hard'. It didn't matter which bowl you chose from, as the eggs were all the same; none of them deserved any of the three advertised descriptions. One bowl labelled 'Rock hard' would've done the job fine.

PART 2: 1960S – GROWTH AND DISCOVERY

'Eh, Paul, hello?' It was clearly too early for my pal. 'Did you hear me? You know the guy in your class with the shaggy beard, looks like he has birds nesting in it?'

'You mean Mick Gleeson?' Paul managed to break through the cranium of his egg. 'Great guy.'

'Yeah, I think that's him. I saw him in the Pembroke last night with a delicious chick on their way to something fancy.'

'Yep, that was Mick okay. And the girl is in our class as well. Gorgeous. Denise Quinn is her name.'

'Are they going out together? Are they an item?' I was very curious.

'Don't think so,' says Paul. 'She's lovely, very smart and a real head-turner.'

I left him boring down into the egg and got myself some of the Hall's more user-friendly sausages. Denise was firmly burnt into my consciousness, and now that had I found a route to her, might an opportunity arise?

I returned to Limerick for Christmas. My writing partner, Niall, was studying medicine at Cork University, so bar the occasional trip he made to Dublin to see his girlfriend, Mary Earls (who worked as a stewardess for Aer Lingus), we only saw each other during the holidays. That Christmas, we wrote a few songs. I wrote an instrumental piece that I recorded with Pete Ahern on flute. I called it 'Denise'. When we finished recording, I sent the demos to Mike O'Mahoney in London.

Mike O'Mahoney was an American whose parents were from Limerick. They had moved to California, and although Mike was born in London, his siblings were born in the US. Mike grew up in sunshine amongst the orange groves of San Diego. He was cliché good-looking: tall, dark and handsome. He carried himself with an unhurried loping gait suggestive of control. His rhythmic stride reminded me of a rower; each step impelled him forward, then a brief pause while the 'oars' were repositioned for the next pull.

In the early 60s, the O'Mahony parents wanted to return to Ireland. They packed up everything. Mike tells how at sixteen, after a long journey from San Diego by sea via the Panama Canal, they arrived

11. COLLEGE LIFE, DENISE QUINN AND LONDON

at Limerick railway station in 1963. It was (surprisingly) raining, and there was litter on the platform and the streets covered with cans, bottles, horse manure, dogshit and other urban detritus. Coming from the clean streets of San Diego, this was the first of many such shocks Mike absorbed when acclimating to the 'old country'.

I didn't know Mike in school but became aware of him when he started appearing at music events, particularly any gig by our local heroes, Grannies Intentions. The Grannies had a hit with 'Never an Everyday Thing', and Mike hung out with them. He met his wife at this time, Jill Griffin, who was the apple of every male eye in Limerick.

Mike also took an interest in up-and-coming music talent, and I was jealously vexed at how taken he was by Dennis Allen, who was emerging as a young Limerick songwriter when I was trying to do the same thing. Mike did land a recording contract for Dennis, but Limerick was too restricting on the O'Mahoney impatience for a career, so in 1966, he left for London, where he worked at several jobs, including as a croupier in Charlie Chesters Casino.

Now that we had a mole in the heart of British culture, I sent him every demo we made, hoping he'd drop them into the right publisher's hands. Amongst those demos was my instrumental 'Denise'. Mike took the demos to Dick James Music and then April Music without a bite. Limbridge Music was the publishing company owned by Richard Harris and run by his brother Dermot. The Harris family were all from Limerick, and one of the brothers, Noel, was a customer in our shop, but I had never met Dermot or Richard. Mike arranged a meeting with Dermot and brought our demos with him. In the plush Limbridge Music offices on the Albert Embankment they had a brief chat, and Dermot said he would listen to the material later. Days passed, Mike heard nothing and rang Dermot, who explained he'd been busy on a film for Richard and hadn't a chance to listen yet. O'Mahoney said that he would have to call around and pick up the tapes as he had an exciting offer from CBS and didn't want to leave any copies lying around. When Mike arrived at Limbridge Music, Dermot was waiting for him: 'Mike, I've just had a listen and played it to Richard. We love it, particularly

the instrumental 'Denise'. Richard wants it as the theme music for his new film.'

'Well, I'm not sure,' Mike didn't display any enthusiasm, 'we're quite advanced with CBS; Bill and Niall are excited about working with them.'

'Where is Whelan?' Dermot was insistent.

'In Limerick. He's studying to be a lawyer.'

'A feckin' lawyer? He's mad. Give me his number, will you?'

Mike faux-reluctantly handed over my number and mumbled something about being embarrassed to disappoint the folks at CBS if this went ahead.

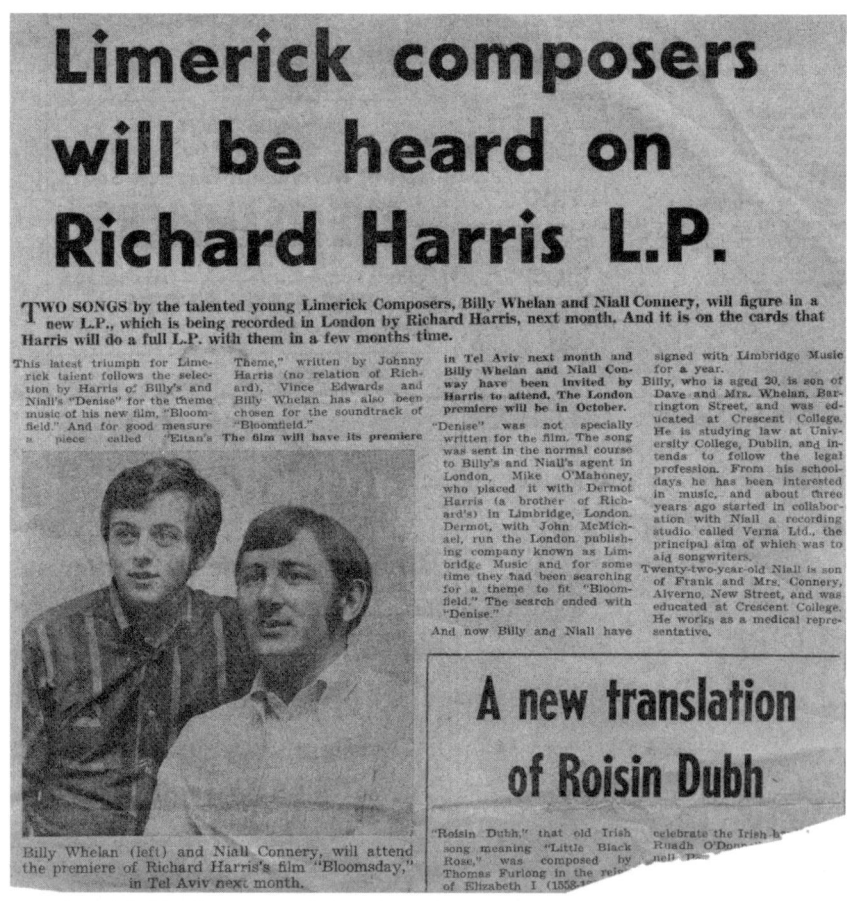

Limerick Leader *paper cutting about Bill Whelan and Niall Connery's songs to feature on a Richard Harris album.*

11. COLLEGE LIFE, DENISE QUINN AND LONDON

Some background here: Richard Harris had recently had an international hit with 'MacArthur Park', written by Jimmy Webb. It was an affecting piece of music for me – all seven minutes and twenty seconds of it. I loved the orchestral break in the middle and listened to it endlessly, picking out the various orchestral lines and marvelling at the tempo changes and the dramatic shape of the whole piece. There was nothing like it in the charts, and it was influential in drawing me towards wanting to be not a performing artist but an arranger, orchestrator and producer.

I was sitting in the kitchen in Limerick when I got a call from Dermot Harris explaining that Richard had heard 'Denise', loved it, and wanted it as the title music for *Bloomfield,* the film he was directing and acting in, with Romy Schneider as co-star. It is hard to describe how I felt as Dermot outlined the plans for the piece. The more he talked, the more excited I got, although Mike warned me to keep my cool and not seem over-interested.

The plan outlined was this: Shirley Bassey's arranger/producer, Johnny Harris (no relation), who orchestrated her hit with George Harrison's 'Something', would be working on my music. While 'Denise' was to be the main theme tune, there would also be music by Maurice Gibb of the Bee Gees. I explained to Dermot that I was in a songwriting partnership with Niall, and we had lots of other material about which CBS was very keen. Dermot suggested that Niall and I come to London to meet Johnny Harris and others involved in *Bloomfield* (unfortunately, Richard was in Israel filming). They would send two airline tickets and arrange our accommodation. So here we were, about to be flown to London for what I imagined would be the gateway to the career in music I dreamed of.

The plane tickets arrived, and Niall and I headed to Shannon and boarded the flight to London. The excitement was intense. I had never been on a plane and was doing my best to conceal my terror. It was pouring rain. You could see nothing out the window except thick cloud as the plane bumped and shuddered its way across the Irish Sea. To me, any routine manoeuvre by the pilot signalled the end, that we'd plummet into the sea and disappear without trace, to say nothing of my glittering career. During this purgatorial journey, my clenching reflex

put paid to my drink; I crushed the plastic glass in my hand, and the woman beside me could no longer ignore the quivering mess beside her. 'Is it your first flight, love?' she said, mopping my ginger ale from the table and from her leather trousers.

'I'm sorry,' I said. 'I didn't think it was going to be this turbulent.'

'Oh, this is nothing,' she said. 'I was on a flight recently where the oxygen masks were lowered, and we had to adopt the brace position on landing. Sure, 'twas nothing – we arrived safely. Don't you be worrying,' she smiled.

I looked admiringly at this brave survivor beside me. She chatted on cheerily for the rest of the flight as I fretted privately about the return journey: the lowering oxygen masks, fire engines on the runway – this new career was not going to be easy.

A uniformed driver stood at the gate with Whelan/Connery written on a placard. He ushered us through arrivals and to a parking spot where a black Rolls-Royce Phantom VI was humming at the kerb. We sat into the plush leather seats where a smiling, dapper man in his early thirties was waiting for us. 'Well now, look at ye! The right pair of Limerick gougers over here in London for the bit o' craic and a glimpse of the high life. Dermot' – he stretched out his hand and gave both of us a firm handshake – 'how was the flight?'

'Yeah, it was fine,' Niall took control, 'a bit bumpy.'

I was silent.

Dermot was the height of urbanity as he told us about the film, the studio we would visit tomorrow, and the people we were going to meet. Names were dropping like autumn leaves, and by the time we got off the motorway and entered the streams of London traffic, we were dizzy. Occasionally we stopped at a junction, and curious Londoners tried to peer through the darkened windows of the Rolls to spot anyone famous, or perhaps a Royal. Dermot was in high spirits: 'Here,' he said to Niall, 'when we stop at the next set of lights, roll down the window.'

We stopped at a junction. A couple shielded their eyes from the streetlights, trying to squint through the darkened glaze.

'NOW!' Dermot shouted.

11. COLLEGE LIFE, DENISE QUINN AND LONDON

Niall complied and rolled down the window.

To our shock, Dermot dropped his pants and presented the peeping pair with an unimpeded view of his bum: 'It may not be a Royal, but it's a Royal Irish Arse!' The driver took off, leaving the couple open-mouthed.

'They probably thought it was Ted Heath when they saw it!' said the bould Dermot, giving one of his wicked laughs, easing back in the leather seat, zipping his fly. We were in for a memorable weekend.

And it was memorable, albeit a bit of a whirlwind. We stayed at Dermot's smart mews in Belgravia, where he lived with his then-girlfriend, the Australian actress Cassandra Waites.[3] Cassandra was a charming hostess, beautiful, and fun company. Dermot took us on a tour around London, visiting his palatial offices and calling in on Johnny Harris at Olympic Studios, where he was producing an album for Shirley Bassey. Johnny played back one of the songs; hearing her powerful voice in a studio environment is unforgettable.

That night Dermot and Cassandra threw a party. The room was full of well-known faces, including some notorious ones. Christine Keeler, the woman whose affair with Profumo caused so many red faces in Harold Macmillan's government, was leaning against the fireplace, smoking a cigarette, looking sultry. I hadn't the nerve to talk to her. A few Bee Gees were dotted around the room and a stunning group of young Australian women – London was a magnet for these Southern Hemisphere beauties. It was the era of Women's Lib, and to wear a bra was considered old-fashioned. It was all miniskirts, hot pants, see-through blouses and not a bra in sight. It was hard on us two Limerick teenagers. Lest we lose the run of ourselves in this sparkling environment, Phil Coulter, also a guest, took out his guitar and brought us back to earth with a couple of his songs, notably 'The Town I Loved So Well' and 'Scorn Not His Simplicity', which he sang while clearly weeping. There was no coming back from where Phil took the party. It had been a long day, so we had an early night.

Sunday morning found us brunching in the Star Tavern in Belgravia, where Dermot explained you could meet everyone from minor Royals

to cockney spivs who sold things that had fallen off the back of trucks. The guy who ran the place, Paddy Kennedy, was famous for his sharp tongue and his habit of picking on one customer and abusing them verbally to the amusement of the bar. He once told Elizabeth Taylor to move her 'fat arse off that stool' as he wanted it for a friend. The Star was where much of the plot for the Great Train Robbery was hatched, and there certainly was a thrill mixing with starlets, escorts, the occasional Duke, and guys who were out on remand.

The rest of the day passed in a haze, and we finished the evening with dinner at Mr Chow in Knightsbridge – a Chinese restaurant staffed by Italian waiters. The food was superb, and I will never forget the star turn of the evening. The lights were lowered, a table was wheeled into the centre of the room, and a Chinese chef came out and, with extraordinary dexterity, made pasta noodles by hand. Threading the dough through his fingers, like someone holding their mother's knitting, he stretched out his arms, and by executing some deft moves and spinning the dough, he increased the spaghetti-like strands bit by bit until he had hundreds of them, which he then cut and popped into a pot. Just amazing. Over fifty years since, and I can still see him doing it to the applause of the entire room.

Between all this eating and drinking, we discussed the movie and music and left London for Shannon the following day, feeling we were on our way. I was so engrossed chatting to Niall about what we had seen and done and about the future that I didn't even notice the near misses and engine failures where we might have fallen out of the sky and crashed.

PART 3
1970s – Learning and Grieving

> I was a free man in Paris
> I felt unfettered and alive
> Nobody was calling me up for favours
> No one's future to decide
> You know I'd go back there tomorrow
> But for the work I've taken on
> Stoking the star maker machinery
> Behind the popular song
> – Joni Mitchell, 'Free Man in Paris'

12. Denise – the Second Sighting

In early February 1970 Paul O'Mahony, Bill Higgins and I took a walk after lunch from Hatch Hall through Stephen's Green to feed the ducks. Two girls walked towards us as we approached O'Dwyer's pub on Leeson Street, waving.

'It's Rosaleen and Denise,' said Paul, rushing to greet them.

We caught up with Paul and the pair of them. Yes, it was *the* Denise. The girl she was with was Rosaleen Leyden from Limerick. Denise looked even more beautiful than I remembered from that chance brush-past in the Pembroke; she was animated with a ready smile and a laugh as we chatted outside O'Dwyer's.

The group split up; Paul and Bill had to be somewhere, and I was left talking to Denise alone. 'Where are you headed?' I asked.

'George's Street, to get something in Dunnes,' she said.

'Would you like a lift?' I nodded towards a motorbike parked at the kerb.

'You have a bike? Wow. Okay,' she said.

I sat on the saddle and motioned her to get on behind me. I could feel her holding on to my midriff. Thrilling. I paused to enjoy that

moment and then owned up: 'Actually, I'm only joking,' I confessed, 'this isn't my bike.'

She bounded off it and onto the footpath. 'What kind of an eejit are you?' She was flushed and embarrassed. 'Do you want both of us to get arrested?' She paused for a moment, then broke into a smile. 'C'mon, walk me through the Green, buy me a coffee to make up for the fact that you are a complete fool without even a motorbike.'

I walked her through the spring sunshine of Stephen's Green and down George's Street to Dunnes. She had to buy some girly things, and I baulked at being her shopping partner. She teased me about it. 'Wouldn't be seen in the women's department, eh? Not macho enough for you? You bikers are all the same!' She pushed the tip of her tongue through her lips, made a mocking face and went into the shop.

I sat on a windowsill and had a smoke, feeling a bit like a stage-door Johnny but excited about being with her. When she came out, we walked to UCD, by which time I mentioned that some American pals of mine, John Flint and Don Smith, were having a party in their flat in Hume Street on Saturday and wondered if she'd like to come with me.

'Are these real friends with a real flat or is it just like your fantasy bike?' she taunted.

She said she'd think about it, although she might have to go home to Kildare at the weekend. I gave her the number at Hatch Hall and asked her to ring me when she knew her plans. We said goodbye at UCD, and I walked over to the Hall, totally smitten. An emotional door had been opened, and I had entered a place I had never been in before. It was exciting, apprehensive, vulnerable and all-absorbing. I was about to discover a very sweet addiction.

Back in the Hall, it was suppertime (Scotch egg – our chef, Patrice, was loath to waste the leftover morning eggs, so she disguised them with sausage meat adding beans and chips on the side). We gathered around the table. Higgins was full of questions. 'Jeez, Whelan, I saw you and Denise heading into the Green hours ago. Where were you? What's she like? She's a real stunner. Did you get to shift her under a tree in the Green?'

12. DENISE – THE SECOND SIGHTING

With his greater sexual sophistication and worldliness, courtesy of all those Canadian Protestant girls he told us about many times, Bill Higgins would have expected me to move to serious matters quickly. I didn't explain that I had never been on a date before, and as I didn't want to reveal my inexperience, I brushed it off with some remark about her 'not being that kind of girl'.

He moved to O'Mahony. 'Paul, the other chick, Rosaleen, is gorgeous. Is she with anyone?'

At this rate, Paul was beginning to see himself as some kind of student procurer. 'C'mon, guys,' he protested, 'do you expect me to keep a file on all of the women in my class?'

'Social science has all the best-looking women, O'Mahony. Sure, it's mostly women in your faculty.' Higgins was insistent. 'Anyway, you must know her – she's from Limerick.'

Paul explained he had known her in Limerick, and she was unattached. He had a suggestion: 'Whelan tells me he has invited Denise to Flint's party on Saturday. Why don't you ask Rosaleen? You can double-date.'

A large hole suddenly appeared in the architecture of Bill's sophistication. 'Me? Invite her? I hardly know her.' He was caught off guard.

'Big wuss,' said Paul, 'I thought you Canadians were fearless regarding women. Or,' he jibed, 'maybe it's because she's not a Protestant!'

Higgins ignored the bait and turned to me, 'Whelan,' he said, recovering slightly, 'will you ask Denise to ask Rosaleen to come with me to Flint's party?'

We all broke up laughing.

'Higgins,' I said, 'you want me to ask a girl I hardly know, to invite a girl you hardly know, to a party with a guy she hardly knows?'

'Hey c'mon,' says Higgins, 'we're in Ireland; everyone knows everyone.'

By whatever diplomatic manoeuvres, Higgins and I found ourselves double-dating Rosaleen and Denise and heading to the party. The room was crowded; a fragrant shroud of incense barely concealed the sweet smell of hash. We found a corner and installed ourselves on the floor, listening to the Grateful Dead, the Lovin' Spoonful, Jefferson Airplane

and the Doors. Inevitably guitars came out, and though we didn't have ours, we joined in the singing. At one stage, when the mood had cooled a bit, Higgins took my arm and placed it over Denise's shoulder. This was a good thing because I am certain if he hadn't done it, we would still be sitting there in Hume Street waiting for me to take the plunge. Denise pulled in close to me, and from that moment on, we became what was referred to as 'an item'. As things turned out, Bill and Rosaleen married in 1972 and Denise and I followed suit in 1975.

※ ※ ※

Denise Quinn and I saw each other every day for the rest of that second-year college term. She had a flat on Mountpleasant Avenue in Rathmines, which she shared with three other girls. We all sat in their living room, listening to albums on the Dansette record player, huddled around the two-bar electric fire. Although we were all very friendly, we had to wait until the girls had gone to bed to have some private time together.

'Bridge Over Troubled Water' had just been released. In the way that music brings us to a time and place, I only have to hear Larry Knechtel's piano intro to the song, and I am back in Mountpleasant Avenue with Denise in those early mornings of our courtship. I had a permanent late key to Hatch Hall, and I must have worn a nocturnal groove in the path along the canal. The sounds of those solitary homeward walks are still in my head: the clock chiming in the Rathmines tower, the xylophone-tinkle of milk bottles, the electric whine of the milk float, the ricochet of my shoe leather along Harcourt Terrace (where Michael MacLiammóir lived with Hilton Edwards) and over into Hatch Street. The city seemed so silent in the early 70s. When I pass this changed pathway today, I think of another of Paul Simon's lyrics:

> *The sounds of the city sifting through trees*
> *Settles like dust*
> *on the shoulders of the old friends*
> *Can you imagine us years from today*

12. DENISE – THE SECOND SIGHTING

Sharing a park bench quietly?
How terribly strange to be seventy[1]

Paul Simon composed those lines in his twenties. As I write this, he is approaching his eightieth year; I have just entered my seventieth. Yet, these memories of my lifelong friendship with, love for, and attachment to Denise Quinn are as close and dear to me as ever, even though my childhood night terrors about time passing quickly and unstoppably have proved to be realized. As Hamm says in Samuel Beckett's *Endgame*: 'The end is in the beginning, and yet you go on.'

Indeed.

13. Richard Harris, *Bloomfield* and the Limerick District Court

The summer of 1970 came with mixed emotions. Reports from home indicated that my father was unwell and needed surgery. He was taken to St John's Hospital in Limerick and underwent a procedure for colon cancer. Not used to sedentary life, he walked the hospital corridors pulling the trolley of intravenous drips after him, a nurse following suit: 'Ah now, Mr Whelan, you're an awful rogue. Would you ever get back into bed and don't be getting me into trouble with Dr Costelloe?'

Eventually, he got out of the hospital to convalesce at home. I moved back to Limerick for the summer to work in the shop; it was all hands to the tiller until my father was on his feet again.

Denise had gone to the US on a work placement at Springfield State Mental Hospital in Sykesville, Maryland. I missed her terribly. When I wasn't in the shop, I recorded and wrote in the studio. My old pal, John Cosgrove, now had a job in the Munster and Leinster Bank in William Street, so we only got together after work, but it was enough to assuage some of the gloom.

13. RICHARD HARRIS, *BLOOMFIELD* AND THE LIMERICK DISTRICT COURT

John had unique intelligence. A fellow school pal, John Halpin, recently sent me a report from our years in the Crescent showing that Cosgrove had received first prize in four of the ten subjects. He was in the top three in four other subjects, leaving just two where he was probably in the top five. But despite his academic achievements, he was no goody-goody. To the casual observer, John might have seemed quiet, studious, bookish (not a star on the rugby pitch), but he'd an independent turn of mind, a quirky sense of humour, and an acute antenna for what was happening in the literary and music world. It was John who introduced me to Simon and Garfunkel, Frank Zappa, the Mothers of Invention, Marvin Gaye, Curtis Mayfield and Randy Newman; to the poetry of Tom Mac Intyre; to the books of Ken Kesey, Ray Bradbury, Flann O'Brien, James Thurber and Jack Kerouac. He was doing his best to pursue his dream of being a writer, sending pieces to publishers, hoping to excite interest. The previous term, he had written a letter to me: 'I will write myself out of this bank in six months – self-ultimatum'.

The way things turned out, I had occasion to often reflect on this letter.

As a counter to the gloom in Denise's absence, my father's illness and the shop's humdrum routine, events were coming alive with *Bloomfield*. One day I got a call from a recording studio in London: 'Hello, is that Bill Weelan?' said a London-sounding receptionist.

From now on, I'd get used to being called 'Weelan'; proper British pronunciation does not accommodate the 'h' in my surname. So, when I give my name on the phone to London, it invariably becomes Weelan, Quillan or Queenan. But irritation aside, my heart skipped a beat.

'I've got Richard Harris on the line for you,' she cockneyed.

It was an excited Richard Harris at the end of the phone. We'd never spoken until now. They'd just finished recording my theme music, 'Denise', for the film, and he was impatient to play it to me. Even allowing for the crackly phone reception one expected on a 'trunk call' from London, the music sounded great, and Harris was pleased with the results. He was coming to Kilkee, he said, and we arranged for Niall and me to meet him there and work on more songs.

PART 3: 1970S – LEARNING AND GRIEVING

Success for composers

TWO young Limerick music-makers spoke last night of the big breakthrough which promises to rocket them to the top of the international scene—the theme music they have composed for Richard Harris's film "Bloomfield".

Said 20-year-old **Billy Whelan:** "We sent a tape of the music to various publishers in London but without any initial sign of success. They all showed an interest for a while but it always died in the end. Finally, our tape arrived in the offices of a publishing firm owned in part by Richard Harris—so here we are with our composition accepted. It's a thrilling prospect."

The world premiere of "Bloomfield" is to take place at the Savoy Cinema, Limerick, on November 6.

Limerick Leader *press cutting about Bill Whelan and Niall Connery's part in Richard Harris's* Bloomfield.

I cannot stress what it was like to hear the music (inspired by that first sighting of Denise) that began life in the attic on Peter Ahern's flute now being performed by a big orchestra in a major London studio. Add to this the fact of working with Richard Harris, a big star and a connection to one of my songwriting idols, Jimmy Webb. And I was still only nineteen. I saw my career stretch out in front of me; access to international music-making was just a step away. It was intoxicating.

The arrival of Richard Harris in Kilkee was an exciting event amongst the local and holidaying communities: 'Dickie's in town' echoed around the pubs. Wealthier Limerick families had holiday homes in Kilkee, and the Harrises were no exception. He spent a lot of his youth there and was a champion rackets player against the sandstone walls at the west end of the beach.

Niall and I were sitting in the Hydro Hotel awaiting our first meeting with Harris, uncertain how we'd approach him, when he swept into

13. RICHARD HARRIS, *BLOOMFIELD* AND THE LIMERICK DISTRICT COURT

the foyer with an entourage of glamorous women and assorted London and Limerick buddies. 'Where's Whelan?' he bellowed.

I stood up.

'Jesus, you're only a young 'un.' He hugged me. 'We love it!' he added.

I assumed he meant the music.

Then turning to Niall, 'Are you Connery? You're a fine big fella; I hear you're a good rugby player? Played for Crescent? You're a wing-forward if ever I saw one.'

It went on like this in that clipped exclamatory way Harris had of speaking, just like his brother Dermot, only more projected as if we were all at the back of a hall and he was on stage. Every sentence sounded like a question or an urgent challenge, and he had a way of starting each phrase as if he had a stammer and then flinging the words out wide like a fisherman's net to envelop the room. He was always on the watch for a reaction in a conversation that might prompt him to throw a provocative or playful question: 'Connery, I'd say you never did anything like that, did you?' winking at the company.

He was charming; we took to him immediately. If you asked him about his career, he'd happily talk about it, starting with: 'I'll tell you a great story about that!' and around we'd go on a magical detour landing back, close (enough) to the original topic. Great storyteller, full of glorious invention, and sometimes when new people joined the company, he'd repeat the story, and we all loved it more on the second telling.

The writing sessions were few. It was remarkable we even got two songs written and later recorded. We'd gather around the piano in the lounge at the Hydro Hotel and get whatever work that needed doing before breakfast. One morning, I was up earlier than Niall or Richard; an elderly gentleman was sitting in the lounge reading the *Telegraph*. 'Morning!' I smiled as I walked over to the piano. 'Lovely day.'

He looked at me as if he had swallowed a lemon.

I played a few phrases at the piano, and soon Niall arrived, passing *Telegraph* man on the way: 'Morning!' said Niall cheerfully.

Nothing from our friend.

Niall sat beside me at the piano. 'Did he say anything to you?'

PART 3: 1970S – LEARNING AND GRIEVING

'Not a word.'

'Lovely,' said Niall.

Five minutes later, Harris breezed into the lounge, singing. He passed the iceman. 'Morning! Great day for the Pollock Holes.'

Nothing, just a curled lip.

Richard arrived at the piano. 'Did that fecker greet either of you?'

We shook our heads.

Richard turned around and with a delivery that could be heard at the cliffs on George's Head, said: 'GOOD MORNING!' bowing low, and then rising, 'you OLD FART!'

The *Telegraph* was quickly folded. Mr Charm vanished.

'Now,' said Richard, 'let's look at that song we had yesterday.'

We pulled closer to the piano and began the morning's work.

The rest of that eventful summer of 1970 passed with many phone calls to Limbridge Music in London, the drawing up of songwriting contracts, the recording and writing of more songs in the studio and, of course, the resitting of one or two subjects in my first-year law exams, which I hadn't exactly passed on the first attempt. Denise was due back from the US in September, and we had the premiere of *Bloomfield* to look forward to, which Richard Harris planned to hold in Limerick in early November.

I still had a notion that I'd be a defence lawyer – the least lucrative arm of the profession. There's a small pocket in the back of a barrister's gown where, historically, the client slipped whatever they could afford for the counsel's service. Under the law, barristers had no right to sue for fees, and it was discretionary for the defendant to pay or not. It was assumed that barristers had independent means to fall back on. When I mentioned my intention to be a defence lawyer to a solicitor friend of mine, he said: 'Oh, I see Bill, heading for the big bucks then?' But, in my young head (filled as it was with idealist principles of justice and equity), this was the area where a good barrister could make a difference.

As I slid toward the music business, my mother's panic increased. Her only son was gravitating from a career in law that might barely

13. RICHARD HARRIS, *BLOOMFIELD* AND THE LIMERICK DISTRICT COURT

support him to a career in an industry where any notion of security was beyond consideration. However, my attraction to that fallow field of law did draw me to attend the Limerick Circuit and District Court sittings from time to time.

The Limerick Courthouse is rarely the place to witness much that is uplifting in the world. Here are real people with real difficulties who have strayed for whatever reason into activities that put them at odds with the law. They now find themselves in a forum that will hopefully attempt to redress the imbalance, if proven, between their behaviour and accepted civil norms. Despite this melancholic environment, occasionally, an ebullient Limerick character will appear and upset the formality of the occasion. I attended one such case in front of Justice Barra O'Briain.

The defendant was being charged with burglary of a well-known Limerick liquor store. His two alleged accomplices had been arrested at or near the scene. He was picked up some days afterwards and identified at an ID parade. The state relied heavily on this piece of evidence, and the defendant knew this was a weakness in the prosecution's argument. His entrance into the dock was theatrically casual as he waved and shouted, 'How are you, Tom?' to one of his pals in the gallery. Justice Barra O'Briain, a small man who was well wrapped up against the cold, adjusted his rug, and frowned at the defendant's barrister, anticipating what might lie ahead. We came to the cross-examination – for clarity's sake, let's call the defendant Josie:

```
                   BARRISTER
        Will you relate to the court your
        movements on the night of July 17
        last?

                     JOSIE
                (scrunching eyes)
        July 17 ...
        (lengthy pondering and tut-tutting)
```

July 17 …
> (deep concentration)

Would that have been a Wednesday, Sir?

BARRISTER
> (impatiently)

I think you know it was a Saturday.

JOSIE
> (eyes/mouth wide open, dawning on him)

Jaze, I remember now. It was a Saturday.
> (looking admiringly at the prosecution)

You got that one right! Anyway, we were at a match in the Markets Field, and we went over to the Half Moon Bar afterwards for a few pints. Then two of us went down to Fongo Ryan's place.

JUSTICE O'BRIAIN
> (stirring)

Who is Farmer Ryan?

JOSIE
> (big smile, as if noticing Justice O'Briain for the first time)

Oh, how're you, m'Lord? No …
> (helpfully including O'Briain in the conversation)

I was just saying to your friend here that we went over to Fongo Ryan's.

13. RICHARD HARRIS, *BLOOMFIELD* AND THE LIMERICK DISTRICT COURT

> JUSTICE O'BRIAIN
>
> Yes, I heard you. Who is Farmer Ryan?
>
> JOSIE
>
> (looks around courthouse, mystified, hoping for a clue as to why this eminent judge is not understanding him)
>
> BARRISTER
>
> (attempting to steady things — the case is slipping away from him)
>
> I think, m'Lud, he may be referring to …
>
> (grimaces)
>
> Fongo Ryan.
>
> JOSIE
>
> (nods encouraging approval to the bench)
>
> JUSTICE O'BRIAIN
>
> (savouring the name with distaste)
>
> Fongo? What manner of appellation is Fongo?
>
> BARRISTER
>
> I think, m'Lud, it may be …
>
> (condescendingly)
>
> some local sobriquet, and if I may suggest …
>
> (exasperated)
>
> it is not relevant to this case.

PART 3: 1970S – LEARNING AND GRIEVING

>JUSTICE O'BRIAN
>(fully engaged, incensed)
>I will deem what is relevant or irrelevant in my court.

>JOSIE
>(loudly slapping the podium)
>Well, feckin' fair dues, m'Lord. You're a horse of a man!

The court collapsed in laughter. O'Brian banged his gavel until order was restored. From then on, the prosecution case slid down the legal sinkhole, and Josie walked out a free man, though I think everyone knew he would be back for an encore in the not-too-distant future. I have often wondered why surgeons call their workplace the theatre; lawyers should have first call on that name.

Bloomfield had its premiere at the Savoy Cinema on 6 November 1970. It has to be one of the most dazzling events in the history of Limerick entertainment. All proceeds were pledged to the Lions Club, and the list of international stars who attended was impressive. While not all of those advertised showed up, it was a sparkling evening, and the parties surrounding the event continued for days afterwards. Among the glitterati were Maurice Gibb of the Bee Gees (who had contributed a song to the score), Lulu (Gibb's wife), Honor Blackman (Pussy Galore from James Bond), Leonard Whiting (star of Zeffirelli's *Romeo and Juliet*), plus a collection of national and local luminaries.

Those of us associated with the production entered the Savoy on the red carpet and made our way up to our seats in the circle. Denise was my escort. Mary Earls joined Niall. Our parents had to be content with seating in the stalls, and we waved down at them as we took our seats. The atmosphere of expectation was electric as Bunny Carr, a leading broadcaster at the time, welcomed everyone to this wonderful occasion for Limerick; one of its favourite sons, Richard Harris, was bestowing such an honour on his hometown by siting this significant film premiere

13. RICHARD HARRIS, *BLOOMFIELD* AND THE LIMERICK DISTRICT COURT

in the historic Savoy Theatre. Bunny continued in this vein until somebody in the wings called him over to the side of the stage and had a word.

'Ladies and gentlemen,' said Bunny returning to centre stage, 'I'm afraid I have to ask you to leave the theatre now. Please proceed in an orderly fashion to your nearest exit. There is no need to panic. We've received notification from the gardaí that they have received a warning that a bomb has been placed in the theatre.'

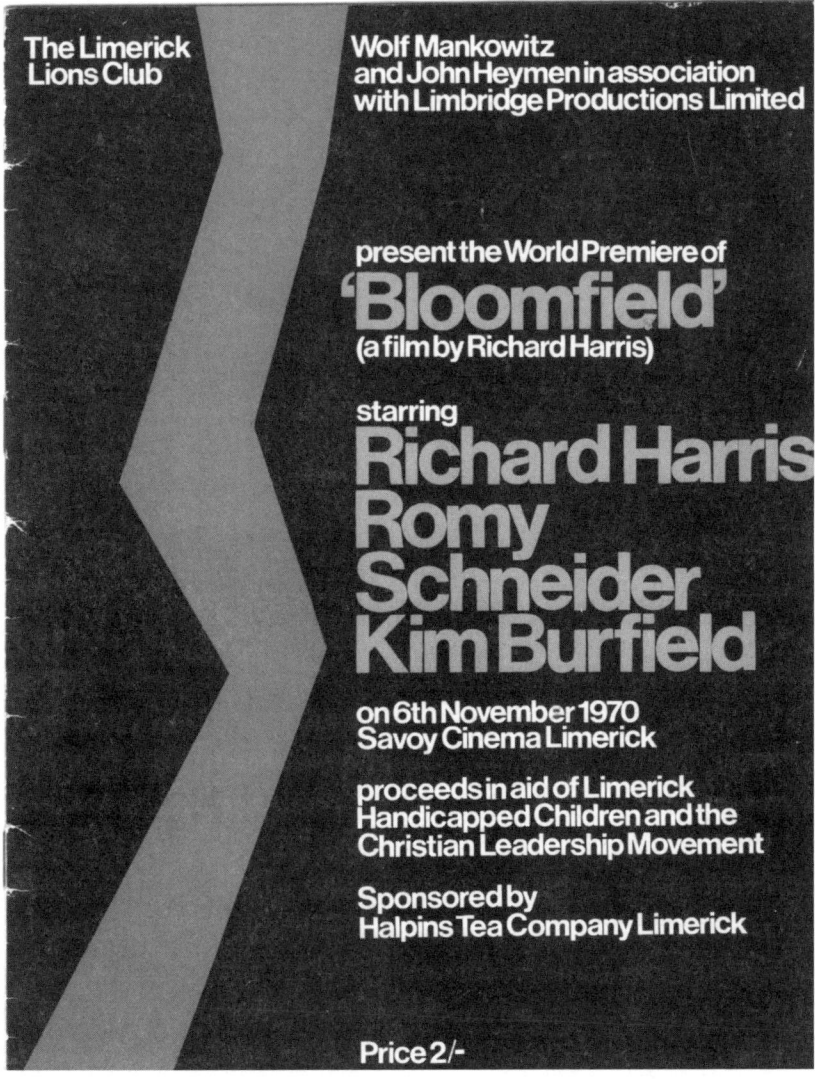

Bloomfield *programme for the Limerick premiere in the Savoy.*

PART 3: 1970S – LEARNING AND GRIEVING

I looked down, trying to spot my parents in the exiting crowd. There was my father, his grey head above those around him, wearing one of his bow ties, protectively shielding his wife from any pushing and shoving. It was a remarkably calm evacuation; we were all back in our seats half an hour later when nothing was discovered – a hoax.

The premiere proved to be the apex of *Bloomfield* the film; it did not mark the beginning of a new career as a director for Harris – the critics panned it, worse still, ignored it. Nor was it the launchpad to our careers as songwriters. Instead, it was an exciting, enjoyable and educational interlude to college. Niall and I got a glimpse of a life we dreamed of, only to realize that in my mother's words (even though she was immensely proud to hear her son's music on the screen), it was time to stop all that nonsense now and be sensible. Back to your studies, get your degree, and you can do what you like after that. Doing 'what I liked after that', I'd learn in time, would take luck, experience and hard work.

Mind you, there was so much hype around the film in Limerick it was forgivable if your head got turned. Around that time, I collected a suit from my father's tailor, Bernard Green. Bernard had a tailor's shop on O'Connell Avenue, and he and my father were friends, going back to their rowing days. He was a good cutter, and my father's suits were favourably remarked upon. A tall, grey-haired man, Bernard wore his facial hair the same spiky length as the crew-cut on his head. He may have been athletic in his younger days but had developed a respectable paunch in middle age, below which his trousers hung suspended by both a leather belt and elastic braces. He always had his measuring tape around his neck and wore a pair of half-frame glasses low on his nose. Serious but friendly, jowly and rheumy-eyed, he bore the air of a benign basset-hound. Bernard had a habit of saying 'a'you?' at the end of his sentences. The intended meaning was 'are you with me?' shortened for convenience.

There had been much coverage of *Bloomfield* in the local papers, and when I arrived to pick up my father's suit, Bernard greeted me with a confidential wink: 'Now, come in here to the backroom 'til I have a quiet word, a'you?'

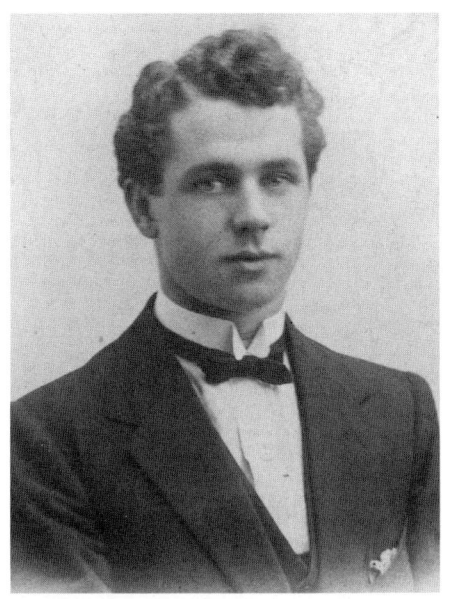
Bill's father – a young Dave Whelan c. 1920.

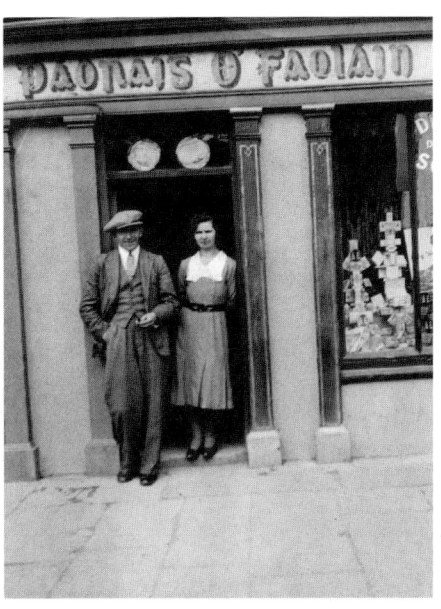
Uncle Pat Whelan's newspaper shop in Wolfe Tone Street, Limerick.

Bill in the enamel bath in front of the fireplace in the kitchen.

Bill with his mother and father.

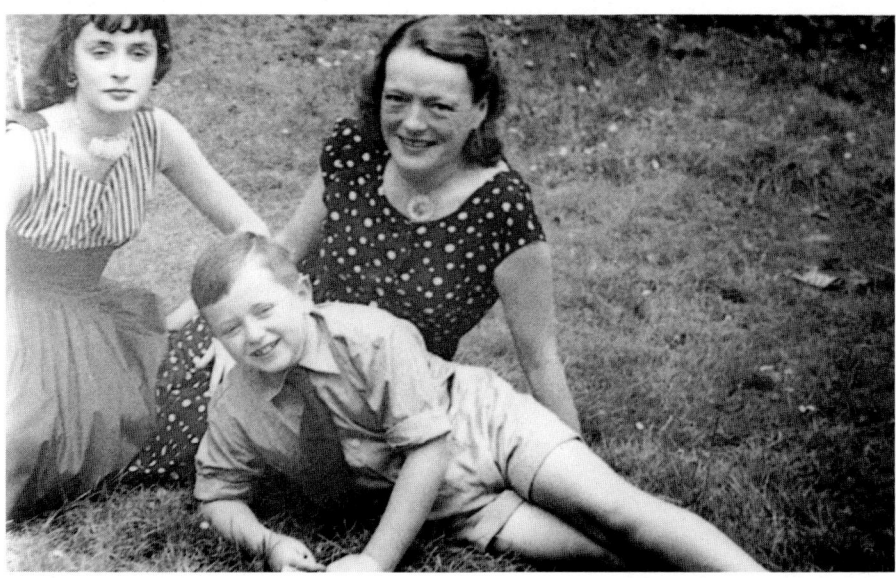

Bill with Imelda Lyons (Lyonzie), much-loved minder and co-conspirator, and her daughter Phyllis (left).

The family shop, Dave Whelan's, the day of a fire at Jim Marshall's garden supplies, 1968.

Bill at the Wurlitzer organ in the music room.

Bill and Denise, 1970.

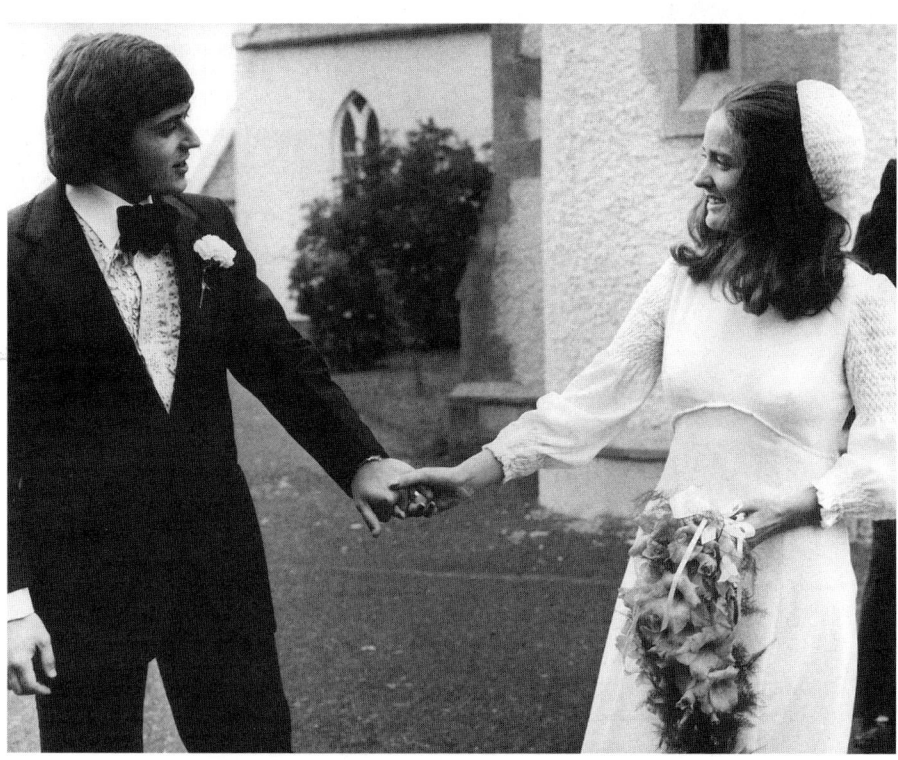
The wedding day, 1974. (Photo: Keith Nolan.)

Stacc publicity photo: Bill, seated in front with (clockwise) Caitríona Walsh, Des Moore, John Drummond, Desi Reynolds and Nicola Kerr. (Photo: Keith Nolan.)

Noel Pearson with Bill at P.J. Clarke's in New York.

(Left to right) Bill, singer Maura O'Connell, Senator Donie Cassidy and Ronnie Drew from the Dubliners.

(Left to right) Bill, Elmer Bernstein and Tony McNeive en route to LA.

Rehearsing for the W.B. Yeats Festival at the Abbey Theatre, 1989.

W.B. Yeats Festival director James Flannery (left) with Bill.

Jimmy Webb and Bill rehearsing for RTÉ's An Eye on the Music, *1991. (Photo: John Rowe, RTÉ Stills Department.)*

(Left to right) Paddy McAloon of Prefab Sprout with Bill and Jimmy Webb. (Photo: McGuinness Whelan.)

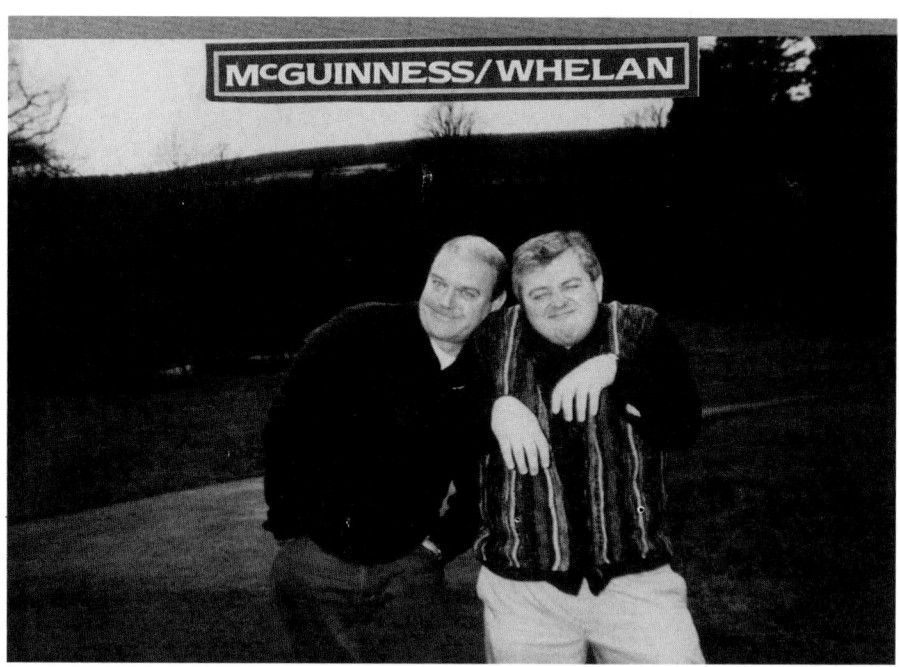

Paul McGuinness (left) and Bill.

13. RICHARD HARRIS, *BLOOMFIELD* AND THE LIMERICK DISTRICT COURT

He led me down the three steps at the rear of the shop to where he did his tailoring. A single bulb hung over the wide table, which was covered in cuts of material, tailor's chalk, scissors, long wooden rulers and other paraphernalia of the trade. 'I was reading about you in last night's *Limerick Leader*,' he said, drawing me close to emphasize that confidential information was about to be passed. 'Dickie Harris's film. Fair dues t'you, Bill. Great news. Dave is delighted. But now I want to give you a small bit of advice, a'you?'

He paused to allow space for what was to come: 'Bricks and mortar, Bill,' he almost whispered. 'Bricks ... and ... mortar ... a'you?' The bulb overhead flickered as if on cue at the importance of this intelligence. 'Now, you'll get loads of fellas trying to drag you this way and that when the big money comes in,' he advised, 'but I'm going to warn you not to pay a blind bit of attention to any of them feckers, a'you? A'you?' – twice for extra emphasis – 'Bricks and mortar, Bill, is where the money will be safe, and you mark my words, you won't make a mistake by staying well away from shysters who are only trying to get their paws on what you have. Remember what I'm tellin' you, Bill, a'you? Bricks and mortar. You're going into a shaky 'oul game with the music business. Cut down on the risk.' With another double a'you, Bernard pushed his glasses onto his forehead to signify the end of the speech, and he smiled. 'Now, c'mon, and we'll get Dave's suit.'

That was the longest address Bernard Green ever shared with me, and I did mark his words. I thought of him when times were good, and when I sat in plush offices with those 'feckers' he alerted me to. He gave me the cheapest and most effective financial advice and I wish I had the chance to thank him. However, the good times, despite expectations, were a long way off. A'you?

14. The King's Inns and John Cosgrove

My second year in UCD marked my induction into the Honourable Society of King's Inns, established during the reign of Henry VIII and situated in a fine building designed by James Gandon in the 1790s. This was where you studied to be a barrister-at-law. Lectures were in UCD and King's Inns concurrently, and you sat two exams at the end of the academic year – it was a full schedule.

King's Inns observed some archaic traditions, chief among them being the requirement to eat sixteen dinners per year, that is, four per legal calendar term: Michaelmas, Easter, Hilary and Trinity. This wasn't optional – the Inns kept attendance records, and signing-in was closely monitored; if you didn't attend the dinners, you didn't qualify as a barrister. Since students consumed ample amounts of alcohol at these dinners going to them was hardly considered a hardship, plus the theatrical activities provided opportunities for hijinks. Fuelled by alcohol, outbreaks of anarchy occurred in the formal surroundings of the dining hall, most likely at Grand Night, which happened once per term. On Grand Night, each student got a bottle of wine with dinner,

14. THE KING'S INNS AND JOHN COSGROVE

compliments of the barristers. A dangerous tradition.

At our first Grand Night, Conor Gunne, Willis Walshe, Jim McArdle, and I assembled at the King's Inns Bar, Henrietta Street, to fortify ourselves before the dinner. Having consumed three or four pints, we rolled up under the arch at the back entrance to the Inns and went straight to the gowning room. Students would enter the dining hall in their gowns, go to their tables and stay standing until the barristers made their stately parade up the hall, nodding at students they recognized along the way. All remained standing until finally, the Benchers appeared. These included such stars in the legal firmament as senior judges, the Chief Justice, the President of the High Court, and various members of the Supreme Court. The entire room bowed as the Benchers passed. On this, our first Grand Night, one of the students (now a successful senior counsel), in a tipsy attempt at humour, undertook a low, ironic bow. Unfortunately, his enthusiasm for drinks before dinner interfered with his sense of balance, causing him to pitch forward and end up on his knees in the posture of a devout Moslem at prayer. The Benchers treated this judiciously by ignoring it, and the dignified promenade of jurists passed on. When all were at their table, the elegant bench steward, who we named Benedictus, said grace: *Benedictus, Benedicat*, and we all sat down.

'Jeez, lads, after all those pints earlier, I'm going to need a piss. Does anyone know where the jax is?' It was Willis Walsh, looking somewhat in extremis.

'Out that door and down the corridor,' Jim McArdle was helpful, 'but you can't leave without asking permission.'

'You're having me on!' said Willis.

'You've to grab Kilkelly's attention. He'll let old Benedictus know, and then old Benedictus will petition the presiding judge.'

'Go away out of it!' said Willis, rising to head for the door. Mr Kilkelly (who was the students' maître d') appeared out of nowhere and placed his hand on the Walsh shoulder: 'There is something I can assist you with?' he inquired.

'I'd like to go to the toilet,' said Walsh.

'Of course,' said Kilkelly. 'I'm sure that won't be a problem. Allow me to petition the Bench on your behalf.' He gently motioned Willis to sit down.

Off wafted Kilkelly up the side of the hall, passing one of the roaring fireplaces until he arrived at the podium where Benedictus was in attendance. They had a whispered exchange, and then Benedictus floated behind the Benchers, coming to a halt at the elbow of the Chief Justice. They had a few words, and His Honour scanned the hall to where we were sitting. Willis was cross-legged and almost cross-eyed. Benedictus returned to Kilkelly, who listened and then made the return journey, gliding down the dining hall until he arrived beside Willis. We were glued to his every word: 'Regarding your request, unfortunately, the Bench has not yet reached a decision,' said the roguish Kilkelly, winking at the rest of us.

Willis was about to explode verbally (and otherwise) when he spotted the grin. Pulling the chair back to let him out, Kilkelly sagely advised, 'Not so much beer next time.'

Kilkelly was a kindly man with a nice line in quiet humour, a strong, discreet type who, with his wing collar and gown, looked just as he might have in the times of Daniel O'Connell – the great nineteenth-century Irish barrister and politician known as the Liberator. Despite comic interventions courtesy of alcohol, there was a potent sense of tradition and formality about the Inns. At the end of each meal, Kilkelly went around and offered everyone a pinch of snuff from the very snuffbox that had belonged to the Liberator (or so it was said). My years there introduced me to the joys of lively conversations around tables well-stocked with good claret, an activity that I enthusiastically embraced. This love of fine wine continued and grew when I departed from my path towards the legal profession and entered the music business in earnest.

Late summer of 1971, I moved from Hatch Hall to a top-floor apartment at 20 Fitzwilliam Square, which I shared with Conor Gunne and, at various times, Paul O'Mahony, Gerry Lynch, Bill Higgins, John

14. THE KING'S INNS AND JOHN COSGROVE

Flint and occasionally Tommy Halferty, a new friend and brilliant guitarist from Derry. Coincidentally, the ground floor served as a clinic for gynaecologist Prof. Declan Meagher, who had delivered many of Denise's siblings into the world.

I was alone during the August bank holiday when I got a call from Ged Spencer in Limerick. He told me he had sad news. His voice was strained, and I could hear something was very wrong. After a pause, he let me know that he had just returned from the city morgue where he had to identify the body of John Cosgrove. The shock was profound. I could barely hear the details, and I struggled to compute that Ged was talking about *the* John Cosgrove, my childhood friend who had started Verno Ltd in the attic with me. Ged explained that John had been at a Marx Brothers movie with Billy Sinden. He was in great form, enjoying the daft humour of Groucho. They took the usual bus home. Billy got off near his own house in Ashbourne Park, but John, instead of disembarking at his stop on the Ballinacurra Road, stayed on the bus until it turned around and made the return journey. He got off at the terminus, miles from his home. That was the last time he was seen alive.

John's body was discovered at Barrington's Pier on the bank of the Shannon. All who knew him were thrown into mental disarray. Not knowing how he died led to speculation, but I could not accept that his death was anything other than an unfortunate accident. Maybe he'd been attacked? But there was no evidence of violence or physical struggle. It took years considering theories before I remembered the letter he wrote the previous year, allowing for another possibility: *I will write myself out of this bank in six months – self-ultimatum.*

My departure to Dublin was a fork in the road of regular access to each other, John was a soulmate during our adolescent years, and my thoughts roam over what he might have become had he not walked onto that riverbank in 1971.

Years later, John's father, Tommy Cosgrove, called to our house in Limerick. We sat in the front room in Barrington Street. He was pensive and quiet: 'Have you any idea clue as to how John died?' he asked finally.

There was no way to answer this. Years had passed by then, but neither of us could explain why. How could I theorize to a father still struggling with the splintered emotions left behind after a death such as John's? There were so many unanswered questions – feelings of guilt, failure, anger and shame, never to be resolved.

15. Dave Whelan – Leavetaking

Since my father's operation in 1970, he'd put on weight, was back on his bike and was behind the shop counter again. But the reprieve was short-lived: by summer 1972, he started to lose weight. Finally, he became so thin he grew a beard to cover his jawbone and neck creases. Soon he was unable to work.

My father was a Pioneer.[1] At the urgings of Uncle Harry (the Jesuit priest uncle), he took the pledge when he got married, vowing never to drink again. I don't know if he had a problem with alcohol before that, but photographic evidence suggests he was no stranger to drinking. However, for as long as I knew him, I never saw him take a drink until now. Most evenings, he watched TV with a bottle of Teacher's or Chivas Regal beside him, pouring healthy measures before bedtime. Sometimes I joined him. This was his version of anaesthesia. He was in pain; the whiskey deadened the ache and helped him to sleep.

This pattern went on for months. I came back from college to work in the shop with my mother. I had to repeat some exams, but while my father was ill, my place was in Limerick. He was weak and diminished in size. One night, after we turned off the telly and my mother had gone

to bed, I took him to his room and settled him down. I sensed that the night would not be easy, so I put a hairbrush beside the bed where he could reach it. 'Dad,' I said, 'if you need anything, I'll be in the kitchen. Just whack that brush off the table, and I'll come up to you.'

I was no sooner in the kitchen when I heard the brush banging on the table.

'Willum,' said my father, 'would you get me my teeth?' He wore dentures he kept in a tumbler in the bathroom.

'Dad, we just took them out. You won't need them until the morning.'

'Will you never do anything I ask you?' he heaved with exasperation.

I brought the tumbler. He slipped in the teeth, lay back and closed his eyes. On the table beside him were his rosary beads, *The Imitation of Christ* by Thomas à Kempis, *Madame Bovary* by Gustave Flaubert and *The Springing of George Blake* by Seán Bourke. In a way, these summed up a large part of the concerns and interests in his life.

Half an hour later, I heard the brush again.

'You okay, Dad?'

He was trying to get out of the bed, 'Will you get me to the bathroom?' he murmured. He was weak. I helped him onto the bedside and took hold of him under the arm. He tried to stand. I lifted as much as I could, but he'd no leg strength. I couldn't get him upright. 'Ah,' he sighed with frustration, 'forget about it, Willum. C'mon, put me back in bed.'

I lifted his legs onto the mattress and covered him with the blankets. He closed his eyes. Feeling that I had failed him I stayed with him and, after a while, noticed his breathing was laboured. 'Dad,' I said, 'Dad, are you okay?'

I gently shook his arm, but there was no response. Now and for the only time in my life, I whispered to him that I loved him. I hoped he could hear me. It was the one and only time those words were spoken by either of us.

I went to my mother and told her that I thought he might be unconscious. She immediately sent me to get a priest from the Jesuit church. Within minutes Fr McCarthy arrived. He'd been my Latin teacher in

the Crescent, severe in class but a welcome consolation now. He said prayers over my father, anointed him with oil and began the rosary. As soon as we had finished, my father breathed his last.

I went next door to Mrs O'Malley, who was a nurse, and she came in, all comfort and efficiency, ushered us gently out of the room and proceeded to lay out my father's body. Most of her nursing career was spent bringing new life into the world, but now she was as much at home tending to my father's departure.

I was twenty-two when my father died. My mother and I now faced a major readjustment to our lives. We made tea and talked about what I had experienced upstairs just before he died. My mother knew what it was about. 'He wanted to look good when he died, hence his dentures, and he wanted to make things easier for those dealing with the body, hence the bathroom; that was the kind of man your father was.' Without him, and with me starting a new life in Dublin, my mother's life changed utterly. The two men she had spent every day caring for were gone. I know she felt alone.

My parents' relationship was complex. They had moved to separate bedrooms by the time I was old enough to notice, and displays of affection were rare. When my mother hugged my father for something she appreciated, he grimaced and pushed his dentures out to give himself a horse face. 'Oh, Dave, 'she'd laugh, 'stop! That's disgusting!' I sensed they were more married to their responsibilities than to each other, their arguments being mainly about the shop. But they were a united force. And devoted to each other. They would go for walks of a summer evening down one side of O'Connell Street and back up the other, an attractive couple: she was petite, and he stood head and shoulders over her, fine-looking, smartly dressed with his bow tie and shock of wavy grey hair. But their differences complemented rather than antagonized each other: she was demonstrative, he was reserved; she seldom read, he always had literature on the go; she had few hobbies, he had many. Now that he was gone, the photography, films, guns and recordings he

had accumulated became redundant. She sold his collection of antique and (some serviceable) guns. She was terrified of having them in the house. He had been refused a gun licence because of his youthful political activities, so any firearm that was not antique was illicit. Also, she feared debt. So, she cleared any outstanding bills by selling his acquisitions – cameras and projectors and the likes.

I did not cry when my father died; my mother was too confused in the aftermath of his death. I felt I had to keep the emotional boat steady. However, months later, I was sitting on the bed when unannounced, as if a bucket of grief was poured on my head, I broke down in floods of tears. He had said to me once, as much a preparation as a warning: 'You know, one day you will be a lone bird.' The glimpse of that narrow void took a while to become a wide vista.

16. Trend Studios and Down in the Pits

In the last years of my legal studies, I divided my time between music, my blossoming relationship with Denise, my mother (now widowed) and sitting and resitting exams. I wanted to support myself financially to take the pressure off my mother, so I took on some part-time jobs. I washed cars at Dublin airport for the Dan Ryan Car Hire Company and assisted in record shops, which I thoroughly enjoyed. Opening a delivery one day, among all the Perry Como and Barbara Streisand albums was 'Can't Buy a Thrill' by Steely Dan. This album was a musical head-turner for me. The customers who came in and out of Golden Discs in North Earl Street must have thought we only ever played this jazz-inflected music as it was rarely off the turntable.

While I was washing cars, some college friends were already out in the real world earning real money. It was the era of the tax-deductible business expense account, so I was invited to dinner in ritzy restaurants where I would have to change out of my overalls, suit up and look professional. It was at such a dinner in Dobbins as a guest of my friend, Pete Ahern, who had a 'real' job in the Industrial Development Authority

PART 3: 1970s – LEARNING AND GRIEVING

(IDA), that the gap between my employment and his became clear. We were on the second course and were well into the wine when a businessman Peter knew arrived with a group of foreign industrialists. He spotted Pete. 'Ah, Professor Ahern,' said this tall pin-striped executive with friendly mock deference, 'glad to see you are taking time away from slaving at your desk.' He turned to his guests and introduced everyone, 'Folks, this is Peter Ahern, a senior executive at the IDA. This is the man you need if you want to open a business in this country.'

Everyone shook hands, and then all looked at me. There was a pause. Pete jumped in to fill the gap. 'Eh, this is my good friend, Bill Whelan,' and without batting an eyelid followed with, 'Bill is involved heavily in APP, y'know, Automotive Profile Projection?'

There was a momentary hiatus while the group (myself included) struggled with this startlingly unfamiliar job description. I doubt if anyone tumbled to Pete's creative redefinition of car-washing. In any case, nobody was going to reveal their ignorance of such an important-sounding and innovative business.

'Ah, an interesting area. Up-and-coming,' said the polite pinstripe.

'Absolutely,' said Pete, 'the future.'

Thankfully the maître d' ushered the group to their table before further questions were asked. Pete and I resumed our dinner. My career in APP was short-lived; it was my stint as record-store manager that had more far-reaching results.

Trend Studios in Lad Lane was the coolest recording venue in Dublin in the late 60s. I'd been following their growth in the music media. They were the first to install a 16-track system and attract rock bands like Thin Lizzy and Status Quo. Eamonn Andrews Studios in Harcourt Street was geared more towards the showband industry.

During my second year in college, I went to their premises and knocked on the door. I was met by a tall languid bespectacled young man with a Van Dyke beard who turned out to be John D'Ardis, the owner and proprietor. I explained I was a songwriter from Limerick who considered recording in Dublin and wanted to see the facilities.

He was polite enough to pretend I was a potential client and showed me around the studio. It had a cosy atmosphere. Conveniently, I'd brought a tape of my songs, which I played. We chatted for a long time about how I should advance my songwriting career. He had a keen sense of humour with an offhanded sardonic twist. We had a lot of interests in common, and I could tell from that first day we would become good friends. He said he would introduce me to his publishing partner and play him my songs.

Peter Bardon was a music publisher and artist manager, and he ran Bardis Music with John. He also owned record stores in the Dublin suburbs. I got a call from Peter within a few days suggesting that we meet. He had heard the songs and wanted to talk about my ambitions. Like many, he was trying to figure out what a guy heading for a career in law wanted with the business of music – he seemed genuinely taken with my songs. I explained that my real passion was for music; I wanted to give it every chance while balancing my law studies.

Peter Bardon was different to John. He was older, blockier and had a murmured style of speaking that implied confidentiality. He would take you aside and deal with you out of prying earshot (and perhaps to avoid the risk of contradiction). Within a few weeks, he convinced Wayne Bickerton at Polydor UK to put up development money for demos. I spoke with John D'Ardis about how I would assemble musicians in Trend and thus began a journey that would take me away from law and set me on a course with many twists and turns towards a career that was to occupy me for the next fifty years.

It was rare back then for bands to play on their own records; a community of experienced session players were relied on to deliver professional performances within strict recording session times.[1] John's list of session musicians was comprehensive, and it was to them I turned for the demos. So, over a couple of weeks, I was in the studio with people like Desi Reynolds, Des Moore, John Drummond, Louis Stewart, Tommy Halferty, Ian McGarry and others.

After the sessions, we'd go to Larry Murphy's pub on Baggot Street 'for the one' before going home. It was here I was introduced to that

PART 3: 1970S – LEARNING AND GRIEVING

world of hilarious storytelling, fuelled by multiple pints of Guinness, that was integral to musicians' lives. Here was a sub-group of society with their own culture, humour, shared experiences and even a common language. When the need arose, they would speak a strange hybrid of Cockney rhyming slang, and something called 'Benlang' – useful when discussing fees in front of a paymaster or the whereabouts of an errant colleague within hearing range of a wife or girlfriend. There was a sense of being an arcane society, less like the Masons, more akin to circus folk or liminal nomadic types. Apart from my admiration for the musicianship of these people, I wanted to be part of this magical fellowship. But most of all, I was hungry to learn the skills and techniques that could help shape the music I wanted to make as a composer, arranger and producer in my own right.

One of my earliest production jobs came from Polydor Records in Dublin. Their CEO, John Woods, asked me to meet him; he'd an album project that might be of interest. I sat in his plush office in Dominick Street as he outlined the idea. I hoped for some exciting new singer or band that he wanted me to produce, but as he spoke, I realized the artist he had in mind was neither new nor a singer in the conventional sense of that word. It was, in fact, a priest. Fr Michael Cleary was the parish priest of Ballyfermot in Dublin and had gained national celebrity by frequently featuring on radio and television. He was the first of the burgeoning phenomenon of 'singing priests' that appeared in Ireland during the 70s and 80s as part of the post-Vatican II breed of younger clergy who were trying to blow fresh air into a church still redolent with the musty tang of Archbishop McQuaid. Known for his charm and charisma, Fr Cleary was active with the poor in his parish and had, among other activities, formed a group of young singers called the Ballyfermot Peace Corps. Polydor intended that this choir would feature heavily on the album.

My first meetings with Fr Cleary revealed two important characteristics about the man. Firstly, whatever vocal skills he possessed in the past were now diminished by throat cancer; his voice was hardly there at all,

unhelped by the packets of cigarettes he consumed endlessly. Secondly, he had no suggestions about the songs we might record and was leaving this up to myself entirely – a dangerous power to hand over to a young producer. I chose material by writers and performers I admired.

So the album included songs like Laura Nyro's 'Save the Country', the Hollies' 'He Ain't Heavy He's My Brother', Garfunkel's 'Woyaya' and the Fifth Dimension's 'This Is Your Life'. Lyrically the sentiments of all the songs were appropriate for a forward-looking man of the cloth but were well outside the range of his musical abilities. We could paper over some of the cracks with input from the enthusiastic Ballyfermot Peace Corps Choir and a team of fine session musicians, but the voice was never up to it despite his best efforts. We all enjoyed making the music – rehearsing out in Ballyfermot with the choir and recording at Trend Studios – but the end result was never going to win a Grammy. Or sell in quantities.

After he died in 1993, it emerged that Fr Cleary had led a secret life and fathered a child with his housekeeper Phyllis Hamilton. This would have been consistent with his long-held view that the clergy should be allowed to marry, but totally at odds with his Church's teaching and a complete shock to many Irish Catholics. He tried to keep it secret, and he did not acknowledge his son. But the dam dividing truth from myth finally burst and flooded the stream of Irish Catholic consciousness leading to the decline of the Church's authority. Later, these revelations were to pall into insignificance when details emerged about some clergy's more sinister sexual abuse against those in their care. Cleary's sin was the disavowal of his partner and son and the double life he chose to keep under wraps.

It is remarkable how swiftly we moved from being a nation of devout Catholics to a society indifferent to formal religion. The Jesuit church my parents visited daily and where I served countless Masses was eventually acquired by a property developer to become a gym and leisure centre – another activity that requires devotion and regular observance. After the financial crash of the noughties, it ended up in the hands of the Institute of Christ the King Sovereign, an organization

devoted to the restoration of the Latin Mass. Like my attempts to paper over the cracks of Fr Cleary's vocals, retro movements like this may suffer a similar fate: the real fire is somewhere else in the building.

Despite the seismic outpourings of shock that emerged from his private life, I found it difficult not to feel affection for Mick Cleary. His parishioners liked him, and I would never presume his work with them was anything less than sincere. Yes, he was a smoker, a gambler, larger than life, but as a Dub, he was at home with his people and never gravitated towards the celebs of the day. Of course, this is not to excuse the hypocrisy of his behaviour, but given my own sometimes turbulent life, who am I to cast the first stone.

The first-call drummer on the Dublin scene, Desi Reynolds, played with *Joseph and the Amazing Technicolor Dreamcoat* and knew that the current pianist was leaving. So, the seat would need to be filled. He asked me if I would join the theatre production. I was nervous at the idea, but Desi got me the piano score and the recording, so while working in Peter Bardon's record shop in Bray, I learnt the part from start to finish. The plan was to come into Sheahan's pub on Chatham Row before the matinée the following Saturday, meet the musical director Jack Bayle, and set a date for an audition.

Sheahan's is across the street from the smarter Neary's. Both pubs are close to the Gaiety. Sheahan's was where all the brass players and actors drank, and while you might bring a girlfriend into Neary's, you'd think twice about taking her into Sheahan's, particularly if she intended to visit the loos. I arrived at the bar as arranged. I had not met Jack Bayle before. He was sitting at the counter, and Desi was there to make the introductions. Jack wore a black poloneck, black balaclava and a black leather jacket. He had a black beard, some would say unshaven, and nursed a black pint in front of him. In the murk of Sheahan's cigarette smoke on a grey Saturday with the curtains drawn, it was a dark encounter.

'Ah, so you're the fella Desi here is going on about. Are you able to play?' he asked.

16. TREND STUDIOS AND DOWN IN THE PITS

'C'mon, Jack, be nice, even though it's against your nature. Of course he can play,' said Desi.

'Do you know the show?' he asked.

'Well, I think so,' said I. 'I've had the book for a few days and been looking through it.'

'Right so,' said Jack standing up and draining his pint, 'you can look through it again now. Come on in and play the matinée.'

Well, it was hardly Mahler, but to me, this was the deep end. Desi and I followed Jack across the street, through the lounge of Neary's, out the back door and in the stage door of the Gaiety. Soon we were in the orchestra pit. Jack spoke to the pianist: 'Chris, take the afternoon off. This young fella will play the matinée – we hope.'

Chris Kineavy gave me a quick tutorial on the cues and, with a 'you'll-be-grand' nudge, vanished gratefully into the daylight. I looked at my fellow orchestra members, some smiling at me, some tuning, some doing the crossword, and as Desi sat behind the kit, I opened the score at the overture, and off we went.

For the first five numbers, I was glued to Jack, and in his unique way, he communicated that all was going well. I began to relax. Then, as I relaxed a bit more and was able to look around during a number where I didn't have that much to do, my eye caught the trombone player. Every couple of bars, as the music went past, he made a tut-tutting sound and raised his eyes heavenwards. Suddenly, all my relaxing was over. No matter what I played, he shook his head, tut-tutted, and again gave that irritated glance towards the ornate ceiling of the Gaiety.

We arrived finally at the end of act one, and then something else happened that I wasn't prepared for. The orchestra pit emptied in seconds, including Jack Bayle. All except for Desi, who was doing something with his kit. I went over to him: 'Sorry Desi, I'm making a hames of it,' I said.

'What!' he said. 'Not at all, it's going great, man. Love what you're doing in the calypso.'

'But that trombone player keeps giving me the eye, making a face, and tut-tutting when I'm playing, and he's right in front of me. He doesn't even hide it.'

PART 3: 1970S – LEARNING AND GRIEVING

Desi thought for a second and then burst out laughing, 'Oh, that's Victor,' he said, 'he has a facial tick he can't control. No, you're doing fine.'

All through the second half, any time I looked over to Desi, he turned his eyes upwards and grimaced as if I'd played an absolute clanger. After the finale, Jack turned to me: 'Are you free from next week?'

I was.

'See you here, 7.30. Black poloneck. Black slacks. Don't be late,' and he was gone.

So began my life as a theatre musician and a session pianist. Along came television shows, then work as an arranger, as a producer and finally as a composer. My songwriting, which had given me my initial entrée to the business, was sidelined as I found my way through a career with no map or compass.

But first, I had to complete my law degree, so in the summer of 1973, I removed all distractions and got down to completing my Bachelor of Civil Law (BCL). At my conferring, my mother was pleased. I was happy to give her something to relax about. But she would only be temporarily appeased; I planned to give my undivided time to whatever music had in store for me.

By now, our group of ex-students or postgrads moved from Fitzwilliam Square to more plush rooms at 77 Wellington Road, Ballsbridge. Our original, very personable landlord, the Rolls-Royce-owning Basil Nulty, sold 20 Fitzwilliam Square but commended us warmly to the purchaser, Mrs Weir. She intended to renovate our current apartment but was happy to relocate us to Wellington Road. She expressed her keenness to have young men as tenants: 'Girls are so untidy,' she said, 'hanging underwear, stockings and towels out the windows to dry, and leaving the kitchen in a mess.'

I suppose the fact that our most taxing use of the kitchen was to boil frankfurters (meaning the oven would be 'as new' on leaving as the day we moved in) made it a fair comment. However, Mrs Weir's observation was to come under pressure over the two years we lived at Number 77.

16. TREND STUDIOS AND DOWN IN THE PITS

The initial occupants were me, Conor Gunne and the O'Doherty brothers (John and Michael). Over the term of our tenancy, a plethora of tenants replaced the O'Dohertys as the need arose.[2] Among what we called our 'menagerie à quatre' was the likeable Des Kennedy, a sometimes stern and serious Northern man – until you got to know him. His accountancy job at Oliver Freaney & Company made him unique in our group since it required him to observe a regular work–sleep regime. Downstairs was the music impresario Roger Armstrong. He managed the band Chips and looked after Horslips, which accounted for the regular traffic of hippie types visiting Roger, all bell-bottomed, platform-heeled and tie-dyed, whose arrival heralded the occasional playing of loud music late into the evening. Des christened these folk the meatheads who, with their nocturnal activities, did little to advance his career. Des shared his room with another short-term tenant, also called Des. Their relationship could be described as 'detached, tending towards the arctic'.

One evening, the meatheads had given a particularly late recital, and Des didn't get to sleep until 2 a.m. Shortly afterwards, the other Des arrived back with a new girlfriend. They were in the first flush of ardent love and had been out nightclubbing. With the exaggerated care inebriates bring to imagining they are being quiet (*besotto voce*, we used to say), the pair crept into the room and began canoodling as young lovers do. As their fondling advanced in intensity, the man from County Down could no longer endure it, and, rising like Banquo's ghost, wrapping himself in his blanket, cursed loudly and strode from the bedroom and into the lounge, slamming as many doors as he could find.

But that was not all.

Having tossed and turned on the uncomfortable couch, not built for a man of his height, he finally drifted into sleep. But, unfortunately, it was at this very moment the industrious pigeons, who resided in the attic, began their scrabbling and early-morning cooing. No amount of shouting and banging could persuade them to fly out early into the day. So Des got a sweeping brush and, attaching one of his shoes (lest the handle pierce the plasterwork), proceeded to whack the ceiling with it, hoping to evacuate our little aviary. No use. He eventually gave up,

got dressed and went out for an early breakfast. Conversation amongst the room-mates was in suspension after this nightmare, and there descended what my father used to call a lengthy 'coolness'.

But that was not all.

On another occasion, as a few of us returned from an evening out, we picked up a few curries at the Bamboo takeaway in Ranelagh. There was an unfortunate misstep at the top of the stairs, and a Bamboo Special parted company from its owner, flying in a wide arc and spattering the flaxen-coloured wall with a spectacular mural of glutinous turmeric that someone remarked would do credit to Jackson Pollock. No amount of scrubbing could make any impression on the luckless wall.

When we terminated our happy stay at 77 Wellington Road, Mrs Weir wrote to Conor Gunne and me as the named tenants. I quote her letter as best as I can remember it:

Dear Messrs Gunne and Whelan,

Rarely in my career as a landlady have I had the misfortune to discover an apartment left in such an execrable condition – from vomit on the walls to footprints on the ceiling!

I will be arranging for contract cleaners to return the apartment to the condition it was in before your unfortunate arrival. I will then be sending you their bill, for which I will expect to be immediately reimbursed.

Yours etc.

She was, of course, correct, though I am sure the prospect of girls hanging towels out the window was more attractive to her from then on.

17. Denise in Belfast – Joining the Dots

During college and my induction into the music business, Northern Ireland descended into a bloody civil war that was to consume it for the next thirty years. To my fearful unease, Denise applied for a position as a social worker in Belfast. She went for an interview and was successful. Her job was in the Rathcoole estate in Newtownabbey, where settled Catholics were being pushed out and replaced by loyalist families as Belfast struggled with the housing crisis brought about by the Troubles.

Newtownabbey was a turbulent part of the city at that time. Denise started work on 10 August 1971 – the same day internment was introduced by the British government. Her father, Denis Quinn, who was an Irish army officer, drove her through the many checkpoints on the way to Belfast. Helmeted heads peered through the car window, asking her father to open the boot and bonnet.

'They're just kids,' her father said as he got back in the car, 'and just as scared as anyone else.'

Internment was called Operation Demetrius, and hundreds of young men in the nationalist community were lifted and interned without trial.

PART 3: 1970S – LEARNING AND GRIEVING

The same treatment was not meted out to the loyalists; no one from that section of Northern Irish society was interned. In the South, we were insulated from what went on. We lived it remotely via the media with TV images of horror and carnage. It rarely touched us physically.

At the beginning of the Troubles, it was rumoured that the Irish army would invade Derry to protect the Catholic community from potential genocide. But once that initial outpouring of Southern nationalist sympathy subsided, we in the South continued our lives. At the same time, the streets of Belfast, Derry, Omagh, Bangor and elsewhere were strewn with torn bodies, shattered glass and broken masonry.

On 17 May 1974 Dublin and Monaghan became targets of attacks by the Ulster Volunteer Force (UVF) with probable collusion from elements within the British Security Forces. Thirty-four people died on that day, and three hundred were injured. All of us in Wellington Road ran over to Pelican House on Leeson Street to give blood. There were so many people already there that it was impossible to get near it; the Transfusion Service could barely cope with the number of volunteers.

Now that Denise lived in Belfast, every news report was of vital interest, particularly when there was a bomb or a shooting. Since there were no mobile phones at the time, anxious periods passed before I'd hear she was okay. As Belfast was not a place of social ease at the time, she drove to Dublin most weekends to see me. On the few occasions I went to Belfast, the presence of British troops pointing guns at you, the constant threat of being involved in an incident, and the nervous and angry discomfort of being searched, made our few weekend hours of being together not much fun.

Meanwhile, as I played Andrew Lloyd Webber's score for *Joseph* night after night, I was getting work as a freelance musician. With a regular income from the theatre, topped up with session fees, I was beginning to feel I could make a living. But I was keen to learn. I wanted to write arrangements but had no training in orchestration, so I looked to any activity, paid or not, that might teach me the techniques. Perhaps I could support myself as a musician and go back to UCD and do a music degree.

17. DENISE IN BELFAST – JOINING THE DOTS

> Dear Miss Quinn,
> Enclosed please find cheque representing my first ever earnings as a musician. I feel that if I give you this now, I will be exempt from handing over any of the BIG money when it starts to roll in.
>
> Your ever lovin,
>
> *[signature: Bill]*

Bill's first cheque to Denise.

I met Prof. Anthony Hughes, and even though I hadn't done music as a subject in the Leaving Certificate (music wasn't taught as an exam subject in the Crescent then), I convinced him to enrol me for a Bachelor of Music degree. This proved to be a bad idea. The growing pressure of studio work, plus playing in the theatre, meant I was a distracted student. The lectures I did attend convinced me that the academic approach never considered the ambitions or aspirations of someone like myself. So, I had to accept that the industry would give me the education I needed to advance within it.

One 'module' of technical education came courtesy of Des Moore. Des was the first-call guitarist in everyone's book. There was hardly a record made or a TV show broadcast without his acoustic or electric guitar work featured on it. Never shy of work and with a large family to support, he supplemented his income with a sideline in music-copying. It is worth pausing to consider what this job entails. Since the dawn of composition, scores had been written by hand. In the Dublin community, written music was colloquially known as the dots. A full score was called a chart. Each chart would contain the music intended for every instrument in the orchestra. But it was distracting for, say, the piccolo player to have music in front of them, which included what the

PART 3: 1970S – LEARNING AND GRIEVING

timpani or violas were to play. So, the music copyist's job was to extract the dots for each instrument, showing each player their unique part.

In Dublin, courtesy of RTÉ,[1] theatre and other entertainment outlets, there was lots of work for arrangers and orchestrators. As they wrote their scores, there was a need for copyists to prepare the music for performance. Des suggested I'd learn a lot (and earn a few bob) by doing this work, observing the conventions of orchestration and the techniques and particularities of the instruments.

So, as well as my session work, I took on music-copying. Des schooled me well in the art. I bought myself a set of calligraphic pens and some good quality music paper, and off I went. The first thing I learned was orchestrators often work to a deadline. They might not finish their scores until the night before a performance. This meant the music copyist received the score late and would spend the entire night copying and then sellotaping the music together, ready for a 10 a.m. start. Denise often joined me to tape the pages together as the clock counted down to the beginning of the session. The ink was still damp on the page when it appeared on the music stands delivered by a bleary-eyed and coffee-soaked copyist.

As I sat in the small hours writing out parts from scores by Noel Kelehan, Jim Doherty, Jack Bayle, John Drummond (and the many other arrangers working in those days), I learned the craft and conventions needed for my future work. Years later, technological advances meant arrangers could use software to extract and print the dots. Music preparation became less about developing a legible copperplate handwriting style and more about knowledgeably setting up and printing the music in a user-friendly way for the musician.

I needed hardware to get myself positioned in the session scene. The Fender company were making the now-famous Fender Rhodes piano. I discovered that if I bought it from Manny's Music in New York and got it freighted here, I'd be at the cutting edge of keyboard technology at a competitive price. My friend and broadcaster Brendan Balfe, who did the inflight entertainment for Aer Lingus, arranged to ship the piano to Dublin Airport. At the same time, I did concerts

17. DENISE IN BELFAST – JOINING THE DOTS

and cabaret appearances with Tony Kenny – Joseph of the *Technicolor Dreamcoat* – a major solo star in Ireland. On the nights that *Joseph* wasn't running, Tony was booked into venues countrywide. He took a band with him led by Eamonn Campbell, the gifted Drogheda guitarist who ultimately became a member of the Dubliners. The rest of the band was Desi Reynolds on drums, John Drummond on bass and me on keyboards. Normally, I'd have a hired keyboard with me, but this particular night I picked up my shining new 88-note Fender Rhodes piano at Keuhne+Nagel (the freight company in Dublin Airport), put it in the station wagon and headed north to give it its maiden performance in Moville, County Donegal.

I was still kneeling on the stage with the manual for the Rhodes open in front of me when they were letting in the audience. With Eamonn Campbell's kind and muscular assistance, we got it up and running. And so began my relationship with this excellent instrument which stayed with me through countless bands, tours, pub jazz sessions, TV shows and theatre gigs. I carried it in and out of inaccessible stage entrances, up and down the stairs of the Merrion Inn and Toners, and often, with Denise's help, loaded it into her Renault and finally back to our apartment – never wanting to leave it in the car in case it was stolen. Mind you; it would take a highly motivated thief to coax all 180 lbs of this instrument plus its two speakers out of the boot.

The Rhodes and I worked together until finally, as technology introduced lighter, more portable keys, and as I began to do less live playing, we drifted apart. I am ashamed to say I don't know where it is today. I didn't sell it, and I doubt anyone had the upper body strength to spirit it away, so I entertain a hope that one day I will wander into the storeroom of some theatre or studio and there it will be, waiting for me like a faithful hound, eager to launch into 'How Sweet It Is', 'Peg' or 'Gone at Last'.

Some of my first sessions as a pianist involved playing on records for showbands. Ireland's music and entertainment scene in the 70s differed radically from the later propulsion of Irish music to international

prominence from the early 80s and onwards. In the early 70s, the music economy still centred around the showbands (and folk music to a lesser extent). The engine behind the industry was driven by a cadre of band managers and dancehall owners. Dancehalls had been thriving for decades, and records kept artists in the public eye – and the charts – attracting audiences to live venues, where the real money was made.

Several producers steered work in this area, namely Gerry Hughes, Dermot O'Brien, Bill O'Donovan, Tommy Ellis and later Liam Hurley and John Ryan. The format for recording was fixed: you turned up at one of the studios, ready to play at 10 a.m. sharp; the music was handed out; you played for three hours with a twenty-minute break; you had lunch and then back at 2 p.m. for another session. Often the singer was missing, and you would just be recording a backing track. You might not even know who the artist was until the record was released. Three or four songs were recorded per session. Everything was efficient; you heard your work played on the radio within a week and in the charts shortly after.

The music was mostly copies of existing recordings by American country-and-western acts. The producer often brought in a disc by Jim Reeves, Patsy Cline or Hank Williams, and we'd mimic the style. The vocalist engaged in the same kind of mimicry. It wasn't unusual for someone with a broad Kerry or Leitrim accent to sound like they came from Nashville or Memphis when they sang. The precedent for impersonation wasn't confined to country music. The bel canto style, originating in Italy, was evident in Irish tenors who pronounced the words as Italians even when singing lyrics in English. When the Liverpool sound became popular in the 60s, pop singers pronounced words like native Scousers and Dublin blues and soul singers coloured their song with accents from the Mississippi Delta.

Country-and-western music had significant resonance here due to its origins amongst Irish and Scottish emigrants; the pedigree was burnt into the Irish rural DNA. As Philip King explored in his *Bringing It All Back Home* TV series, the music was repackaged and sent back to where it came from, changed, but with the threads of its cultural origins still visible. Irish showband singers tended to adopt the cultural

paraphernalia associated with it. Everything from cowboy boots to fringed leather coats to bullhorns on their gateposts to ten-gallon hats – these, and more, were integral to the kit and rig-out showband performers enthusiastically embraced.

Many Irish musicians learned their skills from an early age with the showbands. It was the nomadic training college for those later to appear on the recording scene, on TV or in orchestras. The showbands were thriving when I came along, but you could feel a new energy in the air. Rock music had arrived. A fresh take on traditional music was emerging. The venues were changing from the ballrooms to pubs and cabaret spots. Bands got smaller, and studios slowly became places where music was created instead of recycled.

Picking up experience along the way, I played on a myriad of recording sessions, appeared on many TV series in the band, and began to get work as an arranger and then as a producer. I am indebted to individual musicians who took the time to nudge me ahead in my career. Mike Nolan was a fine jazz trumpet player working freelance. He took me into his jazz band Jump with Keith Donald and gave me tutorials in writing for brass and larger ensembles. He died too young, a superbly sensitive musician – his lyrical flugelhorn is sadly missed. Noel Kelehan, as conductor of the RTÉ Concert Orchestra, nursed me along the arranger's path and was encouraging when I brought one of my charts into the orchestra.

I had just finished arranging an old Irish air for an RTÉ programme and had been up all night doing the copying. Now I descended the stairs into the bowels of the Radio Centre to Studio 1, where the RTÉ Concert Orchestra recorded and rehearsed. It's hard to describe a fledgling arranger's state of mind when bringing their chart into a room full of orchestral musicians. It's a combination of terror, anticipation and excitement that makes you feel like running away and staying put at the same time. To the orchestra, it's another day at the office; to you, it's a matter of life and death. I handed the dots to the librarian, and he set about putting them on the music stands.

PART 3: 1970S – LEARNING AND GRIEVING

Noel Kelehan was leafing through music at the conductor's podium when I sidled up with my score.

'Ah, morning, Dad,' he said. (Dad was the vernacular, friendly way musicians addressed each other.) 'You're up on the gallows first. Did you bring your score?'

I handed him the pages.

Noel always looked the same: thick horn-rimmed glasses framing a face that was thin, pale and ascetic looking; never an ounce of fat on his body, he walked everywhere at a speed that most normal people would regard as a fast trot; in his mouth was a perennial pencil used to correct or mark the score and which doubled as a conductor's baton and surrogate cigarette.

'So, Dad, what have we got today? Aha!' – he saw the title – 'Love this tune. Give me an idea of the tempo you want at the start.'

I tapped out a rough tempo on his stand.

'OK. Got it. Morning everybody' – he addressed the orchestra – 'first up is "The Parting Glass", arrangement by young Mr Whelan here.'

Some of the orchestra players I knew smiled at me and nodded. Others responded as if they'd just heard the weather forecast for Novosibirsk. There was a shuffling of pages as they sorted the music on the stands. This is always a tense moment. You are waiting for the second oboe to say: 'Excuse me, I am missing my part.' Or for the first viola to say: 'We seem to have nothing after bar 47.' Everyone looks at the arranger for an explanation, and you feel that butterfly that has been in your stomach for the last couple of hours turn into a swarm of angry locusts as you scurry between the music stands to sort out the problem. Anyway, on this day, all was going smoothly, and Noel raised his pencil, and the first thing we heard was the harp and piano together. After about eight bars, the bows were raised, and the string section joined in. As every bar went past, I felt a mixture of relief and satisfaction. I was standing right beside Noel. He leaned towards me: 'Very nice, Dad,' he lisped through the pencil, and as the strings played the harmonic voicing I'd spent hours agonizing over, I started to relax.

17. DENISE IN BELFAST – JOINING THE DOTS

Then, just as the melody in the flutes and the orchestral accompaniment built towards the dramatic efflorescence (my intention was to build the piece dynamically), an explosive burst came from the brass section, and we all looked over at the bulging eyes, swollen necks and purple complexions of the trumpets. The shockwave ran through the orchestra, but they kept playing.

'I think you must've meant that down the octave, Dad; we'll fix it in a minute,' offered Noel in his confidential and comforting way.

Of course, I had written the trumpets up the octave, a mistake I have never repeated, having learnt a valuable lesson by trial and embarrassment.

There is no doubt that RTÉ gave freelance musicians valuable employment and, importantly, education and training. I was privileged to be learning while earning. How many musicians, I wonder, wouldn't have acquired these skills without the gift of absorbing the theory while also having access to industry professionals with years of experience and then being able to hear our work performed by a real orchestra.

18. Danny Doyle and *Saturday Live*

I got my first taste of working with folk artists in 1976. Shay Healy was back from the US, and we got to know each other through RTÉ. He contacted me to produce a song he had written for Danny Doyle for the bicentennial of the American Declaration of Independence. This was the start of a long relationship between Shay, Danny and me.

Danny Doyle is hard to categorize in Irish music, partly because he emigrated to the US in 1983 to continue his career there, and partly because his early hits 'Whiskey on a Sunday', 'Daisy a Day' and 'Step It Out Mary' placed him at the borders of folk, pop and traditional music. But songs like 'Rare Old Times' and 'Ringsend Boatman' plus his friendship with the singer and song collector Frank Harte suggested he was essentially a Dublin balladeer. Harte gave him plenty of material to feed this repertoire.

I wrote and played the accompaniment for Danny's 1978 recording of 'The Rare Old Times'. The writer, Pete St John, brought the song into the studio. None of us realized then that we were doing a very early version of the song, which subsequently became a No. 1 record for Danny and a folk standard. Over the coming years, I arranged and

18. DANNY DOYLE AND *SATURDAY LIVE*

produced much for Danny Doyle, exploring and advancing our relationship with trad music. Danny's voice was a joy to work with. He was as far from bel canto as you could imagine, had a glorious and expressive instrument, and sang in his own accent. He never hit a note out of tune and was fastidious about every aspect of the work. There were many good moments in the studio but recording 'The Highwayman' – a musical setting of the emotional narrative poem by Alfred Noyes – stands out.

Des Moore was on guitar, Dónal Lunny on bouzouki, Paul McAteer on percussion, Steve Cooney on fretless bass and me on piano. Philip Begley was the engineer, and Danny was cloistered in the vocal booth. We sat around discussing the emotional topography of the lyric and the dynamic shape and arc of the whole piece. We played it verse by verse, stopping after each one as we dissected what we wanted to achieve until the end of the song. Then we played it a few times in its entirety and finally recorded it. We got it on the second take. It was memorable for the shared focus and intention, which was to deliver a unified and dramatic backdrop for Danny to sing against, which he did, magnificently.

Danny and his American wife, Taffy Millar, were great company, sharing a wicked (though not malicious) sense of humour. He read widely about Irish and Irish-American history. In his later years, he took Americans on historical tours of Ireland, rounding off each evening with a session of songs from whichever part of the country they had visited on that day. Taffy was a costume designer. She dressed many Irish artists as well as designed the costumes for theatrical productions. I don't think I ever saw Danny in a shirt that Taffy didn't make. Very beautiful in a Diane Keaton-esque way, she was solid and quiet support to him while being staunchly independent in her career. Both were sophisticated when it came to food and wine. Many's the night, a table heaving with fine fare would be set out in their home in Crawford Avenue, and songs and stories would go until dawn with artists like Andy Irvine, Luke Kelly and Jim McCann among the guests.

My musical adventures with Danny resulted in five albums.[1] Jumping forward in time, the second-last one, *Twenty Years A-Growin*,

PART 3: 1970S – LEARNING AND GRIEVING

was memorable because it was mixed in New York since Danny lived in the US by then. He got a deal from a studio called the House of Music in West Orange, NJ.[2] I flew out from Dublin on a Sunday in December 1986 with a plan for me to work on 'Irish time' for the week and return home without jet lag on the following Friday night, in time for my regular spot *Saturday Live* on RTÉ.

The studio was grubby, but it was a nice room to mix in. We started the sessions at 8 p.m. and mixed through the night until 8 a.m. (3 p.m.–3 a.m. Irish time). The engineer, Jeff Kawalek, regaled me with stories about Steve Gadd and Richard Tee, who did a lot of work in the studio. To me, this was like working in a shrine.[3]

After mixing and before going to bed for the day, Danny and I went to the historic Carnegie Deli for breakfast. It was a loud, garish, bustling bazaar of Formica; its plastic showcases bursting with gargantuan cakes barely holding their shape under slatherings of icing and mock fruit, sculpted out of cochineal-soaked sugar. The colour of everything was hyperreal like 1950s postcards, and the waiters were a surly bunch of misanthropes who had seen everything and had been disappointed by most of it. The restaurant motto was 'If you can finish your meal, we've done something wrong.' They loved celebrities and courted them by naming menu items after them; hence Paul Simon had to endure the renaming of his song '50 Ways to Leave Your Lover' with a sandwich, '50 Ways to Love Your Liver'. Danny was keen for me to try the much-trumpeted Pastrami sandwich – a corned beef construction that arrived on the plate leaning-tower-of-Pisa style.

The waiter set down two glasses of water. He was at the end of the night shift and, like us, was ready for bed: 'Wha' can I getcha?' he asked, addressing the ceiling and then his watch.

'A coffee, please,' I said.

Danny nodded.

Off he went and returned with a coffee pot. He filled two coffees without looking at us or the cups.

'Let's have a beer,' said Danny, 'it'll help us sleep. Can we have two Dos Equis?' he asked the waiter.

18. DANNY DOYLE AND *SATURDAY LIVE*

'No Dos Equis. Ya want Buds?'

'Yeah, Buds are fine.'

He went to get two Budweisers. When he returned, he made an elaborate show of rearranging the cups, water glasses, beer glasses, bottles and various condiments while tut-tutting his impatience at the size of the table (small) and his annoyance at these customers (large). 'Now I s'pose ya want somethin' to *drink* as well?' he quipped dryly, that being an attempt at humour.

We each ordered pastrami on rye with sides of fries. A small village could have survived happily for a week with what was put in front of us. We did our best, but we were defeated from the start.

'Too much for ya?' the waiter sneered, collecting the plates.

'Can we make those to go?' Danny said.

I looked quizzically at Danny.

'I've a plan for them,' he said as the waiter brought the doggie bags bursting with pastrami.

Danny paid the bill. There was a paltry thirty cents of change, which he left on the plate – surprisingly, since he was usually a generous tipper. 'He's only a bollix,' Danny said as we left.

We were out on the street when we heard a shout from the restaurant: 'Hey, Rockefeller!' said our waiter with enough irony to support the Brooklyn Bridge. 'Ya forgot yer change,' he growled, thrusting the thirty cents into Danny's hand. Then, he turned on his heel and went back to the restaurant, presumably to charm the celebs of New York.

Danny handed the two bags of food to a weary-looking old man sitting at the kerb.[4]

I caught the flight on Friday, arrived in Dublin on Saturday morning, went straight home, showered, and left to RTÉ for *Saturday Live* rehearsals. *Saturday Live* was an extraordinary invention directed by Paul Cusack. His idea was that each week a different presenter would host the chat show with guests of their choosing. The constant item was the band.

Over the show's two years, we had a broad range of presenters, from farmers to bishops to politicians. Rhonda Paisley, for example, had her

father, The Rev. Ian Paisley, on as a guest, calling him Dad, which gave us all a challenge, this being before he became one of the so-called 'Chuckle Brothers' with Martin McGuinness.

On the evening of my return from New York, the host was Lord Henry Mountcharles. His guests were the social activist Sister Stanislaus Kennedy, the junior minister for Northern Ireland 1981–3, Lord Gowrie, and musician Mary Coughlan. Unfortunately, the plan to ease the jet lag by keeping Irish time during the week in New York wasn't proving as effective as I had hoped. I was blurry and befuddled, but at least this week's music wasn't too taxing, and Lord Mountcharles was suavely relaxed. We made it to showtime with everything rehearsed and ready.

Part of my job was to introduce the guest presenter on live television. We played the theme I'd written for the show and the floor manager, Johnny McEvoy, cued my intro. A red dot appeared near the camera lens, telling me I was now speaking to the nation. 'Good evening and welcome to *Saturday Live!*' I said. 'Our guest presenter tonight was born into an aristocratic family; he is the eldest son of the Marquess of Conyngham. However, he is best known for the wonderful concerts he presents at his castle in Slane, will you please welcome—'

It was as if somebody pulled open a trapdoor, and anything I ever knew about anything vanished into it. The name of the presenter deserted me. The little red dot and I stared at each other while the nation held its breath. I was too young for a senior moment, but here it was. For a lifetime it continued until finally, somewhere in my head, a release button was pressed and I was back in the studio with Lord Henry's name intact. I blurted it out, and off we went.

19. A Honeymoon

By 1975 I had a steady flow of work between recording sessions, RTÉ and freelance arranging. I also had a growing list of production clients. However, there was no sense of an overall plan, no hint of security – a permanent and pensionable job was something that most musicians never experienced. Every gig relied on how well you did the previous one; while scary, it drove you to deliver one hundred per cent on each project.

The nature of my employment wasn't ideal for settling down in the conventional sense. Denise and I moved into two apartments in the same building in Sandycove – there was no question of living together, or at least not if our parents had anything to do with it. We decided to get married, so after a five-year courtship and despite my sketchy career, the two families assembled in Kildangan Church in County Kildare. On 5 September 1975, Denise and I tied the knot.

There was ambiguity among both families about what precisely the groom's occupation was: 'I think he plays the piano,' Denise's grandmother was overheard saying at the wedding. She was a tall, forbidding figure with a handsome face. Her eyelids seemed permanently

half-closed, and she had a prominent eagle nose, all of which created the impression that no matter who she stood beside, she was looking down at them.

By now, I knew Denise's siblings well. Barry, her younger brother, followed in his father's footsteps as an army officer; he also played the guitar, and we hung out together, singing and taking the occasional pint. The Quinns became the family I didn't have as an only child. Denise's mother, Mary, was beautiful like her daughters (Fiona was Denise's younger sister). Queenly in bearing, she was a schoolteacher and carried herself with a quiet authority. I got on well with her (mostly) and went for substantial Sunday lunches in their house, followed by evenings around the fire and long conversations about current affairs.

Denise's father, Denis, was tall, broad and good-looking. He had a personal warmth that could heat a stadium, and while he was well regarded and respected in the army, he was more at home with the land. He kept cattle, grew magnificent potatoes and carrots and was never happier than when he was baling hay or when his hands were deep in the earth; he spoke of 'God's time' as distinct from the clocks that regulate human activities. After a few pints, he was likely to break into song, chest extended, head thrown back. 'The Bould Thady Quill' was his party piece. His sons now carry the song tradition when we assemble yearly in August to remember him and Mary. W.B. Yeats used to say that the performance of his plays after he died would provide a portal for him to re-enter the mortal world briefly. If true, then I am sure Denis Quinn has been standing in the shadows of the bar each year as the chorus raises the roof and the Quinn children, Denise, Barry, Declan, Brian, Fiona and Denis (Jnr) plus grandchildren belt out the spiritual epitaph of the much-loved paterfamilias:

> *for ramblin for rovin' for football and sportin'*
> *for drinkin' black porter as fast as you fill*
> *in all your days rovin' you'll find none so jovial*
> *as the Muskerry sportsman the Bould Thady Quill*

19. A HONEYMOON

My uncle, Fr Harry Lawlor, officiated at the wedding Mass. True to form, and in keeping with the joyous occasion, he didn't waste the opportunity to lecture everyone about the evils surrounding us, particularly the blot on Irish life brought about by alcohol and television. As several of the congregation made their living from television, it must have been comforting to hear. Regarding alcohol, occasions came later when I admit there was truth in his words, but there is a time and a place for such admonishments, and our celebrant was clear about the kind of celebrating he disapproved of.

Tony Kenny, former star of *Jesus Christ Superstar* plus *Joseph and his Amazing Technicolor Dreamcoat* sang 'Ave Maria'. Anne-Marie 'Lola' Mooney sang Cat Stevens's 'Morning Has Broken'. Both were accompanied by Eamonn Campbell on guitar and the versatile local pianist, John Grogan.

Niall Connery was my best man; Pete Ahern was my groomsman. Fiona and Cousin Brede were Denise's bridesmaids. My mother brought Tessie Woulfe from Limerick (her friend who could read fortunes), supported by uncle Mick, his wife, Annie, my aunts Edie and Mabel and as many of our side of the family as we could muster.

We booked the Red House for the reception. It was a prized spot in the Kildare countryside, with wonderful cuisine run by the Morgan family. Several of my musician colleagues attended the dinner even though a few of them had to appear later that day at a preview in the Abbey for Jim Doherty and Fergus Linehan's *Inish*. We must have been operating on 'God's time' because there was a panicked evacuation of musicians when somebody realized that they were supposed to be onstage in the Abbey in less than an hour. I shudder to think what the car journey was like heading into the Dublin traffic. They made it, albeit late, resulting in the theatre holding the curtain for ten minutes. It also resulted in Jim Doherty giving me an icy greeting when I next met him: 'Ah, young William. Hijacking my band now, are we?' he said with his customary salt-and-vinegar wit.

The Red House was a success. The wedding band consisted of John Grogan (who had played the organ in the church) on piano. He brought

a drummer friend with him to the hotel, and the two of them played for the dancing after supper. It was not a large orchestra, but it could have been the Count Basie big band for all the fun we knocked out of it. For the first and only time in my life, I danced with my mother. It was one of the few occasions she let her hair down and was relaxed, having resigned herself, as she saw it, to being alone in the world.

I was keen to take my bride to our honeymoon location, which I had secretly and proudly organized. Richard Harris's brother-in-law, Jack Donnelly, managed the Cashel Palace Hotel in Tipperary. So when I called him to ask if he had a room for our honeymoon night, his immediate response was: 'But of course, you'll be our guests; we'll prepare the bridal suite for you!'

Jack Donnelly can't have been more than five foot two; I've never seen him without a black jacket and tie with grey and black striped trousers, and a fresh rose in his buttonhole. He was the kind of person against which all definitions of dapper might be judged. I was excited to take Denise to this secret location; I couldn't wait to get there. We drove to Cashel, leaving the guests to close out the evening at the Red House and onwards to the Quinn family home in Kildare, where a grand celebration was prepared, which lasted for two days and led, by all accounts, to massive hangovers and multiple reprises of 'The Bould Thady Quill'.

Cashel Palace Hotel was an attractive red-brick building designed and constructed in 1728 by the same man who built the Dublin Houses of Parliament: Sir Edward Lovett Pearce. It had been the residence of Irish bishops who obviously adopted a free-and-easy interpretation of Christ's guidance in the bible about living frugally – *the poor you will always have with you*[1] clearly meant outside the walled gardens and sumptuous salons of this eighteenth-century architectural gem. Undistracted by these considerations, Denise and I arrived to the customary Jack Donnelly reception with champagne in our room and a gourmet supper in the historic dining room. It was a glorious evening, sipping brandy in front of a blazing fire and then snuggling up in a massive four-poster bed – the perfect wedding night.

19. A HONEYMOON

We left Cashel the following morning for the second part of the honeymoon. By way of explaining this next part, I must stress that I had very little money. Knowing we would be staying the first night with Jack Donnelly for free, I had a little bit left over for the rest of the honeymoon, so I got in touch with a man in County Kerry, who said he had a beautiful caravan secluded on a quiet boreen, and which had panoramic sea-views overlooking the Rosbeigh Strand.

As we approached Glenbeigh, it started to rain, and there was a dark grey shadow of murk in the sky to the southwest. I did my best to navigate to the field where this luxurious and romantic love nest was situated and for which a key would be placed under the milk churn. We did pass one field with a very ramshackle caravan hoisted precariously on cracked concrete blocks with one window replaced by a pane of cardboard which shuddered in the freshening breeze. We kept going in the gathering gloom until the road petered out to a sandy track, and soon we were on the beach.

'We may have missed it,' I said to my new bride, whose expression was darkening like the sky.

'Are you sure it wasn't that one we passed?' she inquired.

'Let's look at that map again,' I said, and we pored over the chart, trying to find our location. 'No, this looks right,' I said, 'we'll go back the way we came and keep our eyes peeled.'

I reversed the car around the sandy surface and faced it back toward the boreen. Then, as I pressed on the accelerator, there was a sound like someone using a buzz saw, and the rear of the car swayed left and right in a drunken waltz. We were in a deep rut bored into the sand, and as I got out to examine it the rain took on monsoon proportions and the wind joined in, adding to the chaos. It took half an hour of pushing and shoving, wedging rocks under the wheels, sliding into the sand until finally, we were able to get back on the boreen. We pulled up beside the ramshackle caravan we'd spotted earlier.

'Look,' – Denise pointed to the back of the caravan – 'there's a milk churn beside the step.' She glanced at me resignedly. 'Why don't you see if there's a key there? Then, at least, we'll know for certain.'

PART 3: 1970S – LEARNING AND GRIEVING

I dreaded that short walk to the caravan, which in these conditions looked like it was about to become airborne. I did not want to find a key, but as I lifted the churn, a small envelope lay soaking on the grass underneath. A felt-pen message dribbling down its paper face: 'Welcome!' it said. 'Key inside.'

I beckoned to Denise and opened the rickety door.

We spent the second and third night of our honeymoon in surroundings that bore no relation to the first. The four-poster bed in Cashel was far away from the fold-down board with damp duvets and plastic pillows where we lay our heads on these few nights. The gale subsided, but the rain was endless. The advertised panorama over Rosbeigh Strand never appeared through the curtain of sea-brume and torrential downpours. We did go for two nice meals to Ernie Evans' restaurant in Glenbeigh, partly why I chose this spot. In the end, we abandoned ship – anyway, it was nearly afloat by the time we left it.

'Is this honeymoon portent as to what our married life together will be like?' Denise gave me a teasing poke in the ribs as we drove off to Limerick, back to 18 Barrington Street, back to my mother, back to warmth and clean sheets and towels. Mind you, at this stage of my music career I suspected Denise might be close to the truth.

20. Stacc, the Jingles and the Springer Spaniel

Noel Pearson was the impresario and producer of many theatrical shows in Ireland in the 70s and 80s. He occupied an important position in the arc of my career, and we also became good friends, spending hours talking about shows or just gossiping. He wasn't the tallest of men, but he cast a large shadow and had a brand of wit which he used to burrow in behind people's facades and which some found unsettling and others found rude. Never far from his Dublin roots, he was known for his direct manner and often startled a table with a personal remark about one of the guests. However, he was no 'go-by-the-wall'[1] – what you saw was what you got, sometimes more than you needed. His glasses spent long periods on his forehead. He earned the nickname Blinkie thanks to a habit of raising his eyebrows and fluttering his eyelids when emphasizing a point or concentrating on an idea, like someone compensating for a stammer, which he didn't have.

Noel had superb taste in art and decor and was an avid reader, but most of all, he had a real sense of theatre and could spot a hit show with uncanny intuition. Not that everything he did succeeded, but he

was far from risk-averse and often used a hit show to fund something he wanted to try out; Andrew Lloyd Webber's *Joseph* and *Jesus Christ Superstar* were regularly staged to support a show that was less assured of an audience or that cost significantly. So, for example, in 1974, he mounted *West Side Story* in Dublin while I toured around Ireland with *Joseph* to pay the bills.

West Side Story is a real example of Noel's resilience. The day the show was opening at the Olympia, the band were rehearsing, and a break was called at 11 a.m., so they all went for coffee. When they returned, the proscenium arch had collapsed thirty feet into the orchestra pit, decimating the instruments and slicing the piano in half. Had the musicians been in situ at the time, many would have been killed. Pearson's response to this catastrophic setback was to open *West Side Story* that same day in the State Cinema in Phibsboro instead. It wasn't even a regular theatre venue; it was a threadbare and unused cinema. However, he moved the entire company, set and orchestra to this unlikely spot a few miles from the Olympia, arranging for replacement instruments along the way. He also managed to get word to the audience who turned up in Phibsboro – and all this in the days before mobile phones. The show was a success.

His offices were in Merrion Court, a cul-de-sac beside Stephen's Green. The walls were tastefully decorated with works by Robert Ballagh and posters from Noel's previous productions. It was an ideal city-centre location and was presided over by the stoically patient Eddie O'Leary, who did the books.[2] Eddie had few illusions about the entertainment business, though he had a fondness for most people in it (a sentiment that was returned). His popularity was enhanced by the fact that he was the paymaster general for all Pearson ventures, which on occasion might be straining under financial pressure. On several occasions, I called in to Merrion Court to get paid for a job. Eddie, cigar in the jaw, would lead me to his office, where a pile of invoices sat dustily on the desk. He would show me where my invoice was in the stack; then, we'd bend down and scrutinize the structure like a pair of architects looking at the model of a high-rise: 'You're getting closer and closer to the top of this,' he'd assure me, fingering the upper floor

20. STACC, THE JINGLES AND THE SPRINGER SPANIEL

region. 'I estimate a week from Friday you'll be close to the top. I'll have a cheque for you then.'

Noel had a small roster of clients, the Dubliners being the most prominent. However, for a short period, he also managed a band that had grown from a shared attraction to a particular genre of music. This band emerged as a trio playing on a series of shows devised by the broadcaster and comedian Brendan Balfe at the Tailor's Hall in Dublin in 1976. Brendan performed satirical monologues like his acid lampoon of 'Desiderata', a saccharine verse that was popular at the time. The poem guided us to 'go placidly amid the noise and the haste' and be 'a child of the universe no less than the trees and the stars'. Brendan Balfe's humour was in the tradition of Tom Lehrer, Bob Newhart and Victor Borge, with a nod to the Goons and Monty Python.

In between Balfe's surgical shredding of verses like 'Desiderata', Des Moore, John Drummond and I, with the excellent vocals of Anne-Marie Mooney,[3] performed original songs plus covers by Carole King, Laura Nyro, Stevie Wonder and others. It was a fun gig, and we all got on well. John and I were the songwriters, and Des Moore's guitar solos were admired by the many guitar anoraks who turned up. All we needed was a drummer. Desi Reynolds was an in-demand drummer balancing a career between theatre in London and sessions in Dublin. Still, he agreed to join us and Stacc was formed (Stacc was the abbreviation for the musical term 'staccato').

The fourteenth National Song Contest was due to be televised on RTÉ in March 1978. We decided to inject some contemporary energy into it by entering the competition. John submitted 'You Put the Love in My Heart', a medium-funk love song, and I entered 'All Fall Down', a sombre ballad about the end of a love affair. Both songs were finalists. We decided Stacc would perform John's song, and Gemma Craven would sing mine. Gemma was to star in Noel Pearson's theatrical production of *Side by Side by Sondheim*, and her film and TV career in the UK was soaring.

PART 3: 1970S – LEARNING AND GRIEVING

We appeared in the National Song Contest. Stacc won second place, and Gemma came third. The winner was the indomitable Colm Wilkinson with his song 'Born to Sing', which we retitled 'Bound to Win'. Ironically Stacc was Colm Wilkinson's rhythm section, and we toured around various Irish venues with him at the time.[4]

For me, the connection with the National Song Contest and onwards with Eurovision had begun in the previous year when I did the orchestration and arrangement for Swarbriggs Plus Two and their song 'It's Nice to Be in Love Again'. This connection was to continue for ten years, during which I arranged, produced and orchestrated three Eurovision winners: Shay Healy's 'What's Another Year' with Johnny Logan (1980), 'Terminal 3' with Linda Martin (1984) and 'Hold Me Now' with Johnny Logan (1987).

In those years, the writer, singer and orchestral arranger had to be Irish. This was rigidly enforced, although occasionally, an artist's manager convinced Irish musicians to ghost for English writers or arrangers, believing the English knew more about winning the Eurovision than we did (history proved this not to be the case). A further stipulation was that the performance be live, different to now, where virtually everything is mimed, removing much adrenalin from the live performance.

Over the next two years, Stacc added Caitríona Walsh and later Nicola Kerr on vocals. We played two weekly gigs: one in the Merrion Inn in Ballsbridge, the other in the Lawrence Hotel in Howth. One night, in Howth, as we were setting up, Desi phoned the hotel. He was at Heathrow. His friend, cellist Nigel Warren-Green, had driven him to the airport but had got caught in traffic. He missed the flight, but he was booked on the next one and would be with us as soon as possible.

We waited. We had one of our biggest audiences that night; in fact, the hotel had closed the doors, and the house was full. We sat in the dressing room, discussing what to do if Desi didn't show. It was now 8.30 p.m.; we typically started at 8.15 p.m. The audience was restless, and the occasional slow handclap could be heard. Desi's drums weren't even set up yet since they were in his car. (Stacc had no road crew, as my

20. STACC, THE JINGLES AND THE SPRINGER SPANIEL

lower back can testify. We had an excellent van driver, John O'Reilly, but all lifting was a shared band activity.)

8.45 p.m. – still no word from Desi. We decided to go onstage without him. We announced to the audience that we would be beginning the night with an acoustic set. Our usual repertoire got off to a shaky start, avoiding any numbers that relied on drum features. Caitríona was busy, fine; the audience loved her anyway. She was halfway through the gentle 'Mama' by Jennifer Warnes when there was a disturbance at the back of the hall. The first thing we saw was a bass drum being carried aloft on Desi's head, making its way over the crowd, followed by tom-toms, then snare drums and a set of cymbals and hi-hats. An entire kit was wobbling in a stop-start conga line through the audience, some of whom began applauding the sherpas as they lugged all this gear towards the stage.

We abandoned Jennifer Warnes and watched the procession of percussion instruments led by Desi, some bearded guy we didn't know, the hotel manager, the barman, the night porter and a taxi driver. When they arrived at the stage, there was a big cheer from the crowd, and we announced a ten-minute break to allow our drummer to set up.

Desi's bearded drum roadie turned out to be the noted cellist from the London Symphony Orchestra, the London Virtuosi and the London Chamber Orchestra – Nigel Warren-Green. It turned out there was more to the stuck-in-traffic narrative we'd heard earlier. Nigel *had* driven Desi to Heathrow, but they got 'delayed' in the departure lounge. So, when they realized the time, it seemed eminently sensible for Nigel to buy a plane ticket and accompany Desi to Dublin to help load in his gear when he got to the venue and, as a bonus, meet Desi's friends.

After our drummer assembled his kit, amidst a cool reception from the band, we returned to a non-acoustic performance, with Desi receiving massive applause for making a spectacular entrance with his entourage. The rest of the evening went well despite the inauspicious start. However, as we played, I noticed Desi's bearded sherpa at the bar beaming up at us with an expression of admiration and wonder. We hadn't time to be introduced at the break, but as he stood there,

transfixed, I couldn't help thinking we must be playing well, judging by his ecstatic response. I was even more gratified when we were introduced afterwards – such an eminent musician as Nigel Warren-Green loving a Stacc gig was praise indeed.

However, I soon realized that what I thought was the look of a man thoroughly enjoying the music was the look of a man falling in love at first sight. Ten years after that night, we attended Caitríona Walsh's marriage to Nigel Warren-Green at the Capuchin Friary on Church Street, Dublin. In between and beyond, much occurred arising from that first night, including Nigel's playing and touring with the Dubliners, Caitríona singing on many of my production sessions, and her finally taking over the running of the Irish Film Orchestras (IFO), which I set up in the 1980s.

Stacc continued playing its residencies, as well as releasing two singles.[5] However, all of us were becoming busy with other parts of our careers. I was getting more work arranging and producing, and the band eventually folded after two years. We continued to work together on separate projects and remained firm friends. Stacc gave us an opportunity to write, play and experiment with the music we enjoyed at a time when, as a working musician, you didn't often get to make those choices.

Soon I got work from the ad business as a producer and jingle writer. I joined forces with composer Shaun Davey, and we shared an office in Waterloo Road, recruiting Judy Lunny as office manager. Judy was (and is) one of the wittiest people I know. Part of the joy of going to the office was hearing Judy's wry take on anything from the arts to politics. Judy's sister was Susan Slott, the noted Irish actress. Both were Californian-born grandnieces to Irish actor Barry Fitzgerald and had an inherent connection to the arts and theatre. Susan's partner, Mike Nolan, was the trumpet player who earlier in my career had tutored me in writing for large ensembles. Judy was previously married to Dónal Lunny, who would become influential as I engaged with traditional music later.

20. STACC, THE JINGLES AND THE SPRINGER SPANIEL

Both Shaun and I were active as jingle writers; while we had separate regular clients, we often pooled resources, occasionally contributing to each other's work. Writing music for commercials wasn't something either of us wanted to do daily, but for freelance musicians, the key to survival was to be able to turn your hand to different disciplines. Jingles paid well. You could earn enough composing music for a Toyota or Budweiser commercial to keep your family going for months while allowing you to pursue other musical ambitions.

One of my early jobs was for Budweiser. A call from Margo Tracey at Irish International always carried the possibility of a good brief, and this one was. It was a series of five commercials for Budweiser in the style of Irish trad music aimed at the American market. The budget was decent, and I was able to engage several very accomplished traditional musicians: John Sheahan of the Dubliners; Mairead Ní Mhaonaigh and Ciarán Tourish from Altan; Dónal Lunny and Andy Irvine. We recorded in Windmill Lane over several days, and after the final playback in the studio, for this famous American beer, Andy Irvine proclaimed: 'I am now an older *but wiser* man!'

The Budweiser ads were my first foray into writing and arranging for a mix of traditional and contemporary instruments, which led to more ambitious compositions in the years to come. During music recordings for commercials, the studio dynamic was often threaded with complex social subtleties as various roles buffeted against each other. This was particularly true when the ad agency's account executive was in the studio alongside the client. The advertising people want to impress the client; the client wants to impress the public; the musicians just want to get paid. On these occasions, the control room was over-supplied with opinions, and it was a skill to keep the boat steady.

For one session in Trend Studios, the recording was for a well-known brand of tea. Not only were several tea merchants present representing the client but also in attendance was the ad agency's account executive, an outrageously flamboyant figure wearing a black poncho and a wide-brimmed hat in the Hispanic cañero style. A man who used many dramatic gestures when he spoke, he was tall and looked

PART 3: 1970S – LEARNING AND GRIEVING

for all the world like the dark, mysterious figure on the Sandeman Port ads. For narrative purposes, I will call him the Sandeman as I don't remember his name.

I had booked a great collection of musicians, including the legendary guitarist Louis Stewart. Louis was on electric bass, which he played very well, but for which he had little fondness. He was once heard remarking that 'the electric bass is like a fire-extinguisher, something you *have* to have, but hope you never have to use'. And now, here he was about to play it in this session, and I was delighted to have him. As indeed was the Sandeman, who spotted this revered jazz figure immediately, and from then on, addressed him directly to the exclusion of everyone else.

Louis's delight in performing on a tea commercial directed by a caped gaucho in a cañero hat could not be described as over-enthusiastic, but he maintained a polite composure throughout. Another contributing factor to the absurdity of the session was the control room in Trend Studios. It was narrow with a small couch upon which the tea client plus entourage sat, scrunched up together like a family in the back of a Volkswagen Beetle. As well as that, the monitors through which we heard the playback were mounted high on the wall before the recording desk. The Sandeman, having acquainted himself with the room's acoustics by making some alarming hissing noises and clapping his hands to hear the aural response, announced that he could only listen back properly if he were a few feet higher. A stool was sent for him, onto which he climbed, and for the rest of the afternoon, the Sandeman was elevated ten feet above the rest of us while the clients cowered in their tiny nest in the control room. The thirty seconds of music required was played over and over as we strove to achieve a take to satisfy the Sandeman's vision. Disembarking from his perch, he'd appear from the control room with reports on how it sounded together with words of directorial encouragement. Finally, when I began to think that Louis's disaffection for the electric bass might precipitate a public incident, the Sandeman burst out of the control room.

Addressing us first, he said: 'Amigos, you are nearly there. *This* close' – showing us how close by displaying a tiny gap between his thumb and

20. STACC, THE JINGLES AND THE SPRINGER SPANIEL

index finger – and then, turning to Louis, he said, 'Mr Stewart, could I ask you, on the next take to, em ...' – pursing his lips, closing his eyes, and sniffing as if to find the appropriate words floating on the increasingly stale air in the studio – 'pitch it into the deep.'

'Sorry, Dad?' Louis was flummoxed.

'You know, pitch your performance, just a shade more into the deep.'

Louis looked at me for some hint as to where to go from here. I jumped into the breach, 'Y'know Louis, on the next take, maybe just pitch it a bit more, kind of into the *actual* deep.'

The Sandeman nodded his encouraging approval.

'Ah, the deep,' said Louis, wide-eyed, open-mouthed pushing his spectacles back on the bridge of his nose as the meaning of this new musical technique seeped in.

The Sandeman returned to the control room and mounted his perch.

We joined Louis and pitched the tea music into the deep. Jubilation all round. The Sandeman ran around the studio, shaking hands with everyone, pausing for a special private moment with Mr Stewart, whose bass guitar was already safely back in its case. The client and his entourage looked on in wonder at this great display – the magic of recording.

I did one Guinness commercial in 1980, which not only received awards but led to an extraordinary chain of events that ended up with Christy Moore referencing it in a song and my family owning a springer spaniel. I was contacted by an account executive at a Dublin agency who was pitching for a Guinness commercial. There was a big UK agency competing for the job. Their selling point was a guarantee that the Gerry Rafferty Band would play the music. I wondered what exactly they meant by the Gerry Rafferty Band. 'Baker Street' was a hit at the time, but apart from Rafferty himself, the distinguishing characteristic of the song was the saxophone solo. I knew the song was produced by Hugh Murphy, who'd been working at Windmill Lane months previously. I called Brian Masterson at Windmill to see if he had Murphy's contact details. Sure enough, he did, so I found myself dialling Hugh's number.

PART 3: 1970S – LEARNING AND GRIEVING

'Hugh Murphy here,' a friendly voice answered.

I introduced myself then explained, 'I'm doing music for a commercial in Ireland, and wondered who the sax player was on "Baker Street"?'

'Raff Ravenscroft,' Hugh said.

'Well, the commercial is for Guinness, and I wondered if Ravenscroft would consider coming to Ireland to play on the track?'

'Ireland? Always a great place to work,' said Hugh. 'I presume it's Windmill Lane? Yeah, I'm sure he would love it. Why don't you give him a call?'

In minutes I was speaking to Raff Ravenscroft. I explained the project and asked if he'd come to Dublin and play on the track.

'Might there be a few pints of Guinness involved?' he asked.

I assured him yes.

'I'm there,' said Raff.

I called the agency and told the exec that although the UK company had the Rafferty Band, we had the sax player. The job was on.

Within a week, there was the 'Baker Street' sax in the hands of its owner, playing the solo on the track I'd written for what became a famous commercial. Des Moore played a great solo on guitar, and James Morris brilliantly edited the film footage to the music. There were bikinis, athletic surfers and Australian beaches intercut with bubbling clouds of Guinness, all prompting Christy Moore to write in his song 'Delirium Tremens':

> *As I sat lookin' up at the Guinness ad*
> *I could never figure out*
> *How your man stayed up on the surfboard*
> *After 14 pints of stout.*[6]

That Guinness commercial led to Raff asking me to produce an album for him. We assembled in Windmill Lane to begin work with the rhythm section. As well as ex-Stacc member Des Moore, Raff invited a bass player from Detroit called Deon Estus, an astonishing musician,

20. STACC, THE JINGLES AND THE SPRINGER SPANIEL

singer and songwriter, and Doni Hagan, a drummer from Chicago. We spent a week laying down the rhythm track. If I remember anything from these sessions, it was the feeling of euphoria I got from playing with Des and these two black musicians, Deon and Doni. I floated home each evening with the music resounding in my head and couldn't wait to get back in the studio the next morning. Deon was a party animal with a sense of style. He wore Armani suits, and his hair was expertly braided: 'Took twenty-seven hours to do this hair, man,' he explained. And we believed him. He was sitting on a Dublin bus one day, and two Dublin auld dears were in the seat behind him, 'C'mere love, d'ye mind if we touch your hair?' And, of course, he didn't mind.

Deon Estus was charming, combining a version of Southern politeness with a jive talk and spoke enough for two Cassius Clays. When he visited my house, he went to the wrong address on the adjoining road. He rang the bell, and our neighbour opened her door to be faced by this braided and beaded black man in a tailored suit. Before he could introduce himself, she said, 'Ah, you're probably looking for the Whelans. Number 7, around the corner.'

I introduced Deon to the Stacc singer, Nicola Kerr, and it was a *coup de foudre*, as the French say. It was an affair that was to continue for a year or so when Deon returned to London, playing bass and singing with George Michael.

The work continued on the Ravenscroft album in Ridge Farm studios near Dorking, Surrey. It was a lovely environment to work in, with superb catering and a friendly staff. We had to stop recording occasionally since it was on a flight path to Gatwick Airport. Raff financed the album himself by bringing in investors, including an Italian hairdresser and a local garage-owner. I am not sure if they all knew about each other, and there were times when it felt like we were in a rock-music version of *The Producers*. I asked Nigel Warren-Green to book a string section, and he turned up in Ridge Farm with a collection of players who were nearly all section leaders of London orchestras. The car park in Ridge Farm was full of Rolls-Royces, Bentleys, Aston Martins and BMWs.

PART 3: 1970S – LEARNING AND GRIEVING

The work was going well, although the engineer, Bill Sommerville-Large, and I barely slept for two weeks. We did the sax solos after breakfast and the flute and other overdubs in the afternoon. Then, we'd break for a magnificent dinner, after which sleep would have been welcome. However, Deon insisted on going for a hot tub before attempting his vocals, meaning he'd eventually appear and sing or play bass until four or five in the morning. The carousel would start again after breakfast, when a rested Raff would appear with his sax.

One night after dinner, it became clear that there was no more credit available: the money had run out. After a fractious encounter between Raff and the studio owners, the session ended prematurely. We packed our bags and got ready to fly home the following morning. After breakfast, I approached Raff for payment.

'Ah, Bill,' he said, 'I'm afraid I'm going to have to ask you to hang on for a week or two until I sort out the finances here.'

I explained we'd been working flat out for weeks, and we hadn't got a cent.

Raff thought for a few minutes and then said, 'Look, I'll definitely have the money for you, and we'll finish out this album. It is sounding so great. I'll raise money from a record company.'

I didn't look convinced, so he thought of something: 'Would you like a springer spaniel?'

The surreality of this question threw me.

'Here, let me show you something.'

We walked over to the jeep his partner Maxine owned. He opened the boot, and in it was a litter of liver and white spaniels, all licking and tail-wagging.

'You can have one of these,' he said, 'go on, take your pick. I've a little cage to carry him in.'

I thought of my twin daughters back home and measured the difference between arriving home empty-handed and arriving with a dog. I chose the latter.

Tara, our treasured family pet, lived to the ripe old age of twelve.

We never finished the album. Raphael Ravenscroft died in 2014. And the irrepressible Deon died in 2021.

21. The Dubliners, the Bards and Windmill Lane

My connection to the Dubliners began in 1973 when Luke Kelly starred as King Herod in *Jesus Christ Superstar*; I was in the band that accompanied him on solo performances. Later I worked with the Dubliners' fiddle player, John Sheahan, on various creative projects.[1] A man of endless patience and humour, John helped keep the Dubliners' boat steady. But the most sustained period I had working with the Dubliners was when I produced their final album, *Prodigal Sons*, in 1983, with many of the original members. Unintentionally but appropriately, the last song recorded by Luke Kelly is on this album: his moving performance of 'Song for Ireland'. It took a day to record; he was unwell, and we had to take several breaks. When I relisten to it, I can still hear the unique personality in his voice; that underlying compressed power which, as my father once described to me in the kitchen in Limerick, releases Luke's ability to 'float a song'.

In all encounters with the Dubliners, stories were sure to emerge; *Prodigal Sons* was no exception. A memorable recording was Nigel Warren-Green's cello on John Sheahan's compositions at Westland

Studios. Nigel arrived with his love-at-first-sight fiancée (and former Stacc singer) Caitríona Walsh, her sister Annette, and their mother. All three were dressed like models. In fact, Annette was a model.[2] Days preceding Nigel's performance, we'd been waiting for Barney McKenna to arrive to play some banjo overdubs. He didn't appear on the first day; he missed the next two, and so we decided we would press on with Nigel's recordings and catch Barney whenever he turned up.

When I hear the expression 'a bear of a man', my mind runs to Barney. Avuncular and warm, face framed with a big beard and a shock of dark hair, he bore the expression of one who'd been sitting in the pitch dark, and somebody had suddenly turned on the lights. It was a look of perpetual discovery and surprise that gave the impression he was innocently taking things in for the first time, which of course, was far from it.

Nigel was out on the studio floor, playing some counterpoint lines beautifully on one of John's tunes. The ladies were all seated on the couch, eyes closed, attentive. The atmosphere was of quiet and serene appreciation.

Whooosh – the insulated door to the control room flew open, and standing there was a figure in oilskins with a drenched sou'wester hat pulled low over his forehead. His bottle-end glasses were misted and dripping with rain.

Silence.

'Howayez?' he offered to the room in general. 'Sorry, I'm a bit late. We were out fishin' and got caught in a gale. We'd to pull in for shelter in Arklow. I'd no phone to ring yez. Ah! Caitríona,' he was gradually noticing who was in the room, 'how'ya darlin'? Nigel with ya?'

Nigel came into the control room.

'Ah, me auld segosha,' says Barney, noticing him.

John Sheahan, ever observant, noticed something in Barney's paw: 'What've you got there, Barney?'

'Ah, this?' Barney held it up as if he'd just noticed it himself. 'Well, I thought yez've liked a bit of fish!'

We gawped at Barney's right fist, which was clamped around the tail of a six-foot conger eel trailing along the studio floor behind him

21. THE DUBLINERS, THE BARDS AND WINDMILL LANE

like a giant snail leaving a trail of pungent nautical slick. There was nothing to say. The three Walsh women were getting a crash course into what life might be like for Nigel as he began his association with the Dubliners.

Barney parked the eel out in the hallway, saying that we would deal with that later, although Deirdre Costelloe, the studio owner-manager, had other plans for it. Then, to the wide-eyed astonishment of the girls, he removed his oilskins and maritime gear. Annette said afterwards she had heard of the plumber's crack before, but this was her first experience of the sailor's one.

When Barney finished his wardrobe adjustments, he looked at us all and said: 'Listen, c'mere, I'm sorry again about being a bit late but. D'yez mind if we start with a break? I'm bleedin' starvin'.'

Working with the Dubliners, I got an opportunity to understand what kept the group together for so long: they all brought something special to the party, from Luke and Ronnie's different vocal styles to Ronnie's love of flamenco which can be heard occasionally in his guitar style to Barney's home-grown and personal banjo playing (as a melodist or accompanist). John's immersion in trad allowed him to infuse that into a folk band. The distinction between trad and folk is often blurred, but in the early days, you were safe assuming that trad consisted mainly of dance tunes, slow airs and songs originating in Irish, often unaccompanied, whereas folk was mostly songs in the English language, accompanied by ensembles which might, although not always, deliver rousing Irish jigs and reels if required.

Another reason for the Dubliners' longevity was their personalities. They were all great storytellers, and apart from the occasional flare-ups common to all bands, they had a shared sense of humour. Each, in his own way, put that humour to the test from time to time, but it was the glue that bound them. I relish a story Ronnie once told me when I met him at the top of Grafton Street on a sunny morning: 'Good morning, Mr Whelan,' said Ronnie, looking spruced and spry, beard perfectly sculpted and double-breasted pinstripe freshly pressed.

'Good morning, Mr Drew,' said I, joining in the formal approach.

'I suppose you're goin' off playin' the piano somewhere?'

'No such luck,' says I, 'a bit early for that kind of carry-on.'

'C'mere 'til I tell ye,' says he, drawing me close, 'I was just down there in Weir's to collect a watch Deirdre left in for repair. Now, y'know how they are down there – full of themselves – there's auld wans there since the Rising. And what's more, they love *not knowin' ya*,' said Ronnie with relish (he having the best-known face in the country at the time since de Valera and JFK). 'So, up I go to the repair department and wait my turn. There's a little fella up on a ladder cleaning the windows and he gives me a wink, "Howaya!" Your wan is taking her time. "Next," says she eventually. "I'm here to collect a watch," says I' – Ronnie put on a swanky South Dublin accent to mimic the assistant – '"Woz dere a name?" says she, loud as she can, just to show off her not knowin' me. "Hey Ronnie!" the fella up on the ladder shouts. "Tell her it's Matt Talbot."'[3]

The affection felt for the Dubliners across a sixty-year period is extraordinary. As time took its toll, original band members were replaced with such talents as Eamonn Campbell and Seán Cannon, with visits by Jim McCann, Danny Doyle, Patsy Watchorn, Paddy Reilly, Gerry O'Connor and others. The Dubliners became less of a band and more of an idea, a repository of songs and stories that sprung from the political, musical and literary life of urban Dublin. Throughout, John Sheahan remained at the tiller, guiding that idea along the banks of Anna Livia, a peerless craft on the wave of Irish folk and traditional music.

I arranged and produced for a growing number of trad and folk artists, including Johnny McEvoy, Jim McCann, Makem and Clancy, Stockton's Wing, the Wolfe Tones and the Fureys. In 1980 I was approached to produce a group called the Bards. Diarmuid O'Leary was the leader, Ann O'Connor was the singer and Christy Sheridan was the multi-instrumentalist. Diarmuid is a likeable and generous human being. He's tall and gangly with a fringe that continually tumbles into his field of vision, causing him to throw his head back to clear his line of sight. He has a way of greeting that incorporates a flick of the head with

a wink, shoulder shrug and a grin, all of which seems to suggest that rascality mightn't be such a bad idea. He played me a song they were thinking of recording, which began:

> *In the town of Athy one Jeremy Lanigan*
> *Battered away 'til he hadn't a pound.*
> *His father had died and made him a man again*
> *Left him a farm and ten acres of ground.*

Here was a story set up tantalizingly in those first two lines and carrying on a daft narrative that coalesced into this chorus:

> *She stepped out and I stepped in again,*
> *I stepped out and she stepped in again,*
> *She stepped out and I stepped in again,*
> *Learning to dance for Lanigan's Ball.*

I was hooked. We planned to record this as if it were a live performance. We wanted to interpose the verses with flirty dialogue between Diarmuid (the man learning to dance) and 'Julia' (his partner). The record took ages to make, particularly in 1980 when sampling was rare and audience reactions, applause, and laughter had to be painstakingly played in at appropriate places. The floor of Westland Studio was covered in mounds of 1/4 inch tape as Fred Meijer, the engineer, cut and pasted (in those days, literally, with a razor blade and glue) the bits needed into the song performance. It came down to subtle decisions like: 'Would the audience laugh *that* loud at that joke?' or 'Does the applause happen *too* soon after that gag – would a real audience need another two seconds to react?'

The result was a six-minute record where the listener could imagine themselves at a Bards gig. We were rewarded with a hit record which gave the Bards a career boost and stayed on the chart for months. It was an insane project, but I comforted myself with the knowledge that George Martin (aka, the fifth Beatle) spent much of his early production career with Spike Milligan and the Goons.

PART 3: 1970S – LEARNING AND GRIEVING

In the late 70s and early 80s, I believe something changed in how Irish musicians could see their music and its potential to occupy a more prominent place internationally. When I started working in the industry, no artist with an eye to an international career would base their operation in Ireland. Artists like Thin Lizzy, Rory Gallagher, Gary Moore and Van Morrison were exported along with their music. The British record industry saw Ireland as a backwater, peddling recycled country-and-western music to itself. In many ways, they weren't wrong, but I felt we had more to offer; we just had no formal way to offer it. If no one was going to harvest the thriving crop of Irish talent we had better do it ourselves.

In 1977 I went to Córas Tráchtála (the Irish Enterprise Board), suggesting that we recruit some up-and-coming executive from the US and set them up in a New York office as a conduit for Irish music across the Atlantic. It needed to be someone who knew the music scene there, who wasn't afraid to knock on doors, take meetings and create a bridge for what I saw as our major drawback: access.

Córas Tráchtála were interested but only offered the cost of a flight to reconnoitre the New York scene – not enough for what I had in mind. As a result, our conversations fizzled out, and I shelved the idea.

Sometime later, I was working on a project in Westland Studios with the recording engineer Brian Masterson.[4] I had known of Brian's excellent reputation since my earliest recording days, and I admired his attention to detail and pursuit of excellence. He was a great bass player too, whose band, Supply Demand and Curve, had an international following for their psychedelic avant-garde repertoire.[5]

One day, on lunch break, Brian asked if I'd take a walk with him; he had something to show me. We strolled the short distance from Westland Row, passed the disused factories and empty warehouses to the Dublin docks. We stopped at the door of one of the warehouses that littered the area down a grungy street. I was intrigued. Brian opened the door to a courtyard. There were sounds of hammering, drilling and sawing and that great fresh smell of wood shavings and paint – a busy building site. We walked down a hallway, past workers who nodded at Brian from beneath their hard hats, down steps into a tiny foyer and stood outside a thick, soundproofed door with a small window at eye level.

21. THE DUBLINERS, THE BARDS AND WINDMILL LANE

For me, the moment Brian opened that door was as if another wider door was opening for Irish music and all our imaginations. It was a brand-new control room – incredible and as sophisticated, if not more, than any I'd seen. We didn't need to go to New York to peddle our wares; we could make the kind of music we could export with pride right here in Dublin. Not only that, but I also quickly realized, that this was a top-notch facility for international artists to visit and record.

'Where am I, Brian?'

'Windmill Lane Studios,' he smiled. 'A couple of years ago, James Morris, Russ Russell and Meiert Avis invited me to a meeting. They'd wanted to build post-production facilities for the film and television industry. But they also wanted a world-class recording studio, so they asked me to partner that end of the business with them. They raised the money, so I thought, why not?'

Why not indeed. To Brian's many attributes, I now added discretion: we'd been working for months together, and he never mentioned this until today. Next, he invited me to put a session together, test out the studio, and allow him to iron out any wrinkles before Windmill Lane opened for business. I assembled as many recording artistes as possible to ensure the studio got a full test drive.

We had Eamonn Gibney,[6] a rhythm section, backing singers and a full string orchestra and recorded a gospel-style song called 'Let Us Break Bread Together' and a soul-funk cover of Harvey Mason's 'Pack Up Your Bags'. The sound in the studio was so satisfying; as a work environment, there was nothing like it in Ireland.

I can't overstress the importance of having a world-class studio in Dublin. It meant any artist or producer could record in Ireland. And there was another contributing factor: Paul McGuinness. Paul worked with the Windmill partners earlier as a trainee in the film business. When an annexe became available in Windmill Lane, he and Anne-Louise Kelly located the burgeoning U2 operation there. The band were starting to ignite,[7] and Paul had done a record deal with Chris Blackwell at Island Records. They recorded in Windmill Lane for their albums.

Windmill Lane soon became the vibrant location for whatever was stirring in the musical, film and advertising business. The Irish record

industry that had previously supplied a narrow local market started changing. Now we were keeping the people while exporting their music. Added to this was the tax incentive introduced to creative artists based in Ireland; however, to put too much weight on this incentive would be to ignore the seismic shift happening to the self-image among the music community in Dublin. U2 and Windmill Lane were essential to that tidal shift. The growing confidence was infectious.

Soon international artists like Stevie Winwood, Kate Bush, UB40 and Elvis Costello came to Dublin to record. The global reputation of U2 led to Windmill Lane becoming a tourist destination for the band's fans worldwide. They covered the exterior walls of the studio with adoring graffiti, and for years a congregation of young U2 devotees gathered at the gate like pilgrims at a shrine.

PART 4

1980s – Hints and Explorations

So walk on air against your better judgment
Establishing yourself somewhere in between
Those solid batches mixed with grey cement
And a tune called 'The Gravel Walks' that conjures green
 – Seamus Heaney, 'The Gravel Walks'

22. What's Another Year

I was in Madigan's[1] in Donnybrook at lunch when my friend Shay Healy dropped by. Madigan's was the local for RTÉ workers. During the three bank strikes of 1966–77, it became an unofficial cash dispenser for RTÉ employees. The pub cashed cheques for regular patrons, and it held an enormous amount of signed paper money until the strikes were over and the value could be realized; as a result, there was hardly an hour of the day when producers, actors, musicians, camera operators, journalists and directors didn't pop in for coffee or something more potent as the need demanded. Madigan's was a club without formal membership whose loyal adherents would always remember how well they were looked after when those bank doors were shut.

'Ah, Whaylen, the very man!' – Shay addressed me as 'Whaylen', which is also how Americans, and many Limerick folks, pronounced Whelan – 'Guessed you'd be here. Come over for a minute; I want to talk to you about something.'

We moved to a quiet table, and he produced a cassette.

'I'm after getting my song into the National Song Contest final. It's a ballad I wrote for me da. I'm gonna ask Johnny Logan to sing it. It

would be great if you did the arrangement. If we make it to Europe, I'd love you to produce the record. Have a listen to it tonight. Jim O'Neill sang on the demo. I'd like you to throw a bit of Whaylen dust on it.'

I was happy for Shay. You'd have to walk miles to find anyone to say anything but the most positive things about Shay. He was real mensch; he could be relied upon to empathize with you if you were down and be happy with you if you were up. And he had integrity; for example, in 2008, when Ronnie Drew died, there was a wake at the Drew family home in Greystones. I met Shay on my way in. We threaded through the crowd, and Shay led me to the room where Ronnie was laid out looking very much like the spry gentleman I met after that encounter in Weir's some years earlier. He was wearing one of his tailored suits and looked better in death than some of the mourners. I couldn't help but smile seeing him there, calm and rested, his distinguished face evoking memories.

'Here, let me show you something,' Shay whispered. He reached into the coffin and turned back the cuff on Ronnie's shirtsleeve. Nestled in the fold was a half-crown coin.

'What's that?' I asked.

'When Dymphna and I got married, Ronnie gave us this half-crown. I'm just giving it back to him.'

I knew how tenacious Shay was about his music since our Danny Doyle recordings and RTÉ cross-over projects. Without exception, I have never known anyone to strive as hard as him. Undeterred by obstacles, he began each day with fresh optimism, no matter how the previous day went. Even in later years when he developed Parkinson's, which he bore bravely, he continued sending demos to artists at home and abroad, appearing on one-man shows and writing scripts and stories. In addition, he wrote a touching song called 'Stardust' for Dymphna, his beloved wife, who predeceased him during his illness. It's a reassuring song about eternal friendship and, true to Shay form, evokes none of the existential discomfort that death or eternity might otherwise:

22. WHAT'S ANOTHER YEAR

When my life is over
I become a bit of stardust
Out there in the heavens
Out beyond the blue
And if you want to see me
Just look into the night sky
And you will see me twinkling
Shining down on you[2]

The song that Shay entered for the 1980 Eurovision was called 'What's Another Year'.[3] It had an attractive melody, and the plaintive resignation of the lyric was ideal for Johnny Logan; he was a young, good-looking lad, experienced in stage performance, and he had (still has) a great voice. I called Shay and told him it needed an arrangement that opened it out and gave the song some breadth. I suggested a sax intro and a solo in the middle to allow for some dynamic colour in the orchestration.

'Sure, go ahead so and make a bollix of it!' said Shay.

I contacted a young sax player, Colin Tully, who'd been in Dublin with the Scottish band Cado Belle fronted by Maggie Reilly.[4] Colin was perfect for the alto sax solo. We rehearsed in RTÉ, and it came together well.

On the night of the National Song Contest, 1980, Johnny Logan appeared in RTÉ Studio One in a white suit with Colin and three backing singers: Anne Bushnell, Pat Reilly and Rita Madigan. They gave a great performance, and the song won; we were through to the Eurovision.

Next, we recorded the single in Windmill Lane, throwing some 'Whaylen dust' on it as Shay mentioned, so that it was ready for release in case we won Eurovision.

In April, Shay, Johnny and the entourage packed for The Hague to represent Ireland with 'What's Another Year'. It was an exciting event and expectations were high. 'You're coming with us Whaylen, right?' said Shay.

'Can't, Shay, but I'll be there in spirit,' I said.

177

I had declined for two reasons: firstly, I was on a project that was already booked into Windmill Lane the week of the Eurovision final, so my professional attention was needed there; secondly, and more alarmingly, was my mother's health. She'd been finding it hard to swallow the last few months and could not eat properly, so we finally convinced her to go to our Limerick GP, Dr Costelloe, who levelled with us: things were not looking good. He referred her to the noted surgeon Prof. O'Malley at the Mater Private Hospital in Dublin, where she underwent an operation for oesophageal cancer.

After the surgery, I was anxious for an update, but it was hard to pin Prof. O'Malley down. I had the unnerving feeling he was avoiding me. I eventually scurried after him in the hall outside my mother's room: 'Excuse me, Professor, what's the prognosis?'

Without breaking his stride, he muttered something.

'Sorry, I can't hear you,' I said.

He was turning the corner and already bustling down the next corridor, so I pursued him, 'Professor,' I pleaded, 'can you give me an idea of how my mother is doing?'

He paused and looked straight ahead as if speaking to no one: 'Not good at all.'

And he was gone.

I stood transfixed and then inched back towards her room, trying to grapple with this information. I was met by Sister Mary Mercy, the saintly, caring nun who was the boss of the ward. She knew from my face that I had been given the news, and she had a good grasp of the Professor's social skills: 'Ah Bill,' she whispered, taking my arm, 'God is good. And sure, we'll make her as comfortable as we can. Now come on, and we'll have a yarn with herself. Keep the old spirits up.'

This was one of many examples of caring I witnessed during my mothers's hospitalization. My aunt Annie Lawlor got on the Limerick–Dublin train almost every weekday over the coming months (Charlie Haughey introduced free travel back in 1967). Arriving at Heuston, she got the bus to the Mater Hospital and chatted to my mother, giving her all the news from Limerick and reminiscing about old times. Day

22. WHAT'S ANOTHER YEAR

after day she boarded that train until Mum started drifting off into long periods of morphine sleep.

My memories are vivid of that time: seeing her gradually lose her vitality day by day, the stress of balancing a very busy time in work, but ultimately, I was facing the realisation: we were losing her and thus began the final inexorable move away from the shop, 18 Barrington Street, Limerick, and everything that defined my early life.

On the night of the Eurovision, I was busy in Windmill with Dónal Lunny and Andy Irvine, but we had asked the assistant engineer to keep an eye on the voting on the TV in the green room and to call us if things were looking good.

He appeared wide-eyed at the door of the control room: 'Lads, you'd better get out here; it looks like we're winning!'

We piled into the green room and breathlessly watched the last stage of the voting. There were ten points between Ireland and Germany, with Ireland leading as we headed for the last country's vote. Belgium gave Germany a measly seven points and the top prize of douze points to Ireland. The ball was in the net.

Three phone calls to Windmill Lane followed within minutes of the Eurovision being over. The first was from the night nurse in the Mater. My mother watched the contest on TV and asked the nurse to ring the studio and send her love and congratulations. The second was from The Hague. Despite all the excitement and media hubbub immediately after the contest, Shay had made his way to a phone (no mobiles those days): 'We did it, Whaylen. I'll be home tomorrow, and we'll give it a right lash.'

Which we did.

The third phone call was from Brian Masterson, who was the recording engineer on 'What's Another Year': 'Are ye all still there?' he asked, 'I'm on my way with champagne.'

Brian arrived fifteen minutes later with a bottle of bubbly. In our enthusiasm to pop the cork, we split the top off it.

'Not to worry,' said Brian, 'we'll get a corkscrew from the kitchen.'

PART 4: 1980S – HINTS AND EXPLORATIONS

A search revealed that Windmill's state-of-the-art technology did not stretch to a corkscrew. We were losing the will to celebrate when Brian ran into the maintenance room and returned with a Black and Decker drill. The Hague was alive with balloons and streamers, while in Dublin, we stood around with our plastic cups from the water cooler watching Brian Masterson drill down into a bottle of champagne. This was how we toasted Shay and Johnny. A memory to be cherished.

The day after Eurovision, the winning delegation arrived at Dublin Airport to hysterical scenes. It was almost like the Beatles days. I was in the studio so I couldn't be at the airport. However, Shay Healy did something I will never forget. After all the fuss at the airport, he asked his driver to pull into the Mater Hospital. Taking a snipe of champagne with him, he went to my mother's room. The frisson of excitement shook the ward as the same guy who had just won the Eurovision now appeared, and to the open-mouthed astonishment of the nursing staff, he popped the bottle and said: 'Well, Mrs W., I don't see why you should be left out of the celebrations.'

'What's Another Year' went straight into the UK Top 20 at No. 15. This was the first record I produced with a British chart entry. The excitement was huge, as much in the Whelan household as anywhere. But even the sweetest apple has bitter pips. When the record came out, the producer credit read 'Produced by Bill Whelan and Dave Pennefather'. Now, of course, I knew who Dave Pennefather was – he was the company executive responsible for releasing the record. But I also knew that he had no role in the production of the record – except perhaps the label design. Here was my first British chart entry, and I had acquired a second producer? When I got home that evening, I was in such a state I slammed my jacket down on the dining-room table so hard that it left the mark of two coins – permanent reminders to Denise and me of my state of mind.

There followed a ten-day period of argument and negotiation, during which another bitter pip appeared in the apple. O.J. Kilkenny (Ossie as he is known) materialized out of nowhere as an accountant

22. WHAT'S ANOTHER YEAR

representing the record company. He argued that my input to the success of the record was a figment of my imagination; therefore, I would not be receiving any producer percentage. Being a relative greenhorn at the time, I lost the argument on the basis that I did not have an agreement *in writing* before I did the job. I had no money to pursue the matter further. However, I did manage to offload my less than welcome 'producer partner' Dave Pennefather: when the record made it to No. 1 in the UK, I had the relief of finding myself pleasantly alone as the producer credit.

As a result of the success of 'What's Another Year', Muff Winwood[5] at CBS, London, offered me a job producing some tracks for Sutherland Brothers & Quiver. I knew of Iain and Gavin Sutherland from their massive hit in 1972, 'Sailing' (also covered by Rod Stewart). I went to London and Stoke-on-Trent several times to meet them ahead of the recording, calling into the CBS offices in Soho to meet Nicky Graham while I was there. Nicky was one of the Artists and Repertoire (A&R) team at Epic/CBS with responsibility for Johnny Logan's UK and international career. This visit was around the time of the fuss with Dave Pennefather.[6]

'Yay, Bill. How'ya doin' mate?' Nicky greeted me warmly, grasping my hand. 'Great things happening with Johnny's record internationally. Congrats, man. Big in Germany and all kinds of unexpected places.' He motioned for me to take a seat and ordered two coffees. 'Oh, and listen, well done in Dublin with old Dave! That was a fast one he tried to pull. I see you got his name in the right place on the record now – like, nowhere!' he laughed.

The phone rang. It was Nicky's boss. 'Yeah, I'm with Bill Whelan' – he hands over the speaker – 'Muff says hi. Okay, I'll come in now for a minute.' He stood up. 'Sorry, Bill, that's Muff. Have your coffee; I'll be back in five – here,' – pointing to the shelves heaving with LPs and singles – 'have a look through these, anything you're interested in, just stick 'em in this bag!' He handed me a CBS bag and, miming five minutes with his palm, was out the door.

PART 4: 1980S – HINTS AND EXPLORATIONS

I leafed through the LPs and found a few I wanted, which I bagged, and was about to sit down with my coffee when the familiar Epic label on a bunch of singles caught my eye. I was riffling along the shelf when with astonishment, I read this on a '45 German Epic Records label:

'Was ist schon ein Jahr'
('What's Another Year')
Shay Healy
Johnny Logan
Produced by: Nicky Graham und Bill Whelan.

I was reeling from this when Nicky came back into the office. I turned to him, holding out the single with the label facing him and said, 'What's this, Nicky?'

He looked at the label, took a slight breath and without a hint of a blush, said, 'Bleedin' printers! I *knew* they would make a mess of this,' and leaning out the office door, he barked at his secretary, 'Get me those fucking printers on the phone. Bill, I'm sorry, mate. I'll make this up to you.'

Yeah, I think I'd had enough of Nicky's making things up.

I've no memory of how this meeting ended but suffice it to say that my UCD King's Inns education in law was missing around this time. In the enthusiasm to get the record made and catch the wave building around Eurovision, I had overlooked the importance of getting my own business in order. I was suffering from the consequences of trusting that everybody else would behave in a principled way – a lesson hard-learned; and useful for when the stakes were higher years later.

It is remarkable to reflect on what has happened to Ireland's participation in Eurovision over the years. As an arranger and producer, I was involved in several of Ireland's entries: 'It's Nice to Be in Love Again' (1977), 'What's Another Year' (1980), 'Terminal 3' (1984), 'Hold Me Now' (1987) and Eimear Quinn recorded the original vocal of 'The Voice' (1996) in my cramped attic studio in Ranelagh. Since then, Ireland disappeared in the ratings, even though we tried to fit the emerging

shape and fashion of the contest. Increasingly it relied on gimmickry, and it ceased to be about the song. When Tom McGrath was the RTÉ producer of the National Song Contest, the songs were chosen first; then, the singers were found to sing them. The craft supporting the song, the arrangement and the structure, was given close attention; the visual presentation was attended to later. It was no accident that our success depended on the accomplished practitioners of popular song-writing, on people like Shay Healy, Jimmy Walsh, Liam Reilly, the Swarbriggs, Brendan Graham and Johnny Logan (who both won it twice). Since 2005, Ireland has failed to qualify eight times. In 2008 the nation cringed at the spectacle of Dustin the Turkey showing that even if we could no longer produce great songs, we could be dismissively ironic about the whole affair by 'doing something foul with fowl' as someone described it.

23. Irene Departs

In Doireann Ní Ghríofa's highly individual *A Ghost in the Throat*, she refers to being snared by the lyrics of U2's 'With or Without You', having fallen victim to the earworm quality of the repeated phrase 'and you give yourself away'. When I picture my mother, I can't think of a phrase that would more accurately describe her life. From her early adulthood, her whole existence was marked by giving to the extent I often wondered how much of her own 'self' she had left. I never doubted for a moment her devotion to my father and me, but the intensity of that scrutiny could stifle. This was particularly true in my teenage years. What in childhood had been a caring, protective shield became more like a distrustful vigilance as I stress-tested the boundaries drawn around the muddled map of adolescence.

After my father died in 1972, she continued to manage the shop with the support of a few great women, and she cared for my father's remaining sister, Celia, who became invalided and eventually went into a home. We visited Limerick as often as possible and took her to Edinburgh for a weekend. I think this was the only time she was out of Ireland. She had no hobby of her own, and as I became increasingly engaged in my career, I knew she was lonely.

23. IRENE DEPARTS

This is why it was both a revelation and a relief to see her relax and take pleasure from life when our children were born. She doted on them. When David arrived in 1976, she virtually kidnapped him. At one point, she encouraged Denise and me to take a holiday on the Continent with friends. We took off for two weeks while David (a toddler by then) spent a glorious fortnight with his granny in her shop, where there was an endless supply of comics and as much chocolate a little fella could consume. She also bought him an entirely new wardrobe and got his hair cut. When we came home, Denise hardly recognized her son.

She had less time left to enjoy her twin granddaughters, Nessa and Fiona, who arrived in January 1979, but when she had time with them, she indulged them with the same generous enthusiasm as she did David. She perked up when they were around, although clearly, she was slowing down, losing weight and energy. I visited her daily in hospital and brought the kids, which gave her a great lift. In the last few weeks of her life, I walked the hospital corridors with her on my arm; she had become a small creature. The woman who had chased me around the kitchen with a wooden spoon was far away.

'Billy,' she said, 'let's walk up to the chapel and say a prayer.'

We shuffled to the oratory on her floor and sat silently in the last pew. A long time passed as she softly mouthed some prayers with her eyes closed. After a while, she was still. Then she turned, opened her eyes, and, looking straight at me, whispered, 'I loved you, didn't I?'

The chapel spun around me. I had to take a breath. 'Of course, you did, Ma. C'mon, we'll go back and catch the RTÉ news.'

The news was full of the growing chaos in Tehran with Ayatollah Khomeini and his massed followers. Then there was an item about Shay Healy and Johnny Logan and the big win in The Hague. She looked over at me: 'You're on your way now, boy,' she said, 'you're going to go tops.'

By May 1980 she had weakened considerably and was hardly eating. We sat with her, but conversation was now sparse. Then, one day she awoke and beckoned me to draw close to her. 'There are men outside

with guns,' she looked over at the window with a terrified expression on her face. 'Stay away from politics, won't you, love?'

Morphine brought old fears to the surface; her anxiety about my father's involvement as a volunteer in the Fianna Éireann was as raw as the day she was married. It gave me a visceral insight into what life might have been like for her or that generation. Her keenness to sell my father's antique firearms following his death made more sense to me now.

For the last few nights, I slept fitfully in the armchair in her room. She was peaceful, only to wake occasionally and ask for water. In the daytime, when the hospital bustle and routine took over, I'd go home, take a shower and head for the studio. After a few days like this, I got a call. It was the nurse: 'You should come in, Bill, she's very close to leaving us.'

I tore into the Mater to find Sister Mary Mercy sitting with her. Her breathing was shallow. 'She's had the priest,' Sister Mercy said, 'and she's very peaceful.'

Within an hour, the gaps between each breath grew longer. She did not, as Dylan Thomas said, rage against the dying of the light but went gently into that good night and, after a life of giving herself away, Irene Whelan, *née* Lawlor, drew her last breath and was gone.

24. The Winds of Change, the 'Galways' and Planxty

In the early years, my experience was that very few of us took proper care of the business end of our careers. Musicians are, for the most part, passionate about the music but are inclined to let the terms and conditions part slide in their enthusiasm for the work at hand. Much has happened to the conduct of the business with the concept of 'free' music via the Internet. Still, the principle endures: musicians must be paid for their performances, and composers should be recompensed for the use of their copyrights.

A regular topic amongst the music community in Ireland related to royalties from performances on radio, TV and live venues. There was an unease about how this was handled and an instinct that monies were not being collected or distributed to their rightful beneficiaries. The problem was partly because the administration and collection of royalties in Ireland was the responsibility of the Performing Rights Society (PRS). This was a London-based operation that regarded the Irish royalty collection as if it were one of the remote home counties. For this reason, in the late 1970s, a few of us formed an association of songwriters and

composers to lobby for our interests. The earliest meetings took place at Waterloo Road with John D'Ardis, Brendan Graham, Shaun Davey, Ken Stewart, Pete St John and others. The result was the formation of the Irish Association of Songwriters and Composers (IASC).[1]

The purpose of IASC was to engage with both the Dublin and London offices of the PRS to monitor and promote the interests of Irish songwriters. Over the following years, and in tandem with the Republic of Ireland Music Publishers Association (RIMPA), we formed the Irish Music Rights Organisation (IMRO).

IMRO was a bona fide independent company, thus enabling it to gain representation on the board of PRS. Eventually, under the stewardship of our CEO, Hugh Duffy[2] and the dynamic chairmanship of Brendan Graham, independence for IMRO was mooted. After two years of negotiation, the PRS departed from IMRO, leaving the Irish company as the sole administrator of music copyrights in Ireland. It's worth noting that before IMRO took over the administration, the entire value of annual copyright collection in Ireland was approximately GBP£2.5 million. When Hugh Duffy retired in 1999 as CEO of IMRO, that figure had risen to €22.1 million, and by 2019 it stood at €37 million.

The PRS did not cede control of Irish copyrights easily. At one board meeting, their CEO, Michael Freegard, characterized the likelihood of Irish independence as a fantasy. Freegard was one of those well-spoken Englishmen, tall with a very polite manner and an adenoidal overtone when he spoke. This created a curious impression of arch superciliousness – as if he were compelled to hold his nose in the present company. When making a particularly important point, he would join his hands together – posing first like someone at prayer and then aiming them forward like someone diving into a pool, 'The notion of independence for IMRO,' he once said, 'is receding somewhat into the future.' And later, when that independence refused to recede, by virtue of a deft appeal to the Competition Authority initiated by Hugh Duffy, Freegard was forced to admit that independence seemed to now have a 'green light but tinged with amber'. So it was with a certain regret we let Michael and his cohorts go. The meetings may not always have been cordial, but the

24. THE WINDS OF CHANGE, THE 'GALWAYS' AND PLANXTY

socializing around them was. The net gain was an independent collection agency where we could at last look after our own affairs.

I was working in Trend Studios when John D'Ardis stopped me on the stairs and asked if I'd be interested in producing a record for an English major who was at that moment sitting in his office. 'John, you're having me on – an English army man wants to make a record?'

'Well,' John wasn't telling me everything, 'not exactly, you see, he writes these, em, *Galways* and wants somebody to put them to music and record them.'

'John, what's a Galway?'

'I'm not quite sure. Why don't you ask him?'

John's office in Lad Lane wasn't constructed with men like Major James Willson in mind. The man was enormous. When John and I entered, he rose from his seat and immediately connected with the overhead fluorescent light while sending a display rack of cassettes tumbling to the floor. With the three of us in that room, all movement had to be meticulously choreographed, considering the major's bulk and displacement.

'Ah, you must be Whelan. Major James Willson – with two ll's.'

My fingers crunched in the vice grip of his fist, and he spoke at a level typically reserved for people much further away. We shuffled around for an awkward minute and finally sat down. The major was magnificently turned out in a double-breasted pinstripe suit with a pair of brogues glossed and gleaming; he was all cuff-linked, red-hankeyed and tie-pinned.

'John was telling me you might be the man to turn my Galways into music.'

'What is a Galway?' I asked.

'Well, you've heard of a Limerick?' he said.

I nodded.

'In response to the cheap preponderance of Limericks, and as I live in a beautiful county, I have invented the Galway,' he announced this with implied fanfare. 'It is a different verse form. I have composed a

PART 4: 1980S – HINTS AND EXPLORATIONS

plethora of them. But as they are not long poems, I have an idea that they would be wonderful as songs. So I spoke to our friend John here, and he suggested YOU are the very one to make that transition!'

John squirmed in his seat and gave me a sheepish look.

The major then produced a leather-bound volume and, opening it at random, read one of the Galways entitled 'Red Roses for Mary'. His stentorian delivery was at odds with the romantic sentiments of the poem which, it later transpired, he had written for the love of his life – Mary Aliaga Kelly. In fact, most of his Galways were written either for Mary, who we had yet to meet, or for a horse whose name I have forgotten. James Willson was a sweet man who, in his retiring years, was devoting himself to such dreamy and quixotic pursuits as writing paeans to his nearest and dearest – human and equine.

'Do you think you could write melodies for these, Whelan?'

I had to get used to the major calling me by my surname. I suppose he was accustomed to addressing people by their rank 'Lieutenant' or 'Sergeant', and as I didn't have one, he resorted to the surname. 'Bill' would have drawn us closer than our ranks might infer.

A week later, we gathered in the studio with a small ensemble plus a master crooner (Des Smyth) and recorded four Galways. Everyone was happy. Mary Aliaga Kelly brought a handbag of cash for the musicians – always a welcome conclusion to any session. However, when it came to my fee, there was a pause. I was waiting for another springer spaniel, or perhaps a small foal to appear, but the major had a plan: 'Listen, Whelan, I have a proposal. Could we come to an arrangement here of benefit to us both?'

Oh no, I thought, another bartering gig.

'Allow me to explain,' said the major. 'Since I returned from Rhodesia, my cash situation has been rather shaky. Property rich, cash poor, you understand. So, what about I pay you with some cash and the remainder in kind?'

Oh, God. What was the 'kind' going to be?

'Firstly, we will share any royalties the Galways earn.'

Even he could read the level of my excitement at this offer.

24. THE WINDS OF CHANGE, THE 'GALWAYS' AND PLANXTY

'Ah, okay. Well, listen; secondly, I have a lovely eighteenth-century manor house in Craughwell called St Clerans. It is set in a scenic spot with a stream teeming with trout. Why don't you and your family come for a few weeks and enjoy the peace and serenity? You will have your own private three-bedroomed apartment. You can write while you are there, and your kids will have a super time.'

As it happened, Denise and I had just moved house and we were doing renovations to our new home in Ranelagh. If we all got out for a few weeks, it would give the builders a clear run at the work. The second part of the major's plan was suddenly very attractive.

St Clerans (formerly known as Isercleran) is a late-eighteenth-century manor house near Craughwell in County Galway. It stands on the site of a castle that Ulick de Burgh built in 1308.[3] The film director John Huston lived there for nineteen years from 1952. His guests included Arthur Miller, Jean-Paul Sartre and Marlon Brando. Less notably, the Whelans lived there with our son David and twin daughters, Nessa and Fiona, for six weeks in the winter of 1980.

The six weeks were magical. We lived in a spacious apartment on the ground floor with a two-person bath rumoured to have been wallowed in by Marilyn Monroe (though it might just have been her husband, Arthur Miller). I brought my keyboard and settled into a routine, writing for a few hours per day.

The major got up to daft juvenile tricks. David was four, the twins nearly two. One morning they awoke to odd tapping sounds on their window. They saw three bottles of lemonade tied to a string being lowered down from the major's kitchen window overhead. The excitement was intense as they tried to catch the lemonade bobbing up and down like bait on a line.

On one occasion, early in our stay, the phone rang. It was the major: 'Good morning, Whelan! Miserably wet and cold day out there today. Would you care to step up onto the bridge for a minute?'

I understood this meant I was invited to the grand drawing room overlooking the front lawn. When I got there, a roaring log fire crackled

PART 4: 1980S – HINTS AND EXPLORATIONS

in the hearth, and Major James Willson was seated in one of the two massive armchairs that were drawn close to it. A glass full of whiskey sat on the side table for me; the major had already nearly depleted the twenty-year-old Bushmills malt in his hand.

'I thought we'd begin the day with a heart-starter or two and get to know each other better. But first – let's toast the Whelan family's arrival at St Clerans.'

We clinked glasses, and I noticed both tumblers had the lyrics of one of the Galways, 'Red Roses for Mary', hand-cut into the glass. As we sat mesmerized by the fire, the glasses of malt whiskey magically refilled as the major talked about his life: how he lost his son in a tragic canoeing accident; how he was injured in a fall from a horse, which curtailed his agility and affected his cognition; how his life in Rhodesia, now Zimbabwe, changed after Ian Smith declared the Universal Declaration of Independence from the UK in 1965; and how he had to flee during the Rhodesian Bush War taking only what he could carry with him.

I listened to all of this, surrounded by photos of himself walking with Queen Elizabeth, inspecting troops in Africa and leading the Galway Blazers astride a fine-looking horse. Then, finally, the Bushmills did for me, and I had to retreat downstairs and sleep it off in the afternoon.

A few days later, I noticed that the monumental plaque in the entrance hall had the lyrics to his Galway for his beloved horse cut into the stone. Nor were the Galways confined to St Clerans: when we went for oysters at Morans of the Weir in Kilcolgan, we spotted similarly engraved stone plaques there. Being a regular patron, the major had prevailed upon the owners to advance publication of his poetry in granite – he was taking no chances with the immortality of his verse. (I visited Morans recently, and they were still there, signed by the major's whimsical nom de plume, 'Noel O'Coward'.)

Finally, it was time to leave. It had been a singular experience, during which I wrote a planxty: 'Isercleran'. A planxty (*pleancstaí*) is a musical composition written to praise a person or place. The great Irish harpist Turlough Ó Carolan (1670–1738) was renowned for his planxties, which

24. THE WINDS OF CHANGE, THE 'GALWAYS' AND PLANXTY

he wrote having stayed at the great house of some chieftain or earl. I felt I should mark our stay at St Clerans by composing a piece in its memory, using its original name. A year later, when Dónal Lunny and I were composing Planxty's 'Timedance', we included 'Isercleran' in the tunes that made up the piece.

We were to head back to Dublin during the petrol strike of October 1980. The whole of Ireland had to cue for hours; some people slept in their cars to make sure they were at the top of the queue in the morning. So I asked the major if he knew where we could get petrol.

'Petrol? No problem! Follow Mary and me.'

We headed off in convoy. Mary's Renault 4 proceeded at a slanting angle as the major's mass unbalanced the suspension; her slight frame was no match for the gravity of her passenger.

We arrived at a small shop with a single pump outside. Our hopes were dashed. Not only did the shop have CLOSED notices on the door and window, but there was a large sign on the pump that said NO PETROL.

The major dismounted the Renault 4, strode up to the door and banged loudly on it. At that moment, I had a vivid image of him in full army uniform, pounding on some trembling Rhodesian's door.

'Paddy!' he bellowed, whacking the window till it seemed about to break. There was not a stir in the shop, but the major was not to be deterred: 'PADDY,' he thundered, 'get up, Paddy. I can see you. Come on, man. GET UP.'

A red face appeared from behind the counter like someone peeping over the top of a wartime trench. The figure rose slowly and gingerly, with the expression of a schoolboy caught smoking in the bicycle shed.

'Ah! Good man! There you are now.' It was as if the major knew where Paddy was all the time, and Paddy was only discovering it himself now with the major's help. 'Now, Paddy, these good people are going back to Dublin today, so their cars will need full tanks, and while you are at it, you can top up Mary's as well.'

'Ah jeez, Major Willson,' says Paddy, 'we're low enough on th'oul juice here. If anyone sees me, they'll be looking for a fill-up too.'

PART 4: 1980s – HINTS AND EXPLORATIONS

'And if that happens, I'll deal with them,' said the major. 'Now be good enough to get on with it, please. There's a good man.'

I never knew if Paddy was his name or if it was a generic name the major used. But, anyway, he got down to the task, though, by the look on his face, there were moments when, if he could have laid his hand on a pike or a shillelagh, he would have ended the whole business there and then.

We left St Clerans, looking back on yet another flickering image of the ineluctable fade of the British empire that continues to this day. Major James Willson and Mary Aliaga Kelly were extraordinary people in their twilight years, anachronistically occupying a property that no longer functioned in twentieth-century Ireland with the same confident purpose as when it was built in the late eighteenth century. I thought back to my bartering bargain with the major in Trend Studios and reckoned that I got the better part of the deal.

In 1980 Ian McGarry, a senior director at RTÉ, asked me to be the musical director for a weekly TV series called *My Ireland*. Ian had previously directed a series I was in called *Me and My Music* (1975) that gave TV exposure to six young songwriters, each getting a half-hour slot to present their songs. The series included Chris de Burgh, Adrienne Johnson,[4] Fran O'Toole[5] and me.

My Ireland was to feature artists like Red Hurley, Sandie Jones, Jim McCann, Johnny McEvoy and Tony Kenny, and it would include many folk songs. I asked Dónal Lunny and Andy Irvine from Planxty to play bouzouki and mandolin on the series. This was the first time we worked closely together, and the experience inspired me. It gave me pause to reflect on my place in the traditional music scene. I felt a strong kinship with Dónal and Andy, but the task of discovering an access point and feeling at home in their world was daunting. I didn't play trad music, nor had I come through the acceptable entry channels.

It's difficult to appreciate how territorial traditional music was in the 80s. Borderlines were rigorously guarded, consciously by watchful custodians or subconsciously as received modalities by the community

24. THE WINDS OF CHANGE, THE 'GALWAYS' AND PLANXTY

itself. Any attempt to sully the bloodline was met with stiff resistance, active derision, or haughty disregard. Since the foundation of the Irish Free State in 1922, we had searched for forms of artistic expression to identify ourselves. De Valera's Ireland stumbled on an incoherent set of cultural norms that made it feel good about itself: the Irish language, a narrow version of music and dance, a safe and unchallenging theatre, a closely monitored literature, all of which we held close to our breasts, shawled and muzzled, lest a crack should appear in our treasured self-image, and we might lose the glory of our recently achieved separateness. We guarded our culture so tightly that we almost crushed it. How many have sat in classrooms from age four to eighteen and emerged barely able to speak Irish? To a multilingual Swede or a Hebrew-speaking Israeli, this must seem farcical. However, in the 1960s, as we slowly rediscovered our true cultural roots, we found them gasping for water under the weight of the institutions of church and state that valued protectionism over innovation.

Today, these ramparts have been tackled, and without all that fearful rigidity, we have a throng of native Irish musicians and dancers freely experimenting with traditional forms. But in the 1980s, a musty air of suspicion hung over any innovation, making me wonder what kind of aesthetic approach I could take given my lack of perceived legitimacy.

As I worked with Dónal and Andy, the solution came naturally. Planxty made me feel I had a role to play. I had played keyboard on some of their recordings, but it wasn't until the Ballisodare Festival in Sligo in 1980 that I played my first live gig with the band.[6] It was an exciting time for me musically. It was also an introduction to being 'on the road'. Most of my work up to now had been in theatre, playing a week or two in each venue, or in my Stacc days making regular appearances in set venues. This was different. We played in a new location every night.

Planxty had a Ford Transit fitted with aircraft seats which all sounds a bit rock 'n' roll. Far from it. We drew lots to travel in Kevin 'Lofty' Flynn's comfy Merc with its air con as opposed to roughing it in the Transit with its icy draughts. Lofty was in a class of his own

when it came to band management. He was, as the name suggests, tall and thin. He was a hipster with a long Afghan coat he wore draped over his shoulders like a cape, the fur high around his curly locks. I don't think I ever saw him with his arms in the sleeves. He'd a gold medallion and chunky ID bracelet and was never without a cigarette, the smoke always curling up in front of his dark glasses, giving him a shady appearance. As a manager, he cared enormously. He adored Planxty. He had your back, no matter what arose on the road. Once, for example, we arrived in Quimper, Brittany, in a fierce storm. The gig was in a marquee, and we stood looking at the rain running down the tent. But Lofty was focused on something else. Above the stage, a torrent coursed along the lighting cables onto a canopy and down the tent poles forming pools on the ground.

'Hey,' said Lofty to a stagehand splashing through the backstage area, 'can you get the promoter out here, please?'

A small Breton guy appeared.

'Now listen,' said our hero, 'if you think I'm letting my band get fried by a couple of hundred volts running through the mic stands, you have another think coming.' Turning to us, Lofty announced, 'Lads, ye have the night off. Go to the hotel. I'll look after this man here.'

Which he did. He got paid, and we lived to tell the tale.

We had a great team. Norman Verso drove and did the sound mix with Matt Keleghan and Jimmy Hickey. One night, playing the Ulster Hall in Belfast during the Troubles, I decided to take my car up from Dublin and found a good parking spot across from the venue. After the gig, I came out to put my gear in the boot, and two guys were letting the air out of my tyres. 'Hey,' I shouted, 'what the hell are you doing?'

They looked at me as if I was a complete fool: 'Southern reg,' they nodded to my number plate. I was deciding how to engage with these two Northern patriots when Norman and Jimmy ran over brandishing microphone stands like hurleys with serious intent to put them to a use not advertised in the GAA manual. The Belfast lads were gone in jig time.

24. THE WINDS OF CHANGE, THE 'GALWAYS' AND PLANXTY

Planxty was a unique mix of poetic stories in song and boisterous excitement in dance. We played all the great epic numbers: 'Kellswater'; 'Little Musgrave'; exciting Bulgarian tunes like 'Smeceno Horo'; and the heartbreaking 'Táimse im'Chodhladh' with Liam O'Flynn's uilleann pipes and Dónal Lunny's exquisite harmonic accompaniment, which I loved playing on keyboards. However, tension about the repertoire crept in when Christy Moore introduced songs like Mick Hanly's emotive 'On the Blanket', referring to the H-block hunger strikes in the infamous Long Kesh in Northern Ireland. The detainees, as political prisoners, had rightly refused to wear prison clothes. Feelings ran high – north and south of the border – not helped by Margaret Thatcher's, the UK Prime Minister at the time, myopic and ignorant intransigence.

I think each band member agreed with sentiments expressed in the political songs Christy sang, but there was discomfort about Planxty being a vehicle for bald political polemics. At one concert, Liam, Andy and I took a break while Christy sang a few message-laden songs to a sympathetic Breton audience. I watched the French raise closed fists of solidarity as Christy sang about Sacco and Vanzetti[7] and Bobby Sands.[8] This was always going to be a challenge for Planxty and was partly why the band Moving Hearts was formed. I liked the musical possibilities of Moving Hearts but knew it would be shaped around Christy's political vision. The use of music as a weapon in the armoury of political causes has a mixed history, not always glorious. It has true potency and deserves to be handled with care in incendiary situations – which is where we all were at that time.

On the back of *My Ireland*, Ian McGarry next asked me to write the centrepiece for Ireland's presentation of the Eurovision Song Contest 1981. Since winning in 1980 with 'What's Another Year', we'd inherited the honour (or requirement) to host the next contest. Having won seven times, three in a row, the Eurovision was becoming a weight on RTÉ coffers. Nevertheless, it was a chance for the host country to present something homegrown as a magnet for tourism, so it was important to get it right.

PART 4: 1980s – HINTS AND EXPLORATIONS

The centrepiece is usually the part where viewers go off and make tea (or similar) in preparation for the voting. Countries typically presented a montage of scenic images with accompanying music in their traditional style. I suggested it might be interesting to create something for Planxty to perform. Of course, we weren't daft enough to imagine Planxty had the visual impact of, say, Abba, so we decided to use dancers alongside the music and create something unique.

Over the following weeks, Ian, Dónal and I hatched a plan to make the piece about Ireland's musical journey from early history through to medieval times and onwards into the future. Ian suggested we hire choreographer Eilish McCourtney Baldwin alongside the Dublin City Ballet for the dance part.

We got to work.

We would call it 'Timedance'. The piece began to take shape. Liam suggested 'The Humours of Barrack Street', a piece of solo piping as the opener. I contributed the medieval-esque 'Isercleran' for the middle section, and we closed the set with Dónal's powerful tune 'The Ballymun Regatta'. Paul McAteer, together with John Drummond, made up the rhythm section. Ian had a budget for recording, so I orchestrated and recorded the piece with Brian Masterson in Windmill Lane. Warner Elecktra Atlantic (WEA) offered a deal, and the single was released to coincide with the Eurovision performance. The B-side was Christy Moore's plangent 'Nancy Spain'.

Eilish McCourtney Baldwin's choreography was balletic with shades of contemporary dance, sometimes courtly and flowing and other times edgy with jerky geometric arm and body shapes. It was an odd piece in the context of the rest of Eurovision, and it created a stir when released.

In the Planxty tours that followed, we performed 'Timedance', giving Christy an opportunity to flex his caustic and satiric muscle by introducing it as a piece 'Bill and Dónal wrote for the Eurovision Dressmaking Competition'. Christy liked to put some air between himself and the musical direction 'Timedance' hinted at. Later, he often said that if we'd had Flatley and Butler instead of the Dublin City Ballet, we'd at least all be 'farting through silk'. Yes, we could all have

24. THE WINDS OF CHANGE, THE 'GALWAYS' AND PLANXTY

done with a bit of silk through which to expel gas, but Jean Butler was ten when we did 'Timedance'; still working her way through dance competitions in America while Michael was working at a variety of jobs, including occasionally dancing with the Chieftains. There was a bit of development yet to be made before any of us were ready for what happened when we did all eventually collaborate thirteen years later.

Soon, the structure of Planxty changed. Christy Moore and Dónal Lunny went in one direction, forming Moving Hearts; Andy Irvine, Liam O'Flynn and I went in another – planning a reformed Planxty tour with Mattie Fox as manager. Mattie was a contrast to Lofty. He'd been a showband singer-turned-manager,[9] and was softly spoken imparting a sense of confidentiality. He had a great attitude; when things were not going well on tour, he intoned his calming mantra: 'Don't worry 'bout that,' which became a catchcry among the band.

We were joined by a wonderful group of musicians: James Kelly on fiddle; Arty McGlynn on guitar; and Dolores Keane on vocals, who I first heard singing through speakers in a record shop on Duke Street. I was rooted to the spot – her voice had that kind of effect. It was potentially an exciting group except for one thing: despite what it said on our tour adverts, we weren't Planxty, and we knew it. The music didn't deserve to have a finger pointed at it since our identity was, to be candid, a masquerade.

For the first time in my life as a musician, I suffered from panic attacks. I had to leave the tour for a couple of days but managed to return to play a successful concert at the Dominion in London – one of our last gigs. This time is seen as the end of Planxty, but Planxty ended when Dónal, Christy, Liam and Andy stopped playing together. What Andy called Planxty-too-far should have been called something else entirely – something new that we could've been as proud of as we were about the music.

Nevertheless, these were lifelong friends and collaborators. Following all the fun (and grief) over the next decade, I would go on to produce and arrange solo albums for Andy and his band Patrick Street. In 1992 Davy Spillane and Andy joined forces to create East Wind,

I arranged and produced the record. We gathered Irish and Bulgarian musicians together to play a cocktail of Balkan tunes with a splash of jazz. I spent that summer transcribing the Bulgarian and Macedonian tunes Andy had discovered and then arranging them for a rainbow ensemble.[10] Dissecting these complex pieces and creating accompaniments for them took many solitary hours of painstaking work in my new office in the old Trend Studios building, which I now shared with Donald Taylor Black. Not only was the project stimulating, but the strange and novel time signatures burned their way into my musical imagination and soon became an important influence in the development of my own style.

25. Kate Bush

It had been several years since Brian Masterson opened the doors of Windmill Lane, and the studio had gone from strength to strength, fulfilling its vision as a location for world-renowned artists to work in. One such artist was Kate Bush.

Kate came to Ireland to visit together with her partner, sound engineer and bass player Del Palmer. She had rented a remote cottage near Clonbur in County Galway, inviting Denise and me to spend a weekend with them to discuss Kate's upcoming recording sessions. Here, I became acquainted with her skills as a chef and her unique sense of humour. We took a rowing boat out on Lough Mask to a small, deserted island; we laughed all afternoon and had a magnificent picnic with Kate's vegetarian cooking – a rare cuisine back then.

An advantage of recording in Dublin for international artists like Kate was the rich pool of traditional music performers they could draw from locally; and now there was a state-of-the-art studio to record in. I contributed to three of Kate's albums: *The Dreaming* (1982), *The Hounds of Love* (1985) and *The Sensual World* (1989). Kate Bush is fundamentally serious about her music but is not afraid to have recourse to the safety

valve of her humour when things get a bit stressful and creatively claustrophobic. She is one of the hardest-working and most focused artists I have ever worked with. For example, on one of the earliest sessions on her 1982 album *The Dreaming*, I wrote a tune to underpin Kate's vocal on 'Night of the Swallow'. Liam O'Flynn was to play uilleann pipes, and Seán Keane (of the Chieftains) was to play the fiddle. We rehearsed it before she arrived. Del Palmer set up the mics, and the two men played, Seán sitting bolt upright, taller than everyone, even when seated, and Liam with his customary expression of serene concentration. True to form, they got it perfectly first time.

'Oh my, they play so beautifully together, Bill,' said Kate, 'can we run it down again?'

A perfect performance once more.

'Do you think we could record the pipes first and then the fiddle so that I can mix them separately later?'

'No problem,' I said. I explained what Kate wanted to the lads: 'Maybe we'll start with the pipes?'

'Whatever ye like,' said Seán, putting the fiddle back in the case and heading to the green room, 'I'll hang out there until the quare fella is finished on the pipes.'

What followed was a tutorial on how Kate Bush earned her reputation for attention to detail. She took our master piper, Liam O'Flynn, on a kaleidoscopic journey through the tune, adding a curl here, lengthening a phrase there, until they had crafted a superb performance for Seán to add the fiddle. I made regular trips to the green room to see how this giant oak of a fiddler was surviving. 'Shouldn't be much longer, Seán,' I reassured him.

He was fine, watching TV, content, waiting to be called.

However, as the afternoon wore on, I stuck my head around the door, the TV was off, and Seán was looking pointedly at his watch. I was running out of *shouldn't-be-much-longers* when we did a take of the pipes that satisfied everyone.

Kate hugged Liam and gave him a big thanks.

Seán now took his seat in the studio and put on his cans: 'Can I have a listen to what Liam did first?' he said.

25. KATE BUSH

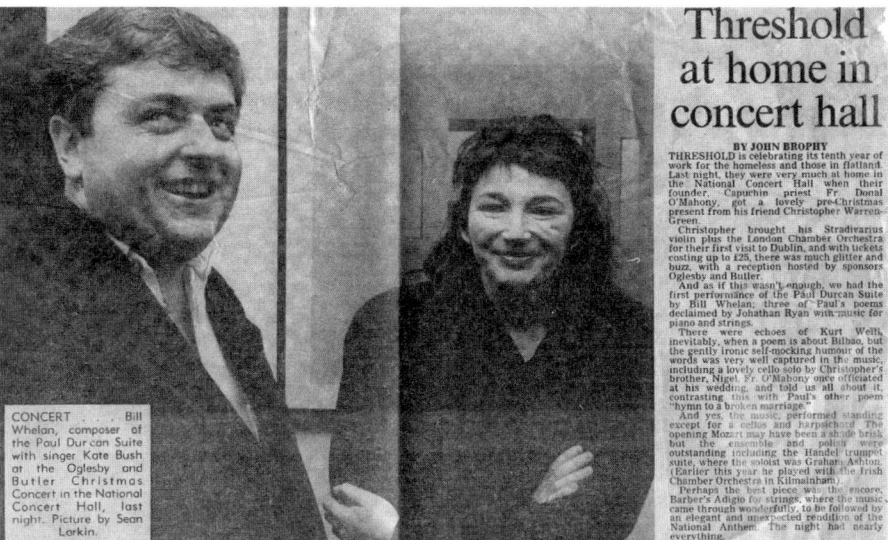

Bill with Kate Bush.

We played Liam's performance. He listened intently.

'Ok, so,' says he, adding rosin to his bow, and off we went.

His performance sat perfectly on Liam's pipes. In two takes, we had a fine fiddle performance. Kate pressed the talk-back button: 'It's perfect, Seán, so beautiful.'

She had a way of saying the word 'beautiful' that gave it more meaning than when anyone else said it. She then turned to me: 'Bill, in the first chorus, do you think we could double-track the fiddle?'

Just as I was about to say yes, the control-room door opened and there, filling the frame, stood the towering figure of Seán Keane wrapped in his overcoat and scarf, fiddle case under his arm. 'Good luck now, Kate,' says he, extending his arm in a farewell handshake. And then, with a grin, 'T'was a great pleasure working with you.'

Kate thanked him warmly, and he was gone.

We all looked at each other, digesting what had just happened. Kate broke the silence, 'Y'know,' she laughed, 'that was refreshing. In London, I'd be listening to some bullshit story about them having to be somewhere else for something important, but Seán just had enough, didn't he?'

PART 4: 1980S – HINTS AND EXPLORATIONS

Later, when Dónal Lunny came in to record the bouzouki, we told him the story: 'Ah yep,' says Dónal, 'that's our Seán!'

Kate had a way of taking tunes, importing them into a track, and crafting an accompaniment that was extraordinary. I wrote a piece for the middle of 'Jig of Life' on *Hounds of Love* with John Sheahan on fiddle and whistle and Liam O'Flynn on pipes. I was thrilled with the percussive accompaniment she added later with Stuart Elliott and Charlie Moran. Her brother, Paddy Bush, was also a fantastic resource for finding unusual instruments and unexpected tunes. He found the piece she stitched into her setting of the Molly Bloom soliloquy from *Ulysses* on the title track for *The Sensual World*, which Kate called her most personal album.

It's worth noting that she deftly navigated the notoriously choppy waters surrounding the James Joyce estate at the time and managed to get permission to use parts of the Joycean text. Davy Spillane and John Sheahan played uilleann pipes and fiddle on the tune. We never knew where the melody came from, other than that Paddy Bush found it and that it was Bulgarian or Macedonian. It wasn't until I was arranging the music for the East Wind album some years later that I discovered it was called 'Antice Djanam Dusice'. Listening to Kate's version of it now, it's extraordinary how skilfully she laced her melody and lyric in 4/4 time around this lovely wandering Eastern tune in 7/8.

26. Van the Man

1984 was the first time Denise and I spent an extended period in Roundstone, Connemara, with our kids. Our youngest, Brian, had now arrived, and we had our final team: two boys and two girls. We rented a cottage on Gurteen Bay, overlooking one of the twin beaches that curve back to back to form a tombolo outside the village. We were blessed with typical spring weather: fresh, sunny days; lambs bleating; growth everywhere, alternating with soft rainy days where the scenery takes a break and the board games appear. For me, an extended time in Roundstone meant a ten-day holiday before returning to Dublin to mix the score for a film called *Lamb*, directed by the English director Colin Gregg. Although set in Ireland, the film was shot in England since the director was uneasy about working in Ireland because of the Troubles.

Lamb was a screen adaptation of Bernard MacLaverty's novel about a boy, Owen Kane (Hugh O'Conor), with epilepsy who is sent to a grim orphanage only to be bullied by the boys and mistreated by the head priest Fr Benedict (played with suitable venom by Ian Bannen). In a misguided fit of altruism, a young priest – the eponymous Fr Michael Lamb (Liam Neeson) – takes Owen away to give him a better life; it ends with tragic results.

PART 4: 1980s – HINTS AND EXPLORATIONS

Maurice Cassidy, promoter, manager and entrepreneur, had approached me about the project the previous autumn. Van Morrison, who was writing the score, was happy to create the instrumental themes, but he did not want to get bogged down with the minutiae of film scoring, which entailed endless consultations with the director and producers. Nor did he want to get embroiled in the technical details around composing for timed sequences of action or dialogue.

Naturally, this is something I was delighted to do.

Maurice's brief was clear: I could contribute additional composed music, if required, for the film, but the only composer credit was for Van Morrison. I accepted this and boarded a plane for Heathrow to meet 'Van the Man' at his London house.

Stories about Van's taciturn manner are legion; he was a man of a few words and had a formidable presence. So it was with apprehension I got a cab to a quiet road in Holland Park. On the way, I decided I'd leave it to Van himself to dictate all conversation. I paid the cabbie and knocked on the door. I heard shuffling inside, and after a lengthy pause, the door opened and there he was. You could feel the energy radiating from his squat Belfast frame.

'Hi, I'm Bill Whelan,' I said, breaking my vow of silence. 'I'm here about *Lamb*?'

If Van said anything, I didn't hear it since he did an about-turn and walked back inside. I interpreted this as an invitation to enter, so I gently closed the door behind me and followed. The front door opened directly into a living area the width of the house. LP sleeves were strewn over floorboards. He gestured to a table, where we took our seats opposite each other.

The blinds were drawn, but two golden shafts of light beamed onto the floorboards like a searchlight over the LP sleeves, stopping short of the table where we sat.

Where we sat …

In silence.

It seemed like it was for years I watched those golden shafts of light move across the floor, observing the dust motes dancing and disappearing

as if in the shadow of a sundial. Then, after several millennia, there was a stirring: 'Wannacoffee?' It was terse, short, four syllables reduced to one.

'Yes, please,' I said. 'Black, no sugar.'

Van went to the kitchen from where I heard clinking and pouring sounds, and he emerged with two mugs of instant coffee. He set one down in front of me. 'Did ye watch this film?'

I nodded.

'What d'ye thinkovid?'

I told him I liked it. Found parts of it very emotional and loved the lead actors' performances.

'Aye,' he stared into his coffee, 'the director, Gregg, says he hears thirty-four sequences where he thinks music needs to be.'

'Hmm,' I said, 'yeah, he spoke to me about them.'

There was a hiatus; the next statement was going to tell a lot.

'I hear three,' said Van flatly with finality and emphasis that only a fool would ignore.

For the second time on *Lamb*, I was given a clear brief. The distance between where Van thought the film needed music and where Colin Gregg imagined music to be would have to be travelled. And I'd be making this journey alone.

'I had an idea for the opening music.' Van jumped up and went upstairs.

I heard the clasps on a case popping open and some tentative rasping notes. Van came downstairs with a sax strapped around his neck; his lips already connected with the reed on the mouthpiece.

'Hold on,' I pleaded. I wasn't expecting this. I thought we were just going to plan how we would work together. I took out my diary and drew five music staves on a spare page. 'Okay,' I said, 'ready.'

He played an achingly plaintive melody that was exactly right for the film's mood. I wrote it down as he played it and asked him to do it again, which he did. Then, for the next hour, he played several musical pieces: 'Here's one for when they run away from the orphanage,' and off he would go, me following along with my biro. When it was all done, he asked what my plans were. I said my return flight was that evening.

PART 4: 1980s – HINTS AND EXPLORATIONS

'D'ye want lunch?' said Van.

We headed to a Greek café in Notting Hill where he was well known. He told stories about his time on the road with the band, Them and of his early career in the US. As I listened, the reputation of a taciturn man of few words evaporated and was replaced by a witty Belfast storyteller. We planned for me to record what he had given me in Holland Park. I mentioned we'd a great sax player, Carl Geraghty, back in Dublin who would do justice to the tunes.

Back in Dublin, I fulfilled the plan and sent the tapes to Van, who was happy with it. The producers were delighted, but the director, Colin Gregg, had additional thoughts. I then spent months crossing the distance between Van's themes and Colin's ideas. At one point, I even brought Enya in to record vocals to Van's score. And then came another obstacle: Colin used some of Brian Eno's music as a temporary score while waiting for Van's to be completed; he'd become afflicted with a condition I had heard of for the first time – 'temp-love'.

Temp-love is where the editor puts temporary music (often anything from the editor's personal collection) over the film while editing. They listen to it so many times that they fall in love with it. When the actual music turns up, the editor and director are still having an affair with the temp-score. It takes psychological skill on the part of the producers to wean the lovesick director off, in our case, Brian Eno. In the end, Van's more appropriate music ended up in its rightful place.

But that wasn't quite the end of it, which brings me back to Roundstone.

We were in the middle of our holiday in Connemara when Judy from the office called: the producers, Neil Zeiger and Martin Proctor, needed me urgently. She tried to discourage them, saying I would be back in a week, but they insisted. I made it to a phone and called Neil, who explained that Colin Gregg had heard some of the rough mixes of the film score and was worried about one of the cues.

'What's he worried about?' I could barely hide my impatience.

'Apparently, the level of the whistle on one of the cues is too loud.' Neil was apologetic.

26. VAN THE MAN

'But listen,' I said, 'I'll be mixing it properly in two weeks. I can fix the whistle then. And even if that's not right, we can bring Davy Spillane back in. We have time.'

'Bill, you know I wouldn't ask this if it wasn't important. Can you get on a flight to London? Bring the tapes with you. We can set up studio time at Olympic, and you can play the track to Colin and show him how the whistle will sound at the end.'

'Neil, I'm in the West of Ireland on my holidays.'

I was going to suggest Colin Gregg come to Dublin, that we could set up the mix there, but then I remembered why the film had been shot in England. Even the Dublin scenes were filmed on the Tottenham Court Road with the red letterboxes painted green.

I arranged to have Philip Begley, who engineered the sessions, pick up the tapes at Windmill. To my family's annoyance, I then left our holiday and, at 2 a.m., drove to Shannon, flew to Dublin on the red-eye flight from the US and met Philip at Dublin Airport, where the two of us boarded a flight to London. Our itinerary had us at Olympic Studios at 10.30 a.m.

We set up the mix. Colin Gregg arrived at noon to hear the cue: 'Morning, Bill,' he said, 'sorry to bring you all this way, but y'know …' he left that hang.

As did I.

Philip played the track with the suggested mix. We looked at Colin, who smiled. 'So much better. I was worried. Thanks for this.'

After some exchanged pleasantries, he was gone.

Philip and I looked at each other. 'Film people!' he sighed.

I was back in Roundstone by midnight.

27. U2, Minor Detail and Dickie Rock

U2's first album, *Boy* (1980), charted within the Top 100 in the UK and US. Their second album, *October* (1981), charted at No. 11 in the UK; the band was gaining momentum. In 1982 they were producing their third studio album, *War*, in Windmill Lane. Although I had not worked with U2, I knew the band socially through Windmill and from the collegiate hothouse of the Dockers pub, a haunt for musicians, producers, advertising executives, filmmakers, editors and, of course, locals. The proprietor, Paddy Dunne, and his staff conducted business on a no-nonsense, non-deferential basis that everyone loved. Famous artists were treated with the same courtesy as regulars, who kept the rhythm of the pub intact despite its growing celebrity. One dock worker, for example, came in for a pint and sandwich at 1 p.m. every day. Once he drained the dregs of his Guinness, he'd slam the glass down on the counter and return to work prompting everyone else to check the time; precisely 2 p.m.

In 1982 U2's manager Paul McGuinness asked if I'd produce a track for their third album, *War*. 'The Refugee' was about finding an alternative home, in this case, in America. Their regular producer, Steve

27. U2, MINOR DETAIL AND DICKIE ROCK

Lillywhite, had to leave the project at short notice. I had no idea how to approach the work since I was now meeting them at a different level than the casual encounters in the Windmill canteen or the Dockers pub. I was daunted but intrigued to be asked, so I set about finding a place for myself in their tight-knit group.

Producers tend to come from either a musical or engineering background. I come from the former, meaning I place more reliance on the engineer to look after the audio. If I bring anything to a project, it's to shape the music and coax the best performance, whether it's from an orchestra or soloist. I like to create a supportive atmosphere so the artist can perform uninhibited in what can be a self-exposing activity. To manifest the spontaneity of a live performance in a clinical studio setting is one of the elusive goals for record producers.

With U2, I landed into a sparking creative hub. The song's shape was happening in real time; the band brought the sense of a live performance to the studio with ease, no coaxing needed. Bono and The Edge would disappear into the green room to work on lyrics, which meant many of the takes were genuinely fresh. There was a hyperreal 'you are HERE' feel to it all.

My work was initially centred on the bass – ironing out some knotty tuning issues – and then on the drums, since that was a significant feature on the track. Larry's drumming belied his reputation as the most elusive and private member of U2; there was nothing shy about his performance. I developed strong regard for his musicality during these sessions.

When I listen back to the song now, I see how relevant the lyrics are forty years later in Trump's America and in Ukraine. But, of course, our people have been refugees throughout history, so it's not surprising that U2 raised their voices to identify with and reach out to those suffering hardships of war and asylum seeking.

Woah, woah
She's the refugee
I see your face

PART 4: 1980S – HINTS AND EXPLORATIONS

> *I see you staring back at me*
> *Woah, woah*
> *She's the refugee*
> *Her mama say one day she's gonna*
> *Live in America*[1]

Reflecting on those U2 sessions makes me think about how much time I spent doing things that I would not do now had I my time over again. The U2 session was brisk, professional and enjoyable. But in those days, we often spent far too much time on the minute details at the expense of the bigger picture. For example, we competed for the best drum sound in the WORLD, spending hours putting microphones in unlikely places: hallways, stairwells and tiled kitchens; stuffing cushions into bass drums; taping gaffer tape onto tom-toms; all in search of the 'El Dorado' of a perfect drum sound – whatever that was. We'd have been better off focusing on the song itself.

Of course, the obsession got worse when digital technology arrived. The entire audio industry headed off into the playroom of digi toys, starting with drum machines and moving on into the magical rabbit hole of sampling and sequencing. These miraculous recording gizmos were great, but it took some time to remind ourselves of who was controlling what. I referred to the affliction of 'temp-love' in the film industry. Well, here was an epidemic of 'tech-love' among studio producers; it took us a while to take back the reins and see those developments as tools, not controllers.

One day while working with U2, the phone in the control room rang, and Caroline from reception said there was a call for me from New York. I assumed it was for U2 and asked which band member they wanted. 'No, Bill,' said Caroline, 'it's for you. It's CBS records in New York.' She transferred the call.

'Hi, is that Bill Whaylen?' the voice on the other end was polite, 'Sorry to disturb you. Your office told us that you were in studio, but we needed to speak with you urgently.'

27. U2, MINOR DETAIL AND DICKIE ROCK

'Is there a problem?'

'Oh no, not at all. We received a demo tape here in the office with four songs on it by an Irish band called Minor Detail.' He pronounced 'detail' in the American way with an emphasis on the 'tail'. 'Everyone here is excited, and your name is the only name on the tape as the producer. So, we wanted to call you and tell you how excited we are and ask if we can talk to anybody representing the band.'

Months previously, Peter Bardon asked me to produce four demos for a band called Minor Detail. Nobody had ever heard of them. They were Dublin brothers, John and Willie Hughes, from a tailoring family in Capel Street; good-looking guys with a knack for writing simple and catchy melodies with an 'earworm' quality that stayed with you after just one or two hearings. John was gifted with a high tenor voice, light in quality, and a capacity to surf on top of any backing track, no matter how dense. Engineers and producers tried to achieve this quality using equalization and compression techniques, but John Hughes had it naturally.

We recorded four rough mixes that Minor Detail sent to record companies, one of which arrived at the A&R department of CBS Records in New York. I was happy to link CBS to Peter Bardon and get back to 'The Refugee'.

A flurry of activity followed between Minor Detail's management and international record companies. The excitement was so great that the band raised money themselves to record the album before doing a record deal. This was highly unusual; but then, the whole project was highly unusual.

I met with Minor Detail and Peter Bardon and agreed to produce the album for a weekly fee and royalty points on the recordings. Philip Begley would be the engineer. Windmill Lane was booked from November 1982, and the first thing the band did was order a Fairlight Series II. This was a state-of-the-art digital sampling keyboard that cost GB£30,000 (equivalent to €120,000 today). I had first seen the Fairlight working with Kate Bush. Peter Gabriel was a big fan of this machine and set up a company to import Fairlights from Australia, where they were

made. Minor Detail had now spent enough money to make three albums before we recorded a note or even knew how to work one of these things.

We also bought a Linn drum machine. This was the first drum machine to use actual drum samples. So now, instead of sticking cushions into bass drums, I had any choice of drum sounds at my fingertips. Again, no expense was spared – this was the level of commitment they had. They believed that a cutting-edge techno-pop album when combined with their songs, would put them at the top of the charts worldwide. If the record company's excitement was any measure of the likelihood of this, they would not be wrong.

That November, we arrived at Windmill to begin the project. John and Willie decided we should start at 7 a.m. daily, work twelve-hour shifts, and have Sunday off. The tape op (assistant engineer – normally a trainee) was to arrive at 6 a.m. His first job was to cook pounds of sausages before the artists arrived. Kevin Killen was the first assistant engineer on these sessions. Today he holds five Grammy Awards for his superb work with, among others, David Bowie, Yo-Yo Ma, Shakira, Allen Toussaint, U2 and Peter Gabriel. These days I like to remind him that none of this would have happened without his having first risen on those cold winter mornings to travel in the frosty dark to Windmill and fire those bulging fingers of pork onto the pan.

It was strange to observe a monastic schedule. Driving through the city each morning, I only encountered milk floats and rubbish collectors. The world passed by Windmill each day, and when we emerged back out into the dark evening, everyone had gone home. We rarely saw sunlight. However, what hummed along in tandem with our dedication was the level of record company interest.

Apart from those demos, nobody had heard their work, and we were careful to let nothing out of the studio. We didn't even take the tapes home to listen to them overnight. As we drew close to completion, the excitement about the album intensified. Peter Bardon allowed A&R executives to visit the studio, where we would play a few rough mixes to them.

For ten days, we were visited by American senior record company executives. One of them, Bruce Lundvall, left New York for London

27. U2, MINOR DETAIL AND DICKIE ROCK

on Concorde in the morning and caught a connecting flight to Dublin. He came to Windmill, met the band, heard the music and was back on Concorde for New York that evening.

The choreography for listening was the same: each executive arrived at Windmill, where they were met by Irene Keogh, Windmill's highly efficient and very charming studio manager, and shown into the green room. The walls were strewn with U2 posters and Irish art. With additional buzz coming from the video part of the building, there was a sense they'd arrived at a cauldron of creativity – which, in those days, they had. Then Peter Bardon would join the visitor, wait until we were ready to invite them in to have a listen. The band kept a discreet distance, and while each executive was welcomed, there was a sense we were impatient to get back to work as soon as this interruption was over.

The reaction to the music was out of the ordinary. Over those ten days, one CBS executive nodded sagely: 'You guys are the next Simon and Garfunkel. We'd be proud to represent you.'

I've never seen responses like it before or since. It was exceptional. It looked like the band's self-confidence was more than justified.

And indeed it was.

Minor Detail signed a plump deal with Polydor Records in New York, one of the first times an Irish artist was ever signed directly to an American record company. They received an advance which recouped what they borrowed with enough left over to make three videos which they did in Windmill Lane. So much had been invested by the record company, a massive promotion was sure to follow, and chart success was assured – we would all just sit back and wait for the royalties to arrive

Which indeed, they didn't.

My mother, Irene, used to say: 'There's many a slip 'twixt the cup and the lip.' I never got to the bottom of what happened to Minor Detail, but the first single, 'Canvas of Life', charted briefly in the US Billboard charts at No. 92 and then disappeared without a trace. There was minimal promotion. There were rumours of something going wrong at Polydor and the band's champion at the record company being fired, leaving them as corporate orphans. This is not an unknown condition

and has happened to other artists; flavour of the month becomes flavour of last month. Somebody's discovery is another's anonymity. To me, it was a reminder that no matter how encouraging a record company is, or any institution for that matter, there is *always* an elusive ingredient, some element of luck, that must accompany all projects to pull them over the line.

The Minor Detail mixes ended in February 1983, leaving me free, if not attuned to twelve-hour days, for more work. Mick Quinn – entrepreneur and artists' manager who looked after a roster of Irish acts, including the inimitable and evergreen Dickie Rock – contacted me about a project.

Dickie's career spans the whole history of the Irish showband business. He had a massive following. Unlike Tom Jones, whose fans threw underwear at him, Dickie's fans invited him to 'spit on me Dickie' in a reversal of the later punk fashion of 'gobbing'. In his 80s now, he still commands strong appearance fees and is as spry as a man half his age. Back then he had a taste for the good life: a Rolls-Royce and some beautiful homes. He wanted a world-class production of a record, no expense spared. 'I want,' said Mick Quinn on behalf of Dickie Rock, 'loads of strings on it, like y'know, big powerful stuff.'

I went to Windmill with a rhythm section, backing singers, and as many strings as the room could accommodate. The sessions went well; Mick loved it, particularly the big string section, which sounded just great, 'despite having cost a bleedin' arm and a leg'. Now he wanted to bring somebody in to lend an extra ear to the track: 'This man is very important,' he said. 'He has hits all over Europe. He'll give us good advice when he hears the record. His name is Roberto Danova.'

Of course. Roberto Danova (real name Giacinto Bettoni) was able to 'make the young girls cry' with the power and emotional strength of his productions. He had a massive track record in Europe, having produced major hits for an array of artists, including Joe Dolan. The atmosphere was tense in the studio prior to Danova's arrival; we all knew that what he thought would carry weight.

27. U2, MINOR DETAIL AND DICKIE ROCK

The door of the control room swung open, and there stood this imposing swarthy Italian in expensive and fashionable threads: 'Ah, Beel!' he greeted me warmly. 'Eet's such a pleasure to meet. I have heard great theengs. Now, you must play me Dickie's track. I will tell you honest thoughts.'

We played the track. Danova stood, arms folded, head bowed, brows furrowed. The song ended, and there was a long pause. Mick Quinn glanced at me and frowned. Danova raised his head and then one finger, 'Again, please.'

The tape op replayed the track. Another long pause. Danova turned to me.

'Beel, this is a heet.' You could feel the room decompress. 'It will be a Top 5 in Germany and Austria, a Top 3 in Belgium and Holland, and …' he curled his mouth downwards and nodded, 'a No. 1 in Italy and Spain. Beel,' Danova put one hand on my shoulder. 'I have one piece of advice for you,' raising that finger again and shaking it, 'this is a very good record. You have done a great job with the orchestration, but now,' and he paused for absolute emphasis, 'you must erase the streengs.'

The entire room was agog.

'Excuse me?' I managed to speak.

'Let me explain. I do this often with Joe Dolan and others in my stable. I get them to sing against a big, beautiful track. I get all the emotion from their performance as they are elevated by the music, then I erase the strings and keep the energy!'

'I see,' I said, keeping an eye on Mick, who would, if I took Danova's advice, be lying at the loss of both arm and leg in exchange for 'energy'.

'You understand, Beel? Keep the energy!'

So saying, Danova hugged me and showering *arrivedercis* and *ciaos* on the room, swept back to wherever he came from, followed by a puzzled Mick Quinn.

Moments later, the door opened. It was Mick: 'Don't touch them fuckin' strings,' he said in a growled whisper.

28. Noel Pearson, the Dublin District Court

In 1981 Noel Pearson wanted to stage a modernized version of Gilbert and Sullivan's *Pirates of Penzance*. Joseph Papp was running it in the Minskoff Theatre in New York and Noel asked me to go to Broadway and observe what could be done with the score for the Dublin version. So, leaving our kids in safe hands with my aunt Peggy in Toronto, Denise and I headed to Broadway.

This was before Rudi Giuliani became a 'hero' by cleaning up New York. Broadway was overrun with pimps, drug dealers, muggers, sex workers and hawkers. The subway was a no-go area, and the atmosphere of menace was pervasive. Denise, who inherited her father's sense of calm and having lived for a few years in Belfast in the 70s, was used to the proximity of danger. I, on the other hand, saw hazards on every street corner and ushered her everywhere at a frantic trot, frustrating her shopper's instinct to pause and peruse.

Even though Arthur Sullivan had higher ambitions for his more 'serious' music and was mildly dismissive of the work he did with W.S. Gilbert, his score is a cornucopia of hit melodies. The young arranger

for this Broadway production, William Elliott, had adapted the original score with humour and respect.

Back in Dublin, we prepared for Pearson's production of *Pirates of Penzance*. Like William Elliott, I stuck closely to the original Sullivan score. And like the Broadway production, I added contemporary instruments and some of my own original music for the dance routines.[1]

On opening night, envelopes were delivered to Noel Pearson, Earl Gill (the musical director), Mavis Ascott (the choreographer) and me. They contained notices of legal action to be taken by William Elliott for breach of what he claimed was a 'grand right' established by him for the New York production. A flurry of legal activity followed. William Elliott's score and mine were subjected to scrutiny by musicologists to establish if I had infringed copyright. This was unlikely for two reasons. Firstly, I never had access to William Elliott's scores, and secondly, I worked exclusively from Sullivan's score. Apart from two pieces of my own compositions, every note was from the original composer's score.

It's worth acknowledging that no modern take on *Pirates of Penzance* would have happened without Joe Papp having first done the Broadway production, but both William Elliott and I drank from the same fruitful cup of Sullivan's score, and if anyone's rights were infringed, it was his. Given that Sullivan died in 1900, his works were in the public domain: copyright free. When the musicologist's report appeared, it was clear there was no breach.

As a sad coda to all this needless stress, William Elliott died in 1985 of cancer at the young age of forty-one, just three years after he contributed to the most celebrated production of a Gilbert and Sullivan musical in history, having done nearly 800 performances on Broadway.

The Pirates of Penzance was so successful that Pearson decided to put on another Gilbert and Sullivan production, *H.M.S. Pinafore,* in Dublin's Gaiety Theatre in 1985. Word on the street about it was so intense that Pearson's office was overcome with applications for auditions. Noel decided to open these to the public, and we spent a few days in the Gaiety with open auditions to be held from lunchtime onwards. The

PART 4: 1980S – HINTS AND EXPLORATIONS

stage manager, Yvette Halley, would greet the prospective performers at the stage door, take their details and usher them onto the stage.

An empty theatre has a spooky gloom about it, particularly when you enter from the brightness outside; your pupils enlarge to accommodate the dark, and slowly you can make out the gothic-like red-velvet curtains and seats, the gold braid and ornate plasterwork. Normally a single glass bulb on a stand in the centre of the stage would serve as a working light, but for the auditions, a few floodlights were set up to illuminate the dazed hopefuls. Airt O'Briain, the director, Earl Gill, the conductor, Noel Pearson and I sat in the stalls as Denis O'Sullivan manned the piano in the pit. All sorts of candidates auditioned. One was particularly memorable. Yvette guided a tall older gent by the elbow to the centre of the stage: 'Mr Ambrose McMenamin,' she announced.

Mr McMenamin carried a briefcase and a paper bag which we assumed to contain a sandwich. He was suited and tied and looked for all the world like an insurance inspector or mid-ranking civil servant.

'Good afternoon,' said Earl Gill from the stalls.

This startled Mr McMenamin; he shaded his eyes with his arm and peered over the footlights to see where the voice was coming from.

'Over here,' said Earl, helpfully.

'Oh, there you are. Sorry, couldn't see you. Thanks for giving me this opportunity.'

'No problem,' said Earl indicating to the orchestra pit. 'This is Denis. Did you bring music?'

'I only heard about the auditions; I haven't brought anything. Denis might know "Here's a Man of Jollity" from the *Yeoman of the Guard?*'

Denis did.

'It's lovely to be here,' Mr McMenamin smiled down at us.

'When you're ready,' said Earl.

Mr McMenamin cleared his throat and engaged in a series of alarming vocal warm-ups and lip buzzes. After many of these, he pronounced himself ready. Denis played the intro.

What emerged from McMenamin's vocal cords was unlike anything we'd heard. Perhaps he was a singer way back, but those days were

28. NOEL PEARSON, THE DUBLIN DISTRICT COURT

long past, and the resemblance of anything to *Yeoman of the Guard* was intermittent and happened by chance. As he opened his mouth to sing the second verse, Earl Gill intervened: 'THANK YOU!'

Denis stopped playing the piano.

'I'm sorry?' McMenamin queried.

'Yes, thank you. That will be fine. Please, leave your contacts with Yvette.'

'That's all you want to hear?'

'Yes, that will be enough to allow us to decide,' said Earl.

But McMenamin was on to us. 'What you mean is you thought I was crap. You hated it.'

Silence from the stalls. Airt O'Briain, Pearson, Earl and I rummaged in our notes.

McMenamin scanned the auditorium, paused to look up at the gods and into the boxes. 'Ah well,' he said resignedly, 'at least I got to sing on this great stage one more time. I sang here in the 40s as a support act to the American pianist and bandleader Charlie Kunz. A great honour. The audience shouting, "We want Charlie! Give us Charlie!" But I didn't mind. At least I got to sing on this stage.'

He took one long last look at the auditorium, picked up his briefcase and sandwich. 'Thank you, gentlemen,' and like the ghost of theatre past, Ambrose McMenamin exited. We all looked at each other. There was nothing to say.

There's a legendary drinking story told about this production, part of which I can confirm. The show was running successfully at the Gaiety, and after its previews and opening, Denise and I took a week-long holiday in Portugal. On the night of our return, I went into the Gaiety to see how things were doing. I arrived backstage just after the second act opened. I was met by the normally unflappable stage manager, Yvette Halley. 'Jesus, Bill,' she was breathless, 'Devlin has walked.'

Alan Devlin was the brilliant, though unreliable, actor who played the Rt. Hon. Sir Joseph Porter, KCB, First Lord of the Admiralty. He was hilarious as the pompous, blustering British naval officer. There

was such knockabout physical comedy in his portrayal that one might suspect he was drunk.

Unfortunately, on this occasion, he was.

Yvette gave me the story: 'Devlin was out of it, he's been scuttered before, we thought he would be okay.'

He had walked onstage for his first big song 'When I Was a Lad'. There's an orchestral introduction to the song, and then what's known as a 'vamp-till-ready' where the orchestra plays an 'oom-cha, oom-cha' round and round until the actor, probably doing some visual comedic stuff, begins the song.

If this goes on too long, the conductor will cue the actor to get on with it. On this fateful night, no amount of cueing from Earl Gill could evoke a response from the befuddled Devlin, who was struggling to remember the words while nervously anticipating his tricky dance routine, which would follow the first verse. A big intake of breath before the first line was followed by an exhalation, like air out of a tyre, as nothing came out of Alan's brain to sing. In the end, he gave up. Mustering all his energy, he faced the audience and bellowed in the character of Sir Joseph: 'Fuck this for a game of soldiers!' and miraculously negotiating the steps at the front of the stage, he disappeared through the crowd via the fire exit theatrically waving his handkerchief. The audience were thrilled, certain this was part of the act, while Yvette struggled offstage with Alan to remove his costume and put it on the understudy, who went onstage to great applause, thus fulfilling the old theatre maxim, 'The show must go on.'

Meanwhile, Yvette furnished Alan with a trench coat to cover his underwear, and he left via the stage door and into the lounge of Neary's Bar. He was obviously in need of a drink after that ordeal.

Which is where I found him, leaning on the counter with the trench coat open to reveal his underpants, a drink in front of him. His exact words were: 'Ah, Bill, me old pal. Back from the holidays? Well, I suppose I'm the worst in the world now?'

'Alan, you're not, but how about heading home and getting a night's sleep? We can talk tomorrow.'

28. NOEL PEARSON, THE DUBLIN DISTRICT COURT

'Give us a fiver, will ya? I'll give it back when I get paid.'

Alan was known for borrowing money but was also well known for paying the lender back. I explained I'd no Irish cash, having just arrived back from Portugal. At that moment, John Curran, who played flute and clarinet in the orchestra, arrived. The show was now over.

'Maestro Curran. Give us a fiver, will ya?' Alan was in full fawning mode.

'Sorry, Alan, I only have enough for this pint, and then I'm off home.'

Then Desi Reynolds arrived in. He was angry, as were many with Alan's behaviour. Drinking was acceptable among performers, but not when it ruins the gig. Alan's face lit up: 'Aha, the great Desi Reynolds! Give us a fiver, will ya?'

'Shag off, Alan,' Desi advised. 'Go home and sleep it off.'

Alan regarded John, Desi and I with a withering contempt. 'Look at you!' he spat before leaving the bar, 'Three miserable Shylocks,' and turning around at the door, his parting shot was, 'and ye owe me fifteen quid between the three of ye.'

The following morning, Alan Devlin, luxuriating in the notoriety of this, still not sober, appeared on national radio interviewed by Mike Murphy. By way of explaining his unscheduled departure from *H.M.S. Pinafore*, he spoke about having an ear infection. It was both hilarious and fundamentally tragic. It wouldn't be long before reports of more binges began to reappear. Alan was spectacularly off the wagon again. He died alone in 2011 after heart surgery following a lifetime of struggling publicly with his demons.

As a footnote to this, *H.M.S. Pinafore* not only ran at the Gaiety but transferred to the Bristol Old Vic and onwards to Melbourne in Australia. For my score, I received a Laurence Olivier Award nomination in 1986. When it transferred to the UK, Joe Dowling was brought in to direct it. After an initial run in Manchester, Noel Pearson brought Alan Devlin back into the show for the transfer to the Old Vic in London. This controversial decision gave the impetus to John Kavanagh, who did not approve of Devlin being re-hired, to leave *H.M.S. Pinafore*. In a lucky

twist, Kavanagh was now free to take the role of Joxer in O'Casey's *Juno and the Paycock* at the Gate which, coincidentally, Joe Dowling was also directing. The inspired teaming up of John Kavanagh with Dónal McCann in Dowling's now-legendary production at the Gate left a memory which those fortunate enough to have seen it will never forget.

Around this time, it was dawning on me that my own alcohol consumption had moved from the realms of recreation to that of self-medication. I began to sit up late, glass in hand, listening to music alone while the house slept, teetering off to bed and into a fitful sleep in the early hours.

One evening I went for a late bite with a friend and colleague. It was a long session with several bottles of wine and the inevitable 'ones' for the road. I had driven to the restaurant earlier, so I had the car and was now contemplating going home. In those days, driving under the influence was prevalent and even socially tolerated. Saying bye to my friend, I got into my car.

Dawson Street had recently been converted into a one-way street, a fact I overlooked, and blithely, I turned right out of South Anne Street and headed to Stephen's Green in the wrong direction. Soon I became aware of a flashing blue light in my peripheral vision. I turned to see the stern face of a garda at my window, which I rolled down, ignorant of the ethanol fumes that must have escaped from the car at that moment.

'Can I see your licence please?' The garda asked.

'I'm afraid I left it at home, Sergeant,' I slurred, promoting the garda in a drunken attempt at flattery.

'Please step outside the vehicle and blow into this bag.'

A breathalyzer? I immediately adopted the position of the outraged drunk whose civil rights were being flagrantly attacked by the mere suggestion that I might be over the limit. I refused to blow into any bag, which by the way, I told him was my legal entitlement.

This resulted in my transfer to the back of his vehicle and my arrival at the guest suite of Pearse Street Garda Station. A bleary-eyed, grumpy doctor arrived and took a blood sample. I spent the rest of the night on a wooden bench in a cold cell.

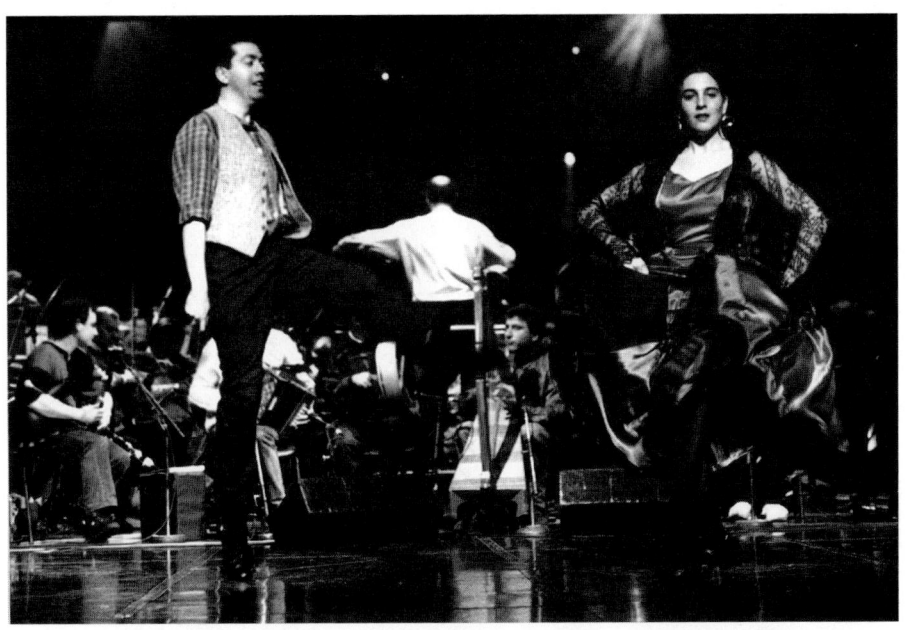

Michael Murphy and Tara Murphy dancing to The Seville Suite *at its first performance, 1992, conducted by Proinnsías Ó Duinn. Davy Spillane is far left.*

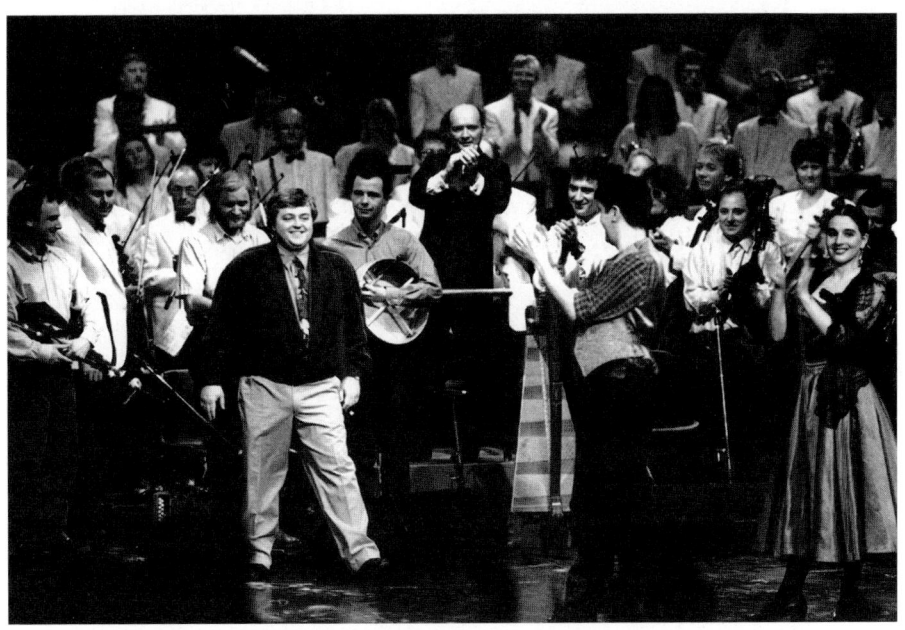

Bill takes encore at the first performance of The Seville Suite, *1992.*

Elmer Bernstein with Denise and Bill.

Bill and President Mary Robinson at The Spirit of Mayo, *1993. (Photo: Frank Fennell.)*

(Left to right) songwriter Ralph Murphy, Brendan Graham (songwriter of the 1994 Eurovision-winning song 'Rock 'n' Roll Kids'), Paul Brady, Shay Healy and Bill Whelan.

Dancers recording the taps at Windmill Lane, 1994.

Michael Flatley drills the troupe at Windmill Lane, 1994.

Taoiseach Albert Reynolds, Michael Flatley, Jean Butler and Bill Whelan.
(Photo: Peter Harding, RTÉ Stills Department.)

Hugh Brady, Bill and Seamus Heaney – UCD Foundation Day.

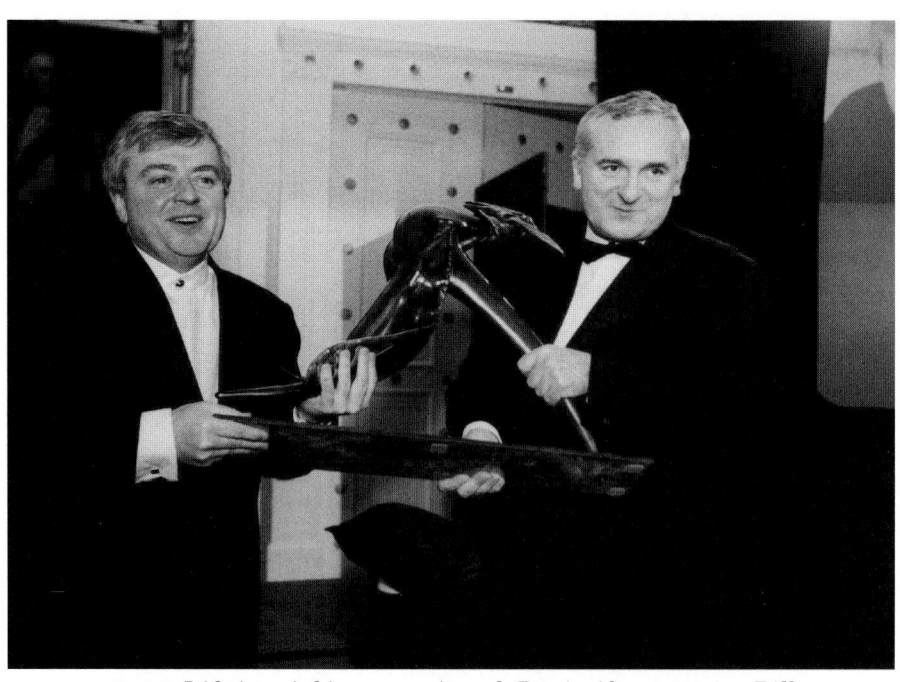

IMRO Lifetime Achievement Award. Bertie Ahern presents Bill with the specially commissioned award by Patrick O'Reilly.

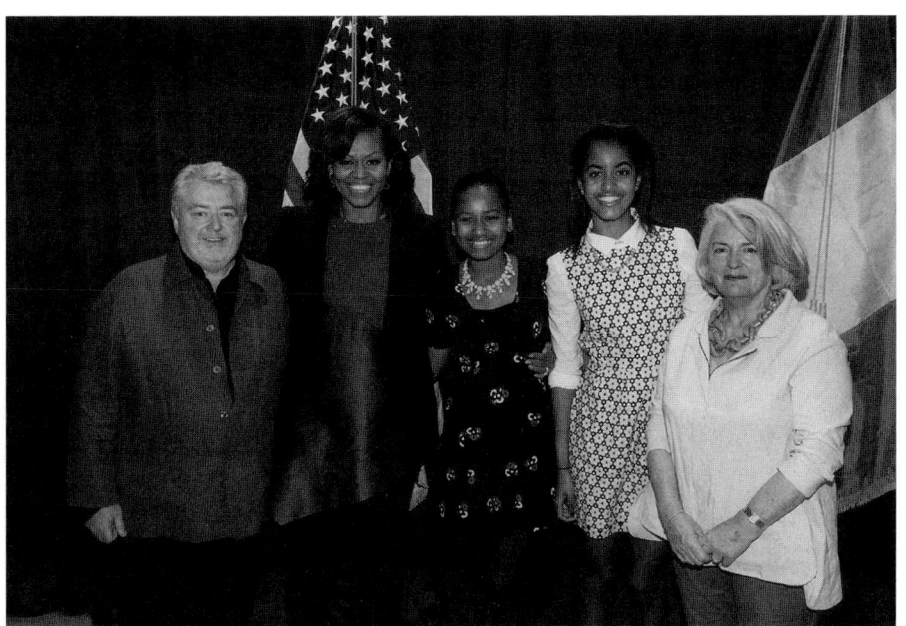

Bill and Denise with former First Lady Michelle Obama and daughters Sasha and Malia.

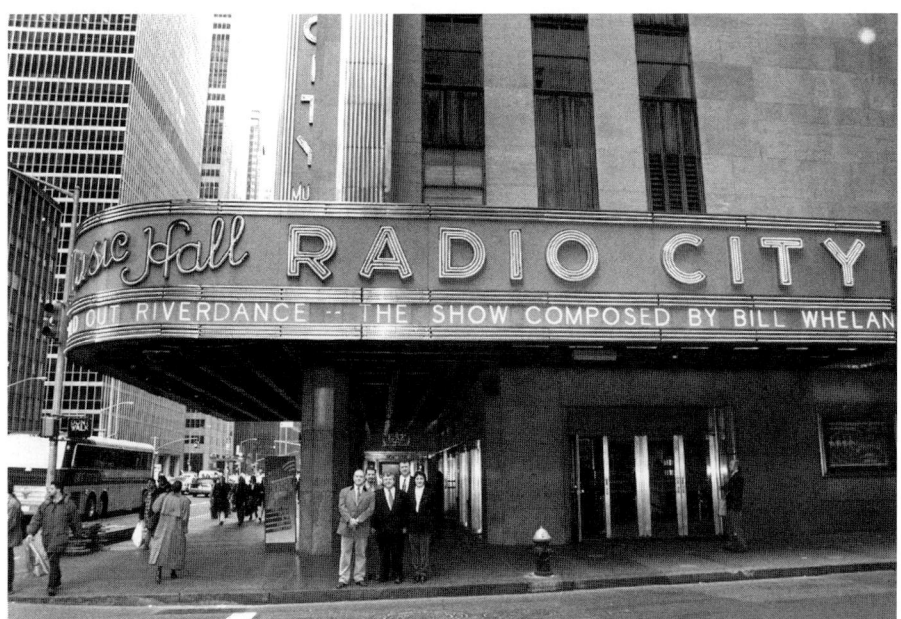

A group shot taken outside Radio City Music Hall, New York, March 1996. (Left to right) Paul McGuinness, Jason Flom, Bill Whelan, Dave Kavanagh and Barbara Galavan.

The Whelan family with Carole King in Kilkee, County Clare.

Bill accompanies Ted Kennedy singing 'You've Got a Friend' at Jean Kennedy Smith's 80th birthday party in NYC, 2008.

Bill with Jimmy Webb in Connemara.

Bill with Quincy Jones.

(Left to right) Gabriel Byrne, Bill and and Liam Neeson at the Spirit of Ireland Awards, 2011.

*Michael Flatley and Bill Whelan at Riverdance video launch, 1995.
(Photo: Thomas Holton, RTÉ Stills Department.)*

*Bill Whelan and Jean Butler, 1994.
(Photo: Peter Harding, RTÉ Stills Department.)*

28. NOEL PEARSON, THE DUBLIN DISTRICT COURT

What followed months later was even more embarrassing: my case came up for hearing in the Dublin District Court in the Spring of 1984. I waited in the courtroom, worrying that I'd be put off the road. Bad enough here, but I had a work trip coming up in the US, and there was no way I could drive there without a licence. I had no idea who the judge would be. I hoped they might be sympathetic to the predicament if I had to go to the US without a driving licence.

'All rise,' said the court clerk.

We stood and waited.

A door opened, and out hurried the district judge. A woman. The eminent Justice Mary Kotsonouris. She was highly regarded on the bench.

And she was also my aunt's sister.

I stared with horror as she took her seat and studied the raft of paperwork before her. In the figure of Mary Kotsonouris, it seemed as if my entire extended family had arrived in the court and were now gazing at me, shocked and disappointed.

It is a testimony to Justice Kotsonouris's professionalism that even up until she died in February of 2021, she never mentioned what happened to me at any subsequent family gathering. I never spoke to her about it either. It's possible, though doubtful that she didn't even know it was me that day; she displayed no sign of recognition in court. She heard my solicitor's case and immediately disqualified me from driving for a year while also imposing a heavy fine. My solicitor pleaded leniency and explained my intention to go to the US for work.

'And how long does your client intend to be in America?' asked Justice Kotsonouris.

'Until September,' replied the solicitor.

'Very well. I will suspend the sentence until 1 October, after which he must serve the term and, in the meantime, pay the fine in full. Next case.'

I paid the fine, and I served my sentence starting that October. After that, wherever else I took a drink, I never got into a driving seat with booze on me again.

29. New York – Beating the Golden Pavements

By the early 1980s, Denise and I and our four children had moved house a few times since being married in 1975. Firstly, from our flat in Sandycove (David arrived) to a small house in Meadowmount in Churchtown (Nessa and Fiona arrived). Then, and for a fifteen-year period, to a semi-detached house in Ranelagh (Brian appeared), which our children would regard as their home. This we bought with the help of the sale on my aunt Celia's house in Limerick, which she left me in her will. Celia was the last surviving member of my father's family. I hadn't any stable employment and was living from job to job, combining record producing with jingle and film writing, performing, arranging and orchestrating. I seemed to be working all the time, but it was tough and required a lot of visits to the bank with inventive tales about my current income and future prospects. Supporting a family with four children in Ireland in the 1980s was quite a strain, particularly in the arts. I occasionally was forced to sell one or two of the paintings that my father had bought over the years. This was a tough decision emotionally, and I remain acutely conscious of how lucky I was to be able to dip

29. NEW YORK – BEATING THE GOLDEN PAVEMENTS

into this resource when things were so grim financially. However, all this fiscal juggling and pandering to the banks was taking a toll on my own self-regard. I seemed to be pursuing a career that gave me many hints that I was doing the right thing but very little financial rewards.

It was early 1984, and I was restless. The economy in Ireland was grim; a stagnant cloud hung over the country, and I wanted to inject new energy into my career, so Denise and I talked about moving to New York to see if I could break into the music industry there somehow. We'd made some contacts there and were keen to give it a try; with a bit of hyperbole, my CV was impressive. In addition, Denise's mother was a US citizen, perhaps we could get a green card, but we thought it would be sensible to do a test run of living there first.

We put our house in Ranelagh up for a two-month swap through Intervac, a service that arranged temporary house swaps between Americans and Irish. The clients mainly were academics who wanted to come to Ireland for courses or research. Most people wanted to swap for just one month. So, we eventually agreed to two separate swaps. The first was with a family from Manhattan called Fitzpatrick who lived on the Upper East Side – an address the significance of which meant nothing to us then. The second was with a family from Smithtown, Long Island. This was inconvenient since I intended to stay close to the heart of New York City, but the house was near the sea, and the kids could have fun on the beaches even if I had to do the two-hour commute.

Before we left Dublin, the Fitzpatricks were already installed in our house in Ranelagh, and when our families met for the handover, we got on well. Of course, house-swapping with strangers is not to everyone's taste, but having met them, we felt comfortable with them being in our house for the next month.

The Fitzpatricks' house, 174 East 95th Street, was a brownstone situated between 3rd and Lexington Avenues. We arrived on a bright Saturday afternoon after a pleasant flight from Dublin (my cousin, Irene, was chief cabin steward, so she had made things extra comfortable for

us). We weren't prepared for the size of the Fitzpatrick home. It was four storeys high, had a magnificent library with a grand piano, and a tree-shaded garden at the rear. This grandeur was different from our house in Dublin, but they were happy, and we certainly weren't complaining. Our swapping arrangements also included a car. The Fitzpatricks had a Volvo station wagon garaged just a few doors down.

Another discovery was where 95th Street was positioned. It was on the edge of what Americans refer to as a very 'tony' or posh neighbourhood. But once you crossed 95th Street and moved northwards, you left the opulence of the Upper East Side and entered Harlem. The contrast was startling. Suddenly the buildings were dilapidated, the cars were battered and burnt out, and there were no fancy restaurants or stores. Things have changed since 1984, but in those days, we'd been warned not to wander northwards and only to take the kids west to Central Park or downtown to one of the green areas dotted around that part of the city.

On our first night, I took the kids around the block to get their first taste of American pizza. It was a tiny hothouse of a pizza joint on the corner of 2nd Avenue called Luigi's, and it boasted 'the best pizza in New York City'. The excitement was immense – three Irish kids and their dad going to a place that *only* sold pizzas? Nothing like this in Ireland. A sweltering bald Italian gentleman we assumed to be Luigi greeted us from behind a high counter: 'What can I get you guys?' His accent was what I'd heard on TV shows, and I associated it with Brooklyn or one of those areas full of wiseacre semi-criminal types.

Fiona wanted to make the order. So, I lifted her up so that she could see over the counter: 'May we have a pepperoni pizza with extra mozza-mozza-rooni, please?' my four-year-old said in her best polite Dublinese.

Luigi laughed: 'Sho' thing lil' Irish lady. You wanna get slices or a whole pie?'

Now, this we weren't expecting. Choice. We would have to get accustomed to choice in America. On our first night in the Big Apple, we had to have the whole pie, which was what I whispered to Fiona.

29. NEW YORK – BEATING THE GOLDEN PAVEMENTS

'A whole pie, please, Mr Luigi.'

'Tell your dad that'll be twelve dollars.'

Fiona whispered in my ear. I paid.

'Ok, folks. Y'all take a seat on that bench over there, and I'll call you when it's ready.'

We sat on a low bench in this sauna of a restaurant while Luigi got on with the culinary activities. Eventually, heaving a box large enough to hold the front wheel of a tractor, he appeared: 'OK lil' Irish lady, here's your whole pizza pie!'

Like worker ants, we carried this massive cardboard slab, tilting it sideways to get it out of Luigi's narrow door, up along 95th Street and back to our new home. Even with the hunger after a long flight, we couldn't make a respectable impression on this glutinous mass of mozzarella, tomatoes, pepperoni and dough. Like a Christmas turkey, it lived with us for days until Denise finally consigned the congealing remnants to the trash. We had arrived in the Big Apple, and so began our two-month stay, full of incidents.

New York was to give me a crash course in rejection. U2's manager, Paul McGuinness, had generously written to various high-powered record company executives, introducing me as a friend and a colleague and suggesting that they have a meeting with me. At the same time, the annual New Music Seminar took place in midtown at a big hotel. I signed on as a registered delegate, hoping I'd meet anyone that counted in the American music industry. What I didn't realize is that I shared this aspiration with 8000 other delegates who had come from all over the world clutching their demo cassettes and their newly printed business cards. It was like being at the busiest day of the National Ploughing Championships in Kildare, except that you'd probably have a better chance of connecting with a music exec in Kildare.

The place was overrun with wannabe rock stars and their managers who moved from seminar to seminar, gathering information from mid-range record company execs and, at the coffee breaks, pressing their cassettes into reluctant hands while imagining that they had made

a promising connection. The seminars themselves did present some great artists and their managers, but late July was a difficult time in New York City. It was the holiday season, and not many real movers and shakers were around. Madonna did speak eloquently at one of the sessions, and around every corner, somebody was demonstrating the new dance craze called breakdancing.

Paul McGuinness appeared on one panel about 'artists on tour'. The panel chairman, Harvey Goldsmith, invented scenarios about an imaginary artist and then asked panel members what they'd do if faced with some of his invented dilemmas.

'So, Paul McGuinness,' said Harvey, 'your artist is now in the middle of a UK tour, and on the morning of their appearance at a sell-out concert in London, you get a call to tell you that the artist has been arrested in the bedroom of a minor British royal with a bag of cocaine and is being held in a drug treatment centre in Wandsworth. Your concert promoter is on the phone in a distressed state. What do you say to him?'

'Well, the first thing I'd say to him,' said McGuinness with his customary poise, 'is that everything is going according to plan.'

The place erupted.

Apart from that, I took little from the New Music Seminar other than a resolve never to return. It was a money-making venture for the organizers cashing in on the aspirations of young performers who genuinely believed this platform would advance their careers.

Over the years, I have seen the music industry growing parasite services that feed on hopefuls working on the Darwinian principle that the strongest will survive. So, for example, many courses have sprung up worldwide for sound engineers. Over a busy recording career spanning forty years and many countries, I've worked with no more than thirty recording engineers. Yet, I see schools advertising courses that turn out thirty graduates per term. What will these young people do when they discover that the music industry has no jobs for them? I don't think W.B. Yeats had 'sound engineering' in mind when he said, 'Tread softly because you tread on my dreams,' but the maxim holds here.

29. NEW YORK – BEATING THE GOLDEN PAVEMENTS

Poster for the Randy Newman musical, 1983. Freddie White's theatre show was based on the songs of Randy Newman, and had a spectacularly short run at Dublin's Oscar Theatre in Sandymount. Bill's working relationship with Freddie White began when he produced the album Frozen Heart *for Freddie and brought this with him on his New York speculative odyssey.*

PART 4: 1980s – HINTS AND EXPLORATIONS

Following the New Music Seminar, I perspired my way through the avenues of NYC with letters of introduction, only to find that those I hoped to meet had gone somewhere cooler than Manhattan for summer. Their assistants informed me that yes, they would love to meet, but in September, when they were back. The few people I did meet were courteous but couldn't figure out what I wanted. I had brought my productions like Freddie White and the Blades,[1] but they were understandably at a loss to see what they could do for me. New York was well served with record producers and arrangers. The music I was playing for them was minority-interest stuff while the streets outside their offices throbbed with early hip-hop and dance music, not to mention Prince, Yes, Phil Collins, and the new wave artists from the UK like Boy George.

I did have one job in New York that legitimized my stay and kept my spirits up. I had produced a live album for Stockton's Wing. Their manager, Danny Kenny, decided it should be cut at Masterdisk in New York.[2] Andrew Boland, who recorded much of my work, arrived with his wife Claire to stay at the up-market Whelan address on 95th Street.

We needed to make a few cassettes from the master tape before the cut, so we looked in the yellow pages for a company offering copying facilities. There was one close to Masterdisk, so I made an appointment. We arrived at a very tall building on Broadway, housing a myriad of businesses. We took the rickety elevator up the building and stepped out at Floor 35 into a hall with six doors. A wide, highly ornate mahogany door was emblazoned with 'Abrahamson and Son, Jewellers' and another advertised the 'Acme Haulage Company'. Finally, we found the smallest door proclaiming:

> The QWIK Cassette Copying Co. of New York City
> WORLD HEADQUARTERS

We rang the bell and heard the sound of locks and bolts being released, and a small face with wire-rimmed glasses and a green poker visor appeared in the narrowest gap the security chain would allow: 'Yes?'

29. NEW YORK – BEATING THE GOLDEN PAVEMENTS

'Hi! We're here to get some cassettes copied?' I held up my 12-inch box.

The face eyed us suspiciously, and then it dawned: 'Ah! You must be Mr Whaylen. You called earlier?'

'Exactly!' I said.

Neither Andrew nor I were small men. I weighed 200 pounds, and Andrew, at over six feet, weighed more. The gimlet face looked us up and down, then politely asked: 'Are both of you gentlemen intending to come in?'

Andrew and I looked at each other quizzically and nodded, 'Well, we'd hoped to.'

'I see. Okay. Well, in that case, please be kind enough to wait there; I'm going to have to get some people out first.'

What followed was a Chaplinesque choreography where, among others, a woman with a buggy was hooshed out of WORLD HEADQUARTERS, and Andrew and I squeezed in.

We came away with cassettes of the Stockton's Wing album, not from the largest copying facility in the world but the smallest.

I was getting used to New York.

It was time to go to Long Island. The family who owned this house had gone to Ireland so their father, who was dying of cancer, could have a last look at his ancestral country. This house was perfect for kids, but the car was a wreck. It had a hole in the floor, and you could see the road whizzing along underneath you as you drove.

We'd never seen anything like Toys 'R' Us in Ireland. The idea that you could wheel a trolley around aisles of toys was surreal to Irish eyes in 1984. Buying toys all year round was equally outlandish, particularly in August when Santa and his reindeer would have been in deep hibernation. Nevertheless, I promised our twins a separate visit to see this extraordinary babel of baubles. So Nessa and I headed off to Main Street, Smithtown, for her private shopping spree.

Picking one of the smaller trolleys, we trawled the avenues of toys. Nessa immediately chose something and popped it into the basket. Then, she saw something else and put the first thing back and replaced

it with the new toy. This went on for half an hour until we got to the checkout with just one lonely teddy.

'Is that all you want, Ness?'

'Dad, there's too many things. I can't make up my mind. This is fine.'

We paid the gum-chewing assistant and got back in the car; Nessa was happy sitting in the passenger seat with her new teddy. About a mile along the highway, I noted the dreaded blue flashing light of a patrol car. I pulled into the hard shoulder with a palpitating heart, even though I knew I had done nothing illegal. The cop drew up a few yards behind us.

'Dad, is it because I'm sitting in the front?'

'Not at all, Ness; he's probably just making sure we're getting on fine on our holidays.'

After what seemed like ages, the cop got out of his car, put on his hat and shades; he walked like Rod Steiger in *In the Heat of the Night* up to the driver's window, which I hastily rolled down. He looked at me and then at a by-now terrified Nessa.

'Afternoon, Officer,' I smiled.

'Sir, I'm going to need you to step out of the vehicle.'

This syntax was unnerving. Firstly, he was 'going to *need*' me to do something. Did it mean that this need had not arrived yet but was on its way? Secondly, what was this imminent great need bearing down upon him that only my exiting of the vehicle could satisfy? I preferred my run-in with the Irish Garda, who, if I remembered correctly, said something more direct and reasonable like, 'Would you ever step outa the car there now, like a good man.'

The cop led me to the rear of the car: 'Is this your vehicle, Sir?'

I explained it belonged to the owner of the house we were staying in. I showed him my paperwork and driving licence. 'We're just on holiday,' I said.

'Sir, you do not have a licence plate legally fixed to this vehicle,' he snapped.

I noticed that was the case, but the owner had placed it on the rear window. It must have dropped off. I pointed this out to the increasingly

29. NEW YORK – BEATING THE GOLDEN PAVEMENTS

officious cop. I mentioned the owner's illness. Unimpressed, he took my details and said I'd be summoned to court.

Which is exactly what happened. I found myself in the District Court of Suffolk County answering a charge of driving a vehicle without displaying a licence plate in compliance with the legal requirements under whatever relevant statute.

My case was called, and I appeared before the judge, a suited gentleman, sans wig or gown and with a computer screen in front of him. The officer read out the charge, and the judge asked how I pleaded.

'Guilty,' says I. But I also pleaded with him to take into account that we were on holiday, using a friend's car and that we were insured and had been unaware that the licence plate needed to be fixed to the rear of the vehicle. I was about to go into an explanation of the unfortunate circumstances of the owner of the car when the judge interrupted me. 'Mr Whaylen, am I to understand that you are here on vacation?'

'Yes, m'lord.'

'And did you bring this fact to the attention of your arresting officer here?'

'I did, m'lord.'

'Mr Whaylen, please accept the apologies of the United States Court for this unnecessary interruption to the enjoyment of your vacation here on Long Island.'

'Thank you, m'lord.'

And with a withering look at the officer, the judge announced: 'Case dismissed!'

I went home to Nessa, who was anxious that her dad had gotten into trouble because of her somehow. Plus, having given her full report on Toys 'R' Us to her sister, Fiona decided she didn't want to go for her shopping spree in case her dad was arrested again.

Two friends came for a short visit. Their travel experience made Homer's *Odyssey* look like a school excursion. Cliona and Fergus Lyons booked an inexpensive flight with Air National. Flight AN45 took off in Athens, stopped in Belfast, where the Lyons boarded and headed to

PART 4: 1980S – HINTS AND EXPLORATIONS

JFK. We prepared to meet them at the airport. However, we got a call from them saying that the Belfast flight would be delayed by twelve hours. So we cancelled our trip to JFK and called a number for an update on flight AN45. Eventually, we heard it would be arriving at 9 a.m. the following day – fourteen hours late. Then there was a three-hour hold up at immigration, so when Cliona and Fergus appeared at the arrivals gate, they looked like survivors of a hijacking. We piled them into our car with its illegal absence of rear licence plates and drove for three miles in a thunderous monsoon, promising food and comfortable beds on arrival at Smithtown.

'Gosh, you can see the road through the floor of this car,' said Cliona, abandoning her customary politeness. Next, I felt the steering wobble, and it was clear we had a puncture. I pulled over. The tyre was in shreds. Luckily, there was a garage fifty yards up the road. I ran in the flogging rain up to the garage and explained to the foreman what the problem was. He was helpful: 'No problem, Sir, where's the vehicle?'

I pointed down the road. 'Just about fifty yards from here. See where the MacDonald's is? Just after that.'

'Ah, okay. So that'll be a call-out then. We'll send our truck and tow your vehicle into the workshop to do the job.'

The thought of explaining to the Lyonses that they would have to walk in the monsoon and wait outside the garage for the tyre to be replaced was unwelcome, but as it happened, they were oddly on autopilot, sleepwalking through the nightmare of their first trip to the US. When we finally got to the house, it was twenty-four hours before they reappeared, having hit the hay immediately.

Their return journey was worse. While they were enjoying their short stay in Smithtown, Air National went bankrupt. We weren't informed, so we drove them to JFK for their return flight on AN46. We parked and went with them into the terminal. Fergus had back trouble, so I carried the bags as we went from kiosk to counter, looking for the Air National check-in. Nobody knew where it was. Eventually, a person at an information desk told us that the airline no longer existed but that Pan Am was taking the Air National passengers. We queued for two hours at the

Pan Am check-in to discover that the flight was now full. However, if we came back tomorrow at the same time, we would possibly get seats.

We drove back to the house with Cliona and Fergus dolefully staring through the hole in the floor at the road whizzing underneath them. We had our second farewell dinner in twenty-four hours and repeated the whole merry dance the next day. Again, we were joined in the queue by the same Greek and Belfast citizens from yesterday who had spent the night on benches in JFK. The line now moved from Pan Am to Eastern Airlines, which had taken over the responsibility of getting all these stranded people home.

As Fergus was in considerable discomfort with his back, I stood in the queue with the luggage while he found a nearby seat. Finally, after hours of waiting, we got near the top of the queue. It was then I heard the Eastern Airlines representative, who wore a big name tag with Randy on it, saying: 'Folks, I'm awfully sorry, but the aircraft is now completely full. Please come back tomorrow, and we will do our best to accommodate you.' So saying, Randy put a 'CLOSED' sign on the desk and gathered up his paperwork.

Behind me was a small Belfast woman in her late sixties. She tapped me on the shoulder. 'What's that man sayin'?' her irritation was palpable.

'He says to come back tomorrow, and they might accommodate us then,' I said.

'Ask him,' she said with teeth bared, her face a picture of loathing, 'if he'd like the shite beaten out of him.'

Her emphasis on the word shite conjured up an image of Randy splayed on the floor of the Pan Am terminal with an unhinged Belfast pensioner jumping up and down on his entrails. I sympathized and said it was certain they would get away tomorrow and left her contemplating ways to deal with the bearer of bad news, who by now had gone. I collected Fergus and Cliona, and we headed back along the all-too-familiar route for a last look at the asphalt blur under their feet and a final farewell dinner. Which, on this occasion, it turned out to be.

30. Seán Ó Ríada and Elmer Bernstein

I returned from New York no wiser about how to advance my music career in America. In Ireland, the economy was still sluggish, and at one point, I even considered going back to the law for money, but music work, however sporadic, still came in. I began to do more work for film. Donald Taylor Black was a friend and an award-winning documentary filmmaker. So, when Trend Studios moved out of Lad Lane, Donald and I rented the upper floor and set up offices there, where I wrote the music for several of his documentaries.[1]

In 1987 Noel Pearson put on a commemorative three-night event at the National Concert Hall to celebrate the life and work of Seán Ó Ríada.[2] The three nights were to be recorded, and Noel wanted me to produce the records. In addition to the production work, he had a particular job for me: many of the scores from the Ó Ríada films had been lost, and he wanted me to reassemble them and present them on the third night of the event as a concert piece to be conducted by the famous American film composer Elmer Bernstein.

30. SEÁN Ó RÍADA AND ELMER BERNSTEIN

This was a tricky test for several reasons: firstly, it was Ó Ríada – a national icon and cherished hero who'd died young, leaving a massive legacy and occupying an unassailable position in the pantheon of Irish music – one would need to tread very carefully here; secondly, the only extant evidence of the scores for two of his films, *Saoirse* and *An Tine Bheo*, was either in the films themselves or on some rehearsal recordings, which RTÉ did back in the 60s; thirdly, film music is written to fit specific visual sequences and is often short, so to assemble these as elongated concert performances would be a challenge.

There was at least a bit of the score for *Mise Éire* available, so I sat down in early 1987 to construct a concert score based on the three films starting with *Mise Éire* as a route into the others. Daily I sat at home at the piano in Ranelagh, transcribing scores and listening to rehearsal tapes. It was never going to be an exact science, but I made every effort to be faithful to what Ó Ríada wrote. Transcribing individual solo instruments was easy enough, but where a full string section was in flight, it was difficult to isolate what, for example, the violas were playing when surrounded by violins, cellos and double basses. It was painstaking work, wearing headphones all day and playing the piano intermittently to pick out separate lines. When all that was done, the individual bits would be sewn into the quilt of a larger concert piece without seeming too fragmented, hopefully.

While this was going on, Denise arranged to get the house painted, so while I worked the score, there was a painter around, moving from room to room, being involuntarily treated to fragments of melody, a few chords, and then long silences as I wrote the score. His name was Tom, and he was a real Dub, rarely without a lit cigarette in the corner of his mouth. On the Friday of the first week he was working, he knocked on my music-room door, and his head appeared. 'How'ya, Mr Whelan, listen, I'm off now, see you on Monday.'

'Great, Tom, thanks. I'll be here.'

The door shut, and after a short pause, it opened again, and Tom reappeared. 'Ah, Mr Whelan,' he said, his face a picture of puzzlement, 'd'ye mind me asking ye somethin?'

'Sure, go ahead, Tom.'

'I was just wondering, d'ye never play an *actual* tune at all?'

Tom was spending his day listening to a chord, a phrase, a line there; it was driving him mad.

'Sorry, Tom,' I said, 'I'll play you the full tune next week.'

And so it was Tom, the painter-decorator, who would be the first to hear the reconstructed Ó Ríada film score.

Three concerts went on at the NCH in late April of 1987. The first night was 'classical' night, where we performed pieces like *Overture Olynthiac*, *The Banks of Sulán* and some of Ó Ríada's *Nomos* series. The second night was 'traditional' night, where Dónal Lunny assembled musicians and singers to perform the music that Ó Ríada made popular with his legendary Ceoltóirí Chualann. The third night was 'film music' night, where Elmer Bernstein conducted the RTÉ Concert Orchestra playing the music that enthralled Tom, our painter-decorator.

Eamon Dunphy came up to me after the concert. It wasn't what he expected, he said. It sounded American. Whether Eamon meant it as a criticism or not, this was an acute observation pointing to Seán Ó Ríada's popularity, range and scope. Ó Ríada had been musical director at the Abbey Theatre, was a lover of jazz and spent time in Paris experimenting with that side of his talent. He was an academic who lectured about music, aspired to be a film composer and travelled to Hollywood at one stage in a short-lived attempt to break into that competitive world. In the end, he nestled into his growing affection for Irish music and language – neither of which preoccupied him in his early life.

But those international influences were always there, and to my mind, Ó Ríada was an outward-looking musician. So, on *Mise Éire*, he took the beautiful Irish air – 'Róisín Dubh' – and reinterpreted it with a rich orchestral setting that could easily have sat comfortably in a Hollywood score. Ó Ríada was presenting his native music in a manner that resonated with a contemporary audience in the 1960s to such an extent that 'Róisín Dubh' became almost a national anthem.

30. SEÁN Ó RÍADA AND ELMER BERNSTEIN

I remember in my teens being sent away for a few weeks in summer to Ballyferriter on the Dingle Peninsula – a Gaeltacht area. It was and still is customary for schools to send pupils to the Gaeltacht to brush up on their spoken Irish. If the weather was bad, the classroom windows would be covered in bedsheets to keep out the daylight, and a film was shown. This is where I first saw *Mise Éire*. The feeling of seeing it for the first time is unforgettable. Ó Ríada's music lifted images of the 1916 Rising to a new level in our consciousness. His emotive orchestral score placed the romantic heroism of revolutionary Ireland up there with the best foreign films we had seen and gave a musically poetic benediction to those black and white grainy images of sacrifice, destruction and resurrection.

The *Ó Ríada Retrospective* was an opportunity to review the influence Ó Ríada had on Irish music and music-making. Much of his promise was never realized not only because of his early death but also due to his restless search for his own voice that characterized much of his music. He worked in the 60s during a period of cultural turbulence with new influences beckoning from all directions. Perhaps by throwing open all the windows, he felt he would clear the air and allow Ireland's tightly guarded identity, since the formation of the Free State, take root. His public utterances were occasionally parochial, but I think he was a radical figure and was a catalyst for much of what was to follow in the decades after his death. It is hard to imagine that the Chieftains, Mícheál Ó Súilleabháin, Shaun Davey, myself and others would have done the work we did without Ó Ríada first opening the doors.

Elmer Bernstein was delighted to conduct the Ó Ríada score and took the project seriously, driving down to Cúil Aodha (Coolea) in Muskerry beforehand to visit with Ó Ríada's son, Peadar and see where Ó Ríada had lived and worked. He got a proper Cork welcome and, after a memorable meal in the Ó Ríada homestead, was taken to the local pub at the summit of a hill outside Cúil Aodha – Top of Coom, as the pub was known – that gave him a panoramic view of the whole region. Here he was introduced to the local historian Cáit Ní Bhuachalla

(Katy Buckley), who enfolded the neat Bernstein frame in a Brobdingnagian embrace, welcoming him to County Cork. He asked about the long ancestry of the people in the area. 'I'll tell you now, Mr Hammerschtein,' Katy said with typical Muskerry mischief, 'the people of Cúil Aodha can trace their ancestry back to Adam!'

During the rehearsals for the Ó Ríada concerts, Bernstein said he was pleased with the orchestral playing, which kicked off conversations about Dublin and Windmill as a venue for international film scoring. I told him I had put together an orchestra for an Israeli composer, Misha Segal, on a film called *Young Lady Chatterley II*. It had been a successful session and proved we could deliver a creditable performance from both musicians and studio.

Elmer and I hatched a plan: since the costs of recording in LA had become prohibitive, American film composers were coming to Europe to record film scores. To divert some of that traffic to Dublin, he would assemble composers and their agents in Hollywood, where we would make a joint pitch, showcasing Windmill as a recording venue and showing a video of the musicians at work.

This would cost. We had no cash, but an old friend, Tony McNeive, who managed the Savoy in Limerick in my teens, offered to finance anything interesting I might be doing musically, so I went to him with the idea, and we set up a company, with him investing some of the cash. Thus, in 1985, Irish Film Orchestras (IFO) was formed. I went to Russ Russell and Brian Masterson at Windmill Lane and asked if they would shoot a short video of the orchestra at work in the studio. I asked Donald Taylor Black if he would direct. Tony convinced Aer Lingus to fly us to LA, and I got McCambridges to supply sponsorship of smoked salmon and their famous brown bread.

With our video, brochure, brown bread, smoked salmon and Guinness, we advanced on the conference room at the Beverly Hilton in Hollywood to meet with Elmer Bernstein's invitees. The room was filled with composers, including the great Henry Mancini, and a collection of agents representing John Williams, Jerry Goldsmith, Randy Newman, Ennio Morricone and Danny Elfman.

30. SEÁN Ó RÍADA AND ELMER BERNSTEIN

This PR exercise resulted in IFO attracting composers and producers to Ireland to record film scores like *My Left Foot* and *The Field*. Over the next decade, over fifty scores would be recorded in Dublin. IFO's clients included Barry Manilow, Richard Robbins, Robert Redford, Stephen Frears, David Shire, John Sayles, Jean-Claude Petit, Robert Folk, Merchant Ivory Productions, and many others.

All this sprang from casual dinner conversations with Elmer Bernstein. We became great friends, and Denise and I visited Elmer and his wife Eve at their home in Santa Barbara. He loved Ireland, all things Irish, and took a strong interest in politics. He'd been blacklisted as a communist during the dark McCarthy era in 1950s and had been reduced to working on third-rate films like *Cat Women of the Moon* and *Robot Monster*. But when the McCarthyist paranoia eased, his career rekindled, and we were gifted with such scores as *The Magnificent Seven*, *To Kill a Mockingbird* and his Oscar-winning score for *The Man with the Golden Arm*.

I never told Elmer this, but one of the first pieces I taught myself on piano was the theme from *The Magnificent Seven*, which I learnt from a 45-rpm disc by the John Barry Seven, a big hit in 1961. To meet the composer twenty-five years later is something I could never have dreamed of sitting at the piano in Barrington Street.

Elmer came to Dublin to do the score for *Frankie Starlight*, and he had previously been working on a project with dancers. His music editor, the legendary Kathy Durning, confided in me that he wasn't in great humour after the experience. He was a bit off-colour when he arrived: 'Never work with dancers,' he said grumpily. Shortly afterwards, he heard I had written the music for 'some TV spectacular'. We had a VHS in the studio, so I played him that first *Riverdance* performance at the Point. He was knocked out: 'Well, now you know,' he said, 'never listen to me.'

In 1992 Robert Redford came to Dublin to record the score for *A River Runs Through It*. There was a buzz about the place and a few cases of neck strain amongst the women of the orchestra. Denise, normally blasé around celebrities, was smitten. She was not inclined to hang around

recording sessions, but her curiosity was piqued when Redford was in. I called her to pop in for lunch and say hello. We ordered Chinese food. When Denise and Nessa appeared, Redford – rugged and tanned in a T-shirt and jeans – was leaning against the wall, eating noodles. I introduced them. Redford was probably used to people dissolving into gibberish on meeting him, so whatever Denise managed to utter (he may have thought it was some Gaelic greeting?), he smiled and said: 'Great pleasure to meet you too, Denise. And your lovely daughter. Hi, Nessa!'

'Oh, hi,' said Nessa, more concerned about Denise. 'Are you okay, Mum?'

Denise came back to land and managed to articulate some words in English before Nessa guided her out of the studio and back to the car.

'Well, Ness, what did you think of Robert Redford?' Denise was still on a high.

'He's ancient, no?'

He was fifty-five at the time, but she had a point.

Redford was a calm and diffident presence in the studio. Every time the tape op brought him coffee, after finishing, he took it back into the kitchen, washed it in the sink, dried it with a tea towel and returned the mug to the cupboard.

'Just as I would have expected!' said Denise when I told her.

Daniel Day-Lewis was in Dublin to work with Pat O'Connor on *Stars and Bars* (1988). IFO was recording parts of the score, so he was in Windmill Lane. Noel Pearson was having a party after the day's work in his house in the Wicklow mountains and suggested inviting Day-Lewis. Denise and I collected him at the Shelbourne Hotel and drove to Wicklow, arriving when the party was in full swing. During the evening, I noticed Noel had corralled Day-Lewis into a corner and was animatedly relating a story that was being listened to with customary Day-Lewis seriousness and concentration.

Heading back to Dublin, the car's steering behaved erratically, and sure enough, we had a puncture. Daniel Day-Lewis got out in the rain and good-humouredly helped change the tyre, and as we drove

30. SEÁN Ó RÍADA AND ELMER BERNSTEIN

on, asked if we'd read Christy Brown's book *My Left Foot*. This was what Noel had been in deep conversation with him about. Little did we know that this night would lead to the Oscars for Day-Lewis and Brenda Fricker and Academy Award nominations for Noel Pearson and Jim Sheridan.

The experience with IFO was formative for me. First, I learnt the craft of film scoring. Second, I observed the work of preeminent composers and orchestrators. For example, Barry Manilow's public image was one of a singer-songwriter with a gift for romantic ballads, which warmed many a lonely heart. However, as a composer and orchestrator in the studio, he was highly sophisticated with excellent musicianship and an amiable and encouraging presence. So, it was no surprise that Bette Midler chose Manilow as her pianist and record producer. Years later, in the early flush of *Riverdance* success, I was in the Beverly Wilshire and was upended by a loud shout from across the hallway: 'Hey, Bill Whelan! Congrats, man. C'mon, Ireland!' It was Barry Manilow, waving as he went by.

Film scoring is a collaborative craft that also has its downsides. Often, a composer's work is tampered with after the score has been recorded, or sometimes it's removed and replaced altogether. I have seen crude hatcheting of cues that had been carefully constructed by the composer and which end up shredded or buried under helicopter noise or other sound design effects. The composer has no control in these circumstances since the director or producers have the final say.

Over the years, the role of the composer has been redefined and diminished while the job of the music supervisor has become central to the film's soundtrack – in many cases, the music supervisor's role has erased the composer's function. The music supervisor will suggest 'source music'. This might be as inconsequential as background music in a bar or as significant as a song by Adele or Justin Bieber. If the producers are also music publishers or own a record company, they will favour using music which will also earn an income for them as copyright owners or administrators.

245

Increasingly, soundtracks are a mashup of music that was never intended for the film but will boost the product's commercial suggestibility to a target market. Sometimes the score functions as product placement, where advertisers benefit from a judiciously promoted brand. It's the usual push-and-pull between the creators and the marketers, between art and commerce. I hope that great compositions will jolt the composer's role back into focus and restore it to its full potential where it can rejoin the other great creative functions in film: lighting, costume, make-up, special FX and camerawork.

As proprietor of IFO, I foolishly nursed a hope that a producer or agent might say: 'Hey Bill, why don't you write the score for our next film?' But unfortunately, I didn't realize that when they looked at me, they saw the guy who put the orchestra together, booked their hotels, arranged the studio, ferried them hither and yon, and was available for their scoring needs. Not for a moment did they consider that I could write a score or want a career as a film composer. The work brought in good money but once distributed amongst musicians and the studio, there was just enough to cover IFO overheads. Eventually, Tony McNeive exited the company, and when *Riverdance* entered my life, I handed the operation over to Caitríona Warren-Greene, who expanded its activities to include albums and concert work.

31. Alcohol – the Yeats Festival

I had not really had any alcohol until I came to college. The ten years that followed was spent around two careers where regular alcohol consumption was endemic and very much tolerated – the legal profession and the media and entertainment business. At the start, I was quite moderate around alcohol. However, I moved in circles where jokes about drinking and stories of hair-raising events and narrow escapes under the influence were told and retold. In fact, it was often regarded as a kind of badge of honour, an extra medal on the proud chest of the drinking man, when some great tale of survival attested to the heroic qualities of the drunk. And in fact, for much of it, it was hilarious and very pleasurable. As time went on, my drinking became more of a daily event, and I began to display some of the characteristics common to those for whom drinking was misshaping their lives. It would take some years before any of this really affected my work, but my family certainly suffered. I was so completely incapacitated by a few days of bingeing that I missed my daughters' Confirmation Day and lay in bed while Denise explained to everyone that I had the 'flu'. I was never violent, but my drinking resulted in the kind of absences that certainly

did not make the heart grow fonder. There were missed opportunities. Hangovers. Lies and cover-ups. Wounds that cut much deeper than physical ones. Cuts and bruises to the heart. Actions and inactions that surely meant I didn't care. Neglected them. Who, me? Never. Sure, I loved my family.

There were times in my later drinking when alcohol impeded my forward track and set up roadblocks. In these early days, not too many people, except some of those close to me, would have been aware of the extent of my drinking. And others, even if they were aware, perhaps decided to ignore it. For some it might have prompted them to confront and admit it in their own lives, and that is the hardest thing for the drinker to do. How much my environment had to do with my drinking is hard to assess. I had, by any standard, a happy, if sometimes solitary childhood. A fellow addict once said to me that she was drinking because she was an alcoholic – the rest, she said, was just scenery. She was one of those who believed that all you had to do to become dependent was to keep on drinking. This may be true for some, but I have often thought that there are as many kinds of alcoholism as there are alcoholics. The causes are probably multi-factorial, genetic, chemical, neurological, psychological and environmental. And perhaps it comes from an urge to medicate an inexpressible sadness, cope with a deep anger or comfort a sense of loneliness and isolation. For whatever reason, alcohol became very much part of my life from the early 80s onward. It was present even when I had periods of abstinence – which were sometimes short, but sometimes months and even years long. And of course, it was there when I relapsed and actively embraced it with all its capacity for chaos and bedlam, denial and guilt. I am mindful that because of alcohol, a shameful part of my story is about a life engaged in a wrestling encounter with a powerful opponent. From time to time I ended up dizzy on the canvas, bloodied and bruised, but for today I consider myself very lucky and grateful to still be alive to tell the tale.

I have often heard it said that alcoholism is a disease of the family. In the centre is the drinker, while around him his family members wheel and spin in an unpredictable, lopsided orbit. My children have said that

when I was an active addict, they had a number of fathers: normal Dad, drinking Dad and recovering Dad. The first of these was usually fine, the second could occasionally be fun, never violent, but heading for that shadowy condition that became familiar to them all. This was when I would ultimately retreat to the twilight of my bedroom, often with a hidden bottle or two, and disappear into a soporific state while they crept about trying their best to get on with life as if everything was normal. It was far from normal of course. One of the engines had fallen off, and we were careering rudderless into an abyss until my shaking return, where nobody said anything, and we all resumed as if nothing had happened. This was recovery Dad. In normal relationships, where a trauma had occurred, (and these events were traumas for everyone), the family would discuss it and try to comfort each other and come to terms with what had happened. In the insane and crepuscular world of the addict, everyone just pushes on through the emotional debris and broken glass, ignoring the wounds that have been inflicted, until the scabs and scars appear years later. I deeply regret these collateral injuries to my family, and even though the hurt might never have been intentional, it is nevertheless there with its cancerous capacity for damage to their confidence, security and self-worth.

I am writing this because no truthful account of my story could possibly be complete without the acknowledgement of the unwelcome position that alcoholism occupied in my life. I am also writing in some trepidation in the knowledge that for many people, the condition remains misunderstood, and although perceptions have improved over the decades, there is still the suspicion that the alcoholic is the sole author of their own wretched condition. And while this may be true in part, I also write this from the perspective of someone who has lived it, and who believes that that same person can be the author of a return to sanity, and that there is a community of like sufferers out there, most of whom are only too willing to illuminate that path along the way.

When Noel Pearson, now chairman and artistic director at the Abbey Theatre, asked me to meet him, as usual, he cut straight to business:

'There's some professor of drama at Emory University in Atlanta who has raised a load of money from Coca-Cola to mount a W.B. Yeats Festival.'

'Coca-Cola and Yeats?' I said. 'Not an obvious pairing.'

'I know,' said Noel, 'but apparently, the head of Coca-Cola is a guy called Don Keough, and he's a massive Yeats fan. The professor's name is James Flannery, and he is even more passionate about W.B. than Keough. Both believe Yeats's plays have been poorly treated by the Abbey – the theatre *he* founded. But listen, Flannery's admiration for the plays is off the scale; he says the dramatic works have been overlooked. He proposes to stage fifteen of them at the Peacock for the next five years.'

'Sounds exciting,' – I was already calculating where I'd be at with my fading dreams in five years – 'when?'

'September. And he wants to run seminars during the festival.'

'Does he need a producer or facilitator or what? Where do I come in?'

'There's a BIG requirement for music. There's lots of lyrics in the plays. You'll have to do brand-new music and song settings for all fifteen plays. Plus, the music for choreography and puppetry. Now listen, are you familiar with Yeats's plays?'

'Vaguely,' I admitted. 'I know *At the Hawk's Well* and *The Countess Cathleen* – that's about it.'

'Ok, well, let's get you the scripts.'

Noel picked up the phone and dialled the librarian's number. 'Hello? Yeah, hi, Noel here. Could you bring up the scripts for Yeats's plays? Bill Whelan's here. He'll be working on the music. Yes, I'll hold.' There was a pause; then Noel's phone buzzed. 'What?' he said. 'How do you mean we don't have them? Oh. I see. Well, would you ever get one of the young fellas to run down to Eason's and get us the Yeats plays? And ask him to be quick about it. Buy a few copies; we'll be needing them.' He put the phone down. 'Jaysus, what do you make of that? Yeats's *own* theatre and they don't even have a copy of the plays? Glad he's dead, or we'd be in trouble. Wouldn't happen if yer wan, Lady Gregory, was around.' He blinked that way Noel did, earning him his nickname.

31. ALCOHOL – THE YEATS FESTIVAL

Noel brought the attitude of 'off-handed' to extremes. Even when talking about critical dramatic works, like the plays of Brian Friel or Tom Murphy, he treated the subject with a breezy familiarity lest anyone lose the run of themselves. His attitude grew from a street scepticism: no matter how great you thought you were, the people three doors down knew exactly what you were like. That didn't mean that he disrespected anyone's work, but the balloon of one's self-inflation was always prey to the prick of Pearson's watchful needle. This quality endeared him to some and caused others to run away. Denizens of Hollywood, operating on levels of earnestness bordering on naive, found Noel's disinclination to gush offensive. Despite his award-winning success in film, he'd never have enjoyed an environment as toxic and artificial as Hollywood. The instinct may have been mutual.

The Yeats project, with its need for original music, suddenly sounded very attractive. It would be an interesting five-year journey spanning the poetic and spiritual landscape of Yeats's dramatic works. For me, it would mark a period of change and re-evaluation. It was during this time I made personal and professional decisions that changed my life and the lives of those around me. Those changes were gradual, but when I look back, the picture of my life at the beginning of the Yeats project was very different to how it looked five years later in 1994.

The format for each year was the same: we started rehearsals in August and performed in September. The casts varied depending on the play's requirements. In year one, there was a large group as we were putting on five plays from Yeats's Cuchulain cycle.[1] Among the actors were Olwen Fouéré, Ciarán Hinds, Derek Chapman, Seán Rocks, Fedelma Cullen, Peadar Lamb and Máire Ní Ghráinne. Sarah-Jane Scaife was the choreographer, and James Flannery directed all five plays.

Ahead of the rehearsals, Flannery spent one-on-one time with me, engaging in detailed textual analysis. As Pearson had said, what became clear was his undeniable passion for Yeats as a dramatist. He would come to my house in Ranelagh and go through the text of each play line

by line, inviting my responses and discussing the shades of meaning and intention of the dramatist.

Sometimes, he would jump from his seat and do an elaborate mime to illustrate how he felt a character could appear. One afternoon when he was talking about the old man in *At the Hawk's Well*, he got himself into a bent and gnarled position and, crouching down behind the armchair in our sitting room, loudly intoned the words of the First Musician in the play describing the old man in a suitably aged and cracked voice:

> *He is all doubled up with age;*
> *The old thorn-trees are doubled so*
> *Among the rocks where he is climbing.*

At this moment, our twin daughters arrived home from school and burst into the room with two pals in tow. All four children were stopped dead in their tracks by the image of this grey-haired man, peering up from behind the armchair, spouting strange words in a sandpaper voice, his face scrunched up and one eye closed.

'It's okay,' Nessa explained. 'It's just one of Dad's friends.'

And then Fiona ushered their puzzled friends out of the sitting room as quickly as she could.

Despite moments of hilarity, the work around the W.B. Yeats Festival was serious. Sometimes members of the company found Flannery's directorial style curious, but nobody could deny his deep knowledge (and zeal) for Yeats as a playwright. Flannery was unable to conceal his emotional responses to the poet's words, and he choked back tears if an actor gave a moving performance in rehearsal. (Olwen Fouéré had a particular gift for provoking a tearful response from Flannery.) Such a raw display of heartfelt reaction unsettled some of the actors who were unaccustomed to directors giving such free rein to their emotions.

The talks and discussions that took place as part of the festival drew on Yeats's visions: political, social, mystical or sexual. Each year was given a title like *Masks of Transformation* or *Art and the Spiritual*

31. ALCOHOL – THE YEATS FESTIVAL

or *Sacred Mysteries*, providing headline references for speakers to base presentations. Writers Robert Bly and Betty Friedan appeared, as did leading public intellectuals in the arts and politics. For me, the experience was inspirational. In the year when we performed *Words Upon the Window-Pane*, Flannery and I had a long session with a psychic medium. We did site-specific performances about the 1916 Rising in Kilmainham Gaol with Anúna and the American cellist Maya Beiser. We ran a fundraiser concert in the Abbey around Yeats's work where Daniel Day-Lewis, Seamus Heaney, Edna O'Brien, and Richard Harris read his work and Bono sang U2's setting of Yeats's poem 'Mad as the Mist and Snow':

> *Bolt and bar the shutter,*
> *For the foul winds blow:*
> *Our minds are at their best this night,*
> *And I seem to know*
> *That everything outside us is*
> *Mad as the mist and snow*

But it was my personal connection to James Flannery that caused me to make serious changes in my life. In the middle of 1991, I stopped drinking – a break that lasted for five years. I did not stop by some great effort of self-will. I relied on family support and the professional advice that became available when I finally surrendered. I had support too from others in the music business who were living through addiction and understood the grip that it had on those unlucky enough to slip into its labyrinth.

What James Flannery did took me by surprise. He gave me a sense that my work as a composer was valuable, and he encouraged me in every way he could. He praised the work. Even though I was slow to believe it, he convinced me to have faith in my skills as a melodist. He wanted me to believe I was equipped with the instinct for the dynamics of drama that a good theatre composer should have. This affirmation was an American thing at the time and wasn't found easily in Ireland,

where we were less inclined to give praise to an artist struggling to find their voice. In an Ireland afflicted with small-island complex, praise is meted out in paltry parcels and not with regularity or fluency. Flannery's endorsements were like water in a desert, and I responded thirstily to his encouragements. He had sown the seed for personal regeneration and reconnection, the centre of my musical creativity.

PART 5
1990s – *Uisce Beatha* – the Watershed

> One fortunate in both would have us choose
> 'Perfection of the life or of the work'.
> Nonsense, you work best on a full stomach
> As everybody over thirty knows –
> for who, unbreakfasted, will love the lark?
> Prepare your protein-fed epiphanies,
> your heavenly mansions blazing in the dark.
> — Derek Mahon, 'Hunger'

32. *An Eye on the Music* and Seville

The W.B. Yeats Festival accounted for work during the summers, but I was busy with other projects throughout the years. Ian McGarry approached me to be the musical director for an RTÉ Sunday night series called *An Eye on the Music* involving the RTÉ Concert Orchestra. I presented him with an idea to invite a wide range of musicians and performers to perform live with the orchestra. The central notion was that we would concentrate on artists of all genres who wrote their own material. We would also include traditional musicians and film composers. I would do the orchestrations required, conduct the orchestra, and interview many performers about their music.

It was an ambitious project, so I enlisted the help of my old colleague, John Hughes, from the now disbanded Minor Detail. John had been working on the film *The Commitments* and had discovered a Dundalk band called the Corrs as part of his research. From my office in Lad Lane, we began the process of connecting with our proposed group of artists. We started with artists we knew, so Elmer Bernstein was one of the first to appear.

With Elmer as bait, we convinced other international film composers to appear, like George Fenton, Ron Goodwin and Barrington Pheloung.

PART 5: 1990S – *UISCE BEATHA* – THE WATERSHED

On the traditional front, we secured Altan, Mícheál Ó Súilleabháin, Dolores Keane, the Chieftains, Liam Ó Maonlaí, the Dubliners and East Wind – the band I'd been playing with and producing for Andy Irvine and Davy Spillane. We also booked world music artists like the Chinese flute player Guo Yue, the Bulgarian choral women Trio Bulgarka, the Indian sarod player Krishnamurti Sridhar, and the Zimbabwean gospel singer Machanic ('Mechanic') Manyeruke. Among the emerging artists were the Corrs giving their first television performance long before becoming an international success. My colleague Andy O'Callaghan took on the job of music associate and did some great arrangements for the orchestra.

When Jimmy Webb agreed to come to Ireland for the show, we landed Lloyd Cole, Tanita Tikaram, Midge Ure, Beverley Craven and Prefab Sprout. Paddy McAloon of Prefab Sprout asked if he could appear with Jimmy Webb, which he did, performing Jimmy's hit 'The Highwayman' to orchestration by George Martin, the Beatles' producer. (It was a thrill to see George Martin's name on the score when it arrived.) We also had some new wave bands like the Pale, the Blades and Mykaell Riley with the Reggae Philharmonic Orchestra. Malcolm McLaren also spoke about his fascination with Strauss waltzes, which the orchestra then performed.

Many stories emerged from this extraordinary mix of performers, not least of which was the experience of working with the charming 'Mechanic' Manyeruke, so-called because, from an early age, he was fascinated with machinery. My friend and music anorak Éamonn Ó Catháin brought Machanic to my attention. Manyeruke was heavily involved with his church in Zimbabwe, where he led his recording group, the Puritans, and was tickled when he received an invitation to perform on TV in Ireland. When it came to his fee, RTÉ presented him with a contract and was arranging for his cheque when he said that he would prefer not to be paid in cash but in wool blankets. The RTÉ production assistant was gobsmacked. Machanic explained that cash would be of no use in Zimbabwe, but they needed bed clothing in his community. So, the RTÉ production assistant had the unique experience of accompanying a black gospel singer to Clery's and purchasing

32. AN EYE ON THE MUSIC AND SEVILLE

blankets to be shipped to Zimbabwe. The RTÉ canteen resounded with stories of this curious remuneration for weeks afterwards.

RTÉ broadcasted *An Eye on the Music* on Sunday nights in the autumn-winter schedule of 1991. Unfortunately, there was scant promotion for the series, and it drifted out on the airwaves like an orphan since no one knew how to market it. Although it bore no resemblance, it sat in a spot generally dedicated to a light variety show called *Sunday Night at the Olympia*. The nearest comparable programme was BBC's *Later with Jools Holland* which began the following year. When I recently looked for some of the series in the archive, I found that RTÉ had erased many of them.

Another project in 1991 led to a significant turn in the road for me. The Department of the Taoiseach approached me to write music for the Irish Pavilion at Expo '92 in Seville. The person in charge was a dynamic producer (and actor) called Denis Rafter, who lived in Madrid but had come home to supervise the Expo. We met in Government Buildings, and he outlined the nature of the commission to me. The Irish pavilion would be in the specially built Expo village in Seville. Exhibitors from Ireland would all have their stands there, and as visitors moved through the building, the music would play as an ambient backdrop.

Seeing the positive effect the Yeats project had on me, I decided that from now on, I would only take on work that required me to write new music. The Expo project almost fitted; however, I didn't want to write ambient music that people barely noticed as they strolled past dairy products, tourist advertisements and Celtic jewellery. But, rather than refuse, I told Denis Rafter I'd think about it.

By our next meeting, I had a plan.

I found a book in my father's library which recorded the history of the Battle of Kinsale in 1601 and the exploits of Red Hugh O'Donnell. The strategy to surround the British in the port of Kinsale with the Irish on the land and the Spanish on the sea fell apart when an informant blew the whistle to the enemy. The Irish were defeated, and the Spanish retreated. Red Hugh O'Donnell fled to Spain to ask for support

to mount a second attack. That journey from Kinsale to La Coruña supplied the narrative for what I proposed to pitch to Denis Rafter, who, with his sharp beard, looked a bit like a Spanish grandee himself.

'Consider a completely novel idea,' I said. 'What if I write an orchestral suite that tells the story of the Spanish and Irish coming together at the Battle of Kinsale. I can incorporate Irish and Spanish traditional instruments drawing on the musical style of both cultures. We could tell the story of the battle, the voyage to Galiçia under Captain Pedro de Zubiaur, the storm at sea, the arrival in La Coruña and finally, Red Hugh O'Donnell's arrival in the great hall of the Earl of Caraçena. The Irish and Spanish unite in an uplifting dance that links both countries!'

Denis looked at me. I thought he might be about to call security, but I continued: 'We could task RTÉ to provide the orchestra; we could perform the piece in Seville on Irish National Day in November 1992. *And* if we record it beforehand' – I tapped the table for emphasis – 'you would have your music for the Irish pavilion as well!' I sat back and drew a deep breath.

Denis looked out the window surveying the palatial government buildings, the fountains and lawns and said nothing. Finally, he swivelled towards me in his chair. 'D'you think we might get the orchestra?'

I was going to like this man. 'We have a good chance. Liam Miller has a senior position in RTÉ, and Simon Taylor manages the orchestra. Both are imaginative types. They'd support the idea.'

As predicted, Liam and Simon proved to be staunch allies.

Over the following weeks, we expanded the plan. I suggested that we bring in John McColgan, who had close ties to RTÉ and was now running his own TV production company. We would do a Dublin performance before going to Seville, and John could produce it for TV. We would add two dancers – one Irish and one Spanish. Denis would source the Spanish dancer from his flamenco contacts in Madrid, and we would ask Fr Pat Ahern in Kerry to find an Irish dancer.

Fr Pat was the artistic director of Siamsa Tíre (the Irish national folk theatre and dance company). I contacted Davy Spillane, Máirtín

32. AN EYE ON THE MUSIC AND SEVILLE

O'Connor and Mel Mercier to provide pipes, accordion and bodhrán, and Brian Masterson put me in touch with Rodrigo Romaní from the Galiçian group Milladoiro to play the Spanish elements. I then sat down to write while John McColgan got to work on producing the Dublin concert.

From Kinsale to La Coruña or *The Seville Suite* was first performed at the National Concert Hall by the RTÉ Concert Orchestra conducted by Proinnsías Ó Duinn in March 1992. The evening was broadcast by RTÉ, compèred by Gay Byrne and also featuring a new piece by Mícheál Ó Súilleabháin. On this occasion, the flamenco section was danced by Tara Murphy. For the Seville performance, Denis Rafter set out to find our flamenco specialist. This search had reverberations not just for *The Seville Suite* but for the still unheard of *Riverdance* and for many flamenco and Irish dancers in the coming couple of decades.

In September of 1992, after exhaustive auditions, he found the twenty-eight-year-old María Pagés, a dancer and choreographer who had been with the Antonio Gades Company and who had just founded her own dance company.

María's enthusiasm for the project was undeniable – she relished the notion of working with an Irish step dancer and finding the points of rhythmic commonality between the two forms. In 1992 she flew to Ireland and onwards to Tralee to begin work on the choreography. She arrived late at night and went straight to bed. She still tells the story of when she woke in the morning, she heard a noise at her window, pulled back the curtains there was a cow looking straight at her.

A chartered jet waited on the runway in Dublin Airport while an entire orchestra complete with double basses, harps, timpani, xylophones and other sizeable orchestral weaponry boarded for Spain. It was October 1992, and we were bound for the newly built Teatro de la Maestranza to perform *The Seville Suite*. It would be the first performance to include our Spanish-Irish dance duo: María Pagés from Seville and Michael Murphy from Kerry.

They had rehearsed in Tralee earlier under the conceptual and choreographic guidance of Fr Pat Ahern. I constructed the melody in

the last movement to allow the dancers from both the Irish and Spanish traditions to explore areas of rhythmic kinship. I tried to create tension and release in the orchestration, building to a theatrical climax when, after an initial standoff, the dancers became more connected. I hadn't seen the Tralee rehearsal, so I was excited to see how it all fit together when we got to Seville.

The organizers wanted their money's worth for transporting an entire orchestra to Spain, so an extra performance was laid on at the Palenque in the afternoon, the day before the Maestranza event. It was here that I saw the emotional impact on the audience when the music and dance came together. Fr Pat, María and Michael had done a superb job, and under the baton of Proinnsías Ó Duinn, the orchestra played a storm. Standing ovations didn't happen easily in 1992; audiences kept them in reserve for when they were really moved, but for this, the standing ovation and cheering went on for a long time.

Serendipitously, the sylphlike Jean Butler, who was in Seville to dance with the Chieftains, was standing beside me at that first performance. We barely knew each other and had no idea what our joined futures would hold.

The days in Seville were packed with activities other than musical. There was a strong Irish presence to celebrate the Irish National Day. The Department of the Taoiseach had commissioned *The Seville Suite* during Charlie Haughey's leadership. However, by the time the piece was performed, instead of Haughey, the new Taoiseach, Albert Reynolds, took his place. We had made a specially bound copy of the score to present to him on his arrival. A photo op was set up, and Taoiseach Reynolds breezed into the venue with a gaggle of hangers-on. We were introduced, and I presented him with the score. Handing it to some attendant, he said: 'Ah, grand, thanks, that's nice. Tell us, when did you get here?'

I was so taken aback that I can't remember how I replied as Albert Reynolds moved on to the next handshake. I even longed for what Haughey might have made of it: expounding on the history of Ireland's link to Spain, the Kinsale defeat and the Flight of the Earls leading to

32. AN EYE ON THE MUSIC AND SEVILLE

the demise of the old Irish order with the departure of the O'Neill and O'Donnell clans from Ulster.

What more than made up for our Taoiseach's indifference was my subsequent introduction to Don Carlos O'Neill, a tall, elegant Spaniard and direct descendant of the great chieftain, Hugh O'Neill, Earl of Tyrone. To meet in Seville a man who could trace his lineage back 400 years to Ulster gave a historical benediction to the project.

Poster for The Seville Suite *performance in Spain.*

33. *Trinity* – Leon Uris

Before performing *The Seville Suite* in Seville on 4 October 1992, I found myself in New York for six weeks in very different circumstances than I had previously with my trial emigration. Leon Uris's novel *Trinity* about the Irish nationalist struggle from the Great Famine to the 1916 Rising, was published in 1976 and spent twenty-one weeks at the top of the *New York Times* bestseller list. Uris now wanted to turn the book into a stage production with music. He teamed up with producer William Spencer Reilly and director Larry Arrick to adapt the novel for the stage. But he wanted an Irish composer for the score, and Tommy Makem recommended me; so, in April 1992, I was on a plane to New York to realize Uris's dream to present *Trinity* as a theatrical piece.

The schedule was tight, so I brought a fledgling composer, J.J. Vernon, to help. J.J. was a graduate of the University of Salford in Manchester, and he had the technical skills for the job. The plan was: I'd spend the earlier part of each day at rehearsal and then switch to my apartment-based studio to write the score; J.J. would stay on at rehearsals, make notes; then, he and I would meet at the end of the day to adopt any required changes.

33. TRINITY – LEON URIS

Trinity as a theatrical piece was meant to be a modest workshop production, so I was surprised to see over thirty actors and singers plus a large crew assembled at the rehearsal space in the West Village on the first day. As everybody milled around introducing themselves, I heard this booming voice: 'Where's Whelan? Which one is Whelan?'

A large, lumbering grey-haired man with sparkling blue eyes appeared from among the leg warmers and crop tops and made his way over to me. 'How'ya!' he said, proferring a large ham. 'Malachy McCourt. I heard you were coming and that you're from Barrington Street in Limerick?'

I shook his hand and nodded.

'How about that for a coincidence?' says he, 'I grew up in the lane behind your house.'

'Schoolhouse Lane?' I said, remembering the terrace of two-storey cottages behind our house. 'You're Ab Sheahan's nephew?'

'That's the one,' he said.

So here was the famed Malachy McCourt. I'd heard about him and his adventures with Richard Harris and Sean Connery when he owned a pub in Manhattan and succeeded in drinking himself out of it. His yet-to-be famous brother was unknown to me at that stage since *Angela's Ashes* hadn't hit the bookstands.

Malachy and I became friends at our first meeting. It was good to have a friend. In the early days of sobriety, I was wary about my non-drinking, living alone in the world's most exciting and tempting city. Malachy was a significant touchstone in those fragile days, and as well as discussing Limerick, we also talked about the booze and how he, too, was getting on with his life, one day at a time.

At the first coffee break, we named off all the families who lived in the Lane, as well as his uncle Ab: the Moores, the Tobins, the Lillises, the Pattersons, the Mahers and my beloved minder, Imelda Lyons, and her beautiful daughters. And, of course, the Italian-Limerick brothers Jack and Junior Bussoli, who made holy statues in the same building where my uncle recruited Fianna Éireann Boy Scouts as volunteers for the IRB in the early 1900s.[1] Gone were the young cadets lining up

for military training, replaced by plastered Blessed Virgins, St Josephs, and the Holy Infant Jesus, awaiting the blush of life to appear on their cheeks via the crimson mist of Bussoli's magic spray. I can still smell the toxic whiff of spirits in Jack's spray gun; feel the snag of charcoal fumes at the back of my throat while the holy icons dried patiently before a clinkering brazier. Malachy McCourt and I had all of this in common as we advanced through *Trinity*.

Leon Uris was a gruff presence in contrast to Larry Arrick's benign directing style. Leon told me that he believed the Irish and the Jews had much in common: we were two small nations who had been uprooted and displaced and who shared a strong belief that education would equip us to make a significant mark on the wider world.[2] Leon also told me that he and his wife Jill (a successful photographer) had lived for a while in Ireland. They would get up before dawn to photograph fairies and leprechauns. This convinced me that Uris's view of Ireland was informed by a mix of nationalist fervour and a metamystical appreciation of Darby O'Gill.

The flaws of *Trinity* might have been ironed out if Uris wasn't so wedded to his original novel. He resisted all changes or deletions. At nearly a thousand pages, the novel was such an epic that the only way to put it on the stage was to spread it over two nights. It was like doing two productions at once. When we previewed it in the Gerald W. Lynch Theatre, some of the audience left relatively 'early' – *Trinity* was so long, some said, they felt as if they had lived through the Great Famine and the 1916 Rising in real time. Some stayed long enough to fill in the survey forms we supplied to them at the end. The overwhelming feedback told us that mounting *Trinity* on Broadway would be a Herculean task. The producers paid attention to the advice, and the project went no further. On opening night, my cousin Harry who was visiting New York, accompanied me. Meeting Uris at the bar afterwards, he was confronted with a question from the author: 'Well, what did you think of *Trinity*?' asked Uris, keen to get an Irish perspective.

Harry struggled to reach for a response. 'It was, eh, interesting,' was all he could muster.

'That's the worst thing you could say to an author.' So saying, the gifted creator of *Exodus*, *Topaz* and *Trinity* stomped off.

While I was working on *Trinity,* the Rodney King riots broke out in LA. A fear came over Manhattan that the black community in Harlem might descend on shops in midtown and create the kind of inferno we were seeing in LA. I sat in my apartment in Stuyvesant Town working on the score while police cars chased kids setting trash cans on fire. A radio station called 1010 Wins, whose slogan was 'You give us ten minutes, we'll give you the world' spewed out inaccurate newsflashes like 'We are getting reports that Penn Station is on fire!' creating panic over the airwaves. Remarkably, this tension is still prevalent on the streets thirty years later as Black Lives Matter expresses the racial and economic disparity and the excessive use of police force experienced by the black community today. Far-right groups like the Proud Boys hold the line for armed resistance within a fractured society. As Martin Luther King said in 1966: 'I think that we've got to see that a riot is the language of the unheard.'[3]

On the lighter side, I went to see Yothu Yindi, an Australian-Aboriginal band, in the company of Mike Scott of the Waterboys, his wife Irene, ex-Windmill Lane, and Liam Ó Maonlaí from Hothouse Flowers. It was not an exciting performance, awkwardly mixing Aboriginal music with disco, complete with three miniskirted backing singers who bumped and ground their way through the evening. Liam was dressed in Native American gear with fancy moccasins and carried a five-foot didgeridoo. He was heading to Bearsville in the morning, he explained, to record with Hothouse Flowers. I asked where he was staying, and it turned out he intended to wander around New York till dawn, then catch a Greyhound to Woodstock, where the studio was. It was raining, so I suggested he stay in my spare bedroom. He chose the sensible option, and we hailed a cab back to Stuyvesant Town.

Stuyvesant Town (or Stuytown) was built to house American war veterans and their families. The apartments weren't stylish but were comfortable, and since they were reserved for army folk, I was lucky to be offered a place through an ex-vet lawyer working on *Trinity*. Across the hall lived Betty de Cillis, who made no secret that she kept an eye on all untoward movements. The morning after Liam's stay, I went to the studio early and shouted into his bedroom to make sure to pull the door after him when he left for Bearsville.

I returned at 6.30 p.m., and Betty was waiting for me in the hallway: 'Mr Waylen, Mr Waylen!' She was agitated, 'There was a strange man in your apartment. He had long hair and a beard and looked like Jesus. I saw him leave this morning wearing bin-liners on his feet.'

'Ah, okay, Betty,' I said, trying to calm her down while wondering what the bin-liners were about. 'That was a friend who plays in a famous band in Ireland. He dresses a bit unconventionally – you know what these rock artists are like! Let me call him and make sure everything is alright.'

'Please do, Mr Waylen. I was about to call the cops in case he was a stalker or a homeless person.'

I didn't let Betty know she was sort of right about the homeless bit, but I assured her that he was a talented, nice man and that she would have enjoyed his company had she spoken to him.

'Are you kidding?' – she was wide-eyed – 'Ya think I'm crazy?'

She closed her door.

In my apartment, the light was blinking on the answering machine. 'Hiya, Bill. Liam here. Listen, thanks for the bed last night. I'm above here in Bearsville, but I left the feckin' didgeridoo in the bedroom. By the way, I stole a few plastic bags because it was pissin' rain, and these moccasins can't take the wet. Anyway, would you mind bringing the didgeridoo to the Lone Star Café tonight where Eileen Ivers is playing? She'll bring it up to Bearsville when she comes to play on the session tomorrow.'

I'd arranged to meet Rosaleen Linehan for supper in the West Village that evening. She was in New York for the Tony Awards, where she was nominated for her portrayal of Kate in *Dancing at Lughnasa*.[4]

33. TRINITY – LEON URIS

So now I had to take Liam's didgeridoo to the restaurant. From the cab driver's expression, I could see that transporting didgeridoos was not something he relished. He stared with distinct distaste at all the painted tribal markings as I manoeuvred it into the back of his cab.

I arrived at the restaurant where I was greeted by the camp and charming maître d': 'Ah, Mr Waylen, nice to see you again. Your guest is already here. Before I seat you, would you like me to check your jacket?'

I was wearing a leather jacket but told him I would keep it with me.

'Of course. And now, what about your log? Would you like me to check your log?'

He was so smooth, this guy; nothing fazed him. I wouldn't have been surprised if he offered to keep it in the back with all the other logs. However, being aware of the almost spiritual aura around the didgeridoo, I told him I would take it to the table with me. What if one of the other patrons mistook it for their log! As I joined Rosaleen for dinner, she glanced suspiciously at my wooden accompaniment, shook her head and said, 'I won't even ask!'

The didgeridoo made it safely to Woodstock courtesy of Eileen Ivers, who played brilliantly on the Hothouse Flowers album. She also played on my score for *Trinity*. A few years later, she would be on the stage (minus the log) at Radio City with *Riverdance*.

34. *The Spirit of Mayo* and Working with the Corrs

I got a call from my brother-in-law Brian Quinn who worked with Mayo Tourism. Prof. Seamus Caulfield – the eminent archaeologist – had done excavation and research leading him to conclude that a Neolithic settlement on the north Mayo coast was evidence of the world's oldest known agricultural field system.[1] This led to the construction of a visitors' centre at the picturesque and remote location of the Céide Fields. Brian wanted to commission music to celebrate this remarkable discovery and run events, including a concert at the NCH. I met Prof. Seamus Caulfield and visited the site, and in 1993 started to write *The Spirit of Mayo*.

Since the piece included ancient Irish history, I wanted it to begin with something elemental: ten drummers unaccompanied. This was followed by an ancient Irish prayer in Latin from a collection of fourth-century monastic writings called *Deus Noster*. I loved the choir Anúna,[2] founded and directed by the gifted Michael McGlynn. I was so struck by their unadorned choral style and beautiful arrangements that I had involved them in the W.B. Yeats Festival and now felt

34. THE SPIRIT OF MAYO AND WORKING WITH THE CORRS

they were ideal for the Mayo project. I drove the length and breadth of County Mayo listening to local choirs to get a hundred voices to join Anúna for 'Deus Noster' as well as to sing my new setting of the Antoine Ó Raifterí poem, 'Anois Teacht an Earraigh' with Caitríona Walsh taking the soprano lead. Declan Masterson played the pipes air, which I called the 'Deserted Village' bringing us up to famine times in Mayo, and then back to a finale involving the drummers, choirs and orchestra.

The Spirit of Mayo received its first performance as part of the Mayo 5000 Concert at the NCH on 8 June 1993 with the National Symphony Orchestra conducted by Proinnsías Ó Duinn and attended by President Mary Robinson. Like *The Seville Suite,* John McColgan produced and directed the concert. Jean Butler and Michael Flatley, both with Mayo connections, danced separate performances.

Michael Flatley did his moonwalk dressed in a short waistcoat, tight trousers with a cummerbund and a wide-brimmed fedora. This style had evolved through Cab Calloway, Daniel Haynes, Rubberneck Holmes, and other black dancers, but Flatley modelled his from Michael Jackson's more recent versions and incorporated it into his Irish dance routine. It was a crowd-pleaser and confirmed Flatley's gift as a flamboyant and magnetic performer.

Jean Butler had a different kind of magnetism. Her soft-shoe performance was poised and graceful, and when she executed a jeté, she became airborne. We used to call her 'she who floats'. Her hard-shoe dance was no less beautiful to watch and was imbued with a feminine strength that made her challenges elegantly sensual and haughtily erotic.

Moya Doherty, now married to John McColgan, was also there. It was remarkable that so many of the elements in that concert were to appear together again within a year for *Riverdance*. It's also fitting that President Mary Robinson was present. Three years earlier, in her inaugural speech, she closed her address by quoting W.B. Yeats: 'I am of Ireland. Come dance with me in Ireland.' For many of us that night in the NCH, we were about to take her at her word.

PART 5: 1990s – *UISCE BEATHA* – THE WATERSHED

Programme for The Spirit of Mayo *performance.*

34. *THE SPIRIT OF MAYO* AND WORKING WITH THE CORRS

This was also the last year of the W.B. Yeats Festival at the Abbey. We performed three plays: *The Cat and the Moon*, *A Full Moon in March* and *The Words Upon the Window Pane*. On the opening night, the new US ambassador appeared. At the cheese and wine reception afterwards, I was drawn to the sparkle and wit of this woman, her grasp of the quirk and kink of Irish humour, her endless curiosity about people, and her flinty lack of sentimentality. Jean Kennedy Smith, sister of JFK, RFK, Ted Kennedy, Eunice, Pat and Kathleen, was to become an excellent friend to Denise and me and our whole family. She hosted memorable evenings at the residence in the Phoenix Park, inviting artists, poets, musicians, authors, journalists, politicos and other ne'er do wells. In fact, during her tenure, her house became a meeting place not only for the arts community but for the broader civic community north and south; JKS, or 'the Ambassadorable' as her friends called her, was to occupy an important place not only in my future career but also in the careers of other musicians – apart from her role at the centre of the Northern Ireland Peace Process.

In March 1994 the Corrs played at the popular Whelan's pub on Wexford Street. I mentioned the gig to Jean Kennedy Smith, and she said she'd love to hear them. So here we were, JFK's sister, her assistant Amy Siegenthaler and me, squeezing through a packed crowd in a steaming pub to listen to this unheard-of band of neophytes from Dundalk. They played a set of original material, well-known covers and some Irish jigs and reels that set the venue alight. Jean loved them and, after the show, invited them to Boston to play at an event hosted by Ted Kennedy. So in June, they boarded a flight to play their first gig in the US.

John Hughes, their manager, not being one to miss an opportunity, brought the band to New York and hung around the door of the Hit Factory, where the record producer David Foster was recording. Through irresistible persistence, he engineered a meeting with Foster. Sharon, Andrea, Caroline and Jim played an impromptu concert in the studio and, within no time, signed a contract with Foster for their first album. That gig in Whelan's had set them on a course leading to

world tours and gold and platinum albums. I visited the Corrs and John Hughes when they were recording at David Foster's home studio in Malibu. It was great hearing the harmonies we'd done on the demos in Windmill Lane faithfully retained on tracks like 'The Right Time'.

The Foster home, previously owned by Arnold Schwarzenegger, was suitably palatial. Spread over acres near the Pacific Coast Highway, it had, among other conveniences, stables and a funicular to take you to the tennis courts. David's then-wife, songwriter Linda Thompson, who was an ex of Elvis and had previously been married to Bruce Jenner (now Caitlyn), entered the room. Brian Avnet (David's manager), the Corrs, John Hughes and I were talking to David about coming to London to see *Riverdance*.

'Hey, darling,' David called to Linda. 'We're chatting about going to Bill's show in London next month. Come with us and see it.'

'But I'll be in Amsterdam with the children.' Linda was doubtful.

'Oh, come on. The nanny will be there; it's just for one night. It is only an hour from Schiphol.'

Linda considered it. And then a solution occurred to her. 'Will you send a plane for me?'

This was a request none of us was expecting and unlikely ever to hear again. But it did keep us on our toes as to the kind of company we were keeping.

35. *Riverdance* – the Interval Act

I've been interviewed countless times in the quarter of a century since *Riverdance* appeared in 1994. As you'd expect, the questions ranged from the banal to the perplexing. For example, in a memorable UK interview, I was asked: 'How many pairs of tights does the *Riverdance* cast go through in a year?' The composer is not usually privy to this kind of specialist knowledge or arcane detail.

In contrast, I was once asked through a translator in Tokyo: 'What influence do you think the album of Seán Ó Ríada *At the Gaiety* had on the development of traditional Irish music?' That stopped me in my tracks, particularly since it came from a culture so distant from our own. However, the question that arose in ninety per cent of interviews was this: 'Did you know, when you were writing *Riverdance*, that it would become the success that it did?' The possibility that any of us involved anticipated its global reach was absurd. We had no idea it would take off as it did and resonate in unforeseen places. I was asked this so often I was tempted to answer: 'Yes. I just put off doing it until I was forty-five.' And the truth is that I had to reach that age and travel through certain musical, personal and career phases before I could join the dots for *Riverdance* to emerge.

PART 5: 1990S – *UISCE BEATHA* – THE WATERSHED

There is a small coffee shop a few doors from Searson's on Baggot Street where Moya Doherty and I arranged to meet in December of 1993 to discuss a project she had in mind. I always enjoyed meeting Moya, who combines a no-nonsense Donegal practicality with an incisive sense of humour. We sat in the window of the café, and she outlined her plan.

She had been appointed the producer of the 1994 Eurovision Song Contest and wanted me to write the opening music for a visual presentation with Macnas, the Galway street theatre company. In addition, she wanted me to write a seven-minute score for the centrepiece of the contest. Her idea was to present Irish dance in a fresh and contemporary way. She had already discussed this with the choreographer, Mavis Ascott, who suggested a long line of Irish dancers as an exciting theatrical experience; no stranger to the choreographic 'kick-line', Mavis used this effectively in *The Pirates of Penzance* and *H.M.S. Pinafore*.

Moya also referenced the drummers and the choir that she had seen at the Mayo 5000 concert in the NCH and suggested working these into the musical piece. Despite this, years later, Mavis told me Moya was not convinced about approaching me to write the music. She wanted a more up-and-coming composer. However, she decided I was the best person to contact on receiving advice from others, including Mavis and John McColgan.

Moya and I discussed how these elements could be included in the seven-minute composition, and before we parted, she gave me a final source of inspiration to consider. She explained that the whole event was to be staged at the Point Theatre on the banks of the Liffey. She had instructed the designers to use the river as a motif for their set designs.

I went away to think about this, and the composition began to germinate over the following days. A river's life was an excellent place to start, beginning as rain feeds the source, moving over the land, nurturing the earth, growing in size and intensity until it enters the sea at an estuary. Then, it ascends back into the clouds, and the journey begins once more.

I wanted to begin with a song for Anúna to represent this musically, as the clouds gather and rain down upon the land. Ironically, this was

the last thing I wrote for the piece – lyrics take a long time to come for me. I saw Jean Butler as the Riverwoman, flowing through the land and bringing life to the soil. (Jean requested me to write a slip-jig for her solo.) Standing for burgeoning growth, Michael Flatley is heralded by the drummers. After his solo, he challenges the Riverwoman in a tense 6/8 and 4/4 dance, ultimately releasing into a full-blown jig – Michael correctly insisted on a jig to finish. At this point, the river widens, and the two principal dancers are joined by increasing numbers of dancers leading to the kick-line Mavis Ascott envisioned.

To suggest I arrived with a completed composition when rehearsals began is far from accurate. Those early rehearsals were highly charged as we all learnt about each other as people and artists. I met Michael for the first time and marvelled at the fluency of his footwork. There was little he couldn't handle, and I was excited at the prospect of writing for two very unique dancers. There were conferences and discussions, and I went back and forth between the rehearsal studio at Digges Lane and my attic atelier at the top of our house in Ranelagh, making amendments to tempo and shortening or lengthening sequences until the piece was honed down to its final state. Mavis Ascott did all the staging choreography. This involved creating the troupe patterns and designing how it was presented theatrically.

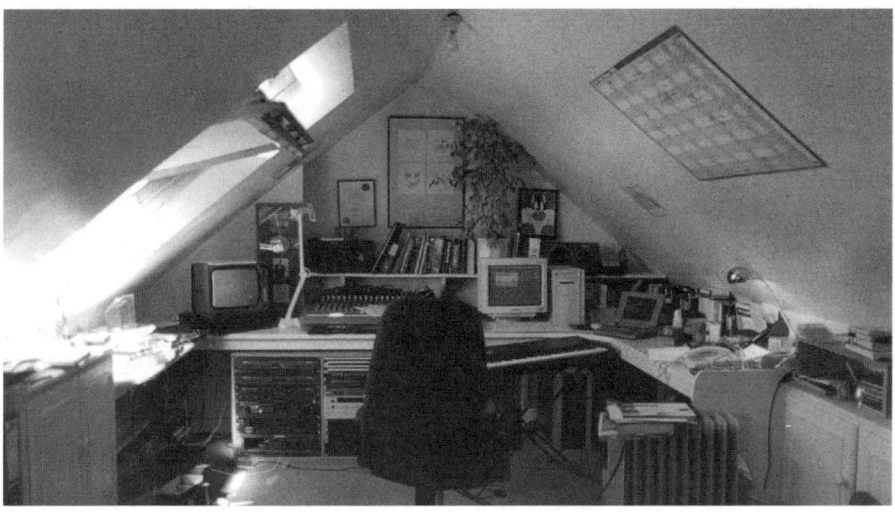

The attic atelier at the top of our house in Ranelagh.

PART 5: 1990S – *UISCE BEATHA* – THE WATERSHED

Meanwhile, Michael and Jean choreographed their own solos and the taps for the ensemble sections. The 6/8 and 4/4 sections were entirely new for the dancers in 1994 because this mixed time signature wasn't native to Irish music. To help the troupe get their heads around the rhythm, I gave Mavis a nonsense mnemonic: 'Chaggada chaggada cheque book cheque book'. This was how many of the troupe internalized the mixed rhythms of those bars. Daft, but it worked.

The working title was *Uisce Beatha,* the translation being *Water of Life*. However, it also means whiskey in Irish – a problem, thematically. So, when the time came to decide on a final title, I called Moya from our kitchen in Ranelagh. In the light of what came afterwards, it was a memorable phone call: 'Moya, I've been thinking,' I said (I heard her hold her breath over the phone). 'What do you think of "*Riverdance*" – all one word?'

I heard the relief in her voice. 'Brilliant,' she said. 'Much better. Since it will be aired as part of Eurovision, *Uisce Beatha* might have been a tongue-twister for some foreign presenters.'

Then, came the Anúna part. The lyrics took time, but I arrived at a piece I named 'Cloudsong' written for soprano voice and chamber choir:

> *Hear my cry in my hungering search for you*
> *Taste my breath on the wind*
> *See the sky as it mirrors my colours,*
> *Hints and whispers begin*
> *I am living to nourish you, cherish you*
> *I am pulsing the blood in your veins*
> *Feel the magic and power of surrender to Life – Uisce Beatha*

I brought 'Cloudsong' to the first Anúna rehearsal. Watching Michael McGlynn rehearse Anúna is like observing a demanding military exercise directed by a sergeant major who is also a poet. Technical issues of breathing, phrasing and tuning are highlighted early and dispatched. Then he creates the kind of unified focus within the choir that produces the ethereal quality which defines Anúna and places it uniquely apart from other choral ensembles. Katie McMahon, who sang the original

35. RIVERDANCE – THE INTERVAL ACT

soprano solo, was gifted with a beautiful instrument that soared with ease over the high melody I wrote for her. Michael demanded that all his group sing in a pure and unadorned voice, free of vibrato and counter to the decorated bel canto style typical in choral singing elsewhere. I loved the performance style of Anúna: pared back, processional and almost ritualistic, tapping into something elemental.

Dance studios are the same the world over: rooms with terrible acoustics; floor-to-ceiling mirrors wildly echoing music and taps; out-of-tune pianos and poor audio playback systems; and sweaty gear strewn everywhere; discarded water bottles; plus dance studios are normally situated in a part of town where real estate is cheap. But Digges Lane, around the corner from Dublin's Gaiety Theatre, was on the upper end as dance studios go – it still has a special place in the hearts of those who were part of early *Riverdance*. For weeks, the building throbbed with the clacking of dance shoes and the pounding of drums. I'm sure passers-by on South William Street stopped to look up, trying to figure out what was going on.

When we gathered in Digges Lane for the first run-through with the whole troupe, everything went against it. The room, already cramped, was stuffed with the TV design team. Mavis Ascott and her excellent dance captain, Belinda Murphy, were present, as well as Moya, Pat Cowap and several of the RTÉ big brass. The dancers were dressed in sweaty workout gear; ventilation wasn't great. There was no professional lighting. No dry ice. No trad musicians. No orchestra. Just my homemade demos played through tinny speakers.

Yet, when that musical built up to the finale, and all the elements came together, and the troupe formed into the kick-line and advanced to the staccato foot stamp and musical stab at the finish, there was a communal intake of breath. We all looked at each other. We had something. Yes, there were things to fix, extend, cut and adjust, but this was something new, and everyone in the room felt it.

Practical issues had to be ironed out before the Eurovision performance. It was going to be live – but how much of it could be live from an audio

point of view? The full effect of *Riverdance* depended on the rhythmic synchronicity of traditional musicians, drummers, choir, orchestra and dancers. In the Point Theatre, with the orchestra in one location, the soloists elsewhere, the choir making a procession around the stage, and the dancers all over the place, it would be impossible for the engineers to record and synchronise the performance. We had no option but to pre-record the music. On the night, the piece would be performed live, but for the broadcast, we needed the security that there was something solid to keep it all together – we needed a backing track.

I set about finding the musicians. One of the first people I called was the saxophonist, Kenneth Edge. In many ways, his sax was the glue that unified all the ensemble musical performances on *Riverdance*. He is technically superb and blindingly accurate for the fast musical playing required in the score. Once I'd secured Ken, I contacted others: Ronan Browne to play uilleann pipes; Máire Breathnach, fiddle; Cormac Breathnach, whistle; and Tommy Hayes and Desi Reynolds, percussion. Together with the RTÉ Concert Orchestra, we assembled at Windmill Lane Studios in its new location in Ringsend and recorded *Riverdance* and the Macnas opening sequence. Noel Kelehan conducted the orchestra, and Andrew Boland recorded and mixed the tracks.

There were further technical issues: the sound of twenty-four dancers pounding through to that finale was an essential part of the visual and musical experience. We wouldn't be able to replicate this on the Eurovision stage – the challenge of getting microphones to pick each dancer's feet as they moved about would be a nightmare, in fact, impossible. So, we went to Studio 8 at the Radio Centre in RTÉ to record the taps.

If Digges Lane was small, Studio 8 was tiny. It already had a concert grand piano in it. Looking back with twenty-five years of experience, it's astonishing that we got through it. Nowadays, a particular floor would be installed, comfortable to dance on and acoustically resonant to catch the characteristics of heel, toe, triplets and stamps. But in 1994, Andrew Boland placed as many mics around the feet as would fit in a confined space. Everybody had to wear headphones – another

35. RIVERDANCE – THE INTERVAL ACT

headache. Despite this, it turned out well except for one thing: the dancers' steel tips shredded the floor and subsequently a flock of RTÉ internal complaint memos flew about, which landed in some drawer upstairs where, thankfully, they remained.

Like everybody else, I'd no idea what the reaction to *Riverdance* might be, but I wanted a permanent record of the piece, other than a one-night stand on Eurovision. I thought we should have a record ready. I went around the Irish record companies, to RTÉ itself, to see if I could interest them in releasing a single of *Riverdance*. I was met with a universally blank response, even from companies I knew well and had released my earlier material, like my long-time supporter John Cook at Tara Records. Nobody could justify spending the kind of money it would take to manufacture, market and distribute a seven-minute piece of music. No radio station would air such a long record, and anyway, an instrumental track with no visible artist to pin it on was not a viable proposition. It was a non-starter.

Then I remembered something. A few years earlier I had produced music for Church and General[1] for a promotional event they had on at the NCH. They were a large insurance company with a major profile in Ireland. I called their head of promotion, Damien O'Neill, explaining what I wanted to do.

'Oh, you mean the part where everybody goes and makes tea while waiting for the voting?' said Damien.

This was not what I wanted to hear.

'Well, yes,' I said. 'This will be a major piece with a full Irish dance troupe led by a brilliant pair of Irish dancers from America.'

He wasn't encouraged by this information. 'And what *is* it exactly?'

'Well, it starts with a choir, a team of drummers, traditional instruments, and then a full orchestra leading to a big finale.'

'Hmm' – Damien was hesitant – 'and how would we fit in?'

'I thought maybe Church and General would sponsor some of the costs and, in return, have the promotional association with the project?'

Damien was still not convinced, but before I nearly gave up, he said: 'Is there any way we can hear it?'

I jumped at this. 'I have a home demo; it'll give you an idea. I'll send a tape to you today. See what you think.'

'Sure, send it over, Bill. I'll play to a few people here and get back to you.'

I couriered a cassette over to Church and General and crossed my fingers.

I heard nothing that day or the following morning, but in the afternoon, a call came. 'Hey, Bill. We've had a good few listens; everyone here likes it. How much are you looking for?'

I swallowed. 'Six grand to cover manufacture, printing and promotion.'

He swallowed. 'Mother of God.' He thought for a minute. 'Could we have the Church and General logo on the front cover?'

He could have it tattooed on my chest if he wanted. 'Of course,' I said.

'Ok then, Bill. We're on board.'

I needed a label to put the record out. Paul McGuinness and I had formed a publishing company years before this, so our company, McGuinness Whelan, could be the music publisher for *Riverdance*. Still, we needed a record company to operate the mechanical rights. Since Paul McGuinness was U2's manager, it was convenient and neighbourly that the single would be released on one of the U2 labels. But there was a hitch: Dave Pennefather. The guy I had a thorny run-in with over 'What's Another Year' was now the head of U2's label Son Records. In a business not noted for mature behaviour, I put our botched history behind us.

Pennefather negotiated a deal with RTÉ for the use of the recording, and the single was pressed and ready for release the morning after Eurovision – proudly (and discreetly, it must be said) bearing Church and General's logo on the cover. The irony that a conservative and prudent insurance company enabled the record's release while the capricious and impulsive music business stood mutely by has never been lost on me. At the time, I was just happy that we had a permanent and publishable recording of *Riverdance*. But as things turned out, the production of the single was much more significant than I realized at the time.

35. RIVERDANCE – THE INTERVAL ACT

Rehearsals for Eurovision began at the Point Theatre in the last week of April 1994. When we did 'Timedance' in 1981 only twenty countries were involved, but now we had seven new Eastern European countries making their Eurovision debuts. The excitement around the city and the Point Theatre was immense. The delegations from each country watched the competition's rehearsal performances, and the bookmakers began to declare the odds for the various entrants. Normally, the tea-making spot, as Damien O'Neill called it, is granted a few rehearsals, but generally, it goes unnoticed in the tumult of competitiveness that permeates the contestants' rehearsal slots.

But something unusual was happening. Early in the week, word spread that the Irish centrepiece was creating a stir. More and more countries were arriving at the *Riverdance* rehearsals, and by the end of the week, virtually all the countries were checking the schedule and turning up, cheering and applauding. It was unheard of in Eurovision circles. When we did 'Timedance' back in 1981, the piece was pre-recorded and just played from VTR. This was often the case with this segment on Eurovision, but Moya insisted that it be live with all the other acts. This injected nervous energy and excitement into the performance of *Riverdance*, and while it ate into the overall rehearsal schedule, it proved to be the right instinct. The audience at the Point would experience a raw first performance instead of looking up at screens to see a polished and edited pre-recorded presentation.

The RTÉ director was Pat Cowap. He was a young director and had his hands full with songs from twenty-five countries plus a seven-minute segment with a choir, twenty-six dancers, onstage drummers and an orchestra. But, what I remember from that maelstrom of a week was how calm it all was. Pat had a gentle way of exercising control, and Moya had assembled a team around her who were highly competent and experienced, mostly women. The production office at the Point emanated calm. I'm sure some might now describe it as a rictus brought on by panic, but I remember going in the day of Eurovision and wondering if they knew we were going on air that night. There is no doubt that preparation was the key to this, and Eurovision '94 had

all the signs of being a well-oiled and serviced craft that would withstand whatever three hours of live television with 400 million viewers could throw at it.

Denise and I sat for the performance though I felt like pacing around until it was over. I have no memory of the songs except for the Irish entry: Brendan Graham's 'Rock 'n' Roll Kids'. With his unique eye and ear for creating something that stands apart from the crowd, Brendan had chosen Paul Harrington and Charlie McGettigan to perform this catchy tune. The two Irish artists did it simply, one on piano, the other on guitar, without any other accompaniment in sharp contrast to other entries drenched in gimmickry and fuss. They were in a different class altogether.

We came to the centrepiece, and our troupe were backstage adrenalin pumping. The idea to perform this live was good for the energy of the performance but bad for the nerves. Twenty-six dancers up on the stage executing all that detailed choreography with Mavis Ascott's staging moves in front of such a massive audience was enough to put the blood pressure into the red zone. Jean Butler had an extended solo to execute before anyone else joined her. She had mentioned to me earlier that the floor was slippery. What if her natural grace was upended by a slippery floor? Michael Flatley asked me to write a special fanfare for his entrance. What if he flew out of the wings and onto his rear end? 'I'm gonna go BAM, Bill,' he promised with characteristic Michael understatement. What if one of the twenty-six slid on the floor and brought the others down with them? These thoughts occurred many times before the performance, but once it started, we were all just as caught up and as mesmerized as the audience who were seeing it for the first time.

As the music built and the stage filled with dancers, you could hear the gasps and one or two waves of spontaneous applause. And just like at that first Digges Lane rehearsal, there was the moment after the last staccato chord, a split second of silence. Then, a massive eruption and the whole Point Theatre was on its feet. At moments like this you remember absurdities like the security guards standing expressionless amid the euphoria. I will never forget that image of contrasts. I looked

35. RIVERDANCE – THE INTERVAL ACT

up at the TV monitors as the cameras panned over the audience and paused on the smiling face of President Mary Robinson. I remembered her inauguration speech: 'Come dance with me in Ireland.'

That night, all of Europe heeded the call.

Then the voting happened, and the juries decided that a simple song with just guitar and piano should take first prize. Brendan Graham and his two 'Rock 'n' Roll Kids' had won it for Ireland, leaving Poland behind by over sixty votes. All the RTÉ top brass looked like they'd need to be resuscitated as they faced another year of Eurovision prep and expenditure.

Celebrations went long into the night and the whole evening was a blur as we processed what had happened. *Riverdance* evoked responses from all over Europe – except for Spain, incidentally. For some unknown reason, Spanish TV decided to ignore the Irish interval act and so missed the performance. Their viewers were treated to commercials, news and other fillers. However, everybody else had got it, and Son Records had serviced all the radio stations with the single.

By Monday, it was being played off the air. The BBC commentator on *Eurovision*, Terry Wogan, plugged it on his radio programme every morning. It went straight into the Irish charts at No. 1 and remained the top-selling single for eighteen weeks. It hit the British Top 10. This was gratifying for a record with no pre-promotion and no artist to link it to. But there was a more significant result, and it is why I am ever grateful to Damien O'Neill and Church and General: there would have been nothing to play on the radio after the Eurovision had we not had the single. The performance at the Point would have been a memory, but the record immediately reminded everyone of what they had seen. The record was what kept *Riverdance* in the public consciousness while we figured out where to go from here.[2]

After the dust settled and everyone recovered from Eurovision week, discussions began to see what we could do in response to the undeniable audience enthusiasm for *Riverdance*. It was evident that there was a big enough appetite to justify mounting a full-length theatre show, using

PART 5: 1990S – *UISCE BEATHA* – THE WATERSHED

Riverdance as the model and incorporating the original seven-minute piece into the narrative – whatever that might be.

Irish Top 30 Singles of 1994

1 RIVERDANCE........ Bill Whelan feat. Anúna and the RTÉ Concert Orchestra *(Son, RTÉ)*

2 LOVE IS ALL AROUND Wet Wet Wet *(The Precious Organisation London)*

3 SATURDAY NIGHT ... Whigfield *(Energy)*

4 COME ON YOU REDS The Manchester United Football Squad *(PolyGram TV)*

5 GUGALIONE .. Perez "Prez" Prado *(Bmg)*

6 STREETS OF PHILADELPHIA...................... Bruce Springsteen *(Columbia)*

7 I SWEAR .. All 4 One *(Atlantic, WEA)*

8 WITHOUT YOU ... Mariah Carey *(Columbia)*

9 THE SIGN .. Ace of Base *(Arista, Mega)*

10 LOVE ME FOR A REASON ... Boyzone *(Polydor)*

Source: https://www.ukmix.org/, Irish Year End Charts of 1992, 1993 and 1994.

36. Riverdance the Show

Moya Doherty spent the next six months raising funds from investors to mount a full-length show – which at that time did not exist. However, the goodwill towards the original *Riverdance* was such that investors felt there would be a ready audience if the creative team were reassembled. Moya knew that Flatley and Butler would have to be involved, but no director was in place. She asked me what I thought if John McColgan, her husband, were the director? I'd never worked with John on a theatre project, but we'd worked closely on *The Seville Suite*, *The Spirit of Mayo* and countless TV projects where he proved himself to be a smooth and efficient director. We were also personal friends. I saw no reason why John shouldn't be the person to take this on. We were all taking leaps of faith.

Investors included the promoters Maurice Cassidy and Tommy Higgins and my publishing partner, Paul McGuinness. RTÉ, through Liam Miller, also committed to a significant first investment. Together with funds Moya and John raised personally, there was now sufficient capital to get the show on the road.

But what show?

I was convinced of two things as we considered where to go from here. First, the river as a central motif could be elegantly transposed from a seven-minute piece to a two-hour show. Second, an entire evening of Irish dance wouldn't engage the audience for long. Irish dance has a very specific, technically challenging, but limited choreographic vocabulary, unlike ballet or contemporary dance. Arm movements are not encouraged, body movement from the hips up is restricted, and the overall body posture is straight with little facial expression.

I imagined a very loose narrative. The river becomes a metaphor for a native people with their customs and traditions. They are forced out of their homeland and exposed to different cultural forms. They interact with and are influenced by those styles and return, like the river to its source, changed and invigorated to begin the next stage of their journey.

As the producer, Moya Doherty insisted we have the show ready before Eurovision the following year, meaning that the whole production would have to be written, recorded and rehearsed before the 4 February 1995 – a scant six months.

If we were to stray into other cultures, I wanted to work with music forms I was familiar with. My recent connection to Spanish music and dance beckoned, and, as I had recorded an album of Eastern European music with Andy Irvine, I felt comfortable there. Also, since jazz informed my compositions, that was another port of call. These thoughts began to coalesce, so Moya and I decided we'd travel around to experience these styles of music at source.

Our itinerary would take us to Seville to meet with María Pagés and onwards to Budapest, where Nikola Parov, the gadulka and kaval player on *East Wind*, could introduce us to some choreographers and musicians. Since Michael Flatley was choreographing the Irish steps, Moya invited him along, and the three of us headed off in the hot July of 1994.

María Pagés had her own dance studio in Seville, where she spent time with Michael exploring how they might work together. We left them to it and wandered around the beautiful Moorish surroundings of this historic Andalusian city. All the time, we were discussing what

36. RIVERDANCE THE SHOW

Riverdance the Show might be and what international elements we could incorporate. We were starting to realize that our days would be focused on nothing but *Riverdance the Show* for the following year.

We returned to the studio to find Michael and María exhausted, having probed the points of commonality and disparity in the footwork of their native cultures. After a necessary siesta María, always the generous and willing hostess, took us around the old town, visiting tapas bars and savouring the nightlife of Seville. It was the first time I ever tasted Rabo de Toro, amazed that a bull's tail could be tenderly succulent and delicious.

On our second day, María brought the flamenco guitarist Rafael Riqueni to meet us. A native Sevillano, Riqueni was identified as a unique talent at an early age. He studied guitar under Manolo Sanlúcar, and when we met him in 1994, he was thirty, had already released four albums, and was one of the most celebrated flamenco guitarists in Spain. He was quiet and reserved with an aura of fragility, but when he picked up the guitar, he became a different animal altogether.

When Rafael played, I had my first glimpse of *duende* up-close; that indefinable quality that infuses flamenco and has, I believe, a cousin in Irish sean-nós song and dance. Not to trivialize it, but *duende* is like sean-nós, only hotter. Bob Quinn, in his instinctual and engaging film *Atlantean,* explored the vein that runs through the music and dance of North Africa, Morocco, Andalucia and onwards as far as the Aran Islands and the Scottish Isles. It is a quality that combines sadness and yearning, perhaps the same quality Isabel Fonseca heard when she lived among gypsies and wrote about it in her fascinating book *Bury Me Standing*.

I felt energized having María Pagés on board. I had spent time getting to know her at the Expo '92, and it's fair to say that both of us felt we had only scratched the surface with *The Seville Suite*. We had been keeping an eye open for further collaborative opportunities, and now I looked forward to rekindling my collaboration with her and writing music for this virtuoso, Rafael Riqueni.

We next headed for 'the jewel of the East' – Budapest. Budapest began as three settlements on the Danube – Buda, Obuda and Pest

that conjoined in the late 1800s and became the city we know today. Since its earliest Celtic beginnings, it had been occupied by the Mongols and the Ottomans and was one of the twin capitals of the Austro-Hungarian Empire with Vienna. Budapest was central to the Hungarian Revolutions of 1848 and 1956. As a boy in Limerick, I remember hundreds of Hungarian refugees housed at Knockalisheen, a former army camp just outside the city in Meelick. The Russian soviets had dealt with the Revolution of 1956 brutally by sending 1000 tanks onto the streets of Budapest, killing 4000 Hungarians. The Russian army withdrew in 1991, but when we visited in 1994, there was evidence of the conflicts that had taken place everywhere. One night I was awoken by an explosion. Somebody had planted a bomb at the historical Matthias Church on the hill in Buda, damaging the beautiful stained glass but injuring no one – one isolated incident in a city used to gunfire and conflict.

Nikola Parov had lined up several musicians and choreographers for us to see. We visited one of them in his apartment in the centre of Budapest. It was a grey, Soviet-style building, functional and devoid of any decoration. We went up in a rickety elevator and out onto an open passageway, where the walls were pockmarked with bullet holes, pitted and gouged from shellfire. We knocked on a door, all brown-stained and cracked. After a while, a distinguished-looking man appeared: 'Szia, Nikola,' he said, beckoning us to enter. The transformation was breathtaking; we had passed into another world. It was a tastefully decorated apartment, hung with unusual art and had elegant furniture. We were in the home of Zoltán Zsuráfszky, a noted ethnic choreographer who greeted us in that somewhat reserved Hungarian way. We had an illuminating afternoon looking at videos of his work and listening to him talking about the dance styles of the region. When we left Zoltán's apartment, Nikola explained that it was impolite to have any outward display of wealth but that many homes in Budapest were like Zoltán's – beautiful inside and dilapidated outside.

Nikola also took us to what is called a 'dance house'. The nearest thing we have to it in Ireland would be a céilí in a community centre or

a big kitchen. What was extraordinary was the sight of this large room filled with Hungarian families – grandparents, parents and children – all dancing together to a band playing the most rhythmically complex tunes and everyone in lockstep with the music. It was unforgettable. Since childhood, I've been fascinated by rhythmic complexity, and here I was in an Eastern European dancehall where grandads and grandkids were on the floor together, beating out those off-centre patterns with familiar ease and grace. Inspirational.

One afternoon, the three of us were walking down Vámház Körút, one of the main shopping streets in Budapest. Moya and I were chatting when suddenly we noticed that Michael Flatley was no longer with us. We looked around and there he was, waving from in front of a jewellery shop. 'Guys, guys, you gotta see this!' he shouted. He was very excited. We walked back.

He was standing at a garish shop window. The display consisted of shelf after sparkling shelf, like steps of stairs, luridly dripping with baubles, a glittery Niagara of knick-knacks and trinkets. Michael stood with an outstretched arm and gestured with an open palm at the display. 'This,' he proclaimed, 'is our show! Can you see the dancers walking down steps like these?'

We laughed.

Michael didn't.

There was an awkward moment where we wondered what to say.

'Let's get a drink,' said Moya.

That was in July of 1994, and I still hadn't written a note of music for the show. It was impossible to contemplate sitting down to write until we had an idea of what the show might be. John, Moya and I had several meetings and decided that I would write a rough treatment, and in early September 1994, we'd reconvene.

What took place at this meeting defined what *Riverdance the Show* would be about. Unfortunately, it would also drive a wedge into our relationships which, for me, from that moment on, were never to return to what they were before the meeting.

PART 5: 1990s – *UISCE BEATHA* – THE WATERSHED

I brought a four-page document that laid out the show as I envisioned it. I had titles for the pieces: 'Reel Around the Sun', 'Countess Cathleen', 'Firedance' and 'Lift the Wings'. I outlined the arc of the loose narrative that would tell the story. While changes were made over the coming months (and years), the basis for what was to become the full version of *Riverdance* was on those four pages. I felt I had a framework that we could all work on, and I could get down to writing.

However, surprisingly, John arrived at the meeting with his own document outlining what he thought the show should be about. It was less developed and had sections in it described as the 'Doc Martin Rap Routine'. The two documents were so fundamentally different that it was impossible to imagine how we could even make a composite of them. So intrinsically at odds were they that it had to be either one or the other: they were two different shows.

To describe the meeting as heated wouldn't be correct; we had a show to do, and a major fracture before a note was written would have been foolish. We were still excited at the possibilities hinted at in the original, but we had to make some serious decisions and get on with the work.

There were also personal issues to complicate matters – I felt awkward having this kind of conversation when the producer and director were husband and wife. In the end, it was a producer call. It was one of several that Moya would find herself making over the coming years, and I am sure that it caused her no end of difficulty. By the time the meeting was over, we had decided to proceed with my original proposal. Moya's heft behind this was essential. Creatively, we were back on track. Emotionally though, and in terms of my long association with John, the mood changed, and the ease with which we had worked began its slow fade into the past.

Now the deal had to be done.

In the 1980s Paul McGuinness and I formed McGuinness Whelan Music Publishers (McGW). The original idea was that we would provide the services of an old-style music publisher, finding and developing writers and placing their music in the marketplace. Paul would supply the funding and the access, and I would deal with the creative

end. It's ironic that some years afterwards, McGW would have only one writer on its books. Earlier on, we had tried to place songs by artists like Scullion and Paul Tiernan, but then *Riverdance* happened, we cleared the decks, and McGW managed and administered only my copyrights.

An essential person and eventual partner in McGW was Barbara Galavan. Barbara had worked for Principle Management and U2, where, as well as having a reputation for efficiency and hard work, she showed a natural flair for music publishing. Paul had called the legendary Freddy Bienstock and arranged for Barbara to go to London and study publishing at the headquarters of Chappel & Company. By her mid-twenties, she was one of the most experienced and capable executives in the Irish music industry.

Barbara and I got on very well. She took a keen interest in my compositional work going back to *The Seville Suite* and before. Paul and I had discussed the possibility of him managing me, but he insisted that since I wasn't a performing artist, I didn't need a manager. So, a role evolved that Barbara took on – a hybrid of personal manager, agent and publisher. We have remained close friends and allies for over thirty years; I'm blessed to have her as a colleague and consigliera to consult in bad weather and to join in appreciating the sun when it shines.

The creative end of *Riverdance the Show* was becoming solid, and it was essential that the nature of the relationships should be formalized. I had learned from experience that carrying on in a loose and casual manner rarely delivers satisfactory outcomes. It is better for everybody's mental and fiscal health to have the basis for working together agreed ahead of time – no matter how impatiently enthusiastic one might feel about the artistic side of the project. And so began the negotiations between all the parties. Moya's company, Abhann Productions, were the producers, McGW the publishers, I was the composer and RTÉ as a major investor were also stakeholders. It was a complex web of interests and rights-holders. I was represented by McGW, and we took on the services of a London lawyer, Nicholas Pedgrift.

As a historical aside, it is worth remarking that in 1994, there were almost no lawyers in Ireland who specialized in what we now call 'media'

law. James Hickey was the only one, and he was already employed by Abhann Productions. Paul had worked with Pedgrift in the past on U2 matters. I remember the first time I met Nick. He had a very English public-school vibe about him: sartorial, camelhair-coated, widely read and good company. He told me at that first meeting that among his clients were the band Gaye Bykers on Acid. That name, when delivered in a posh accent, sounds surreal, even hilarious. However, despite the prospect that I would be sharing lawyers with the Gaye Bykers on Acid, Pedgrift, for all his cultured politeness, turned out to be something of a bulldog in negotiations. And the trick with a bulldog is to know when to take off the leash and, perhaps as importantly, when to put it back on.

Over August and September we were mired in detailed negotiations. I found it hard to switch off that side of my brain and concentrate on writing. I did write 'Firedance' in that period, but it wasn't until the ink was dry on the contracts that the composing began in earnest – and that was late in October of 1994. A two-hour show had to be written and recorded by early January, when *Riverdance* rehearsals were scheduled to begin.

As the negotiations dragged on, I became impatient to start writing. Just like the first Eurovision *Riverdance*, we had no idea what public reaction we'd get when we launched the full show. I wanted to record the music I'd write over the coming months. That was a big thing for me. I would not be able to afford to record this myself. Friday 18 November was the deadline for agreeing the contracts, and as the time ticked up to a 5 p.m. cut-off, I was under pressure to agree.

There were conditions being demanded which I found unacceptable, but the dilemma was whether I could hold the line without jeopardizing the whole project. One of those conditions was that Abhann Productions insisted that they own the recordings. At 4 p.m. I got a call from Paul McGuinness: 'Hi Bill. Just wondering if you've heard anything from the other side?'

I told him that the last I heard was that I had until 5 p.m. to agree, or the deal was off.

36. RIVERDANCE THE SHOW

'Okay,' said Paul, 'well, I'm just ringing to say that no matter what happens, we will record the album. So whatever decision you make, be assured that we will fund and promote the album, one way or another.'

This was like a shot of vitamin B12 straight in the vein. That gesture of support gave me the confidence to hold out for what I believed was appropriate – as the creator of the score, I felt I had the right to own and control the recordings.

Five p.m. came and went, and we heard nothing. My mother-in-law was staying with us that weekend; she couldn't understand why I wouldn't just pick up the phone and take what was offered. Finally, at 7 p.m., the phone rang. Their offer was adjusted in a way I found acceptable, and after much legal huffing, puffing and face-saving, the deal was signed – not that I regarded this as a triumph. I had to live with parts of the agreement that were only adjusted years later when that contract ended, and terms could be renegotiated. However, there was, and still is, a culture that permeated the thinking in the music business, particularly in RTÉ, that writers should be grateful to be considered for a project in the first place: a mindset that creates an imbalance in negotiations where all parties cannot contract as equals.

Now began the most engrossing, exhilarating, frustrating, exciting and exhausting period of my career as a composer and a producer. Between November 1994 and February 1995, I rarely slept more than three hours a night. I began writing in earnest late October at my attic studio in Ranelagh. (Our neighbours, the Glennons, claim that they knew the score for *Riverdance* by heart before the show opened.) That December I installed myself in Windmill Lane, driving home at 3 a.m. and back into the studio before the traffic at 7 a.m. The young assistant engineer, Ciarán Cahill, would come in to open the studio for me and then return to bed until the whole team assembled later in the morning. I had one full day with my family during that time – Christmas Day.

As I wrote each piece, I sent them around to Michael Flatley, Jean Butler, John and Moya, María Pagés and Mavis Ascott to get their

early responses. But it wasn't until the whole dance company assembled in January that the hectic interplay between choreography and music began.

Abhann Productions assembled a superb staff to run what was to become a major touring show. Julian Erskine came on board as executive producer, a role he fulfilled until his retirement in 2020. He was the lynchpin, the fulcrum around which the show revolved, and his professionalism was only equalled by his love and care for *Riverdance*. More than any of us, his influence ranged over every aspect of the show, from the performing talent to the technical crew and the various promoters around the world. All of this he conducted with equanimity combined with a wacky sense of humour that involved wordplay and occasional clowning – especially on a night off (what goes on on the road, stays on the road – particularly that toilet seat he wore as a necklace in Tokyo!) It was no accident that his wife was the gifted and now sadly departed actress Anita Reeves. They were a perfect match. Julian displayed an immovable loyalty to Abhann Productions, and his discretion and reliability formed the backbone of the company.

On the music side, I had one major requirement. I wanted the band to be onstage and in view of the audience for several reasons. I'd played in orchestras for theatre shows and knew the isolation and disconnection they felt when hidden behind screens or down in a pit. Plus, dancers liked proximity to the musicians in a show where interplay was essential and theatrical. I also knew it was exciting for an audience to see the musicians play, particularly since we would have such a varied and interesting line-up.

I put together a dream team of players: Davy Spillane (pipes and whistles), Máirtín O'Connor (accordion), Máire Breathnach (fiddle), Kenneth Edge (saxes), Nikola Parov (gadulka and kaval), Rafael Riqueni (flamenco guitar), Tommy Hayes (bodhrán and berimbau), Des Moore (guitar), Eoghan O'Neill (bass guitar) Desi Reynolds (drums), Noel Eccles (percussion) and David Hayes (keyboards and music director). I had worked with all of these in the past and had a strong rapport with them.

36. RIVERDANCE THE SHOW

I had recently heard the singing of Áine Uí Cheallaigh and loved the authenticity of her expression and the beauty of her voice. So I sent her 'Lift the Wings' and asked her to choose a traditional Irish song – even though the show was to comprise all new music, I thought it essential to visit the Irish tradition during the evening. Áine chose 'A Chomaraigh Aoibhinn Ó' (O Sweet Comeraghs) – a paean to the Comeragh Mountains in Waterford from the perspective of an emigrant's voice. I since discovered that the song was written by Maurus Ó Faoláin, with whom I share a surname – keeping the score in the family. Next, I contacted Anúna to perform the choral pieces, so apart from a black choir, we now had all the vocal elements.

The search for a black choir would be easier in the Dublin of 2022 than in that of 1995. Two people were helpful in this search. The first was Bill Myers from Louisville, Kentucky, a composer whose earlier musical peregrinations had taken him to University College Cork to spend time with Mícheál Ó Súilleabháin and to Coolea to spend time with Peadar Ó Ríada. The second was Jim Flannery from the W.B. Yeats Festival.

I had a memorable visit to Atlanta with Flannery to observe a big gospel choir rehearsal in action. The choir rehearsed in a hall beside a Baptist church in an Atlanta suburb. We were late, and the choral director nodded to us when we arrived and gestured to a seat at the side. There were fifty people in the choir of all ages, all black (we were the only white folks in the room). The music was transcendent, and what distinguished it from any live choral singing I had heard before was the personal connection each singer had with the music. Everyone was visibly engaged in what they sang, full of passion, and had their own way of performing the piece, but each one of those unique performances meshed and integrated into a sense of an ensemble. I watched the conductor home in on single words or phrases repeatedly, demanding detailed attention to dynamics. How was all this personal investment achieved? I got a clue. We had come to the end of the singing, and the conductor made a few announcements to the choir about upcoming performances. Finally, he asked: 'Would anyone like to share anything today?'

A woman stood up and told a harrowing story of how her son had been shot during a raid on a liquor store and was in the hospital fighting for his life. As the story unfolded, there were expressions of sympathy from the choir. You heard 'uh-huhs' and 'mm-mms' bubble up in empathy from around the room. She ended her story with a request for prayer, which was greeted with loud assent.

Then another choir member stood and told a story that evoked similar voices of consolation. This sharing period went on for fifteen minutes, and then everybody stood and formed a circle. Some of the women beckoned to us. We hesitated at first, but they took our hands, and we were included in that extraordinary circle. There was a short prayer, a call and response, and the rehearsal was over. Was it a rehearsal? I wasn't sure. It was a moving experience, a spiritual joining of transcendent music with the everyday human challenges of black lives in Georgia.

This massive choir was not practical for our show, but it was useful to see their work and get a sense of the style and culture peculiar to American gospel singing. Eventually, through Bill Myers and Patti Shupe, we discovered James Bignon & The Deliverance Ensemble. They were a compact group, and James was easy to deal with. I wrote two songs for them: 'Hope to the Suffering' and 'Heal Their Hearts'. As the songs were completed, I sent the scores to Bill Myers in Atlanta, and he rehearsed the choir with James. He recorded their rehearsals which he sent back to me so that we could iron out any wrinkles. He then went into a studio in Atlanta with the recording engineer Joe Neill and recorded the choir there. He brought the tapes to Dublin, and we mixed them into the album.

It is amusing to reflect that in 1995 the Internet was a slow-moving tool. We were all amazed by the technology, and I was driven to adopt it quickly. I got a modem in my studio and signed on for an account at CompuServe. Nightly, I sent pages of the vocal score to Bill in Atlanta. The modem would yawn into life and make a few *Star Wars* beeps, followed by a long *s-h-h-h* noise that sounded like bacon on a frying pan. That was apparently a good sign: transmission had begun. In the

studio the following morning, I'd be lucky if this tiny file had made the transatlantic journey into Bill's CompuServe account in Atlanta. Nevertheless, when the James Bignon ensemble arrived in Dublin, they were rehearsed and ready for their performance.

Meanwhile, Abhann Productions searched for the other international dance elements for the show. I had written several dance themes for the Eastern European section. I hoped we could find a choreographer and dancers who would be comfortable working with the 15/16 metre and create a piece that accented those stresses like I had seen at the céilí in Budapest.

Our probing visit there hadn't delivered as we imagined, so we looked at the more gymnastic style unique to Russian folk dance. John McColgan contacted Elena Shcherbakova, the artistic director of the Moiseyev Dance Company of Moscow. Her company was the foremost folk-dance company in Russia. Their founder, Igor Moiseyev, had developed a style that mixed ballet techniques with the gymnastics of folk dance resulting in a highly theatrical and spectacular presentation. In our early meetings, we had some funny linguistic collisions. Elena kept referring to 'trooks', which we assumed were esoteric Russian dance moves: 'Yes, yes,' Ms Shcherbakova promised, in that serious and earnest Russian way she had about her. 'We will have many trooks.' It took a few meetings to realize she meant 'tricks'.

When I finished the demo, I sent it to Moscow so Elena could choreograph and rehearse it with her dancers. We didn't see Elena or the Russians until they arrived in the SFX rehearsal hall a week before *Riverdance the Show* opened.[1] They arrived with the piece completely choreographed and ready to go. Much of it has remained as it was at that breathtaking first performance. All the other pieces in *Riverdance*, Irish and international, were developed by close collaboration between the music and the choreography. My process was to attend rehearsals and adjust the music as needed. The Russian section was unique in that it went straight into the show without changes. Later, when the show was running for a number of years, the Russian dancers contributed

additional choreography – namely for 'Shivna', which they performed together with the choral group.

Over the years, the Irish and non-Irish elements in the show became increasingly integrated. In the beginning, virtually all the Irish dance in *Riverdance* was performed by amateurs, while the international dancers were all professionals. Our Irish dancers included students, chemists, accountants and bank clerks. What has evolved since is that there is now a large community of Irish professional dancers worldwide. Also, the influence of different dance disciplines being performed together over time has led to a cross-fertilisation that's very healthy for the development of dance and the approach to training and fitness. The young Irish dancers observed the workout techniques of the Russian, Spanish and African-American dancers and adopted their rigorous physical regimes. When we were performing in Limerick I met Keith Wood, the Irish international rugby player, and brought him in to look at the troupe in training. He watched as a male Irish dancer did a series of fast press-ups with one of the female troupe sitting on his back: 'Mother o' God,' said the great Irish hooker, 'c'mon away out of here. I'm getting palpitations looking at how fit they are!'

The final international element to join were the black tappers. This was our most controversial addition. Abhann Productions found a trio in London led by the Cameroon-born Jelly Jermaine. I was working on the album in the studio when Jelly arrived to meet me. I played him the piece. He listened and then looked askance at me, shaking his head: 'I don't do that kind o' thing.'
'Sorry?'
'No, Sir, that's not my bag. Let me show you what I do.'
He mimicked a jazz hi-hat pattern à la Papa Joe Jones and did a shuffle routine that was nowhere close to what I had in mind. But given how late the tappers had been cast, we had to progress with it. Their whole section was worked out on the floor in rehearsal, and they ended up dancing to something cobbled together with our rhythm section

ending with a tune I wrote last minute as a playoff. I was unhappy with that part of the show, even though our Irish audiences loved it.

My instincts were confirmed. When Elmer Bernstein came to see it, he said: 'Are you intending to bring *Riverdance* to America?'

'If it goes well in London, yes, we hope so,' I said.

'Well, you can't possibly bring this tap piece there,' he said, 'it's too much like the cakewalk. Things have moved on. This has echoes of minstrelsy and Jim Crow. The Irish can't be bringing this to America.'

He was right, and everyone knew it. It led us to develop a star turn in *Riverdance* called 'Trading Taps', which Colin Dunne and Tarik Winston brilliantly choreographed and the music for which I wrote when we were in London. At last, the Irish and black tappers had a number that integrated well and no longer seemed like a variety-show turn. In those early days, we workshopped pieces like this iteratively even while the show was up and running. It took several years of tinkering before we arrived at a stable version *of Riverdance the Show*. We did a complete facelift when we went to Broadway, we took out some pieces and added new ones, but after our two-year run there, we reverted to the original.

The days in Windmill Lane became a whirlwind. While the dance routines progressed in Digges Lane, we recorded the music for the show and album. Caroline Henry joined our team. She was the best artist traffic controller (ATC) I have ever worked alongside. With the help of copious amounts of Barry's tea, she coordinated all the recording artists and orchestras who were coming and going. Everything went seamlessly under her guiding hand.

As we got close to D-Day, we used every square inch of Windmill Lane. We converted the drum booth into a mini control room and installed a tape machine; while out on the floor, we laid down a dance surface, and all the taps were recorded there by Willie Mannion. Willie deserves every medal known to man for his calm professionalism in the line of fire. Andrew Boland and I were mixing in the main control room, and occasionally I would duck out onto the piano when the dancers weren't there to work on an orchestration. In the end, there

was so much to do that I had to take on the skills of an additional pair of hands. I turned to London-based orchestrator Nick Ingman.

Nick had a list of credits that included Björk, Eric Clapton, Radiohead, Oasis, David Bowie, Elton John and Annie Lennox. In Dublin and in between takes in the studio, he and I set up a room downstairs, and I briefed him on the style of orchestration I wanted. I gave him my home demos, my original *Riverdance* orchestrations, and sang bits of brass and string lines into his cassette recorder while he made sketches on manuscript. With all of these under his arm, he went back to London and started work. The relationship between composer and orchestrator at these times is critical. It's fraught with risk, and unless there is an understanding of the style and intent of the composer, the orchestrator can get things very wrong. There is also a subtle requirement to submerge one's own ego and not to over-embellish or smother the existing work. I could see from the early drafts Nick sent back from London that he understood exactly what was required.

After Christmas, as the pressure mounted, I was excavating a path between the recording studio and the dance rehearsals. Opening night was only one month away; from now on, we had to be decisive about everything; the time for dithering was over. So it came as a shock when I learnt that Michael Flatley was heading for a week to the Maldives to tan up and relax. His absence had a disruptive knock-on effect on my writing schedule, which led to further upsets in my relationship with John and Moya.

It concerned the finale, 'Heartland'. There were three structural components to the piece: a duet for Michael and Jean, then an unaccompanied dance section, and finally, a big orchestral piece for the whole troupe. I cannot stress how critical the timing was to complete it as the opening night was encroaching.

We had set the tempo while Michael was around, and once he said he was happy with it, I recorded the whole number – including the orchestra. When Michael returned, all tanned and refreshed, he decided that he did not like the tempo, and it would have to be speeded up. The

technical details of what would be required to do this were momentous. We would have to bring the entire orchestra back into the studio. There just wasn't time for that. Putting my irritation aside for the sake of the show, I racked my brain for a solution. Between myself and Andrew Boland's engineering legerdemain, we altered the tempo, and sent the recording to the rehearsal studio the day Michael was scheduled to work on it.

Later I got a call to say that Michael had done the choreography and could I come down at 5 p.m. to see it. When I got there, the excitement was palpable. The investors had been brought in to witness the unveiling of this crucial part of the show. The music began, and Michael and Jean led the troupe into the first part. The second part (the unaccompanied dance section), which Michael had choreographed with his usual military-style taps, came next. It was impressive and would form part of an effective closing number. But then, when the third part – the finale – started, the dancers stopped dancing. Instead, they applauded each other and sat on the floor as if it was the end of the piece. I had spent time altering this piece for Michael, so where was the choreography?

'What about the finale?' I asked.

'Oh, that,' said Flatley, 'yeah, I hadn't time to get to that bit.'

I was being told that Michael 'hadn't time' to work on the piece I'd spent days reworking to suit his schedule? Something snapped in me. I spoke frankly, not giving a thought to who heard me: 'Do you realize that I have spent *days* at your request changing the tempo of a previously recorded track? Now you have dragged me down here when time is precious to look at the results, and you haven't even worked on it? Michael, I don't think I have *ever* met anyone as unprofessional and less respectful of other people's work than you!'

I left the room to get back to the studio, but John McColgan stopped me: 'Moya and I would like a word.' He pointed to the office beside the dance space.

'That was a disgraceful display,' said Moya, shutting the door. 'How dare you speak to the star of the show like that. It is completely unacceptable!'

'Do not ever, EVER, speak to the star like that again!' John added. His voice had dropped an ominous octave.

I stared at them. My partners. The moment affected me profoundly. It set a marker in our relationship and created an uneasy ambience that has been sustained to the present day. I had to get used to being seen not as a partner, not as the creator of the music, or the narrative idea of *Riverdance*, but as somebody lucky to have been asked. I took personal offence at being treated like an errant schoolboy, being carpeted by the headmistress.

Despite spats and disagreements like this, no matter how worrying and revelatory, there was a buoyancy and momentum that drove us all forward. We had a deadline of 9 February 1995 at the Point Theatre, and for my own part, I was writing music right up to opening night – and beyond. There was considerable public anticipation for the show based on what they had seen and heard on the Eurovision, and ticket sales were brisk. *Riverdance the Show* opened to a full house at the Point where it ran for four weeks and then transferred for ten nights to the Hammersmith Theatre. We came back to Dublin for a further six weeks while preparing to return to London in response to the massive public interest.

Little did any of us know then that within weeks, on the day we were about to open for an extended run in at the Hammersmith Odeon in London, Moya would be calling me to ask for my opinion since she was about to let Michael Flatley go. His remunerative and creative demands had been mounting week by week until they had finally reached a breakpoint. I felt we should decide whether we had a show that stood on its own or a career vehicle for one dancer. Moya had a tough call to make, and I applaud her for taking this brave decision without the support of the promoters and the investors who were nervous at the prospect of a show without Michael Flatley. But, for the sake of the future *Riverdance*, she made the right call.

So now *Riverdance* was about to begin its second London run, with all the press attention of an opening night, with our much-publicized male lead missing. Breandán de Gallaí, Pat Roddy and Colm Ó Sé were

36. RIVERDANCE THE SHOW

about to stand in and take Michael Flatley's solos. I did not witness the next event that would cause a further spectacular tremor, but when I subsequently heard about it, I could only imagine the consternation in the theatre when, a few hours before the show opened, Jean Butler turned up on crutches! She had sprained her ankle, and there was no way she could dance. The female understudy was quickly called up, and feverish rehearsals began.

In October 1995 *Riverdance the Show* opened at the Hammersmith Odeon without its two principal dancers. The audience loved it. They rewarded the relieved cast with a standing ovation. More significantly, a new confidence had started to sprout in the company as they realized that they were in a show that did not depend on any one person. Its success resulted from the talent and commitment of many gifted young people, and they could all feel connected and proud to be part of this community of performers. On that October night in London, *Riverdance* stood on its own two feet and announced itself to the world of theatre. And the London audiences came – 3000 people each night for thirty-six weeks until it moved out into the wider world in February 1997.

Bill Whelan Esq.,
c/o Stage Door
Labatt's Apollo Hammersmith
Queen Caroline Street
London W6 9QH 27th June 1995

Dear Bill Whelan

I felt I had to write and let you know how much I enjoyed "Riverdance". I thought some of the sequences - particularly in the first half - were some of the most outstanding pieces of musical theatre I have ever seen and your work is truly remarkable.

Thank you for a terrific evening in the theatre.

With best wishes

SIR ANDREW LLOYD WEBBER

Sir Andrew Lloyd Webber writes to Bill after seeing Riverdance the Show.

37. Reflections

Riverdance would travel to some of the most unexpected venues in the world. It would play in such disparate locations as the Great Hall of the People in Beijing and the Sydney Opera House. It would break records as the longest-playing show in Radio City Music Hall in New York, apart from their own Rockettes. I witnessed the crown prince of Japan (now emperor) getting a bodhrán tutorial from Johnny McDonagh and coming to grips with Declan Masterson's uilleann pipes. We played for the queen of England and the pope. Michelle Obama brought her girls to see it in the Gaiety, and we did a special performance for Xi Jinping, president of the People's Republic of China.

My personal relationships with the husband-and-wife team of John McColgan and Moya Doherty took a battering over the years. I still have fondness for the times we worked together, but the creation of *Riverdance* put stress on our professional equilibrium. Had I not owned the score and the name *Riverdance*, which I licensed to their company, we would have separated earlier. However, we were inextricably bound, and while other relationships shattered around us, the trio of composer, producer and director remained.[1]

37. REFLECTIONS

Riverdance opened doors for me. I won a Grammy Award. I was made a freeman of the city where I was born. I befriended some of my teenage idols like Jimmy Webb and Carole King, and I met others like Burt Bacharach, Quincy Jones and James Taylor. I wrote scores for films starring Liam Neeson, Meryl Streep and Helen Mirren and orchestral scores for Sir James Galway, John O'Conor and Vanessa-Mae. I wrote works that were performed in Carnegie Hall with the Irish Chamber Orchestra and the Royal Albert Hall with the Ulster Orchestra, and in the US by the Chicago Symphony Orchestra. I wrote for emerging artists like Zoë Conway, Haley Richardson, Lyra, and Séamus and Caoimhe Uí Fhlatharta.

My days as a player musician fell away as my dream of composing took over, and the muscles in my hand were reserved for computer keyboards. I did, however, have a chance to play on some very enjoyable albums from time to time, notably recently on Colm Mac Con Iomaire's *The River Holds Its Breath*.

Riverdance gave me eye-opening and pleasurable experiences. I had the privilege to serve on the boards of Berklee College of Music in Boston with Paul Simon and Phil Ramone, the boards of the University of Limerick Foundation, Limetree Theatre, Crash Ensemble and Music Generation.

Denise and I holidayed in Venice with the contemporary artist Julian Schnabel and Dennis Hopper, and I spent Thanksgiving with Bette Midler, Henry Winkler ('The Fonz') and the lyricist Carole Bayer Sager. At Jean Kennedy Smith's invitation, we went to dinner parties with Lauren Bacall and Stephen Sondheim.

Jimmy Webb, George Martin and I had dinner together, where I had to suppress (somewhat) a head full of questions about his work with the Beatles. George was as I expected him to be – thoughtful, witty and a gentleman. Andrew Lloyd Webber hosted dinner at his Belgravia home for Denise, John McColgan and me, where we played board games until the small hours.

The incidents that filled my career after *Riverdance* were so different to those I met on the uphill climb throughout the 70s and 80s. I set

the work of Irish poets to music, including Frank McGuinness and Paul Durcan. I worked with artists like Bobby McFerrin and wrote for contemporary groups like Chamber Choir Ireland, ConTempo Quartet and Tarab and taught theatre music with Paul Muldoon at Princeton. Colin Dunne and I spent time in Salvador, working with Brazilian *capoeiristas* and the Irish dancers Mick Donegan and Ciarán Maguire. Colm Tóibín, Maurice Cassidy, Conall Morrison and I travelled to Cuba and Brazil to do research for a stage musical, and, although the script still languishes without a producer, we had some unforgettable experiences.

The enthusiasm and energy that led to the creation of *Riverdance* at the beginning remain in my mind. There was no eye on a grand prize or commercial success back then. Most of us simply coalesced over an instinct that a pearl might be inside if we prised open the shell. Until we saw the two-hour show in the Point Theatre, we hadn't a clue how the audience would respond.

I should leave the analysis of *Riverdance*'s impact culturally and artistically for others to assess, but there is no doubt that it affected the lives of the 700 dancers and 300 musicians the show included down the years who met their partners, fell in and out of love, had children, bought houses, became Irish citizens, became American citizens, founded Irish dance schools in places like Moscow and Tokyo, gave up other careers, lost themselves, found themselves, learnt to fly, acquired other languages and settled in parts of the world that they never dreamed of.

Our children – David, Nessa, Fiona and Brian – grew up in a world where their mother devoted her time to caring for them full time and their father's undulating career meant that comfort and panic alternated as work ebbed and flowed in a country where making music was barely imaginable as a career.

Having graduated from Berklee College of Music in Boston, Brian works with me as a gifted writer and producer. Nessa works in New York for the United Nations, and her diligent sister Fiona (ex-nurse, now cook) enjoys sharing the mothering duties for her much-loved nephews. David is a lawyer, surely a cause for great celebration by my mother, who,

37. REFLECTIONS

from the Elysian fields of the dreaded Eternity, is undoubtedly crying 'At last!' We are proud to watch our five (so far) grandsons grow up and equally proud of their Irish, Moroccan and Czech heritage and parentage. Anytime I see them, I feel hope for the planet.

I mentioned earlier that there is always an elusive element or luck that pulls a project over the line, but what about an entire career? Was it luck that steered me away from a safer career in law rather than disentangle myself from what W.B. Yeats referred to as a 'sweet wandering snare' – that non-negotiable desire to write music?

Some years ago, the musician Paul Brady and I were guests at a dinner with Conor and Mareta Doyle in Kinsale. It was a sumptuous evening, with excellent food and great conversation. During a lull in the chat, one of the guests addressed us: 'I am amazed at you two guys! How brave to have chosen music as a career.'

Paul and I looked at each other and, in almost one voice, replied: 'It had nothing to do with bravery. We couldn't have done anything else.'

> I have heard in the night air
> A wandering airy music;
> And moidered in that snare
> A man is lost of a sudden
> In that sweet wandering snare.[2]

NOTES

1. A LIMERICK CHILDHOOD – HOME AND FAMILY

1. Frank McCourt put Limerick on the literary world map with his Pulitzer Prize-winning memoir *Angela's Ashes* (1996).
2. Years later, when the house next door to Ab's was vacated, we went in and saw that they used the pantry under their stairs as a toilet. Many of inhabitants of School House Lane were relocated to alternative corporation housing. The lane was demolished in the 1970s and replaced with sheltered cottages for seniors.
3. McBirneys of Aston Quay closed in 1984. It is where the SuperValu is now. You can still see the carved plaque 'McBirney & Co. Ltd' above the central entrance. In the early 1900s it was a popular destination for aristocrats who came from all over the country to visit the fashion floors.
4. *Daily Express*, 20 December, 1881.
5. It was common among those with strong feelings about Irish nationhood to adopt Irish names. My father had 'Daithí Ó Faoláin' (David Whelan) painted over our shop in William Street, although probably like his brother Pat, he spoke almost no Irish. He had left Leamy's school in his early teens and never learned to speak or read it.
6. Bureau of Military History, 1913–21. Document no. W.S. 1420. Witness: Patrick Whelan.
7. My generation's only other Whelan offspring were the three MacEoin brothers: Seán, Gearóid and William. They were the sons of Margaret 'Babs' Whelan and her husband, John MacEoin. The MacEoins were spoken of in respectful tones as being intelligent, academic achievers. Seán was an air-traffic controller, and Gearóid was an eminent professor of Old Irish at Galway University (NUIG), so the respect accorded to them was well-founded. Unfortunately, the third brother, William, died when he was just forty. For most of my life, these cousins remained remote – it was only in our later years we reconnected. Having gotten to know them, I regretted not having them as friends earlier.

4. DAVE WHELAN – OPENING MY EARS

1. Moore, T., Stevenson, J., *A Selection of Irish Melodies,* Vol. IV. London, 1895.
2. Corinne Harris, singer; Arthur Gillies, pianist; and Danny Williams, singer.
3. When I was a kid, we took in lodgers to supplement the household income. Shannon Airport was a busy international hub in the 1950s, and there was a demand for accommodation for foreign employees occasionally with their families. I recall one or two long-stay Dutch families – Piet Tabak and his children in particular lodged with us for months; I was quite afraid of them.
4. These were like vinyl records, except they were made from harder material like shellac and rotated at 78 revolutions per minute. Consequently, they could not contain as much recorded material as the later vinyl invention. They also weighed a lot.
5. Like so many churches, the Jesuits' church was designed in the shape of a cross, with a long central nave and two smaller sections to the left and right, like the arms of a crucifix. The section reserved for the well-off Limerick folk was only to the right (and perhaps the centre) and was managed by Brother Priest. This area also had an altar dedicated to the Blessed Virgin. The opposite left arm of the cruciform had a corresponding altar dedicated to St Joseph. It was at the back of this that my father knelt. Right behind him was a very small altar to the Mother of Perpetual Succour – the Madonna. Incidentally, after Mass was over, my father always turned around and said a quiet prayer at this tiny shrine before leaving for the shop.

5. IRENE LAWLOR – LOVE AND SACRIFICE

1. O'Keefe, Donald, 'At the End of the Day', Chappell & Co. Ltd, London, 1951. *Vocal Popular Sheet Music Collection.* Score 3848. *DigitalCommons@UMaine*, The University of Maine, https://digitalcommons.library.umaine.edu/mmb-vp-copyright/3848/.
2. The song most likely filtered down to Limerick via the war film *They Were Expendable* (1945) directed by John Ford. The song by was popular with the Twenty-Seventh Infantry Regiment (Wolfhounds) during the Phillipines Campaign (1941–2) but goes further back with lyrics codified by band conductor G. Savoca, during the Filipino–American War (1899–1902). The notion that the song might be derogatory to Filipinos then or ever was not as apparent then. (See Walsh, Thomas P., *Tin Pan Alley and the Philippines: American Songs of War and Love, 1898–1946, a Resource Guide*, Scarecrow Press, Lanham, MD, 2013, pp 127–9.)

6. THE JESUITS – MUSICAL FIRST STEPS

1. This prayer is taken from a collection of Legion of Mary prayers in Irish.
2. He was the school manager – the second man in the school hierarchy after the rector.
3. The pandybat was an instrument used for corporal punishment in Jesuit establishments as recorded in Joyce's *A Portrait of the Artist as a Young Man*: 'In the silence of the soft grey air he heard the cricket bats from here and from there: pock. That was a sound to hear but if you were hit then you would feel a pain. The pandybat made a sound too but not like that. The fellows said it was made of whalebone and leather with lead inside: and he wondered what was the pain like.'
4. www.yourclassical.org.
5. Firmin Van de Velde was in Limerick from 1919–35. He contributed greatly to the 1930s' revival of plainchant and *a capella* singing in the Irish Catholic church.
6. The use of turk is not meant in a derogatory way here. The saying originated from Young Turks – a twentieth-century revolutionary party in Turkey. In this context it means that the students from Elements and Rudiments had an air of insurgency about them.
7. The words famously open Joyce's *Ulysess* as Buck Mulligan parodies the ritual of Mass with his shaving bowl as a chalice.

7. COMEDY, BANDS AND TRAVEL

1. Alfred Roy/Gibson Andy. The Hucklebuck lyrics © Range Road Music Inc., United Music Corp., Quartet Music Inc, Boca Music Inc.
2. Paul Vance/Lee Pockriss. Itsy Bitsy Teenie Weenie Yellow Polka Dot Bikini lyrics © Music Sales Corporation, Emily Music Corp., Emily Music Corp, Pincus G & Sons Music Corp.

8. CRIME AND PUNISHMENT – THE DOCKET BOOK

1. Patrick (Pa) Whelan went on to captain the Irish rugby team and was on the legendary Munster team that beat the All-Blacks in 1978.

9. LIMERICK'S ABBEY ROAD – THE VORTEXION

1. Niall's house was called Alverno after Mount Alverno, where St Francis of Assisi was given the stigmata. I'm sure we didn't know that at the time, but just liked the sound of the name.
2. The event occurred on 16 November 1920. The four men (also known as the Scariff Martyrs), were IRA volunteers Michael 'Brud' McMahon, Alphie Rodgers, Martin Gildea plus Michael Egan – a civilian who had sheltered them. They were shot dead on the bridge of Killaloe by British forces. The event was clearly still sharp in folk memory when the Shannon Folk Four recorded in Verno Ltd. in the late 1960s.

10. UCD AND A CRASH AT LISSYCASEY

1. Hatch Hall was still used for students' accomodation up until 2004. Around 2009 it became a Direct Provision centre to house asylum seekers. It closed in 2019 in preparation for refurbishment as a five-star hotel.
2. The pollock holes are a part of the Duggerna Reef at the mouth of Kilkee's Horseshoe Bay, inhabited by small pollock. For around six months of the year, swimming spots can be accessed at low tide, and temperatures can reach 20°C in the holes in July and August.

11. COLLEGE LIFE, DENISE QUINN AND LONDON

1. See https://www.ucd.ie/news/may07/052107_farewell_to_the_terrace.html.
2. Joni Mitchell. 'In France They Kiss On Main Street' © July 3, 1975; Crazy Crow Music (as 'In France').
3. Later Cassandra married Dermot Harris. Dermot died suddenly in 1978 at age forty-three, and Cassandra then married the Irish actor Pierce Brosnan. Cassandra died aged forty-one in 1991. We were lucky to have experienced these two lively characters when we did.

12. DENISE – THE SECOND SIGHTING

1. Paul Simon. Old Friends/Bookends lyrics © Universal Music Publishing Group.

15. DAVE WHELAN – LEAVETAKING

1. In the Pioneer movement there were only three simple conditions of membership: twice daily recitation of a prayer for the conversion of excessive drinkers, total abstinence from intoxicating drink, and public wearing of a small emblem of the Heart of Christ, a symbol of divine love. The significant exception is during illness when alcohol is prescribed by a doctor. This is,

perhaps, an instance of the situation envisaged in 1 Timothy 5:23 where Paul advises Timothy: 'You should give up only drinking water and have a little wine for the sake of your digestion and frequent bouts of illness that you have.' See Father McGuckian, B. 2013. Taking the pledge gave impetus to historic religious movement. *The Irish Times*. Available at: https://www.irishtimes.com/culture/taking-the-pledge-gave-impetus-to-historic-religious-movement-1.229347.

16. TREND STUDIOS AND DOWN IN THE PITS

1. The Musicians Union of Ireland (MUI) determined that a session ran for three hours with a twenty-minute break in the middle. So the practice was for sessions to begin at 10 a.m.– 1 p.m., then 2–5 p.m. and maybe 6–9 p.m. When I started, the rate was £9 per session. If I brought my electric piano, I was paid £2 extra for porterage.
2. The house in Wellington Road had three apartments. Two sisters, Maggie and Finola Vereker occupied the garden flat (I would end up knowing Finola well in later life). We occupied the top floor. Roger Armstrong occupied the middle floor.

17. DENISE IN BELFAST – JOINING THE DOTS

1. As the years went by, this work almost completely dried up. With farming out TV productions, RTÉ stopped producing programmes that used an orchestra, so the demand for new arrangements diminished.

18. DANNY DOYLE AND *SATURDAY LIVE*

1. *The West's Awake*, 1976 (arranger). *Raised on Songs and Stories*, 1980 (musical director, co-producer plus harpsichord, piano and harmonium). *The Highwayman*, 1981 (arranger and producer plus synth, Fender Rhodes, harmonium and piano). *Twenty Years A-Growin*, 1987 (arranger plus piano, synth, DX.7 and Emulator II). *Dublin Me Darlin*, 1989 (producer and arranger plus piano, DX.7 and Emulator II).
2. We worked there from 7–11 December 1986. Jeff Kawalek was the studio's mixing engineer.
3. Steve Gadd was a legendary drummer who performed and recorded with many artists including Paul Simon and Steely Dan. Richard Tee played keyboard for the likes of Quincy Jones, Bill Withers and Paul Simon.
4. Over thirteen years and five albums with Danny Doyle, I am hard pressed to recall a more enjoyable collaboration. I always looked forward to working with Danny. He was interested in exploring new roads along which the

music might lead us. He encouraged me to invite musicians I was beginning to form creative connections with. Over the years we had Davy Spillane, Andy Irvine, Dónal Lunny, Paddy Keenan, John Sheahan, Steve Cooney, Nollaig Casey, Tommy Hayes and many others, the amber warmth of Danny's voice soaring over it all, ever attentive to the lyrics, to the phrasing and to the expression. In his later years, he suffered a debilitating condition that prevented him from performing, though his humour and love of the craic was intact until he left us in 2019.

19. A HONEYMOON

1. Deuteronomy 15:11. Matthew 26:11. Mark 14:7. John 12:8.

20. STACC, THE JINGLES AND THE SPRINGER SPANIEL

1. A sleeveen or sneaky person.
2. As well as Eddie O'Leary, Yvette Halley also occupied the office. Yvette was an excellent stage manager for Noel's productions. Liz O'Donnell (later to become Tánaiste) and Emer O'Kelly (later the noted theatre reviewer) were also employed over the years as office manager and personal assistant to Noel.
3. 'Lola' of the New Blues Showband.
4. The other contestants in that year included Chips (whose manager lived underneath us in Wellington Road), Reform (from Limerick and for whom I produced one record), Sheeba (who I also produced), Jamie Stone (who John Drummond produced) and Danny Doyle for whom I subsequently produced five albums.
5. 'The Same Kind' and 'You Put the Love in my Heart'.
6. 'Delirium Tremens' © Christy Moore.

21. THE DUBLINERS, THE BARDS AND WINDMILL LANE

1. I produced John Sheahan's popular composition 'The Marino Waltz' for Bord na Móna (the Irish turf board), which was used in their TV and radio advertising campaigns.
2. Annette had starred as the photographic model on a very famous Harp calendar in the 70s.
3. Matt Talbot was an ascetic who lived in Dublin in the late nineteenth century. After an early life of dissolution with alcohol, he 'took the pledge' and devoted his life to helping the poor of Dublin and, in particular, those whose lives had been ruined by alcohol. His name is synonymous with teetotalism.

4. Eventually, Brian and I recorded many albums, singles and film scores together.
5. SD&C had some membership changes over the years, but they were essentially a four-piece with membership including Brian Masterson, Greg Boland, Jolyon Jackson, Roger Doyle, Paddy Finny and Paul McAteer. Jolyon Jackson was an essential lynchpin of the band who sadly died in 1985.
6. Eamonn Gibney had a very successful duo with Gerry Donovan. They had a unique vocal blend together and released a number of records. Eamonn passed away in 2018.
7. I know that 'the band' is a singular noun after which we expect 'was' instead of 'were'. However, U2 were always seen by everyone who worked with them as a collective of consensual opinions and so somehow the plural verb seemed to appropriately reflect that.

22. WHAT'S ANOTHER YEAR

1. Now the Donnybrook Gastropub.
2. 'Stardust' © Shay Healy.
3. Unlike most popular songs, the song has no chorus. It has just a one-line refrain: *what's another year*. Gerry Rafferty's 'Baker Street' also has no chorus – not even a refrain – just a sax solo. It shows that changing old song structures does not prevent you from having a big hit.
4. Like Gallagher and Lyle, the Average White Band, Gerry Rafferty, John Martyn and others, Cado Belle produced a kind of transatlantic rock, soul and funk, which you didn't hear as much of from England. You felt that they looked West for their influences toward black and soul music.
5. Stevie Winwood's brother.
6. 'If you are a moaner and you can't take getting fucked and screwed the few times out, then find another business, for the hauling over is your entry fee and part of the territory.' Oldham, A. L., Ross, R., & Dudfield, S., *Stoned: A Memoir of London in the 1960s*. St Martin's Press, 2001, p. 321.

24. THE WINDS OF CHANGE, THE 'GALWAYS' AND PLANXTY

1. A happy and partly intentional pun on the Irish word for 'fish'.
2. Duffy, Hugh, *Mister Duffy Mind the Rats*, (self-published, 2021).
3. 'The Burke family can trace their ancestry at St Clerans, from 1308, when a castle was built there by Sir Ulick Burke. It was then known as Isercleran Castle.' Henry, William, *St. Clerans: The Tale of a Manor House*, Merv Griffin, 1999, p. 5.
4. In his memoir, *Crazy Dreams* (Merrion Press, 2022), Paul Brady offers a candid insight into life on the road with the talented Adrienne Johnson during his time with the band the Johnsons.

5. Soon afterwards, on 31 July 1975, Fran O'Toole, singer with the Miami Showband, was killed by the UVF at a bogus British army checkpoint while returning from a gig in Banbridge, County Down. Five members of the band were shot, and three were killed.
6. Incidentally, it was there I also met Stockton's Wing and Steve Cooney, later to lead to further collaborations.
7. Nicola Sacco and Bartolomeo Vanzetti were defendants in a controversial murder trial in Massachusetts, US (1921–7), that resulted in their executions. Socialists and radicals protested the men's innocence.
8. Bobby Sands died after sixty-six days on hunger strike in the Maze prison in 1981.
9. Mattie Fox and the Grassroots.
10. The East Wind ensemble was Andy Irvine, Davy Spillane, Nikola Parov, Marta Sébestyén, Máirtín O'Connor, Kenneth Edge, Rita Connolly, Mícheál Ó Súilleabháin, Noel Eccles, Tony Molloy, Anthony Drennan, John Sheahan, Carl Geraghty and Paul Moran.

27. U2, MINOR DETAIL AND DICKIE ROCK

1. 'The Refugee' © U2: Adam Clayton, Bono, Larry Mullen, Jr, and The Edge. From *War* (1983).

28. NOEL PEARSON, THE DUBLIN DISTRICT COURT

1. It was a commercial success for Noel Pearson with John Kavanagh as the Pirate King, Caitríona Walsh as Mabel, and an hilarious chorus of ladies and sailors, led by the deliciously funny Anita Reeves as Ruth, the Maid of All Work. At one of the audition sessions a young soprano, Marilyn Cutts, turned up with her own accompanist. This young lady created such an impression at the audition that we hired her as well as Ms Cutts. Her name was Dillie Keane, later to star with the successful satirical trio Fascinating Aïda. For *Pirates* her face was painted with freckles and her hair plaited. She was gangly and gawky to a fault – the hit of the chorus. *The Irish Times* said that if you didn't keep an eye on her you'd 'miss a comic pearl cast with effortless ease by one of Major Stanley's daughters'.

29. NEW YORK – BEATING THE GOLDEN PAVEMENTS

1. I produced the single 'Downmarket' for Paul Cleary and the Blades in 1983.
2. This is the last process in making vinyl albums where the producer gets to listen to the album in a highly critical audio environment and makes any final changes to the sound before the master is cut and the disc is pressed.

30. SEÁN Ó RÍADA AND ELMER BERNSTEIN

1. *At the Cinema Palace: Liam O'Leary* (1983), *Sam Thompson: Voice of Many Men* (1986), *Oliver St John Gogarty – Silence Would Never Do* (1987), *Great Were Their Deeds, Their Passions and Their Sports* (1988), *David Farrell: Elusive Moments* (2008).
2. Seán Ó Ríada was an Irish composer and arranger of Irish traditional music. By incorporating modern and traditional techniques, he became the single most influential figure in the revival of Irish traditional music during the 1960s.

31. ALCOHOL – THE YEATS FESTIVAL

1. The plays in Yeats's Cuchulain cycle are: *On Baile's Strand* (1904), *The Green Helmet* (1910), *At the Hawk's Well* (1916), *The Only Jealousy of Emer* (1922) and *The Death of Cuchulain* (1939).

33. *TRINITY* – LEON URIS

1. Intended to counteract the pro-British Baden-Powell Boy Scouts.
2. It's interesting to contrast Leon Uris's view of the American Jew with his contemporary, Philip Roth. Roth raised the ire of some US Jewish opinion which regarded him as a 'self-hating Jew'. However, Roth considered Uris's portrait of the warrior patriotic Jew so silly as to be 'not even worth disputing'. In *Trinity*, Uris's heroic character of Conor in the Irish struggle for nationhood would have evoked a similar Rothian response.
3. Martin Luther King in an interview with Mike Wallace on CBS in 1966.
4. In the 1992 Tony Awards, Brian Friel's *Dancing at Lughnasa* won three Tony awards and five Tony nominations.

34. *THE SPIRIT OF MAYO* AND WORKING WITH THE CORRS

1. This claim has since been disputed and has led to debate in the world of academic archaeology. See Siggins, L. 2017. Archaeologists clash over dating of Céide Fields complex. *The Irish Times*. Available at: https://www.irishtimes.com/news/ireland/irish-news/archaeologists-clash-over-dating-of-c%C3%A9ide-fields-complex-1.2962907.
2. Originally called An Uaithne, the name derives from the collective term for the three ancient types of Irish music: *suantraí* (lullaby), *geantraí* (happy song) and *goltraí* (lament).

35. RIVERDANCE – THE INTERVAL ACT

1. Now Allianz.
2. In August, four months after Eurovision, a video of the performance was released by RTÉ at a charity event to raise relief funds for the humanitarian disaster which had begun with the Hutus' slaughter of Tutsis in Rwanda in April 1994. The Irish public response was generous, and the project raised half a million for the charity; all artists involved in the performance contributed their royalties.

36. RIVERDANCE THE SHOW

1. We had taken the St Francis Xavier hall for the weeks before the show opened as Digges Lane could not accommodate the full-sized show.

37. REFLECTIONS

1. In later years, as the McColgan-Dohertys mounted other productions, additional strains between us appeared, but that is for another volume.
2. *The Dreaming of the Bones*, W.B. Yeats.

NOTES TO EPIGRAPHS

Part 1: extract from *Istanbul: Memories and the City* by Orhan Pamuk is reproduced by kind permission of the author's estate and Faber and Faber Ltd. Part 2: quote by Victor Hugo from *William Shakespeare* (1864). Part 3: lyrics from 'Free Man in Paris' by Joni Mitchell © 28 November 1973; Crazy Crow Music. Part 4: extract from 'The Gravel Walks' by Seamus Heaney from *The Spirit Level* is reproduced by kind permission of the author's estate and Faber and Faber Ltd. Part 5: extract from 'Hunger' by Derek Mahon from *The Poems (1961–2020)* is reproduced by kind permission of the author's estate and The Gallery Press. www.gallerypress.com. There are instances where we have been unable to trace or contact the copyright holder. If notified the publisher will be pleased to rectify any errors or omissions at the earliest opportunity.

CATALOGUE OF COMPOSITIONS BY BILL WHELAN

'Bloomfield' (1971)
Score composition for the film of the same name starring Richard Harris.

'Timedance' (1981)
Composed with Dónal Lunny as part of the RTÉ television production and performed by Planxty.

'The Age of de Valera' (1983)
Music for the Peter Feeney RTÉ television documentary.

Lamb (1985)
Film directed by Colin Gregg and starring Liam Neeson. Bill composed and arranged additional music for the score with Van Morrison.

'Hymn to a Broken Marriage' (1988)
Setting of Paul Durcan's poem and performed by Jonathan Ryan and The London Chamber Orchestra.

'Child of Our Time' (1989)
Setting of the Eavan Boland poem for spoken voice and piano and performed by John O'Conor at the National Concert Hall.

'Music of a Lost Kingdom' (1989–93)
Original music for fifteen plays by W.B. Yeats for the Abbey Theatre production of the W.B. Yeats International Theatre Festival.

The Seville Suite (1992)
Suite for uilleann pipes, accordion, bodhrán, Galician pipes, harp and symphony orchestra. Performed at the Maestanza in Seville as part of Ireland's presentation at Expo '92.

CATALOGUE OF COMPOSITIONS BY BILL WHELAN

The Spirit of Mayo (1993)
Suite for symphony orchestra, chamber choir, 200-piece choral ensemble and drum corps performed at the National Concert Hall by the RTÉ Symphony Orchestra as part of the Mayo 5000 celebrations.

'Riverdance' (1994)
Seven-minute piece for traditional instruments and orchestra composed for Eurovision 1994 and performed by the RTÉ Concert Orchestra and soloists.

Riverdance the Show (1995)
Score composed for full-length show and album release.

'Flying Blind' (1995)
Song written for and recorded by Niamh Kavanagh for her debut studio album of the same name.

Some Mother's Son (1996)
Music for the Terry George film starring Helen Mirren, written by Jim Sheridan and Terry George.

Dancing at Lughnasa (1998)
Music for the Pat O'Connor film of Brian Friel's play starring Meryl Streep with screenplay by Frank McGuinness.

Riverdance on Broadway (2000)
Additional compositions for a special Broadway version of *Riverdance the Show* and accompanying album release.

Seven Ages (2000)
Music for the television series on the history of the Irish state by Seán Ó Mórdha and performed by the RTÉCO.

'Quis Est Deus' (2001)
Written for Charlotte Church and featured in *Christmas Carol: The Movie*.

'Emerald Tiger' (2004)
Written and produced for Vanessa-Mae and released on her album *Choreography*.

'Poitín' (2007)
A new score, specially commissioned for the re-release of a 35mm print of Bob Quinn's film *Poitín*, originally released (with no music) in 1977 and starring Cyril Cusack, Dónal McCann and Niall Tóibín.

The Connemara Suite (2007)
Composed for the Irish Chamber Orchestra and subsequently released on album comprising three movements:

> 'Inishlacken' (2007): 'The Currach', 'The Island Terns' and 'Evening Céilí'. Concerto for violin, fiddle and chamber orchestra performed by Fionnuala Hunt, Zoë Conway and the Irish Chamber Orchestra.
>
> 'Errisbeg' (2007): Concerto for fiddle, Irish harp and chamber orchestra performed by Michelle Mulcahy, Zoë Conway and the Irish Chamber Orchestra.
>
> 'Carna' (2007): 'Dawn', 'Macdara's' and 'An Chistin'.
> Concerto for fiddle, voice and Irish step dancer. Premiere performance by Zoë Conway, Colin Dunne and Morgan Crowley with the Irish Chamber Orchestra in Carnegie Hall.

'Jazzical Cyclebike' (2009)
Concert piece for cello and chamber orchestra performed of the Dutch Magogo Chamber Orchestra in Tilburg, Holland and by the Crash Ensemble in Dublin.

'The Currach' (2009)
Commissioned work for piano played by Alexaj Gorlatch, winner of the 2009 Dublin International Piano Competition and for which he won the RTÉ Lyric FM prize for the best performance of a commissioned Irish piece. It has had many subsequent performances notably by John McHale and Conor Lenihan.

'The Woman of the House' (2010)
Setting of the Peter Fallon poem for voice piano and orchestra performed by Julie Feeney as part of the Gallery Press celebrations 2010.

'After the Titanic' (2010)
Setting of the Derek Mahon poem for voice and piano performed by Morgan Crowley as part of the Gallery Press celebrations 2010.

'Walk of a Queen' (2011)
Written for the visit of Queen Elizabeth II to Ireland on 17 May 2011. It was performed by the No. 1 Army Band at Áras an Uachtaráin.

'The Highline' (2011)
Song composed by Bill with lyrics written by Brendan Graham.

'The War Graves' (2012)
Setting of Michael Longley's poem performed by Julie Fowlis and the Ulster Orchestra at the Waterfront Concert Hall.

Riverdance Symphonic Suite (2013)
Orchestral suite of the music from the show *Riverdance* performed by the National Symphony Orchestra at the National Concert Hall and by the Ulster Orchestra at the BBC Proms in the Royal Albert Hall in 2014.

'A State of Light' (2013)
Setting of the Michael Coady poem for soprano and string quartet performed at the Clifden Arts festival by the Kaleidoscope Ensemble and Deirdre Moynihan.

'Sun and Moon and Stars' (2013)
Setting for choir and cello of the Frank McGuinness poem and performed by the UCD Choral Scholars.

'Waiting for Riad' (2014)
Written for Thérèse Fahy's 'Handprint' series. This piece for piano was inspired by Bill's waiting for the birth of his first grandson, Riad.

'Linen and Lace' (2014)
Concerto for flute and symphony orchestra performed by Sir James Galway with the Irish NSO, and subsequently with the Chicago Symphony Orchestra at the Ravinia Festival.

'The Lighting Plot' (2015)
Setting of the Seamus Heaney poem for voice, piano and violin and performed at the Samuel Friedman Theatre New York by Lisa Dwan, Gregory Harrington and the composer.

The Train (2015)
Theatre show with music by Bill and words by Arthur Riordan about the legendary Irish contraceptive train of 1971.

'Elegy' (2018)
Music set to words by poet Frank McGuinness in memory of the five family members who lost their lives in the waters of Lough Swilly. Performed by the UCD Choral Scholars.

'Educo' (2018)
Music for soprano voice, guitar and string quartet performed by Máire Carroll, Shane Hennessy and the Crash Ensemble.

'Samhlú' (2020)
Music for traditional instruments and choral ensemble for the Telefís na Gaeilge 4 television programme *Samhlú*.

'Fragments' (2020)
Setting of fragments of poetry by several Irish poets for solo voice and cello. Performed by Naomi Berrill at the Music for Galway Cellissimo Festival 2021.

Riverdance: The Animated Adventure (2021)
Score for the Netflix/SKY animated feature film directed by Dave Rosenbaum and Eamonn Butler. Starring Pierce Brosnan, Aisling Bea, John Kavanagh, Lilly Singh, Jermaine Fowler, Pauline McLynn and Brendan Gleeson.

INDEX

Note re song titles: Bill Whelan's compositions and collaborations are listed under his name; all other song titles are indexed under the general heading 'songs and tunes'.

Page references in *italics* denote illustrations.

Abba, 198
Abbey Theatre, Dublin, 67, 149, 240, 249, 250, 253, 273
 Yeats Festival. *see* W.B. Yeats Festival
Abbot and Costelloe, 28
Abhann Productions, 293, 294, 296, 299, 300
Academy Awards, 245
Adare, Co. Limerick, 45
Adele, 245
Aer Lingus, 88, 136, 242
Africa, 192
Ahern, Fr Pat, 260, 261, 262
Ahern, Pete, 73, 87, 88, 104, 123–124, 149
Air National, 235, 236
Aiséirí, 18
Albert Embankment, London, 89
Alexandra College, Dublin, 83
Allen, Dennis, 89
Alphonsus, Sister (Flo Lawlor, Bill's aunt), 19, 20–21, 33
Altan, 159, 258

America. *see* United States of America
American charts, 54
American Declaration of Independence, 142
American films, 28
Americana, 86
Amsterdam, 274
An Eye on the Music (TV series), 257–259
An Phoblacht, 18
An Tine Bheo (film), 239
Andalucia, 288, 289
Angerer, Edmund, 44
Annacotty, Co. Limerick, 12
Antonio Gades Company, 261
Anúna, xvi, 253, 270–271, 276, 278–279, 297
April Music, 89
Arab–Israeli conflict (1967), 58
Aran Islands, Co. Galway, 289
Arklow, Co. Wicklow, 166
Armstrong, Roger, 131
Army Surplus Store, Limerick, 60, 61
Arrick, Larry, 264, 266

INDEX

Ascott, Mavis, 219, 276, 277–278, 279, 284, 295
Asher, Jane, 56
Atlanta, Georgia, 297–298, 299
Atlantean (film), 289
Atlantic Ocean, 170
Atwell, Winifred, 27
Australia, 59, 213
Austria, 60, 217
Austro-Hungarian Empire, 290
Avis, Meiert, 171
Avnet, Brian, 274

Bacall, Lauren, 307
Bacharach, Burt, 72, 307
Balfe, Brendan, 136, 155
Ballagh, Robert, 154
Ballinacurra, Limerick, 10, 13
Ballisodare Festival, Sligo, 195
Ballsbridge, Dublin, 130, 156
Ballyfermot, Dublin, 126, 127
Ballyfermot Peace Corps Choir, 126, 127
Ballyferriter, Co. Kerry, 241
Bamboo takeaway, Ranelagh, 132
Band, The, 86
Bangor, Co. Down, 134
Bannen, Ian, 205
Bardis Music, 125
Bardon, Peter, 125, 128, 213, 214, 215
Bards, 168–169
Barry's tea, 301
Bassey, Shirley, 91, 93
Bayer Sager, Carole, 307
Bayle, Jack, 128–129, 130, 136
BBC, 259, 285
BBC Radio One, 75
Beach Boys, 'Pet Sounds,' 71
Beano, The, 18
Bearsville Theatre, Woodstock, 267, 268
beat groups, 58–59
Beatles, The 54, 56, 80, 169, 180, 258, 307
 With the Beatles, 48
 Sergeant Pepper, 58, 86

Beckett, Samuel, *Endgame*, 101
Bee Gees, 91, 93, 110
Beethoven, Ludwig van, 32
Beezer, The, 18
Begley, Philip, 143, 209, 213
Beijing (China), 306
Beiser, Maya, 253
Belfast, 10, 133, 134, 196, 206, 208, 218, 235, 236, 237
Belfast/Good Friday Agreement (1998), xv
Belfield (UCD campus), 83, 84–85
Belgium, 60, 179, 217
Belgravia, London, 93, 307
Benchers (King's Inns), 115, 116
Berchmans, Sr, 21
Berklee College of Music, Boston, 307, 308
Bernstein, Elmer, 238, 240, 241–243, 257, 301
Bernstein, Eve, 243
Bettoni, Giacinto (Roberto Danova), 216–217
Beverly Wilshire hotel, Hollywood, 242, 245
Bickerton, Wayne, 125
Bieber, Justin, 245
Bienstock, Freddy, 293
Bignon, James, 298, 299
Björk, 302
Björling, Jussi, 27
Black, Donald Taylor, 200, 238, 242
Black and Tans, 13
Black Lives Matter, 267
Black Panther movement, 85
Blackman, Honor, 110
Blackwell, Chris, 171
Blades, The, 232, 258
Blakey, Art, 27
Blood Transfusion Service, 134
Bloomfield (film), 91, 103, 106, 110–113, *111*
Bly, Robert, 253

Boherbuoy, Limerick, 24
Boland, Andrew, 232–233, 280, 301, 303
Boland, Claire, 232
Bono, 211, 253; *see also* U2
Borge, Victor, 27, 155
Boston, Massachusetts, 273
Bourke, Seán, *The Springing of George Blake,* 120
Bowie, David, 214, 302
Bowyer, Brendan, 56
Boy George, 232
Bradbury, Ray, 103
Brady, Paul, 309
Brando, Marlon, 191
Bray, Co. Wicklow, 128
Brazil, 308
Brazil '66 (band), 72
Breathnach, Cormac, 280
Breathnach, Máire, 280, 296
Bristol Old Vic, 223
British army, 133–134
British Top 10, 285
Brittany, 196, 197
Broadway, New York, 218, 219, 232, 266, 301
Broderick, David, 42
Brooklyn, New York, 228
Brown, Christy, *My Left Foot,* 245
Browne, Louis, 53
Browne, Ronan, 280
Brubeck, Dave, 27, 71
Budapest, Hungary, 288, 289–291, 299
Budweiser, 159
Bulgarian tunes, 197, 200, 204
Bunratty, Co. Clare, 12
Bunty, 18
Bureau of Military History (BMH), 13
Burma, 16
Bush, Kate, 172, 201–204, *203,* 213
 The Dreaming, 201, 202
 The Hounds of Love, 201, 204
 The Sensual World, 201, 204
Bush, Paddy, 204

Bushnell, Anne, 177
Bussoli, Jack and Junior, 265–266
Butler, Jean, 198–199, 262, 271
 and *Riverdance,* xvi, 277–278, 284
 and *Riverdance the Show,* 287, 295, 302, 303, 305
Byrne, Gay, 261

Cado Belle, 177
Caherciveen, Co. Kerry, 38
Cahill, Ciarán, 295
California (USA), 88
Callaghan J, Fr Tom (The Bull), 60, 65
Calloway, Cab, 271
Cameroon, 300
Campbell, Eamonn, 137, 149, 168
Campbell, Mary (Bill's grandmother), 11
Canada, 44
Canadians, 99
Cannon, Seán, 168
Capuchin Friary, Church St, Dublin, 158
Caraçena, Earl of, 260
Carmen, 6
Carnegie Deli, New York, 144–145
Carnegie Hall, New York, 307
Carr, Bunny, 110–111
Carroll, Jim, 25, 69, 70
Carroll's cigarettes, 63, 64
Cashel, Co. Tipperary, 151, 152
Cashel Palace Hotel, Co. Tipperary, 150
Cassidy, Maurice, 206, 287, 308
Cassius Clay, 163
Cat Women of the Moon (film), 243
Catholic Church, 127–128
Catholic churches, Limerick, 29; *see also* Crescent Church
Catholics, 77, 83, 127, 133, 134
Catskills (USA), 79
Caulfield, Seamus, 270
CBS Records, London, 89, 90, 91, 181–182

CBS Records, New York, 212–213, 215
Cebu (Philippines), 34
Céide Fields, Co. Mayo, 270
Ceoltóirí Chualann, 240
Chamber Choir Ireland, 308
Chaplin, Charlie, 28
Chapman, Derek, 251
Chappel & Company, London, 293
Charlie Chesters Casino, London, 89
Checker, Chubby, 'Hucklebuck,' 56
Checkmates, 27
Chicago (USA), 163
Chicago Symphony Orchestra, 307
Chieftains, The, 199, 202, 241, 258, 262
China, 306
Chips (band), 131
Chopin, Frederic, 32
Christian Brothers, 39
Christian Brothers School, Limerick, 39, 55, 75
Church and General Insurance, 281–282, 285
Churchtown, Co. Dublin, 226
Circular Motion Group (CMG), 86
Civil War (1922-23), 12, 13, 18
Claffey, Úna, 84
Clancy Brothers, 27
Clapton, Eric, 302
Clare, County, 43
Clarke, Annette, 60
Cleary, Fr Michael, 126–128
Clery's store, Dublin, 258
Cliff Richards and the Shadows, 59
Climax 6 Plus 3 (band), 60
Cline, Patsy, 138
Clonbur, Co. Galway, 201
Clongowes Wood College, 33
Clune, Mr, 43
Coca-Cola, 250
Cole, Lloyd, 258
Collins, Phil, 232
Comeragh Mountains, Co. Waterford, 297

Commitments, The (film), 257
Como, Perry, 123
Competition Authority, 188
CompuServe, 298–299
Concorde, 215
Concorde Hotel, Catskills, 79
Connemara, 40, 205, 208
Connery, Niall, 149
 songwriting partnership with Bill, 69–70, 71, 73, 80–81, 88, 90, 90, 91–94, 103–106, 110, 112
 'Lady Anne,' 69
 'The Company Line,' 69–70
Connery, Sean, 265
ConTempo Quartet, 308
Conway, Zoë, 307
Conyngham, Marquess of, 146
Cook, John, 281
Coolea, Co. Cork, 241–242, 297
Cooney, Steve, 143
copyrights, 187–189, 219, 245, 293
Córas Tráchtála, 170
Cork, County, 241–242
Cork Examiner, 17
Cork Feis Ceoil, 45
Cork University, 88
Corr, Andrea, 273
Corr, Caroline, 273
Corr, Jim, 273
Corr, Sharon, 273
Corrs, The, 257, 258, 273–274
Cosgrove, John, 58, 69, 71, 102–103, 117–118
Cosgrove, Tommy, 117–118
Costello, Elvis, 172
Costelloe, Deirdre, 167
Costelloe, Dr, 102, 178
Coughlan, Blookie, 15, 16
Coughlan, Mary, 146
Coulter, Phil, 93
Count Basie Big Band, 150
country-and-western music, 138–139
Cowap, Pat, 279, 283

Crash Ensemble, 307
Craughwell, Co. Galway, 191
Craven, Beverley, 258
Craven, Gemma, 155–156
Crescent Church, Limerick, 48–49
Crescent College, Limerick (Sacred Heart College), 38–49, 55, 103, 105, 121, 135
 An Cumann Caidreamh, 55
 corporal punishment, 40–42, 63–65, 66
 drama productions, 67–68
 European school tour (1965), 60–61
 Leaving Certificate year, 63–69
 music, 44–45, 58–59
 Mission Concerts, 25, 59
 religious observance, 47–49
 sexual abuse, 65–66
 teaching, 66–67
Crescent Hall, Limerick, 59
Crowley, Brian, 87
Cuba, 308
Cúil Aodha (Coolea), Co. Cork, 241–242, 297
Cullen, Fedelma, 251
Curran, John, 223
Cusack, Paul, 145

Dan Ryan Car Hire Company, 123
Dancing at Lughnasa (film), 268
Dandy, The, 18
Danova, Roberto (Giacinto Bettoni), 216–217
Danube river, 289
Darby O'Gill (film), 266
D'Ardis, John, 124–125, 188, 189–190
Davey, Shaun, 158, 159, 188, 241
Davis, Sammy Jr, 54
Dawson Street, Dublin, 224
Day-Lewis, Daniel, 244–245
de Burgh, Chris, 194
de Burgh, Ulick, 191

de Cillis, Betty, 268
de Gallaí, Breandán, 304–305
de Valera, Éamon, 168, 195
de Valera family, 18
de Zubiaur, Captain Pedro, 260
Deane, Ed, 87
Debussy, Claude, 32
Deeney, Des, 58–59
Deliverance Mass Choir, 298, 299
Dell comics, 18
Dennehy, Dennis, 85–86
Department of the Taoiseach, 259, 262
Derry, 117, 134
'Desiderata,' 155
Detroit (USA), 162
Deus Noster (monastic writings), 270
Devlin, Alan, 221–223
Dick James Music, 89
Dickens, Charles, 75
Digges Lane studio, Dublin, 277, 279, 280, 284, 301, 302
Dillon, Miss, 44–45
Dingle Peninsula, Co. Kerry, 241
Dobbins restaurant, Dublin, 123
Dockers pub, Dublin, 210, 211
Doherty, Jim, 136, 149
Doherty, Jim and Linehan, Fergus
 Inish, 149
Doherty, Moya, 271, 306
 and *Riverdance,* 276, 279, 283
 and *Riverdance the Show,* 287–288, 291–292, 293, 295, 302, 303–304
Dolan, Joe, 216, 217
Dominion, London, 199
Donald, Keith, 139
Donegal, 276
Donegan, Mick, 308
Donnelly, Jack, 150, 151
Donnybrook, Dublin, 175
Doors, The, 100
Dorking, Surrey, 163
Dowling, Joe, 220–221, 223, 224
Down, County, 131

INDEX

Doyle, Conor and Mareta, 309
Doyle, Danny, 142–145, 168, 176
 Twenty Years A-Growin, 143–144
Drew, Deirdre, 168
Drew, Ronnie, 167–168, 176
Drew family, 176
Drogheda, Co. Louth, 137
Drummond, John, 125, 136, 137, 155, 198
Dublin, 9, 11, 27, 31, 88, 97, 98, 100, 115, 117, 121–124, 126, 128, 135, 136, 138, 142, 143, 145, 149, 153–158, 162, 163, 167, 168, 170, 171, 172, 177, 178, 180, 181, 193, 196, 199, 201, 205, 208, 209, 213, 215, 218, 219, 224, 227, 228, 242, 243, 244, 260, 273, 279, 297, 298, 299, 302, 304
 Bill's college life, 74–86; *see also* King's Inns; UCD
 Bill's office, Waterloo Road, 158, 188
 Bill's residences in, 116, 130–131, 132, 134; *see also* Hatch Hall; Ranelagh
 bombings (1974), 134
 Houses of Parliament, 150
 international students, 84
 record stores, 123, 125
 student protests, 85–86
 student residences, 83; *see also* Hatch Hall
 studios, 124; *see also* Digges Lane studio; Lad Lane; Trend Studios; Westland Studios; Windmill Lane
 theatres. *see* Abbey Theatre; Gaiety Theatre; Point Theatre
Dublin Airport, 123, 136, 137, 180, 209, 261
Dublin City Ballet, 198
Dublin Corporation, 76
Dublin District Court, 225
Dublin Housing Action Committee (DHAC), 85

Dubliners, The, 87, 137, 155, 158, 159, 165–168, 258
 Prodigal Sons, 165
Duffy, Hugh, 188
Dundalk, Co. Louth, 273
Dunne, Colin, 301, 308
Dunne, Mick, 24
Dunne, Paddy, 210
Dunnes Stores, Dublin, 97, 98
Dunphy, Eamon, 240
Durcan, Paul, 308
Durnin SJ, Fr, 64
Durning, Kathy, 243
Durty Nelly's pub, Co. Clare, 80
Dustin the Turkey, 183

Eamonn Andrews Studios, Dublin, 124
Earls, Mary, 88, 110
Earp, Wyatt, 41
Eason's bookshop, Dublin, 250
East Wind, 200, 204, 258, 288
Easter Rising 1916, 168, 241, 253, 264, 266
Eastern Airlines, 237
Eastern Europe, 283, 288, 291, 299
Eccles, Noel, 296
Edge, Kenneth, 280, 296
Edge, The, 211
Edinburgh, 184
Edwards, Hilton, 100
Elfman, Danny, 242
Elizabeth II, Queen, 192, 306
Ellington, Duke, 27, 69
Elliott, William, 219
Elliott, Stuart, 204
Ellis, Tommy, 138
Elton John, 302
Emory University, Atlanta, 250
England, 6, 209, 306
Ennis, Co. Clare, 34
Eno, Brian, 208
Enya, 208

Epic Records, 181, 182
Erskine, Julian, 296
Estus, Deon, 162–164
Europe, 60–61, 176, 216, 242, 285
Eurovision Song Contest, 288, 304
 1980 (The Hague), 156, 177–178, 179–180, 185, 197; *see also* 'What's Another Year'
 1981 (Dublin), 197–199; *see also* 'Timedance'
 1994 (Dublin), xv–xvi, 276, 278, 279–285, 294; *see also Riverdance* 'Rock 'n' Roll Kids' (Graham), 284, 285
 Ireland's involvement with, 182–183
Evans, Ernie, 152
Exodus, 59
Expo '92 (Seville), 259–262, 289

Fabulae Faciles, 66
Fairlight Series II, 213–214
Faithfull, Marianne, 56
Fanny O'Dea's, Kilkee, 81
Farn, Jackie (Valentino – King of the Music), 54
Father Mathew Hall, Cork, 45
FCA, 15
Fedamore, Co. Limerick, 55–56
Fender Rhodes piano, 136–137
Fenton, George, 257
Fianna Éireann, 186, 265
Fianna Fáil, 18
Field, The (film), 243
Fifth Dimension, 127
Fine Gael, 18
Fitzgerald, Barry, 158
Fitzgerald, Fr Jim, 27
Fitzpatrick family (Manhattan), 227–228
Fitzwilliam Square, Dublin, 116, 130
flamenco, 167, 260, 261, 289, 296
Flanagan, Anne, 56–57

Flannery, James, 250, 251–254, 297
Flatley, Michael, 198–199, 271
 and *Riverdance,* xvi, 277–278, 279, 284
 and *Riverdance the Show,* 287, 288, 289, 291, 295, 302–303, 304–305
Flaubert, Gustave, *Madame Bovary,* 120
Flight of the Earls (1607), 262–263
Flint, John, 98, 99, 116–117
Florence (Italy), 61
Flynn, Kevin ('Lofty'), 195–196, 199
Foley, Connie, 27
Folk, Robert, 243
folk dance, 299
folk music, 167, 168, 194
Fonseca, Isabel, *Bury Me Standing,* 289
Ford, Emile, 27
Foster, David, 273, 274
Fouéré, Olwen, 251, 252
Fox, Mattie, 199
France, 60
Frankie Starlight (film), 243
Fraser, Mick, 7
Frears, Stephen, 243
Freegard, Michael, 188
Fricker, Brenda, 245
Friedan, Betty, 253
Friel, Brian, 251
Fureys, The, 168

GAA, 196
Gabriel, Peter, 213, 214
Gadd, Steve, 144
Gaelic games, 17, 39
Gaeltacht, 241
Gaiety Theatre, Dublin, 128, 129, 279, 306
 H.M.S. Pinafore (1985), 219–223
Galavan, Barbara, 293
Galiçia (Spain), 260, 261
Gallagher, Rory, 170
Gallivan, Roddy, 67

INDEX

Galway, 276
Galway, Sir James, 307, 308
Galway Blazers, 192
Galways (verse form), 189–191, 192
Gandon, James, 114
Garda Síochána, 85, 86, 224, 234
Garfunkel, Art, 127; *see also* Simon and Garfunkel
Garryowen, Limerick, 19
Gate Theatre, Dublin, 224
Gatwick Airport, 163
Gaye, Marvin, 103
Gaye Bykers on Acid, 294
Gaynor, Brian, 80–81
Gaynor, Mr, 81
Gaynor, Mrs, 80
George's Head, Co. Clare, 106
Geraghty, Carl, 208
Gerald W. Lynch Theatre, New York, 266
Germany, 60, 179, 181, 217
Gerry Rafferty Band, 161, 162
Gibb, Maurice, 91, 110
Gibney, Eamonn, 171
Gielgud Theatre, London, 67
Gilbert, W. S., 218
Gilbert and Sullivan
 H.M.S. Pinafore, 219–223
 Pirates of Penzance, 218–219, 276
Gill, Earl, 219, 220–221, 222
Giuliani, Rudi, 218
Gleeson, Mick, 88
Glenbeigh, Co. Kerry, 151
Glennon family, 295
Glynn, Jack, 72, 73
Golden City Dixies, 24–25, 75
Golden Discs, Dublin, 123
Goldsmith, Harvey, 230
Goldsmith, Jerry, 242
Gonzaga College, Dublin, 33
Goodwin, Ron, 257
Goodwin Gallery, Limerick, 26
Goons, The, 155, 169

gospel singing, 297–298
Gowrie, Lord, 146
Graham, Brendan, 183, 188
 'Rock 'n' Roll Kids,' 284, 285
Graham, Nicky, 181–182
Grammy Awards, 127, 214, 307
Grannies Intentions, 89
Grateful Dead, The, 99
Great Famine, 264, 266
Great Hall of the People, Beijing, 306
Great Train Robbery, 94
Green, Bernard, 112–113
Gregg, Colin, 205, 207, 208, 209
Gregory, Lady, 250
Greystones, Co. Wicklow, 176
Griffin, Jill. *see* O'Mahoney, Jill
Grogan, John, 149–150
Guinane, Fr ('the Guinner'), 29–30
Guinness, 126, 161–162, 210, 242
Gunne, Conor, 77–79, 84, 86, 115, 116, 131, 132
Guo Yue, 258
Gurteen Bay, Co. Galway, 205

Hagan, Doni, 163
Hague, The (Eurovision 1981), 156, 177–180, 185
Haight-Ashbury, San Francisco, 71
Haley, Bill, 27
Halferty, Tommy, 117, 125
Halley, Yvette, 220, 221–222
Halpin, John, 103
Hamilton, Phyllis, 127
Hammersmith Odeon, London, 304–305
Hanly, Mick, 197
Harlem, New York, 228, 267
Harold, Josh, 61
Harold's Cross Gaol, Dublin, 11
Harrington, Paul, 284
Harris, Billy, 42–43
Harris, Dermot, 89, 90, 91, 92–93, 105
Harris, Johnny, 91, 93

Harris, Noel, 89
Harris, Richard, 42, 43, 89, 90–91, 103–106, 150, 253, 265
 Bloomfield (film), 103–104, 110–113
Harris family, 43, 89
Harrison, George, 91
Harte, Frank, 142
Hartigan's pub, Dublin, 76
Hatch Hall (University Hall), Dublin, 75–77, 83, 86, 87, 88, 97, 98, 100, 116
Haughey, Charlie, 178, 262
Hawtrey, Charles, *The Private Secretary*, 67
Haydn, Joseph, *Toy Symphony*, 44
Hayes, David, 296
Hayes, Tommy, 280, 296
Haynes, Daniel, 271
H-Block hunger strikes, 197
Healy, Dymphna, 176
Healy, Shay, 142, 175–177, 179–181, 183, 185
 Eurovision entry 1980. *see* 'What's Another Year'
 'Stardust,' 176–177
Heaney, Seamus, 253
 'The Gravel Walks,' 173
Heanor Record Centre, Middlesex, 58
Heath, Ted, 93
Heathrow Airport, 156, 157, 206
Helvick Irish College, 80
Henry, Caroline, 301
Henry VIII, 114
Heuston Station, Dublin, 178
Hickey, James, 294
Hickey, Jimmy, 196
Higgins, Bill, 86–87, 97, 98–100, 116
Higgins, Tommy, 287
Hinds, Ciarán, 251
Hit Factory, New York, 273
H.M.S. Pinafore (Gilbert and Sullivan), 219
 Pearson's production, 219–223, 276

Hodges, Johnny, 27, 69
Hogan, Bertie, 7, 8, 56
Holland, 217
Holland Park, London, 206, 208
Hollies, The, 56, 127
Hollywood, California, 240, 242, 251
Holmes, Rubberneck, 271
Homer's *Odyssey*, 235
Honourable Society of King's Inns. *see* King's Inns, Dublin
Hopper, Dennis, 307
Horslips, 131
Hothouse Flowers, 267, 269
Hotspur, The, 18
House of Music, New Jersey, 144
Howth, Co. Dublin, 156
Hucklebuck (dance), 56
Hudson, Eileen, 45
Hughes, Prof. Anthony, 135
Hughes, Gerry, 138
Hughes, John, 257, 273–274
Hughes, John and Willie, 213, 214
Hughes, Paddy, 42–43
Hume Street, Dublin, 98, 100
Hungarian refugees, 290
Hungarian Revolutions (1848 and 1956), 290
Hurley, Liam, 138
Hurley, Red, 194
Huston, John, 191
Hydro Hotel, Kilkee, 80, 104, 105
Hyland, Brian, 61–62

Iloilo (Philippines), 34
In the Heat of the Night (film), 234
Independent Group, 18
Industrial Development Authority (IDA), 123–124
Ingman, Nick, 302
Institute of Christ the King Sovereign, 127–128
Intervac, 227
Invincibles, 11

INDEX

Irish army, 134
Irish Association of Songwriters and Composers (IASC), 188
Irish Bar, 74, 78
Irish Chamber Orchestra, 307
Irish dance, xvi, 55, 167, 195, 260, 261, 262, 276, 288, 300
 'The Walls of Limerick,' 55
Irish dance schools, 308
Irish Film Orchestras (IFO), 158, 242–243, 244, 245–246
Irish Free State, 195, 241
Irish Independent, 18
Irish International, 159
Irish language, 39, 55, 195, 240, 241
Irish music, xvi, 55, 195, 240; *see also* traditional music
 Ó Ríada Retrospective (NCH, 1987), 238–242
Irish Music Rights Organisation (IMRO), 188
Irish National Day (Seville, 1992), 260, 262
Irish Press, 18, 28
Irish Republican Army (IRA), 9
Irish Republican Brotherhood (IRB), 9, 11, 13, 265
Irish Sea, 91
Irish Times, The 18
Irvine, Andy, 143, 159, 179, 194, 195, 197, 199–200, 258, 288
Isercleran, Craughwell. *see* St Clerans
Island Records, 171
Israel, xv, 58, 91
Italy, 60, 61, 138, 217
Ivers, Eileen, 268, 269

Jack Bourke's City Theatre, Limerick, 53
Jackson, Michael, 271
Jagger, Mick, 57
James Bignon & The Deliverance Mass Choir, 298, 299
James Bond films, 61, 110
Japan, 306
Jefferson Airplane, 99–100
Jehovah's Witnesses, 36, 72
Jelly Jermaine, 300
Jenner, Bruce, 274
Jensen, Kid, 75
Jesuits, 16, 29–30, 33, 38–49, 55, 59, 60, 63, 75, 77, 119, 120, 127; *see also* Crescent Church, Limerick; Crescent College, Limerick
 'Brother Priest,' 49, 55
 corporal punishment, 40–42, 63–65
 education philosophy, 66
 student hostel, Dublin. *see* Hatch Hall
Jesus Christ Superstar, 149, 165
Jethro Tull (band), 75
Jews, 266
JFK Airport, New York, 236–237
Jobim, Antonio Carlos, 71
John Barry Seven, 243
Johnson, Adrienne, 194
Jones, Joe (Papa Joe), 300
Jones, Quincy, 307
Jones, Sandie, 194
Jones, Tom, 216
Joseph and the Amazing Technicolor Dreamcoat, 128–130, 134, 137, 149, 154
Joyce, James, *Ulysses,* 204
Judy (comic), 18
Jugendfahrkarte, 60
Jump (jazz band), 139

Kavanagh, John, 223–224
Kawalek, Jeff, 144
Keane, Dolores, 199, 258
Keane, Seán, 202–204
Keating, Seán, 4, 25–26
Keaton, Buster, 28
Keaton, Diane, 143

Keeler, Christine, 93
Keleghan, Matt, 196
Kelehan, Noel, 136, 139–141, 280
Kelly, Anne-Louise, 171
Kelly, James, 199
Kelly, John Maurice, 79–80
 Fundamental Rights in the Irish law and Constitution, 79
Kelly, Luke, 143, 165, 167
Kelly, Mary Aliaga, 190, 193–194
Kelly SJ, Fr Paddy, 60
Kelly, Wynton, 27
Kempis, Thomas à, *The Imitation of Christ,* 120
Kennedy, Des, 131–132
Kennedy, Eunice, 273
Kennedy SJ, Fr, 59
Kennedy, John F., 168, 273
Kennedy, Kathleen, 273
Kennedy, Paddy, 94
Kennedy, Pat, 273
Kennedy, Robert F., 273
Kennedy, Sr Stanislaus, 146
Kennedy, Ted, 273
Kenny, Danny, 232
Kenny, Tony, 137, 149, 194
Keogh, Irene, 215
Keough, Don, 250
Kerouac, Jack, 103
Kerr, Nicola, 156, 163
Kerry, County, 10, 151, 241, 260, 261
Kesey, Ken, 103
Keuhne+Nagel (freight company), 137
Khomeini, Ayatollah, 185
Kidd, Johnny, 27
Kilcolgan, 192
Kildangan Church, Co. Kildare, 147
Kildare, 98, 150, 229
Kilkee, 17, 33, 61, 80, 81, 86, 103, 104
Kilkelly, Mr, 115–116
Killaloe, Co. Clare, 72
Killen, Kevin, 214
Kilkenny, O. J. (Ossie), 180–181

Kilmainham Gaol, Dublin, 11, 253
Kilrush, Co. Clare, 34
Kineavy, Chris, 129
King, Carole, 80, 155, 307
King, Martin Luther, 267
King, Philip, *Bringing It All Back Home* (TV series), 138
King, Rodney, 267
King's Inns, Dublin, 79, 85, 114–116, 182
King's Inns Bar, Dublin, 115
Kinsale, Battle of (1601), 259–260, 262–263
Kinsale, Co. Cork, 309
Knechtel, Larry, 100
Knightsbridge, London, 94
Knockalisheen, Meelick, 290
Kotsonouris, Mary, 225
Kunz, Charlie, 221

La Coruña (Spain), 260
Labour Party, 13
Lad Lane, Dublin, 189, 238; *see also* Trend Studios
 Bill's studios, 238, 257
Lahinch, Co. Clare, 33, 61
Lamb (film), 205–209
Lamb, Peadar, 251
Lansdowne Road, Dublin, 29–30
Larry Murphy's pub, Dublin, 125–126
Later with Jools Holland (BBC series), 259
Lauder, Harry, 27
Laurel and Hardy, 28, 53
Laurel Hill school, Limerick, 55
Laurence Olivier Award, 223
Lawlor, Annie (Bill's aunt), 149, 178–179
Lawlor, Edith (Bill's aunt), 33, 149
Lawlor, Florence ('Flo') (Bill's aunt). *see* Alphonsus, Sister
Lawlor, Frederick (Fred) (Bill's uncle), 33, 34–35

INDEX

Lawlor, Gladys (Bill's aunt), 33
Lawlor SJ, Harold (Harry) (Bill's uncle), 25, 33, 35, 119, 149
Lawlor, Irene (Bill's cousin), 227
Lawlor, Irene (Bill's mother). *see* Whelan, Irene
Lawlor, John (Bill's uncle), Redemptorist, 33, 34
Lawlor, Mabel (Bill's aunt), 33, 149
Lawlor, Mary (Bill's cousin), 44, 45
Lawlor, Mary (*née* Hughes) (Bill's grandmother), 9
Lawlor, Michael (Bill's grandfather), 9
Lawlor, Michael (Mick) (Bill's uncle), 33, 149
Lawlor, Peggy (Bill's aunt), 218
Lawlor, Thomas (Bill's uncle), 33
Lawlor, Tom (Bill's cousin), 44, 45
Lawlor family, 9–10, 31–32
Lawrence Hotel, Howth, 156
Leeson Street, Dublin, 97, 134
Lehrer, Tom, 155
Lennox, Annie, 302
Les Miz, 32
Lewis, Jerry Lee, 32, 53
Leyden, Rosaleen, 97, 99–100
Liberace, 54
Liffey river, 276
Lightfoot, Gordon, 86
Lillis family (Limerick), 6, 265
Lillywhite, Steve, 210–211
Limbridge Music, 89, 106
Limerick, 43, 53, 54, 58, 60, 63, 72, 75, 80, 85, 88, 89, 90, 92, 93, 97, 99, 102, 104, 106, 107, 110, 117, 119, 149, 165, 175, 178, 184, 265
 Barrington Street, 4, 5, 7–8, 9, 117, 265
 Whelan home. *see* Whelan family (Limerick)
 Bill's childhood in, 3–14, 17–18, 31, 33, 290; *see also* Whelan family (Limerick)
 churches, 29; *see also* Crescent Church
 Freedom of Limerick, award of, 307
 O'Connell Avenue, 8, 12, 13, 45, 112
 O'Connell monument, 38, 48
 O'Connell Street, 3, 26, 58, 121
 People's Park, 24
 railway station, 8, 27
 Riverdance the Show, 300
 Schoolhouse Lane, 5, 7, 265
 schools and colleges, 19–22, 38–49, 55, 75; *see also* Crescent College; Presentation Convent
 theatres and cinema, 53; *see also* Savoy Cinema, Limerick
 Verona Villas, 16, 17
 William Street, 17, 29, 102; *see also* Whelan's shop, Limerick
Limerick Chronicle, 3
Limerick Circuit and District Court, 107–110
Limerick Courthouse, 107
Limerick Leader, ix, 3, 90, 104, 113
Limerick Pipe Band, 24
Limerick Prison, 46
Limerick School of Music, 45, 46
Limetree Theatre, 307
Linehan, Fergus, 149
Linehan, Rosaleen, 268–269
Linn drum machine, 214
Lions Club, 110
Lissycasey, Co. Clare, 80–81
Little Cicero (band), 60
Little Richard, 53, 54
Liverpool, 138
Lloyd, Harold, 28
Lloyd Webber, Sir Andrew, 134, 154, 307; *see also Jesus Christ Superstar; Joseph and the Amazing Technicolor Dreamcoat*
 letter to Bill (after *Riverdance the Show*), 305

338

INDEX

Logan, Johnny, 156, 175, 177, 180, 181, 183, 185
London, 58, 88, 89, 91–94, 103, 104, 106, 155, 163, 181, 187, 188, 199, 203, 206, 209, 214, 230, 274, 293, 300, 301, 302
 Riverdance the Show, 304–305
London Chamber Orchestra, 157
London Symphony Orchestra, 157
London Virtuosi, 157
Lone Star Café, New York, 268
Long Island, New York, 233–236
Long Kesh prison, 197
Loreto Convent, Dublin, 83
Loreto Hall, Dublin, 83
Los Angeles, 242, 267
Lough Mask, 201
Louisville, Kentucky, 297
Lovett Pearce, Sir Edward, 150
Lovin' Spoonful, The 99
Lundvall, Bruce, 214–215
Luigi's, Manhattan, 228–229
Lulu, 110
Lunny, Dónal, 143, 158, 159, 179, 193, 194, 195, 197, 198–199, 204, 240; *see also* "Timedance"
Lunny, Judy, 158
Lynch, Gerry, 87, 116
Lyons, Cliona and Fergus, 235–237
Lyons, Imelda, 6, 265
Lyons, Phyllis, 6
Lyons, Sylvia, 6
Lyra, 307

McAloon, Paddy, 258
McArdle, Jim, 115
McAteer, Paul, 143, 198
McBirneys store, Dublin, 9
McCambridges, 242
McCann, Dónal, 224
McCann, Jim, 143, 168, 194
McCarthy SJ, Fr, 120–121
McCarthy era (USA), 243

McColgan, John, 260, 271, 276, 287, 306, 307
 and *Riverdance the Show,* 291–292, 295, 299, 302, 303–304
Mac Con Iomaire, Colm, *The River Holds its Breath,* 307
McCormick, Paddy, 43–44
McCourt, Frank, 5
 Angela's Ashes, 265
McCourt, Malachy, 265–267
McCourt, Malachy Jr, 5
McCourt family (Limerick), 5
McCourtney Baldwin, Eilish, 198
McDonagh, Johnny, 306
McDonnell, Dr, 5
McDonnell, Leo, 8
Macedonian tunes, 200, 204
McEntee, Patrick, 78
McEvoy, Johnny, 146, 168, 194
McFerrin, Bobby, 308
McGarry, Ian, 125, 194, 197, 198, 257
McGettigan, Charlie, 284
McGlynn, Arty, 199
McGlynn, Michael, 270, 278–279
McGonigal, Charlie, 75
McGrath, Tom, 183
McGuinness, Frank, 308
McGuinness, Martin, 146
McGuinness, Paul, 171, 210, 229, 230, 282, 287, 292–295
McGuinness Whelan Music Publishers (McGW), 282, 292–293
Mac Intyre, Tom, 103
McKenna, Barney, 166–167
McKenzie, John, 45, 46
McKenzie, Margaret, 45
McKenzie, Scott, 'San Francisco,' 71
McLaren, Malcolm, 258
MacLaverty, Bernard, 205
MacLiammóir, Michael, 100
Mac Lochlainn SJ, Fr Vailintín, 55
McMahon, Katie, xvi, 278–279
McMahon family (Limerick), 7

339

INDEX

McMenamin, Ambrose, 220–221
Macmillan, Harold, 93
McNeive, Tony, 242, 246
McQuaid, John Charles, Archbishop of Dublin, 126
Macnas, 276, 280
Madigan, Rita, 177
Madigan's pub, Donnybrook, 175
Madonna, 230
Madrid, 259, 260
Magnificent Seven, The (film), 243
Maguire, Ciarán, 308
Maher family (Limerick), 265
Mahler, Gustav, 129
Mahon, Derek, 'Hunger,' 255
Makem, Tommy, 264
Makem and Clancy, 168
Maldives, 302
Malibu, California, 274
Man with the Golden Arm, The (film), 243
Manchester (England), 223, 264
Mancini, Henry, 242
Manhattan, New York, 227–229, 232, 265, 267
Manilow, Barry, 243, 245
Mannion, Willie, 301
Manny's Music, New York, 136
Manyeruke, Machanic ('Mechanic'), 258–259
Marmion SJ, Fr Joe, 65–66
Martin, George, 169, 258, 307
Martin, Linda, 156
Martin, Nellie (Limerick), 58
Marvin, Hank, 'Apache,' 59
Marx, 'Groucho,' 117
Marx, Karl, 85
Marx Brothers, 117
Mary Mercy, Sister (Mater Hospital), 178, 186
Mason, Harvey, 'Pack Up Your Bags,' 171
Masterdisk, New York, 232

Masterson, Brian, 161, 170–171, 179–180, 198, 201, 242, 261
Masterson, Declan, 271, 306
Mater Private Hospital, Dublin, 178, 179, 180, 186
Matterson family (Limerick), 6
Matthias Church, Budapest, 290
Mayfield, Curtis, 103
Mayo, County, 270, 271
Mayo 5000 Concert (NCH, 1993), 270, 271, 272, 276
Mayo Tourism, 270
Me and My Music (TV series), 194
Meadowmount, Churchtown, 226
Meagher, Prof. Declan, 117
Mechanics' Institute, Limerick, 53, 54
media law, 293–294
Meelick, 290
Meijer, Fred, 169
Melbourne, Australia, 223
Melody Maker, 58
Memphis, Tennessee, 138
Merchant Ivory Productions, 243
Mercier, Mel, 261
Merrion Inn, Dublin, 137, 156
Metcalfe, Granville, 45
Michael, George, 163
Midler, Bette, 245, 307
Milladoiro, 261
Millar, Taffy, 143
Miller, Arthur, 191
Miller, Basil, 84, 85
Miller, Glen, 27
Miller, Liam, 260, 287
Milligan, Spike, 169
Minor Detail, 213–216, 257
 'Canvas of Life,' 215
Minskoff Theatre, New York, 218
Mirren, Helen, 307
Mississippi Delta, 138
Mitchell, Joni, 84, 95
Moiseyev, Igor, 299

Moiseyev Dance Company of Moscow, 299
Monaghan, 9
 bombings (1974), 134
Mongols, 290
Monk, Thelonious, 27
Monroe, Marilyn, 191
Monty Python, 155
Moody Blues, 75
Mooney, Anne-Marie ('Lola'), 149, 155
Moore, Christy, 162, 197, 198, 199
Moore, Des, 125, 135–136, 143, 155, 162, 163, 296
Moore, Gary, 87, 170
Moore, Springer, 161
Moore, Thomas, 23
Moore family (Limerick), 265
Moran, Charlie, 204
Morans of the Weir, Kilcolgan, 192
Morgan family (Red House), 149
Mormons, 36
Morocco, 289
Morricone, Ennio, 242
Morris, James, 162, 171
Morrison, Conall, 308
Morrison, Van, 170, 206–208
Moscow (Russia), 299, 308
Mothers of Invention, 103
Mount St Lawrence Cemetery, Limerick, 46
Mountcharles, Lord Henry, 146
Mountjoy Square protest, Dublin, 85–86
Mountpleasant Avenue, Rathmines, 100
Moville, Co. Donegal, 137
Moving Hearts, 197, 199
Mozart, Wolfgang Amadeus, 32
Mr Chow, Knightsbridge, 94
Mulcahy's pub, Limerick, 12
Muldoon, Paul, 308
Mullen, Larry, 211
Mulrooney, Vincent (Vinny), 36

Mungret, 8
Munich, 61
Municipal Technical Institute, Limerick, 12
Munster and Leinster Bank, Limerick, 26, 27, 102
Munster Gaelic games, 17
Murphy, Belinda, 279
Murphy, Hugh, 161–162
Murphy, Michael, 261, 262
Murphy, Mike, 223
Murphy, Senan, 39, 40
Murphy, Tara, 261
Murphy, Tom, 251
Murray SJ, Fr, 76
music copyright. *see* copyrights
Music Generation, 307
Muskerry, Co. Cork, 241–242
My Ireland (RTÉ series), 194, 197
My Left Foot (film), 243
Myers, Bill, 297, 298–299
Myers, Kevin, 84

Nash, Jack, 3–4
Nashville, Tennessee, 138
National Concert Hall, Dublin (NCH), 77, 238, 240, 261, 281
 Mayo 5000 Concert (1993), 270, 271, 272, 276
National Ploughing Championships, 229
National Song Contest, 155–156, 175–176, 177, 183
National Symphony Orchestra, 271
Naughton's chip shop (Limerick), 6
Neary's Bar, Dublin, 128, 129, 222
Neeson, Liam, 205, 307
Neill, Joe, 298
Nelson, Sandy, 'Let There Be Drums,' 59
Neustift (Alpine village), 61
New Music Seminar, New York, 229–230, 232
New Musical Express (NME), 58

INDEX

new wave, 258
New York, 136, 144, 145, 146, 170, 171, 212, 214, 215, 218, 219, 264, 266, 267–268, 273, 308
 1010 Wins radio, 267
 Whelan family in, 227–237, 238
New York Times, The 264
Newhart, Bob, 155
Newman, Randy, 103, 231, 242
Newtown Pery, Limerick, 3, 15
Newtownabbey, Belfast, 133
Ní Bhuachalla, Cáit (Katy Buckley), 241–242
Ní Ghráinne, Máire, 251
Ní Ghríofa, Doireann, *A Ghost in the Throat*, 184
Ní Mhaonaigh, Mairead, 159
Ní Mhurchú, Cynthia, xvi
Nolan, Mike, 139, 158
Noonan, Jack (the Bard of Killaloe), 'The Four Who Fell,' 72, 73
North Africa, 289
Northern Ireland, 84, 146, 197
 civil rights marches, 84
 internment, 133–134
 Peace Process, 273
 'Troubles.' *see* 'Troubles,' the
Notting Hill, London, 208
Noyes, Alfred, 'The Highwayman,' 143
Nulty, Basil, 130
Nyro, Laura, 127, 155

Oasis, 302
Obama, Michelle, 306
O'Briain, Barra, 107–110
O'Brien, Dermot, 138
O'Brien, Edna, 253
O'Brien, Flann, 103
O'Callaghan, Andy, 258
Ó Carolan, Turlough, 192–193
O'Casey, Seán, *Juno and the Paycock*, 224
Ó Catháin, Éamonn, 258
O'Connell, Daniel (the Liberator), 116

O'Connell Monument, Limerick, 38, 48
O'Connor, Ann, 168
O'Connor, Eamonn, 54
O'Connor, Gerry, 168
O'Connor, Máirtín, 260–261, 296
O'Connor, Pat, 244
O'Conor, Hugh, 205
O'Conor, John, 307
O'Doherty, John, 131
O'Doherty, Michael, 131
O'Donnell, Red Hugh, 259, 260
O'Donnell clan, 263
O'Donovan, Bill, 138
Ó Duinn, Proinnsías, 261, 262, 271
O'Dwyer's pub, Dublin, 97
Ó Faoláin, Maurus, 297
Ó Faoláin, Pádraig, 12
O'Flynn, Liam, 197, 198, 199, 202–203, 204
O'Grady, Eddie, 75–76, 77, 86
O'Keefe, Donald, 'At the End of the Day,' 32
Old Vic, London, 223
Oldfield, Mike, 75
O'Leary, Diarmuid, 168–169
O'Leary, Eddie, 154–155
Oliver Freaney & Company, 131
Olympia Theatre, Dublin, 154
Olympic Studios, London, 93, 209
Omagh, Co. Tyrone, 87, 134
O'Mahoney, Jill, 89
O'Mahoney, Mike, 88–91
O'Mahony, Claire, 74, 75
O'Mahony, Paul, 63, 75, 86, 87–88, 97, 99, 116
O'Malley, Prof., 178
O'Malley, Mrs, 121
O'Malley family (Limerick), 4
Ó Maonlaí, Liam, 258, 267–268, 269
O'Moore, Eoin, 66–67
O'Neill, Damien, 281–282, 283, 285
O'Neill, Don Carlos, 263
O'Neill, Eoghan, 296

342

O'Neill, Hugh, Earl of Tyrone, 263
O'Neill J, Fr Hugh, 66
O'Neill, Jim, 176
O'Neill clan, 263
Ontario (Canada), 86
Ó Raifterí, Antoine, 'Anois Teacht an Earraigh,' 271
O'Reilly, John, 157
Ó Ríada, Peadar, 241, 297
Ó Ríada, Seán, 45, 238–241
 The Banks of Sulán, 240
 At the Gaiety (album), 275
 Mise Éire (film), 239, 240, 241
 Nomos series, 240
 Overture Olynthiac, 240
 Saoirse (film), 239
Ó Ríada Retrospective (NCH, 1987), 238–242
O'Riordan, Mickel, 57, 80
Osborough, Niall, 79–80
Oscar Theatre, Sandymount, 231
Ó Sé, Colm, 305
Ó Súilleabháin, Mícheál, 241, 258, 261, 297
O'Sullivan, Denis, 220–221
O'Sullivan SJ, Fr (Tiny), 47
O'Toole, Fran, 194
Ottomans, 290

Pacific Coast Highway, 274
Pagés, María, 261, 262, 288, 289, 295
Paisley, Rev. Ian, 146
Paisley, Rhonda, 145–146
Pale, the, 258
Palenque, Seville, 262
Palmer, Del, 201, 202
Pamuk, Orhan, *Istanbul: Memories and the City,* 1, 9
Pan Am, 236–237
Panama Canal, 88
Papp, Joseph (Joe), 218, 219
Paris, 84, 240
Parker, Alan, *Angela's Ashes* (film) 46

Parov, Nikola, 288, 290–291, 296
Patrick Street (band), 199
Patterson family (Limerick), 265
Peacock Theatre, Dublin, 250
Pearse Street Garda Station, Dublin, 224
Pearson, Noel, 153–155, 218–223, 238, 244–245, 249–251
Pedgrift, Nicholas, 293–294
Pelican House, Dublin, 134
Pembroke pub, Dublin, 76, 87, 88, 97
Penn Station, 267
Pennefather, Dave, 180, 181, 282
Pennywell, Limerick, 19
People's Republic of China, 306
Performing Rights Society (PRS), 187, 188
Peter & Gordon, 'True Love Ways,' 61
Petit, Jean-Claude, 243
petrol strike (1980), 193–194
Pheloung, Barrington, 257
Phibsboro, Dublin, 154
Phoenix Park, Dublin, 273
Pink Floyd, 75
Pirates (band), 27
Pirates of Penzance (Gilbert and Sullivan), 218–219
 Pearson's production, 218, 219, 276
planxties, 192–193
Planxty, 193, 194, 195–199; *see also* 'Timedance'
Poe, Edgar Allen, 75
Point Theatre, Dublin, 243, 308
 Eurovision (1994), xv–xvi, 276, 279–285
 Riverdance the Show (1995), 304
Poland, 285
Pollock, Jackson, 132
Pollock Holes, Kilkee, 80, 106
Polydor Records, Dublin, 126
Polydor Records, New York, 215
Polydor Records, UK, 125
Portugal, 221, 223
Power, Dee, 69, 71

INDEX

Prefab Sprout, 258
Presentation Convent, Limerick, 19–22, 38, 39, 55
Presley, Elvis, 27, 274
Prince, 232
Princeton University, 308
Principle Management, 293
Proctor, Martin, 208
Producers, The, 163
Profumo affair, 93
Protestants, 18, 83, 99
Proud Boys, 267
Puritans, The, 258

Quimper, Brittany, 196
Quinn, Barry, 148
Quinn, Bob, *Atlantean* (film), 289
Quinn, Brian, 148, 270
Quinn, Declan, 148
Quinn, Denis (Bill's father-in-law), 133, 148
Quinn, Denis, Jnr, 148
Quinn, Denise (Bill's wife), xv, 102, 103, 106, 110, 180, 185, 191, 201, 205, 218, 221, 226, 227, 229, 239, 243–244, 247, 273, 284, 307, 308
 first encounter with Bill, 87, 88, 104
 friendship and courtship, 97–101, 117, 123, *135,* 136, 137, 147
 living in Belfast, 133, 134, 218
 marriage and honeymoon, 100, 147–152
 children and grandchildren, 185, 308–309
 parents and siblings, 148
Quinn, Eimear, 'The Voice,' 183
Quinn, Fiona, 148, 149
Quinn, Mary (Bill's mother-in-law), 148, 227, 295
Quinn, Mick, 216, 217
Quinn, Ruairí, 84
Quinn family, 148, 150
Quinn twins, 60

QWIK Cassette Copying Co., New York, 232–233

Radio Centre, 139
Radio City Music Hall, New York, 269, 306
Radio Luxembourg, 75
Radiohead, 302
Rafferty, Gerry, 'Baker Street,' 161–162
Rafter, Denis, 259–260, 261
Ramone, Phil, 307
Randy Newman musical (1983), *231*
Ranelagh, Dublin, 74, 132
 Whelan family home, 191, 226, 227, 239, 251, 277, 278
 attic studio, 183, 277, 295
Raphael, Sister, 19, 21
Rathcoole estate, Newtownabbey, 133
Rathmines, Dublin, 100
Ravenscroft, Raphael (Raff), 162–164
Rebellion of 1798, 23
Record Mirror, 58
Red House, Co. Kildare, 149–150
Redemptorists, 34
Redford, Robert, 243–244
Reeves, Anita, 296
Reeves, Jim, 138
Reggae Philharmonic Orchestra, 258
Reilly, Liam, 183
Reilly, Maggie, 177
Reilly, Paddy, 168
Reilly, Pat, 177
Reilly, William Spencer, 264
Republic of Ireland Music Publishers Association (RIMPA), 188
Republican Club, 85
Reynolds, Albert, 262, 263
Reynolds, Desi, 125, 128–130, 137, 155, 156–157, 223, 280, 296
Rhodesia, 190, 192
Rhodesian Bush War, 192
Richardson, Haley, 307

Ridge Farm studios, Surrey, 163–164
Riley, Mykaell, 258
Ringsend, Dublin, 280
Riqueni, Rafael, 289, 296
River Runs Through It, A (film), 243
Riverdance, 243, 245, 246, 261, 269, 271, 274, 287, 293, 294, 306, 307
 'Cloudsong,' 278
 Eurovision 1994, xv–xvi, 275–285
 impact of, 308
 record single, 281–282, 284
Riverdance the Show, 286, 287–305, 306, 307, 308
 contract negotiations, 293–295
 investors, 287, 293
 performances, 304–306
 team of players, 296–297
 'Trading Taps,' 301
Robbins, Richard, 243
Robinson, Mary, xv, 271, 285
Robot Monster (film), 243
Rock, Dickie, 216–217
rock bands, 124, 139, 229
rock 'n' roll, x, 27
Rockettes, The 306
Rocks, Seán, 251
Roddy, Pat, 304
Rolling Stones, The, 56, 57
Romaní, Rodrigo, 261
Rosbeigh Strand, Co. Kerry, 151, 152
Rosbrien, 8, 9
Rosc, 18
Roscrea Cistercian Abbey, 12, 13, 14
Rosslare, Co. Wexford, 60
Roundstone, Co. Galway, 205, 208, 209
Roxboro, Limerick, 19
Royal Albert Hall, 307
Royal Irish Academy, 45
royalties, 187–189
RTÉ, 86, 136, 141, 142, 147, 155–156, 175, 176, 177, 183, 185, 194, 239, 260, 261
 An Eye on the Music, 257–259
 and *Riverdance the Show,* 287, 293, 295
 Saturday Live, 144, 145–146
 song contests, hosting of; *see also* National Song Contest
 Eurovision, 197, 279, 281, 282, 283, 285
RTÉ Concert Orchestra, 139–141, 240, 257, 260, 261–262, 280
RTÉ Radio Centre, 280–281
rugby, 29–30
Russell, Russ, 171, 242
Russian army, 290
Russian folk dance, 299–300
Ryan, Gerry, xvi
Ryan, John, 25, 138
Ryan, Ma, 58

Sacco, Nicola, 197
Sacred Heart College, Limerick. *see* Crescent College
St Clerans (Isercleran), Craughwell, 191–192, 193, 194
St John, Pete, 142, 188
St John's Hospital, Limerick, 101
St Joseph's Church, Limerick, 4
St Joseph's Mental Hospital, Limerick, 46
St Michael's Church, Limerick, 5
St Philomena's School, Limerick, 39
Salvador, 308
San Diego (USA), 88, 89
San Francisco (USA), 58
Sandeman, the, 159–161
Sands, Bobby, 197
Sandycove, Dublin, 147, 226
Sanlúcar, Manolo, 289
Santa Barbara, 243
Sartre, Jean-Paul, 191
Saturday Live (RTÉ), 144, 145–146
Savoy Cinema, Limerick, 24, 58, 242
 Bloomfield premiere, 110–112, *111*
Sayles, John, 243

INDEX

Scaife, Sarah-Jane, 251
Scarlatti, Domenico, 32
Schiphol Airport, 274
Schnabel, Julian, 307
Schneider, Romy, 91
Schöne Aussicht (Tyrol), 61
School Friend (comic), ix, 18
Schwarzenegger, Arnold, 274
Sciascia, Charlie, 45, 46–47
Scott, Irene, 267
Scott, Mike, 267
Scottish Isles, 289
Scullion, 293
Seale, Bobby, *Seize the Time*, 85
Searson's pub, Dublin, 276
Segal, Misha, 242
Senators (band), The 60
Sergio Mendes (band), 72
Seville (Spain), 262–263, 264, 288–289
 Expo '92, 259–262, 289
 Irish National Day (1992), 260, 262
Seville Suite, The, 261–263, *263*, 264,
 271, 287, 289, 293
SFX, Dublin, 299
Shakespeare, William, *The Merchant of Venice,* 67
Shakira, 214
Shannon, Co. Clare, 91, 94
Shannon Airport, 4, 44, 209
Shannon Estuary, 44
Shannon Folk Four, 72–73
Shannon River, 117
Shcherbakova, Elena, 299
Sheahan, Ab, 5–6, 265
Sheahan, John, 159, 165–167, 168, 204
Sheahan's pub, Dublin, 128–129
Shelbourne Hotel, Dublin, 244
Shelley, Mary, 75
Sheridan, Christy, 168
Sheridan, Jim, 245
Shire, David, 243
showbands, 124, 137–138, 138–139,
 199, 216

Shupe, Patti, 298
Siamsa Tíre, 260
Side by Side by Sondheim, 155
Siegenthaler, Amy, 273
Simon, Paul, 100–101, 144, 307
Simon and Garfunkel, 80, 100, 103, 215
Sinden, Billy, 58–59, *59,* 86, 117
Sinn Féin, 85
Six-Day War (1967), 58
Slane Castle, Co. Meath, 146
Slattery, Mrs, 16
Sligo, 195
Slott, Susan, 158
Small Faces, 69
Smith, Betty (Bill's godmother), 17
Smith, Don, 98
Smith, Ian, 192
Smith, Jean Kennedy, 273, 307
Smithtown, Long Island, 227, 233–236
Smyth, Des, 190
Soho, London, 181
Sommerville-Large, Bill, 164
Son Records, 282, 285
Sondheim, Stephen, 307
songs and tunes
 albums. *see individual artists and groups*
 Bill's compositions and collaborations. *see under* Whelan, Bill
 Ireland's Eurovision entries, Bill's involvement with, 182–183
 'Hold Me Now,' 156, 183
 'It's Nice to Be in Love Again,' 156, 183
 'Terminal 3,' 156, 183
 'The Voice,' 183
 'What's Another Year'. *see* 'What's Another Year'
 titles cited
 '50 Ways to Leave Your Lover,' 144
 'A Chomaraigh Aoibhinn Ó,' 297

346

INDEX

'All My Loving,' 48
'Antice Djanam Dusice,' 204
'Apache,' 59
'At the End of the Day,' 32
'Ave Maria,' 149
'Baker Street,' 161–162
'Banks of My Own Lovely Lee,' 45
'Brazil,' 32
'Bridge Over Troubled Water,' 100
'Can't Buy a Thrill,' 123
'Daisy a Day,' 142
'Delirium Tremens,' 162
'Deus Noster,' 271
'Early Morning Rain,' 86
'Free Man in Paris,' 95
'Gone at Last,' 137
'He Ain't Heavy He's My Brother,' 127
'How Sweet It Is,' 137
'Hucklebuck,' 56
'I Can't Get No Satisfaction,' 57
'Itchycoo Park,' 69
'Itsy Bitsy Teenie Weenie Yellow Polka Dot Bikini,' 61–62
'Jig of Life,' 204
'Kellswater,' 197
'Let Us Break Bread Together,' 171
'Little Musgrave,' 197
'Living Doll,' 59
'MacArthur Park,' 91
'Marching to Pretoria,' 25
'Morning Has Broken,' 149
'Nancy Spain,' 198
'Never an Everyday Thing,' 89
'Night of the Swallow,' 202–203
'On the Blanket,' 197
'Peg,' 137
'Rare Old Times,' 142
'Red Roses for Mary,' 190, 192
'Ringsend Boatman,' 142
'Rock 'n' Roll Kids,' 284, 285
'Róisín Dubh,' 240
'Sailing,' 181
'Save the Country,' 127
'Scorn Not His Simplicity,' 93
'Scotland the Brave,' 24
'Smeceno Horo,' 197
'Something,' 91
'Song for Ireland,' 165
'Stardust,' 176–177
'Step It Out Mary,' 142
'Táimse im'Chodhladh,' 197
'The Ballymun Regatta,' 198
'The Bould Thady Quill,' 148, 150
'The Highwayman,' 143, 258
'The Humours of Barrack Street,' 198
'The Minstrel Boy,' 23
'The Parting Glass,' 140
'The Right Time,' 274
'The Town I Loved So Well,' 93
'This Boy,' 56
'This Is Your Life,' 127
'What'd I Say,' 32
'Whiskey on a Sunday,' 142
'Wichita Lineman,' 71
'Wild Thing,' 56
'Woyaya,' 127
'You Put the Love in My Heart,' 155
'Zamboanga,' 33–34
Sorohan, Séamus, 78
South African songs, 25
Southern Dixie music, 86
Soviet Union, 290
Spain, 217, 259–262, 285, 288–289
Spanish army (1601), 259, 260
Spanish dance, 260, 288; *see also* flamenco

INDEX

Spanish music, 260, 261, 288
Spencer, Ged, 58–59, 71, 117
Spillane, Davy, 200, 204, 209, 258, 260–261, 296
Spirit of Mayo, The (Whelan), 270–272, 272, 287
Springfield, Dusty, 54
Springfield State Mental Hospital, Maryland, 102
Sridhar, Krishnamurti, 258
Stacc, 155–156, 156–158, 162, 163, 166, 195
Star Tavern, Belgravia, 93–94
Stars and Bars (film), 244
State Cinema, Phibsboro, 154
Status Quo, 124
Steele, Tommy, 27
Steely Dan, 123
Steiger, Rod, 234
Stephen's Green, Dublin, 83, 97, 98, 154, 224
Stevens, Cat, 149
Stewart, Ken, 188
Stewart, Louis, 125, 160–161
Stewart, Rod, 181
Stockton's Wing, 168, 232–233
Stoke-on-Trent, 181
Stokes, Maurice, 55–56
Stokes, Mrs, 57
Stokes family, 56
Strauss, Johan II, 258
 Prince Methusalem, 67
Streep, Meryl, 307
Streisand, Barbara, 123
Stretton, Eugene, 43
Students for Democratic Action (SDA), 84–85
Stuyvesant Town (Stuytown), New York, 267–268
Suffolk County District Court, 235
Sullivan, Arthur, 218–219
Summer of Love (Haight-Ashbury 1967), 71

Sunday Night at the Olympia (TV series), 259
Supply Demand and Curve, 170
Sutherland, Joan, 27
Sutherland Brothers (Gavin and Iain), 'Sailing,' 181
Sutherland Brothers & Quiver, 181
Swarbriggs, 183
Swarbriggs Plus Two, 156
Sweet Afton (cigarettes), 63, 64
Swinging Four (band), 58–59, 59
Switzerland, 60
Sydney Opera House, 306
Sykesville, Maryland, 102

Tailor's Hall, Dublin, 155
Talbot, Matt, 168
Talk of the Town, Limerick, 58
Tara Records, 281
Tarab, 308
Taylor, Elizabeth, 94
Taylor, James, 80, 307
Taylor, Simon, 260
Teatro de la Maestranza, Seville, 261, 262
Tebaldi, Renata, 27
Tee, Richard, 144
Tehran (Iran), 185
Telegraph, The, 105, 106
Thalberg, Sigismond, 'Home Sweet Home with Variations,' 32
Thatcher, Margaret, 197
Thin Lizzy, 124, 170
Thomas, Dylan, 186
Thomond Park, Limerick, 29
Thompson, David, 42
Thompson, Linda, 274
Thurber, James, 103
Tiernan, Paul, 293
Tikaram, Tanita, 258
'Timedance' (Whelan and Lunny), 193, 198–199, 283
Tinsley family (Limerick), 7
Tipperary, 43

348

To Kill a Mockingbird (film), 243
Tobin family (Limerick), 5, 265
Todds of Limerick, 9, 31
Tóibín, Colm, 308
Tokyo, Japan, 275, 296, 308
Tom & Paschal's Christmas Crackers, 53–54
Toners pub, Dublin, 137
Tony Awards, 268
Top of Coom, Coolea, 241
Topper, The, (comic) 18
Tormey SJ, Fr, 39–40, 41, 42
Tornados, 'Telstar,' 54
Toronto (Canada), 218
Tottenham Court Road, London, 209
Tourish, Ciarán, 159
Toussaint, Allen, 214
Toyota, 159
Toys 'R' Us, 233–234, 235
Tracey, Margo, 159
Tradaree, Co. Limerick, 43–44
traditional music, 167, 168, 194–195, 201, 258, 275, 279, 280, 297
Tralee, Co. Kerry, 261, 262
Trend Studios, Dublin, 124–125, 127, 159–160, 189, 194, 200, 238
Trinity College Dublin, 83
Trio Bulgarka, 258
Troddyn SJ, Fr Willie, 47
Troggs, The, 56
Trotsky, Leon, 85
'Troubles,' the, 133–134, 196, 197, 205
Trump, Donald, 211
Tully, Colin, 177
Tynan, Dorothy, 44–45
Tyrol, 61

U2, 171, 172, 210–212, 214, 215, 229, 253, 282, 293, 294
 Boy, 210
 October, 210
 'The Refugee,' 210–212, 213
 War, 210
 'With or Without You,' 184

UB40 (band), 172
UCD (University College Dublin), 74–86, 98
 college life, 83–86
 Earlsfort Terrace campus, 83–84
 Great Hall, 77, 85
 Kevin Barry Room, 84
 law studies, 79, 114, 182; *see also* King's Inns
 conferral (1973), 130
 Literary and Historical Society (L&H), 85
 music in, 86–87, 134–135
 student population, 83, 84
 student protest (1968), 84–85
Uí Cheallaigh, Áine, 297
Uí Fhlatharta, Séamus and Caoimhe, 307
Ukraine, 211
Ulster, 263; *see also* Northern Ireland
Ulster Hall, Belfast, 196
Ulster Orchestra, 307
Ulster Volunteer Force (UVF), 134
Uniacke, Eddie, 66
United Irishman, 18
United Kingdom, 24, 59, 60, 73, 155, 161, 192, 197, 199, 223, 230, 232, 275
 Top 20, 180
 Top 100, 210
United Nations, 308
United States of America, 59, 79, 84, 85, 106, 142, 144, 159, 170, 199, 208, 209, 210, 211, 225, 227–238, 273, 281, 301, 307; *see also* New York
 country and western music, 138
 gospel singing, 297–298
 Jim Crow, 301
 McCarthy era, 243
 record companies, 214–215
University College Cork, 297
University Hall, Dublin. *see* Hatch Hall
University of Limerick Foundation, 307
University of Salford, Manchester, 264
Ure, Midge, 258

INDEX

Uris, Jill, 266
Uris, Leon, 266–267
 Trinity, 264–267, 266, 268, 269

van de Velde, Firmin, 45
Vanessa-Mae, 307
Vanzetti, Bartolomeo, 197
Vatican II, 126
Venice, 61, 307
Verno Ltd, 71–73, 117
Verno Studios, Limerick, 72, 73
Vernon, J. J., 264
Verona Villas Bombers, 17
Verso, Norman, 196
Vienna, 290
Vietnam War, 84
Villiers school, 57
Vortexion (tape recorder), 70–71
Vos, Paul, 70–71

Waites, Cassandra, 93
Walsh, Annette, 166, 167
Walsh, Caitríona. *see* Warren-Greene, Caitríona
Walsh, Jimmy, 183
Walshe, Willis, 115–116
Wandsworth, 230
War of Independence (1919–21), 12, 13, 72
Warner Elecktra Atlantic (WEA), 198
Warnes, Jennifer, 'Mama,' 157
Warren-Green, Nigel, 156, 157–158, 163, 165–166, 167
Warren-Greene, Caitríona (*née* Walsh), 156, 157, 158, 166, 167, 246, 271
Watchorn, Patsy, 168
Waterboys, The, 267
Waterloo Road, Dublin (Bill's office), 158, 188
W.B. Yeats Festival, 250–253, 257, 259, 270, 273, 297
Webb, Jimmy, 71, 80, 91, 104, 258, 307

Weir, Mrs, 130
Weir's jewellers, Dublin, 168, 176
Wellington Road, Ballsbridge (Bill's apartment), 130–131, 132, 134
West Orange, New Jersey, 144
West Side Story, 154
West Village, New York, 265, 268
Westland Studios, Dublin, 166, 169, 170
'What's Another Year' (Shay Healy), 156, 177, 179–181, 182, 183, 197, 282
Wheatley, Dennis
 To the Devil a Daughter, 75
 The Devil Rides Out, 75
Whelan, Bill, 59, 77–78, 90, 203
 childhood and family in Limerick, 3–18
 parents, 9–10, 23–30, 31–37; *see also* Whelan, Dave; Whelan, Irene
 wider family, 11–14; *see also* Whelan family (Limerick)
 education
 Limerick schools, 19–22, 38–49; *see also* Crescent College, Limerick
 musical education, 23–25, 44–45, 58–59, 86–87, 134–135
 third-level (Dublin), 74–86; *see also* King's Inns; UCD
 family, marriage and personal life, 248–249
 alcohol consumption, 80, 114, 149, 224–225, 247–249, 253, 254, 265
 children and grandchildren, 10, 185, 226, 308–309
 family home, 226; *see also* Ranelagh
 marriage and honeymoon, 147–152; *see also* Quinn, Denise (Bill's wife)

film orchestra. *see* Irish Film Orchestras
film-scoring, 205–209, 238–246, 307
Freedom of Limerick, 307
Grammy Award, 307
Kinsale and Seville project, 259–263; *see also* Seville Suite
Mayo project. *see* Spirit of Mayo, The
music-copying, 136
music publishing, 282, 292–293
musical collaborations, 69–73; *see also* Connery, Niall
 'Kennington Lane' (with Power), 69
 'Lady Anne' (with Connery), 69
 'Reality' (with Cosgrove), 69
 'The Company Line' (with Connery), 69–70
 'Timedance' (with Lunny). *see* 'Timedance'
 Verno Ltd, 71–73
musical compositions, 307; *see also* Riverdance; Riverdance the Show; Seville Suite; Spirit of Mayo, The
 'All Fall Down,' 155
 'Cloudsong,' 278–279
 'Countess Cathleen,' 292
 'Denise,' 88, 89–90, 91, 103–104
 'Deserted Village,' 271
 Eurovision, involvement with, 182–183; *see also* Eurovision Song Contest
 'Firedance,' 292, 294
 'Heal Their Hearts,' 298
 'Heartland,' 302
 'Hope to the Suffering,' 298
 'Isercleran,' 192, 193, 198
 'Lift the Wings,' 292, 297
 'Reel Around the Sun,' 292
 'Shivna,' 299
 'Trading Taps,' 301
musical copyrights, involvement with. *see* copyrights
recording studios in Dublin, work with. *see* Lad Lane; Trend Studios; Windmill Lane Studios
Yeats Festival, involvement with. *see* W.B. Yeats Festival
Whelan, Brian (Bill's son), 205, 226, 308
Whelan, Celia (Bill's aunt), 12, 13, 184, 226
Whelan, Daniel, 11
Whelan, Dave (Bill's father), 9, 10, 11, 12, 13, 14, 17, 23–30, 37, 67, 74–75, 81, 112, 113, 184, 226, 259
 illness and death, 113, 119–122
 and Lawlor family, 31–32, 33, 35
 music and other interests, 23–28, 69
 religious observance, 28–30
Whelan, David (Bill's son), 185, 191, 226, 308–309
Whelan, Denise (Bill's wife). *see* Quinn, Denise
Whelan, Fiona (Bill's daughter), 185, 191, 226, 228–229, 235, 251, 308
Whelan, Irene (*née* Lawlor) (Bill's mother), 9, 10, 13, 17, 20, 21, 22, 27, 28, 31–37, 60, 61, 72, 74, 81–82, 106–107, 112, 119–120, 123, 130, 149, 150, 152, 184–185, 215, 308–309
 death of husband, 121–122
 illness, 178–179, 180, 185–186
 death, 186
Whelan, John (Bill's uncle), 12, 21
Whelan, Kathleen (Bill's aunt), 12, 13
Whelan, Nessa (Bill's daughter), 185, 191, 226, 233–234, 235, 244, 251, 308
Whelan, Pat (Bill's uncle), 12, 13
Whelan, Stephen (Bill's brother), 9
Whelan, William (Bill's grandfather), 11, 13, 36
 obituary, *11*
Whelan, Willie (Bill's uncle), Cistercian monk, 12, 13–14

INDEX

Whelan family (Limerick), 5–7, 8–14, 91, 192, 226
 Bill's parents, 9–10, 23–37; *see also* Whelan, Dave; Whelan, Irene
 family home, 18 Barrington Street, 4, 5, 9, 74, 80, 152, 179, 243
 attic studio, 70–73
 home cinema, 27–28
 shop in William Street. *see* Whelan's shop, Limerick
Whelan's pub, Dublin, 273–274
Whelan's shop, Limerick (William St), 17–18, 24, 26, 29, 53
White, Freddie, 231, 232
Whiting, Leonard, 110
Wicklow mountains, 244
Wilkinson, Colm, 'Born to Sing,' 156
Williams, Hank, 138
Williams, John, 242
Willson, Major James, 189–194
Windmill Lane Studios, Dublin, 159, 161, 162, 170–172, 177, 198, 201, 209, 216, 267, 274
 international film-scoring, 242, 244
 Minor Detail project, 213–216
 Riverdance, recording of, 280
 Riverdance the Show, 295, 301
 U2 sessions, 210–212
Winkler, Henry ('The Fonz'), 307
Winston, Tarik, 301
Winwood, Muff, 181, 182
Winwood, Stevie, 172
Wogan, Terry, 285
Wolfe Tones, The, 168
Women's Lib, 93
Wonder, Stevie, 155

Wood, Keith, 300
Woods, John, 126
Woods, Nellie, 17
Woodstock, 267, 269
World War II, 63
Woulfe, Tessie, 35, 149

Xi Jinping, 306

Yeats, William Butler, 148, 230, 250, 271, 309
 annual Festival. *see* W.B. Yeats Festival
 The Cat and the Moon, 273
 The Countess Cathleen, 250
 Cuchulain cycle, 251
 A Full Moon in March, 273
 At the Hawk's Well, 250, 251
 'Mad as the Mist and Snow,' 253
 Words Upon the Window Pane, 253, 273
Yeoman of the Guard, 220, 221
Yothu Yindi, 267
Young Lady Chatterley II (film), 242
Yo-Yo Ma, 214

Zappa, Frank, 103
Zeffirelli, Franco, *Romeo and Juliet,* 110
Zeiger, Neil, 208–209
Zeller, Carl, *The Bird Seller,* 67
Zevon, Warren, 'Nightime in the Switching Yard,' 8
Zimbabwe, 192, 258–259
Zsuráfszky, Zoltán, 290